Readings in
American Art
1900–1975

Readings in American Art 1900-1975

Edited by
BARBARA ROSE

PRAEGER PUBLISHERS
New York

Published in the United States of America in 1975
by Praeger Publishers, Inc.
111 Fourth Avenue, New York, N.Y. 10003

This is the revised edition of a book originally published in 1968 by
Frederick A. Praeger, Inc., under the title *Readings in American Art Since 1900*.

Library of Congress Cataloging in Publication Data

Rose, Barbara, comp.
 Readings in American art, 1900–1975.

 Published in 1968 under title: Readings in American art since 1900.
 Bibliography: p.
 Includes index.
 1. Art, American—History—Addresses, essays, lectures. 2. Art, Modern—
20th century—United States—Addresses, essays, lectures. I. Title.
N6512.R64 1975 709'.73 74-17891
ISBN 0-275-46710-4
ISBN 0-275-89120-8 pbk.

Printed in the United States of America

Acknowledgments

Grateful acknowledgment is made for the use of the following material:

"Statements by the Artist," from a press release for *Nancy Graves*, an exhibition of drawings at the Albright-Knox Art Gallery, Buffalo, New York, 1974, reprinted by permission of the Albright-Knox Art Gallery and Nancy Graves.

Statement by David Smith, from "A Symposium on Art and Religion," *Art Digest,* December 15, 1953. Excerpt from "Specific Objects," by Don Judd, in *Contemporary Sculpture* (New York: The Art Digest [Arts Yearbook 8], 1965). Both reprinted by permission of *Art Digest.*

Statement by John Flannagan; excerpt from "Poverty, Politics, and Artists, 1930–45," by Burgoyne Diller and Reginald Marsh. Both from *Art in America,* LIII, No. 4, 1965. Statement by Ronald Bladen, from "ABC Art," by Barbara Rose, *Art in America,* LIII, No. 5, 1965. Excerpt from "The Artist Speaks: Robert Rauschenberg," an interview by Dorothy Gees Seckler, *Art in America,* LIV, No. 3, 1966. Excerpt from "The Sensibility of the Sixties," compiled by Irving Sandler and Barbara Rose, *Art in America,* LV, No. 1, 1967. Statement by Chuck Close, from an interview by Linda Chase and Ted McBurnett, in Linda Chase, Nancy Foote, and Ted McBurnett, "Photo-Realists: 12 Interviews, *"Art in America,* LX, No. 6, 1972. All reprinted by permission of *Art in America* and the authors.

Excerpt from "Art-as-Art," by Ad Reinhardt, *Art International,* VI, No. 10 (December 20, 1962). Statement by Ellsworth Kelly, from 'Interview with Ellsworth Kelly,' by Henry Geldzahler, *Art International,* VIII, No. 1 (February, 1964). Both reprinted by permission of *Art International* and the authors.

Excerpt from "Is Today's Artist With or Against the Past?" an interview with Willem de Kooning by Thomas B. Hess, *Art News,* Summer, 1958, (© 1958 by *Art News*). Selected portions of "What Is

Acknowledgments

Pop Art?" interviews by G. Swenson with Roy Lichtenstein and Andy Warhol, *Art News,* November, 1963 (© 1963 by *Art News*), and with James Rosenquist and Jasper Johns, *Art News,* February, 1964 (© 1964 by *Art News*). Excerpt from "Questions to Stella and Judd," by Bruce Glaser, *Art News,* September, 1966 (© 1966 by *Art News*). Statement by Bruce Nauman, from an interview by Joe Raffaele and Elizabeth Baker, "The Way Out West: Interviews with Four San Francisco Artists," *Art News,* Summer, 1967 (© 1967 by *Art News*). Excerpt from "Chartres and Jericho," by Barnett Newman, *Art News,* April, 1969 (© 1969 by *Art News*). Excerpt from "Interview with Willem de Kooning," by Harold Rosenberg, *Art News,* September, 1972 (© 1972 by *Art News*). All reprinted by permission of *Art News.*

Excerpt from "Andy Warhol," by Larry Bell, *Artforum,* February, 1965. Statement by Helen Frankenthaler, from an interview by Henry Geldzahler, *Artforum,* October, 1965. Excerpt from "Entropy and the New Monuments," by Robert Smithson, *Artforum,* June, 1966. Excerpts from "Notes on Sculpture," Parts I, II, and III, by Robert Morris, *Artforum,* February, 1966, October, 1966, and April, 1969, respectively. Statement by Dan Flavin, from "Some Remarks," *Artforum,* December, 1966. Excerpt from "Talking with Tony Smith," an interview by Samuel Wagstaff, Jr., *Artforum,* December, 1966. Excerpt from "Talking with Roy Lichtenstein, an interview by John Coplans, *Artforum,* May, 1967. Excerpts from "Earthworks and the New Picturesque," by Sidney Tillim, *Artforum,* December, 1968. Excerpt from "Notes on American Painting of the Sixties," by Walter Darby Bannard, *Artforum,* January, 1970. Statement by Eva Hesse, from "An Interview with Eva Hesse," by Cindy Nemser, *Artforum,* May, 1970. Excerpt from "Problems of Criticism, IX," by Jack Burnham, *Artforum,* January, 1971. Statement by Hans Hofmann, from "A Conversation with Hans Hofmann," by Irma B. Jaffe, *Artforum,* January, 1971. All reprinted by permission of *Artforum* and the authors.

Excerpt from "Optical Art: Pending or Ending?" by Sidney Tillim, *Arts Magazine,* XXXIX (January, 1965). Excerpt from "America: War and Sex, Etc.," by Claes Oldenburg, *Arts Magazine* XLI (Summer, 1967). Excerpt from "Serial Art, Systems, Solipsism," by Mel Bochner, *Arts Magazine,* XLI (Summer, 1967). Statement by Adolph

Gottlieb, from "Adolph Gottlieb: Two Views," an interview by Jeanne Siegel, *Arts Magazine,* XLII (February, 1968). Excerpt from "Play It Again, Sam," by Richard Serra, *Arts Magazine,* XLIV (February, 1970). Statement by Bruce Nauman, from an interview by Willoughby Sharp, *Arts Magazine,* XLIV (March, 1970). Excerpt from "An Omnivorous and Literal Dependence," by Robert Hughes, *Arts Magazine,* XLVIII (June, 1974). All reprinted by permission of *Arts Magazine.*

Statement by Jackson Pollock, from *Arts and Architecture* February, 1944, reprinted by permission of *Arts and Architecture.*

Excerpt from *An Artist in America* by Thomas Hart Benton, rev. ed. (Kansas City: University of Kansas City Press, Twayne Publishers, 1951), reprinted by permission of the author.

"Thoughts on Sculpture" and "Second Thoughts on Sculpture" by David Smith, *College Art Journal,* Winter and Spring, 1954, reprinted by permission of *College Art Journal.*

Excerpt from an unpublished manuscript by Mark di Suvero, reprinted by permission of the author.

Excerpt by Martin Friedman, from *Projected Images,* catalogue of an exhibition at the Walker Art Center, Minneapolis, 1974, reprinted by permission of the author.

Statement by Charles Sheeler, from *Charles Sheeler: Artist in the American Tradition,* by Constance Rourke (New York: Harcourt Brace, 1938), reprinted by permission of Harcourt Brace Jovanovich, Inc.

Excerpt from "The 'Modern' Spirit in Art," by Kenyon Cox, *Harper's Weekly,* March 15, 1913, reprinted by permission of Harper's Magazine, Inc.

Excerpt from "The Renaissance and Order," by Willem de Kooning, *trans/formation, arts, communication, environment: a world review,* I, No. 2, 1951. Edited by Harry Holtzman. Copyright © 1951 by Harry Holtzman and Martin James, reprinted with their permission.

Statement by Mark Rothko, from *Interiors,* May, 1951, published through the courtesy of *Interiors.* Copyright © 1951. Whitney Publications, Inc.

Excerpts by Robert Rosenblum and Alan R. Solomon, from *Toward*

Acknowledgments

a New Abstraction, catalogue of an exhibition at The Jewish Museum, New York, 1963, reprinted by permission of The Jewish Museum.

Excerpt from "Lexicon of Mapping," by Nancy Graves, *Nancy Graves,* catalogue of an exhibition at the La Jolla Museum of Contemporary Art, La Jolla, California, 1973. Copyright © 1973 by the La Jolla Museum of Contmporary Art. Reprinted by permission of the La Jolla Museum of Contemporary Art and the author.

Excerpt from "An Address to the Students of the School of Design for Women, Philadelphia, Written in 1901," in *The Art Spirit,* by Robert Henri, edited by Margery Ryerson (Philadelphia and New York: J. B. Lippincott Co., 1960). Copyright 1923, 1930 by J. B. Lippincott Company. Copyright renewed 1951 by Violet Organ. Reprinted by permission of the J. B. Lippincott Company.

Selected portions of Clement Greenberg's introduction to *Post-Painterly Abstraction,* catalogue of the Los Angeles County Museum. First published in 1964 and reprinted by permission of the Los Angeles County Museum and the author. Excerpts by Lucy R. Lippard and Clement Greenberg in *American Sculpture of the Sixties,* catalogue of an exhibition at the Los Angeles County Museum of Art, 1967, reprinted by permission of the Los Angeles County Museum of Art.

Statement by Jackson Pollock, from *Jackson Pollock: Energy Made Visible,* by B. H. Friedman (New York; McGraw-Hill, 1972). Copyright © 1972 by McGraw-Hill, Inc. Used with permission of McGraw-Hill Book Company.

Excerpt from "Notes on Painting," by Edward Hopper, first published in *Edward Hopper Retrospective Exhibition,* catalogue of an exhibition at The Museum of Modern Art, New York, edited by Alfred H. Barr, Jr., 1933. Copyright © 1933 and renewed 1960 by The Museum of Modern Art, New York. Excerpt from "A Brief Note on the Exhibition," by Charles Sheeler, first published in *Charles Sheeler, Paintings, Drawings, Photographs,* catalogue of an exhibition at The Museum of Modern Art, New York, 1939. Copyright © 1939 and renewed 1966 by The Museum of Modern Art, New York. Statement by Ivan Le Lorraine Albright in *American Realists and Magic Realists,* edited by Dorothy C. Miller and Alfred H. Barr, Jr., copyright © 1943 and renewed 1970 by The Museum of Modern Art, New York. Statement by Willem de Kooning, from "What Abstract Art Means to Me," *Bulletin of the Museum of Modern Art, New York,*

Acknowledgments

XVIII, No. 3, Spring, 1951. Statements by Jasper Johns and Robert Rauschenberg from *Sixteen Americans,* edited by Dorothy C. Miller, copyright © 1959 by The Museum of Modern Art, New York. Excerpt from *Josef Albers: Homage to the Square,* by Kynaston L. McShine, copyright © 1964 by The International Council of The Museum of Modern Art, New York. All rights reserved. All reprinted by permission of The Museum of Modern Art, New York.

Excerpt from ". . . in daylight or cool white," by Dan Flavin, in Brydon Smith, *Fluorescent Light, etc. from Dan Flavin,* catalogue of an exhibition at the National Gallery of Canada, Ottawa, and the Vancouver Art Gallery, Vancouver, 1969, reprinted by permission of the National Museums of Canada and Dan Flavin.

Excerpt from ". . . And This Is About Conceptual Art," by Rudolph Arnheim, from *The New York Times,* July 13, 1974. Copyright © 1974 by The New York Times Company. Reprinted by permission.

Excerpt from *The Selected Writings of John Marin,* edited by Dorothy Norman (New York: Pellegrini & Cudahy, 1949). Reprinted by permission of Dorothy Norman and the author. Excerpt from "Writings and Conversations of Alfred Stieglitz," edited by Dorothy Norman, reprinted from *Twice a Year,* Nos. 14–15, 1947, by permission of Dorothy Norman.

Selected portions of "Twilight of the Superstars," by Barbara Rose. A revised version of this essay appeared in *Partisan Review,* No. 4, 1974. Copyright © 1974 by Partisan Review, Inc., and printed with their permission.

Excerpt from "Statement by Hans Hofmann," *It is,* Winter-Spring 1959, reprinted by permission of Philip Pavia.

Excerpt from *Men of Art* by Thomas Craven (New York: Simon & Schuster 1931). Copyright © 1931 by Thomas Craven, copyright renewed © 1958 by Thomas Craven. Reprinted by permission of Simon & Schuster.

Excerpt from *The Gist of Art* by John Sloan (New York: American Artists Group, 1939), reprinted by permission of Mrs. John Sloan.

Statement by Jules Olitski, from *Catalogue of the International Biennial Exhibition of Art,* Venice, 1966, reprinted by permission of The International Art Program, National Collection of Fine Arts, Smithsonian Institution.

Acknowledgments

Excerpt from "The Ides of Art" by Adolph Gottlieb, *Tiger's Eye*, December, 1947, statement by Barnett Newman, from *Tiger's Eye*, December, 1948, and statement by Mark Rothko, from *Tiger's Eye*, October, 1949, all reprinted by permission of Ruth Stephan.

Statement by Clyfford Still, from *Clyfford Still: Paintings in the Albright-Knox Art Gallery*, Buffalo (Buffalo, N.Y.: The Buffalo Fine Arts Academy, 1966), reprinted by permission of the author.

Selected portions of "Interview with Franz Kline," by David Sylvester, *Living Arts*, (edited by John Bodley and Theo Crosby), No. 1, 1963. Statement by Willem de Kooning, from an interview by David Sylvester, BBC, December, 30, 1960. Both reprinted by permission of David Sylvester.

Excerpt from *Arthur Dove*, by Frederick S. Wight (Berkeley: University of California Press, 1958). Reprinted by permission of the Regents of the University of California.

Excerpt from *Letters of John B. Flannagan* (New York: Curt Valentin, 1942). Reprinted by permission of the heirs of Curt Valentin.

"Aviation: Evolution of Forms under Aerodynamic Limitations," and excerpt from a letter from Arshile Gorky to his wife, May 31, 1941, published in *Arshile Gorky*, by Ethel Schwabacher (New York: Macmillan and Whitney Museum of American Art, 1957). Reprinted by permission of the Whitney Museum of American Art. "On Abstract Art," Stuart Davis's introduction to *Abstract Painting in America*, exhibition catalogue of the Whitney Museum of American Art. Published in 1935 and reprinted by permission of the Whitney Museum of American Art. Published in 1935 and reprinted by permission of the Whitney Museum of American Art and Mrs. Stuart Davis. Excerpt from an essay by James Monte, in *Anti-Illusion: Procedures/Materials*, catalogue of an exhibition at the Whitney Museum of American Art, New York, 1969. Copyright © 1969 by the Whitney Museum of American Art. Reprinted by permission of the Whitney Museum of American Art.

Statement by Harold Rosenberg and Robert Motherwell, statement by Mark Rothko, and "My Painting" by Jackson Pollock, *Possibilities*, No. 1, 1947–48. Excerpt from *Modern Artists on Art*, edited by Robert Motherwell and Ad Reinhardt (New York: Witteborn, Schultz, 1952). All reprinted by permission of George Wittenborn, Inc., New York, New York.

Contents

Contents

well / Arshile Gorky / Mark Rothko / Barnett Newman / Adolph Gottlieb / Hans Hoffman

Readings in American Art 1900–1975

Editor's Note

These documents have been assembled for the purpose of providing a portrait of the artist in America through his own writings and those of contemporary critics. They are arranged to correspond with the chapter divisions of the revised and expanded edition of *American Art Since 1900,* so that they may be used as supplementary primary source readings. Original sources are cited at the beginning of each passage. Commentary has been supplied by the editor.

Introduction: The Practice, Theory, and Criticism of Art in America

PRACTICE

Our drama, when it is anything but foolishness, is realistic; our engrossment, not with allegories and old-world myths, but with the actualities of the present; our life is a fast and strenuous race, heeding little of ceremonial formalities; the cast of our mind toward seriousness and subtleties; our capacity for pain and pleasure multiform and complex. For all the youth of the nation, we have been born into a late time.

—Charles Caffin, in *Camera Work*, No. 17 (1907)

If the situation of the modern artist has always been precarious, then the practice of modern art in America has been particularly hazardous; this much, at least, emerges from the testimony offered in the following pages. The documents assembled record various ways in which American artists have responded to the fourfold task of founding and legitimizing a tradition of art in America; defining the American subject and extending its meaning to encompass an American style; imposing high art on a democratic, pluralistic society basically hostile to the concept; and creating a spiritual art in a materialistic environment.

Many factors have contributed to the difficulties of making art in America. To begin with, in Europe, the avant-garde, although divorced from the Academy and middle-class society, quickly established its own tradition and society, but, in America, Puritanism and provincialism for many years prevented the evolution of a Bohemian milieu capable of nourishing and sustaining an avant-garde. As a consequence,

3

d, not only from a hostile society but also from each
ichi Hartmann complained:

...ure, this indifference to contemporary achievements is
...us a natural condition . . . we are always twenty years behind the
rest of the world in all artistic and literary matters. No wonder; the
painters of New York do not even know their confreres in Boston and
Philadelphia.
For their excuse it may be said that the conditions to acquire such
knowledge are exceedingly unfavorable. There is an utter lack of oppor-
tunities for the interchange of ideas. We have no *salons,* no art-centers
of any pretension, and no *esprit de corps* among artists themselves. Every-
body goes his own way, intellectually isolated, and depending largely on
the observations of his student years.[1]

Isolation and alienation, characteristic of any avant-garde, came, in
America, to be the defining conditions of the artist's life. Eventually,
this lack of contact was seen as a positive virtue, even a necessity, not
only by the artists themselves but by critics such as Harold Rosenberg
and Clement Greenberg. Greenberg insisted, "The American artist has
to embrace and content himself, almost, with isolation if he is to give
the most of honesty, seriousness, and ambition to his work. Isolation is,
so to speak, the natural condition of high art in America."

In addition to painful isolation, other problems vexed the American
artist. Not only did he have to contend with the snide critical attacks
and the lack of a market for his work that usually meet the avant-
garde; he also had to face certain other, uniquely American, reactions.
Take, for example, the popular suspicion that making art was not use-
ful work, either because in a pioneer society it had been traditionally
the province of women or because it was unremunerative and, there-
fore, of low status in a success-oriented culture. The result was that
some artists, such as George Luks, compensated for feelings of inferi-
ority with a swaggering braggadocio that emulated the respected "he-
man" stereotype. More secure figures, such as Robert Henri, John
Marin, Stuart Davis, and David Smith, held that the artist was first of
all a worker, and that making art was the noblest kind of work. From
such a position, it followed easily that the artist identified with the
worker and that strong liberal, socialist, and sometimes anarchist lean-
ings marked the political thinking of many American artists.

[1] Sadakichi Hartmann, "On the Lack of Culture," *Camera Work,* No. 6 (1904),
pp. 19–20.

4

From the outset, the best artists in America have been among the most relentless critics not only of American politics but of American culture in general. In the early years of the twentieth century, this criticism often ended on an optimistic note; it was believed that, if the repressive and inhibiting pressures of the Puritan heritage could be discarded, the "art spirit," as Robert Henri called it, would naturally flourish and grow, defining and enlarging the intelligence and sensibilities of the people. This was essentially Walt Whitman's view, and it is reflected in the optimistic hopes Henri, among others, had for American culture. Henri predicted:

> To have art in America will not be to sit like a pack rat on a pile of collected art of the past. It will be rather to build our own projection on the art of the past, whatever it may be, and for this constructiveness, the artist, the man of means and the man in the street should go hand in hand.[2]
>
> In America, or in any country, greatness in art will not be attained by the possession of canvases in palatial museums, by the purchase and bodily owning of art. The greatness can only come by the art spirit entering into the very life of the people, not as a thing apart, but as the greatest essential of life to each one.[3]

Despite such Utopian optimism, Henri and his contemporaries were not to see an aesthetic millennium. Others, like the caricaturist Marius de Zayas, grew pessimistic toward the prospects for art in the United States. In 1916, De Zayas gloomily assessed the situation:

> In all times art has been the synthesis of the beliefs of a people. In America this synthesis is an impossibility, because all beliefs exist here together. One lives here in a continuous change which makes impossible the perpetuation and the universality of an idea. History in the United States is impossible and meaningless. One lives here in the present in a continuous struggle to adapt oneself to the milieu. There are innumerable social groups which work to obtain general laws—moral regulations like police regulations. But no one observes them. Each individual remains isolated, struggling for his own physical and intellectual existence. In the United States there is no general sentiment in any sphere of thought.
>
> America has the same complex mentality as the true modern artist. The same eternal sequence of emotions and sensibility to surroundings. The same continual need of expressing itself in the present and for the present,

2 Robert Henri, *The Art Spirit*, compiled by Margery A. Ryerson (Philadelphia: J. B. Lippincott Co., 1960), p. 130.
3 *Ibid.*, p. 190.

with joy in action, and with indifference to "arriving." For it is in action that America, like the modern artist, finds its joy. The only difference is that America has not yet learned to amuse itself.

The inhabitants of the artistic world in America are cold-blooded animals. They live in an imaginary and hybrid atmosphere. They have the mentality of homosexuals. They are flowers of artificial breeding. America does not feel for them even contempt.[4]

Soon, instead of fantasizing a Utopian community united through art, American artists would be happy receiving at least the measure of acceptance accorded to art in Europe. Of the artists forced to return to America by World War I, art dealer and critic Horace Holley wrote, "they have grown aware of the status enjoyed by the artists as a type essential to civilization," implying that artists were not yet acknowledged as a type essential to American civilization. Holley advised: "we should recognize the artist's status as it always has been recognized in civilized communities. In Europe successive generations of the same recurrent type have gradually impressed society with a tone favorable to the artist."

Holley's admonitions fell on deaf ears. Instead of raising the status of local artists, collectors continued to add to the prestige of the European masters by buying their works and neglecting the Americans.

Painter Marsden Hartley, too, agreed that art would have to reach a larger public before a native American art could take root. But, as Hartley foresaw, acceptance would go to popular and imitative art, not to the difficult and original art he and his friends were producing. In 1921, he wrote:

Art in America is like a patent medicine, or a vacuum cleaner. It can hope for no success until ninety million people know what it is. The spread of art as culture in America is from all appearances having little or no success because stupidity in such matters is so national. There is a very vague consideration of modern art among the directors of museums and among art dealers, but the comprehension is as vague as the interest . . . the public finds no shock in the idea of art. It is not melodramatic enough and America must be appealed to through its essentially typical melodramatic instincts. . . . There is altogether too much of comfortable art, the art of the uplifted illustration. It is the reflex of the Anglo-Saxon passion for story-telling in pictures which should be relegated to the field

[4] Marius de Zayas, in *Camera Work*, No. 47 (1916).

of the magazines. Great art often tells a story but great art is always something plus the idea. Ordinary art does not rise above it.[5]

Gradually, the tone of these criticisms grew more hostile as it became clear that Whitman's vision of art rising from the people was not about to materialize. As Hartley ventured,

> I often wonder why it is that America, which is essentially a country of sports and gamblers, has not the European courage as well as capacity for fresh developments in cultural matters. Can it be because America is not really intelligent? I should be embarrassed in thinking so. There is nevertheless an obvious lethargy in the appreciation of creative taste and a still lingering yet old-fashioned faith in the continual necessity for importation. America has a great body of assimilators and out of this gift for uncreative assimilation has come the type of art we are supposed to accept as our own.[6]

Oscar Bluemner put it even more bluntly: "American art is, to my critical mind, and has been, absolutely European. . . . But the fundamental elements for an American art are here. . . . The art will come, of course."

Recognition did not come, however, for the American artist during the twenties, and Hartley became more discouraged. In 1928, he speculated, "I am not quite sure that the time isn't entirely out of joint for the so-called art of painting, and I am certain that very few persons comparatively speaking, have achieved the real experience of the eye either as spectator or performer."

But others saw brighter prospects. Stuart Davis, commenting on his trip to Europe, also made in 1928, claimed it enabled him "to spike the disheartening rumor that there were hundreds of talented young modern artists in Paris who completely outclassed their American equivalents." His trip proved to Davis "that work being done here was comparable in every way with the best of the work over there by contemporary artists." It proved to him as well "that one might go on working in New York without laboring under an impossible artistic handicap." Counting as positive factors in the American atmosphere its enormous vitality, "the hundreds of diverse scenes, sounds and ideas in

[5] Marsden Hartley, *Adventures in the Arts: Informal Chapters on Painters, Vaudeville and Poets* (New York: Boni & Liveright, 1921), p. 60.
[6] Marsden Hartley, "Art—and the Personal Life," *Creative Art*, II (June, 1928).

a juxtaposition that has never before been possible," Davis came to the radical conclusion that one could "regard the necessity of working in New York as a positive advantage." This was, perhaps, to view the situation through rose-colored glasses; nevertheless, it marked a decided turning point in the self-esteem of the American artist. Although America would continue for years to import art, she would no longer export artists at the previous rate.

Davis' optimism, as well as his faith in the distinctiveness and vitality of American art, was shared by the critic Thomas Craven, whose preference for realistic art, however, was antithetical to Davis' abstract orientation. Two years after the 1929 Crash had destroyed the art market as well as the stock market, Craven, like Davis, saw salvation in acknowledging the cultural differences between America and Europe and in embracing and expressing those differences. In *Men of Art,* he wrote:

> Home again, after our long journey through European traditions, we enter a new environment for art. We are confronted not only with new physical conditions, but with what is more significant, a new mental attitude toward the world of the spirit. America possesses no revered or time-honored art culture, and our country as a whole, in word and deed, does not seem to regret it. If we do not look ahead, we surely do not look very far into the past for salvation, and the absence of an art tradition does not in the least interfere with our industrial development. America is the land of machines, and our new attitude toward the world —our indifference to cultural precedents and observances—is both the cause and the effect of our mechanized civilization. Our psychology is profoundly conditioned by our changing instruments and our control over them. Our machines wear out, and we construct newer and better models; we build and invent, destroy and replace, attaching no value to our handiwork beyond that of function and service. Thus we have come to have no use for things themselves, and no time to polish up memories of things when the moment of their usefulness is over.[7]

Even those who violently opposed Craven's critical position found themselves agreeing with his view that American art needed to free itself from its European ancestry. Beginning in the thirties, there was some justification for the feeling that a major art style might come out of the New World. Eminent European artists, like Fernand Léger, even began to visit the United States. Some, like George Grosz,

[7] Thomas Craven, *Men of Art* (New York: Simon & Schuster, 1931), p. 506.

refugees from the European catastrophe, remained in the United States, convinced, as was Clement Greenberg, that "the immediate future of Western art, if it is to have any immediate future, depends on what is done in this country." The development of Abstract Expressionism during the postwar period has proved the validity of Greenberg's prophecy. During this period, American painting at last emerged as an independent cultural force capable of evolving a major style and even of influencing European art.

But independence from the models of European art was won at a price. Victory was viewed with mixed feelings by those who had fought for it. Left to assess their situation, artists like Robert Motherwell began to ask how "our epoch meant to replace the wonderful things of the past—the late afternoon encounters, the leisurely repasts, the discriminations of taste, the graces of manners, and the gratuitous cultivation of minds." Now that American art was free to pursue its own course, there was the issue of the direction it would take. The question could not help but be raised as to whether the loss was not as great as the gain. In a 1960 journal entry, Jack Tworkov acknowledged, in a passage that echoes Henri's admonition:

> The old world, the world of aristocratic dreaming, has been shaken to bits; nothing but memories and pieces lie around like broken columns. It's a nuisance when we speak of culture to speak of the pieces we have inherited—however noble the pieces. The noblest libraries and museums and the noblest memories do not make us cultured. Only our own making gives being to our culture. Not the man who quotes—but the man who speaks out of himself for himself. Nothing archaic can help us or set us an example. Everything in the world is new—like ourselves. Not new like an invention for newness' sake—but new because it is out of our own nerves, our nerves vibrated by the world good or bad.[8]

In the introduction to the first edition of these documents, I wrote that the difference between the genuine and the spurious "new" might possibly not be widely understood and that the restless experimentation American artists felt driven by might lead to a search for novelty rather than true innovation. I also cautioned against confusing technical accomplishment with honest ambition or creativity. Subsequent events gave substance to my pessimism. The chaos of the late sixties, a period disastrously affected by the capacity of the

[8] Jack Tworkov, as quoted in Edward Bryant, *Jack Tworkov* (New York: Whitney Museum of American Art, 1964), p. 48.

news media to publicize ephemeral styles, invent personalities, and focus on novelty in their appetite for the "newsworthy," created a bewildering situation for a public just becoming aware of modern art as a fact of modern life. From 1945 until the economic recession of the late fifties wiped out the market for derivative "second generation" work, Abstract Expressionism had been the dominant avant-garde style in America. Battle lines were clearly drawn, with such apologists for modernism as Clement Greenberg, Harold Rosenberg, and Thomas B. Hess polemicizing for the acceptance of the New York School as the legitimate heir of the School of Paris, and such conservatives as Frank Getlein and John Canaday (now the restaurant as opposed to the art critic of the *New York Times*), calling for the end of "Schmeerkunst." By the end of the sixties, *Time* magazine was no longer deriding Pollock as "Jack the Dripper," and critics of the New York School were writing encomiums to the triumph of American culture.

The celebration of the American avant-garde that began in the sixties, when European dealers, collectors, and curators began to turn to New York for leadership, continued with even greater momentum in the seventies. But as the population of artists in New York grew and SoHo became the new downtown art center, the art community itself disintegrated. The vital sense of shared values and goals that sustained the Abstract Expressionists through the difficult times when their art was not accepted was lost; moreover, the permissive climate of the sixties produced a situation in which no statement, no matter how outlandish, insulting, boring, or pornographic, could shock the sophisticated public.

As it became more difficult to produce a reaction, artists escalated the level of anti-authoritarian behavior, exhibiting empty rooms in museums and, if necessary, mutilating themselves in performances of "body art" that emphasized the sado-masochistic voyeurism in the curious new relationship between artist and public brought about by media intrusion into the privacy of the art world.

Thus, in many ways the contemporary American artist is no better off than he was at the beginning of the century. As Sadakichi Hartmann complained, "the artists in Boston and Philadelphia do not know each other." Today, contact between the art centers of Los Angeles and New York has paradoxically broken down as media

information has replaced personal contact. The avant-garde is once again vulnerable to attack because it has lost a sense of its own identity. It is especially vulnerable because the basic American taste for fact and realism has reasserted itself in the widely popular antimodernist style of Photo-Realism. Gaining ascendancy, at least in terms of popular taste and media acceptance, Photo-Realism is the latest version of American Scene painting. Only now, barren streets are devoid of human presence, and neon signs glow with a bleak and tawdry light.

Despite the popularity of Photo-Realism, which imitates the documentary quality of photography (and reflects the increasing popularity of photography, seen as an alternative to painting by many younger artists), abstract painting does not stand still. Painting in isolation once again, a new generation of abstractionists is building upon the achievements of earlier native giants and fighting to maintain ties with a tradition of art older than America itself. Many of them have returned to a smaller, more intimate scale, accepting the limitations of easel painting rather than trying in any way to interact with the environment, which they perceive as hostile to seriousness. Watercolor, gouache, and colored pen or pencil on paper are favored mediums because of their cheapness and because storing and transporting works on paper is so easy—essential considerations in a period of economic recession.

Gone is the great optimism of the sixties. Although government and corporate patronage is bringing more art to more people than ever before, many have reservations regarding the quality of that art and the continual leveling effect of the democratic process when the taste of the mass rules in matters of art. On the other hand, though the avant-garde finds itself as embattled as at any time in this century, ethnic minorities, blacks, and women are becoming active and are vitally enriching and changing the history of American art.

THEORY

In the seethe of things, in the interest of this, in the doing of that, terms, abstract, concrete, third or fourth dimension—bah. Don't bother me.

—John Marin, "John Marin by Himself," *Creative Art*, III (October, 1928)

Introduction

Art theory in the United States, like art itself, has shown the same fluctuating dependence on, and independence of, European sources. Theoretical treatises, by means of which the ideologies of art movements are disseminated, were not popular in America until the late 1960s. Neither were manifestoes. In fact, Synchromism, the only significant movement to issue a manifesto of aims and intentions, did so in Europe. On the contrary, the anarchistic spirt of the modern artist in America has kept him from banding together with others or issuing treatises or proclamations. His resistance to formulas and to art that is purely cerebral has made him wary of systems and theories. Marsden Hartley's view is representative of the American attitude: "Theoretical painting has little or no meaning for me, because it takes place above the eyebrows—I want the whole body, the whole flesh in painting." This does not mean, however, that twentieth-century American painting is without its theoretical foundations; it merely means that, for the most part, these premises are tacitly understood rather than explicitly stated. Daring and creative American artists did not, in general, concern themselves with abstract arguments; they preferred to derive their values from the general outlines of American culture, and to attack art with the pragmatic and empirical approach that characterizes American thought.

It is not surprising that, when an American artist has passed his ideas on, he has done so as teacher rather than as theoretician. In this way, many of the greatest teachers, suspicious of formulas and reluctant to freeze their beliefs into systems or ideologies, have communicated their advice as lessons to their students. Others have exchanged ideas with their peers over a drink.

The most challenging ideas in American art gained currency not in high-sounding publications but in the classroom or the barroom. (Only the patience of Henri's and Sloan's students in compiling their class notes has made it possible to reconstruct their lectures.) Despite such reluctance to formulate ideas into closed aesthetic systems, American artists have provided some theoretical literature that has had an influence on the practice of art in America and so deserves consideration. Arthur Wesley Dow, Denman Ross, Jay Hambidge, and Thomas Hart Benton are among the most important of these theoreticians who set out to systematize and codify the rules of composition and design. It is worth noting that they were all teachers.

Theories of Composition

As elsewhere in the Western world, awareness in the United States of the problems of two-dimensional design was first stimulated by contact with Oriental art. Returning from Asia sometime in the early nineties, the celebrated Orientalist Ernest Fenellosa drew attention to Chinese and Japanese art in his lectures at Harvard and the Boston Museum. These lectures on design and *notan* (light-dark contrasts) in Oriental art were early attempts to show that there were other possibilities than a naturalistic art. Tone, design, and pattern, rather than truth to nature, were stressed as compositional factors.

One of Fenellosa's eager listeners was Arthur Wesley Dow. Because he had come under Gauguin's influence in Pont-Aven, Dow was already prepared for such an approach to composition. Later, at Pratt Institute, where he instructed Max Weber, and subsequently at Teachers College, Columbia University, where Georgia O'Keeffe became his faithful disciple, Dow emphasized the importance of abstract design. In this, he was the most progressive art teacher in America of his time.

Pure design was also the concern of Denman Ross, another Harvard professor. In *A Theory of Pure Design,* published in 1907, Ross stressed pattern, abstract design, rhythm based on arithmetical measure, and movement. He advocated a vocabulary of form based on plant motifs that would suggest growth in a "gradual and regular change from one shape to another."

By isolating the purely plastic qualities of design from those of subject matter or representation, Ross found himself in the ranks of the most advanced aestheticians. His analysis of the formal elements, such as harmony, balance, rhythm, and movement, in pictorial composition influenced not only his own countrymen but the English critic Roger Fry as well. Singled out as particularly significant by Fry was Ross's observation that "a composition is of value in proportion to the number of the orderly connections it displays." Such an assumption was also to be at the root of most of the later theories of abstraction, such as Mondrian's manifesto on pure plastic art, which stresses the importance of formal relationships within a painting.

In the order of nature, Ross found "the order of a great number and variety of terms and of different principles in combination." From natural forms, he deduced a series of stylized plant motifs. These he

13

cited as examples of harmony, balance, and rhythm—the three major compositional factors. The source of Ross's theory must be sought not in America but in the work of the nineteenth-century German and English theoreticians Alois Riegl, Gottfried Semper, and Owen Jones, who traced the transformation of natural forms into abstract motifs in the decorative arts. Shortly after it was published, Semper's work on ornament was translated into English by the architect John Wellborn Root, who apparently introduced Semper's ideas to Louis Sullivan. From this point of departure, it was but a short step to applying principles of abstraction to composition in general. But, despite the advanced concepts he explored, Ross stopped short of advocating that they become the basis for an abstract pictorial art. Typically, the analysis of art had outdistanced its practice in America.

Although Americans who worked in Europe naturally came into contact with Post-Impressionist assumptions about painting, art schools in the United States did not emphasize pattern, structure, and design. On the contrary, even progressive artists like Henri stressed realism based on observation, spontaneity, and personal expression. But the Armory Show helped make Americans more aware of the importance of form. George Bellows, Alfred Maurer, and even Henri himself, searching for the means to order and structure their compositions, found an answer in the system of dynamic symmetry proposed by Jay Hambidge. The most influential American art theoretician of the twenties, Hambidge had constructed a mechanical system, based on analysis of the structural principles of older art. In *Dynamic Symmetry,* published in 1919, Hambidge set forth a mathematical system of composition, purportedly of ancient origin, based on the relationship of the diagonal to the sides of the rectangle. As an added advantage, such structures supposedly conformed with certain types of plant growth, thus uniting the authority of history with that of nature. Hambidge, like Ross, lectured at Harvard. Later, he was an instructor at Yale, where he published the magazine *Diagonal* in 1919 and 1920.

According to Hambidge, "The difficulty is that while we have a more or less consummate science of draftsmanship, we have scarcely made an approach toward a science of design." This he sought to provide in a series of loose-leaf lessons illustrated with drawings and diagrams, which he began circulating in 1921. Like Henry R. Poore and Dr. Albert Barnes, who also analyzed works of art of the past for

geometrical patterns and lines of construction, Hambidge was convinced that, once revealed, the underlying structure of the compositions of the masters could serve as models for contemporary artists.

This discovery he thought astonishingly modern, whereas he found Cubism an "academic union between an elementary geometry and those orthodox rules of composition that have been taught in art schools for many decades." In his article "The Ancestry of Cubism," Hambidge sought to find examples of "cubistic" reductions to simple geometric volumes in older art, from the Egyptians to Albrecht Dürer. His purpose was to prove that "Cubism is at bottom not radical, but blindly, haltingly conservative."

Hambidge's was a typically American confusion. He saw in Cubism only a superstructure, haphazardly applied as a stylistic effect, instead of a revolutionary new attitude toward art. His effort to reduce art to a scientific system of "foolproof" compositions paralleled Dr. Barnes's attempt to construct a verifiable scientific method of evaluating works of art. The search for some constant principle of authority, preferably scientific, occupied so many American artists, critics, and theoreticians that it must be taken as evidence of some very basic insecurity and discomfort that the practical American mind experienced when confronted with an art based not on science and observation but on the subjective qualities of feeling, imagination, and intuition.

Hambidge's investigations had some validity, however. Respected scholars defended his analysis of dynamic symmetry as a governing principle of ancient painting, and his diagrammatic analyses of paintings have been absorbed into art education and appreciation at all levels. It is likely that Dr. Barnes incorporated Hambidge's models in his own complex system of formal analysis.

Another formulator of mechanistic theories of composition was Thomas Hart Benton. Published as a series of articles in *The Arts,* in 1926–27, Benton's method, in opposition to flat, two-dimensional design, emphasized the deep space composition of Rubens and El Greco. Part of Benton's interest in movement in space, which stressed the interlocking of surface patterns with analogous patterns and rhythms in depth, must be attributed to his contact with the Synchromists, who were interested earlier in deep space composition.

Finding that "flat areas are inevitable," Benton counseled that they were also "mechanically necessary, affording a base for projection.

Their flat character emphasizes the cubic character of the forms with which they are associated." But, in general, Benton wished to eliminate flatness, considering deep space more meaningful because it was more complex and called forth greater empathy. Rejecting his Synchromist past on the question of color, he considered color a means, not an end— an excellent means, however, because of its ability to indicate space. According to Benton, "Color *is* a constructive factor in painting, but it is what it constructs that gives it its full sense and value."

Like the critic Willard Huntington Wright, Benton was interested in the *Einfühlung* (empathy) theory of the German philosopher Lipps. Although he rejected the ultimate physiological basis of the theory, he concluded, "In the practical field of actual construction, however, observation of the rich and intricate field of muscular action is responsible for much fine compositional work." Originally, it was his observation of Renaissance anatomy that led Benton consciously to apply the physiological principle in the building up of plastic structures. For Benton, this translation of muscular-action patterns into mechanical compositional forces had enormous value. Thus, he concluded:

> Forms in plastic construction are never strictly created. They are taken from common experience, re-combined and re-oriented. This re-orientation follows lines of preference also having a definite biological origin. Stability, equilibrium, connection, sequence, movement, rhythm, symbolizing the flux and flow of energy are the main factors in these lines. In the "feel" of our own bodies, in the sight of the bodies of others, in the bodies of animals, in the space of growing and moving things, in the forces of nature and in the engine of man the rhythmic principle of movement and counter-movement is made manifest. But in our own bodies it can be isolated, felt and understood. This mechanical principle which we share with all life can be abstracted and used in constructing and analyzing things which also in their way have life and reality.[9]

Theories of Expression

"It is an odd reversal of usual conditions," wrote Frank Jewett Mather, Jr., in 1914, "that the French writers on the new painting, MM. Apollinaire, Gleizes, and Metzinger, should be hopelessly unintelligible, whereas the most distinguished German practitioner and

[9] Thomas Hart Benton, "Mechanics of Form Organization in Painting," Part IV, *The Arts* (February, 1927).

critic of Post-Impressionism, Wassily Kandinsky, is entirely lucid." One can only speculate as to why the American mind found Cubist theory largely useless and Expressionist theory entirely compatible with local attitudes. It may have been the Neo-Platonic and abstract philosophical cast of Cubist thinking that alienated Americans, or perhaps its cold objectivity. In any event, although the core of Cubist thinking —that the painting represented an independent reality as concrete as actual experience—eventually came to be accepted by American artists, the idealistic bias and complex time-space metaphors of the French Cubists made virtually no inroads on American thinking. Instead, the single most important theoretical discussion in twentieth-century American art has centered around the issue of Expressionism.

The Expressionist controversy is linked directly with the argument that painting is related to music. Both find their roots in Kandinsky's essay *"Über das Geistige in der Kunst,"* excerpts from which appeared in English in 1912, the year of its German publication, in the pages of *Camera Work*. Translated completely into English, in 1914, as "The Art of Spiritual Harmony," Kandinsky's tract quickly found both disciples and enemies in America. Among the first to take a stand against Kandinsky's doctrine that art was the expression of an "inner need" was the conservative critic Mather. Writing in *The Nation,* in November, 1914, Mather dismissed Kandinsky's formulation that creation grows out of the artist's inner need as "at first blush . . . merely the familiar Romantic theory of the artist as self-sufficing titan." Antagonistic to abstract art to begin with, Mather dismissed Kandinsky's assertion that emotion provides the true content of art: "In bluntest words, the notion of a specialized emotion, creative or otherwise, wholly shut off from the residual feeling and thinking is merely bad psychology." As for Kandinsky's analogies between music and painting, Mather opposed assigning psychological and spiritual values to specific colors and forms. He observed, "Music itself does not play with fixed abstract terms, such as Kandinsky wishes the colors to be. An oboe, for instance, is neither a sad nor a glad instrument; it all depends on circumstances. . . . In short, any color may take on the most varied emotional values, just as the bow may draw from a single note of the violin the most various shades of feeling."

Numerous other critics agreed with Mather. In a much more scathing attack, Thomas Craven, in his 1931 discussion of modernism in

Introduction

Men of Art, characterized Expressionism as the worst scourge of modern art:

> Like the other sects, *Expressionism* has flaunted a far-fetched aesthetic, but at bottom it professes a fairly simple creed: "Our contacts with nature—the facts of the visible world—for creative purposes are more important than any amount of learning or traditional knowledge. Given a genuine insight into the world of everyday experience, it is possible for the artist to dispense with all old forms and to create directly, trusting to the pull of such impulses as follow his sensations. So working, the artist inevitably produces new forms. The burden of dead learning which stultifies academic practice is overthrown by an earnest and truthful expression of experience." . . . This notion lends authority to that brand of self-satisfaction posing as genius; allows for every imaginable kind of stupidity, and lack of knowledge; and raises children, freaks and incompetents into the ranks of the masters.[10]

Stilled for a time in the thirties, when Cubist formalism and representational art held the field, the debate over Expressionism was renewed in the forties and fifties, with the rise of a painterly style that sought to add emotional content to the pure formalism of abstraction. From the first, Abstract Expressionism was primarily interested in emotional content, and its practitioners rejected any attempt to label them as formalists. The "subject" of the artist was uppermost, whether this subject was the myths of the collective unconscious or the personal autobiographical statement to be communicated through the charged stroke.

As a spokesman for Abstract Expressionism, Harold Rosenberg often reflected the artists' consensus in his writing. He explained:

> With regard to the tensions it is capable of setting up in our bodies the medium of any art is an extension of the physical world; a strike of pigment, for example, "works" within us in the same way as a bridge across the Hudson. . . . If the ultimate subject matter of all art is the artist's psychic state or tension (and this may be the case even in non-individualistic epochs), that state may be represented either through the image of a thing or through an abstract sign. The innovation of Action Painting was to dispense with the *representation* of the state in favor of *enacting* it in physical movement. The action on the canvas became its own representation.[11]

[10] Thomas Craven, "Cubes and Cones," in *Modern Art—the Men, the Movements, the Meaning* (New York: Simon & Schuster, 1934), pp. 225–26.
[11] Harold Rosenberg," Hans Hoffman: Nature in Action," *Art News,* May, 1957.

Here we are not far from Kandinsky's system of equivalents, made less specific and modified by Existentialism's concern with "action" and a modernized version of the *"Einfühlung"* theory. In any event, whether or not the "ultimate subject matter of all art is the artist's psychic state or tension" was soon brought into question by a younger generation of American artists who rejected the subjectivity of Abstract Expressionism, exchanging it for the cool impersonality of pop art, the "new abstraction," and "primary structures." Weary of the rhetoric of Abstract Expressionism, and suspicious of the possibility of staging or simulating extreme psychic states, these young artists were, moreover, skeptical as to whether psychological states are, in fact, communicable in abstract art. Pop artist Claes Oldenburg, for example, assumed this detached position, characteristic of the present generation. He claimed, "It is possible for me to treat my subjectivity and that of others objectively and this is a unique thing in my art: the emotion in it is the observation of emotion."

Those who embraced the new abstraction, on the other hand, tended, tacitly at least, to maintain the art-for-art's sake view implicit in Symbolist theory, which has run as an aesthetic undercurrent in American art, though usually overshadowed by the more popular and more frequently discussed Expressionist point of view.

Beginning in the sixties, the antitheoretical bias of American art reversed itself, and a number of artists began to write treatises on aesthetics. Don Judd, Robert Morris, Dan Flavin, Walter Darby Bannard, and the late Robert Smithson were especially articulate. Graduate students began to descend upon practicing artists, who had become living myths in their own time, and scores of interviews were published by such art magazines as *Art News, Arts,* and *Artforum.* In some cases, whole periodicals such as *Avalanche* and *Art-Language* were devoted to theoretical and philosophical matters. Art schools proliferated, and universities began offering more and more courses in contemporary art, with the inevitable result that an academic approach evolved, heavily weighted toward the theory of art. As the seventies opened, intellectual content was held by many in greater esteem than emotional response. Gestalt psychology, cybernetics, structuralism, phenomenology, and other purely abstract formal approaches to art became dominant; the names Wittgenstein, Merleau-Ponty, Piaget, and Lévi-Strauss began to replace those of Rubens and

Raphael—even those of Picasso and Matisse—in the rapidly expanding literature of artists writing on art. Like the Mannerist epoch of the sixteenth century, when the Idea, or concept, took precedence over spontaneous expression, the beginning of the seventies in America was an academic period in art, within a general context of social, political, and economic upheaval.

CRITICISM

It is not entirely the fault of the American people that they lag far behind all other civilized nations in aesthetic appreciation. The aggressive ignorance and theopneustic cant fed them by the majority of native critics . . . are in themselves sufficient to bring about an indefinite deferment of intelligent artistic taste . . . and as long as their influence persists, America will retain its innocence of all those deeper problems of art which must be mastered before a true understanding be brought about."

—**Willard Huntington Wright**, "The Aesthetic Struggle in America," *Forum*, LV (January–June, 1916)

Art criticism in America, denounced at every turn by its own practitioners, has, nonetheless, produced a substantial body of writing, some of it durable, and some of it distinguished. But, whether academic or progressive, American critics have tended to share a shortcoming: they have taken too literally Baudelaire's advice that a critic ought to be passionate and partisan. The result has been that, no matter what the stature of the critic, he has aligned himself closely with one group or artist, and has been noticeably blind, antagonistic, or insensitive to other developments. Consequently, American criticism has at times had depth, but seldom breadth.

Critics in America have tended to fall into four major categories: moralist, social historian, formalist, or propagandist. As one would suspect, art criticism has seen equally varied interpretation. It has been interpreted as a branch of ethics, art history, sociology, aesthetics, or journalism. Seldom has art criticism been considered a profession. Many art critics earned their living as academics, and several of the most successful came to the field from literature, whereas lesser reviewers have been recruited from the ranks of artists and poets. Only recently have art historians entered the area of contemporary criticism.

Internecine warfare has characterized dealings among artists, at least since the Renaissance. But critics, too, have vehemently taken sides, and, in America, they have done so with particular venom. Outspokenness, brutal directness, and a general lack of delicacy are as characteristic of American art writing as of American art. In 1916, Willard Huntington Wright had this to say of his colleagues: "In America it is only too plainly evident that the majority of our critics choose, with fatalistic invariability, the inferior and decadent painters on which to spill their praise." To Wright's mind, his colleagues (with two exceptions, Leo Stein and Christian Brinton) were guilty of misleading the public. In order to expose their irresponsibility, he gave a devastating analysis of the competition, a favorite game of American literary critics as well.

In "The Aesthetic Struggle in America," Wright indicted his contemporaries on a number of counts. Royal Cortissoz, "the *doyen* of our art reviewers," he considered most guilty of all. Characterizing him as "an industrious, sincere, well-informed, commonplace, unillumined writer, who possesses a marked antipathy to all that is new," Wright chastised Cortissoz' timidity and fear of the present. "He belongs," Wright concluded, "to the aesthetic and intellectual vintage of the 'sixties: he is, in fact, almost pre-Raphaelitic in attitude."

For Charles H. Caffin, he had equally unkind words: "He is a compiler, a historian, a chronicler, a disher-up of information—a kind of head-master in the kindergarten of painting." Caffin's main fault, in Wright's opinion, was not his attitude toward modernism—Wright condescended to mention that "Mr. Alfred Stieglitz converted him to modern art, largely through hypnotism." It was to Caffin's lack of critical judgment and his willingness to tolerate all points of view that Wright objected.

Wright summed up Kenyon Cox's contribution as "his naïve assertion that all progress in painting is an illusion." He reprimanded Cox for his aggressive and loud tone. Cox, according to Wright, was "apparently unconscious that the world is moving forward. He belongs to the academy of antiquity. Even modern academicism is unknown to him. . . . He believes that painting stopped with the Renaissance and sculpture with Phidias."

Pointing out that Frank Jewett Mather, Jr., was a professor of painting at Princeton, Wright denounced him as a "typical scholastic

pedant." Mather's mind he found conventional, and his prejudices, "of educational rather than emotional origin." As for what Mather chose to praise, Wright characterized it as "that which is inoffensive from the standpoint of puritan culture, provided it is thoroughly established and has the indelible imprint of traditional approval upon it."

Wright's judgments, though severe, were in many ways accurate. His basic criticism of art writing was the same as that leveled by Clement Greenberg nearly half a century later: that it lacked a firm grounding in aesthetics. As outspoken as Wright, Greenberg took his fellow critics to task in "How Art Writing Earns Its Bad Name." The interesting difference, however, is that, although the subject remained the criticism of American painting, many of the critics Greenberg named were European. Among the Americans, Harold Rosenberg was the major target. Of Rosenberg's interpretation of Abstract Expressionism, Greenberg wrote:

> The very sound itself of the words "Action Painting," had something racy and demotic about it—like the name of a new dance—that befitted an altogether new and very American way of making art: a way that was all the newer, all the more avant-garde, and all the more American because the art in question was not actually art, or at least not art as the stuffy past had known it. At the same time, Mr. Rosenberg's ideas themselves sounded very profound, and most art critics have a special weakness for the profound.[12]

In general, Greenberg found appalling "the fundamental repetitiousness of most criticism of contemporary art, as well as . . . its rhetoric and logical solecisms."

When American critics have not been throwing brickbats at each other, they have faced a number of common problems. For the critic as much as for the public, the question remained for much of this century whether America could produce a great artist. Forced to evangelize for American art, native critics had constantly to fight against an equation of European art with quality in art. They fought not only for the transcendence of their own personal point of view but also for the acceptance of American art in general, both at home and abroad. In 1917, Wright lamented that Henri, "like all significant Americans . . . has been victimized by the public's snobbery. His na-

[12] Clement Greenberg, "How Art Writing Earns Its Bad Name," *Second Coming*, March, 1962.

tionality weighs heavily against him; for I cannot help believing that, wer: he a foreigner (why did he not pronounce his name Ong-ree?), he would be hailed as a great painter." The situation had obviously not changed much when, in 1952, Greenberg complained that, had Pollock been a European instead of an American, he would already have been acknowledged as "maître."

In America, art criticism has been published in newspapers, general periodicals, and specialized art reviews, which tended to expire as new magazines, in touch with current developments, appeared on the scene. Usually, the art magazines were limited by an editorial policy that strongly favored one or another of the art-world factions. Thus, their scope was narrow, and their claim to objectivity, discredited. Criticism in newspapers, with a few important exceptions, such as the columns of Elizabeth McCausland in the *Springfield Union* and the recent reviews by Hilton Kramer in *The New York Times,* seldom transcended the journalistic level, and tended toward preserving the vested interests of conservative and academic viewpoints. From the first decade of the century, the *New York Sun* was one of the few exceptions; it printed the criticism of Frederick James Gregg and James Fitz-Gerald, which was favorable to The Eight, and later employed Henry McBride, a vocal partisan of modernism, as art critic.

In the first two decades of the century, important criticism was published in such general magazines as *The Century, Forum,* and *Harper's Weekly.* Several political journals, too, gave space to intelligent art writing. *The New Republic* employed Leo Stein from 1916 to 1926, and *The Nation,* beginning with Mather's tenure (1907–17) and continuing to the present, has enjoyed a distinguished line of critics, which included Clement Greenberg, Hilton Kramer, and Max Kozloff. Beginning in the late thirties, and continuing through the forties and fifties, *Partisan Review* published influential art criticism by, among others, George L. K. Morris and Clement Greenberg.

The art magazines, by and large, have passed in and out of vogue along with the artists they have supported. About the time of the Armory Show, the leading art magazines were *Arts and Decoration* and *The Craftsman.* Both were rather strongly oriented toward the Henri point of view, as was *The Touchstone,* edited by Henri's friend Mary Fanton Roberts. At the same time, the hyperreactionary *The Art World,* edited by F. Wellington Ruckstuhl, gave a fanatical interpreta-

tion of the academic position. Writing as Petronius Arbiter, Ruckstuhl denounced the "Bolsheviki" and "madmen" who were "foisting" modern art on an innocent public.

During the twenties, *The Arts,* intelligently edited by Forbes Watson, maintained a high level of discourse, printing the criticism of such informed critics as Virgil Barker, and alternating articles on contemporary European art with praise of the coteries of both Henri and Stieglitz. Since many avant-garde writers as well as artists gravitated toward Stieglitz, his protégés were particularly well received in the little magazines such as *Seven Arts, Broom,* and *The Little Review.* In their pages, writers like Paul Rosenfeld, Waldo Frank, and Lewis Mumford often defended Stieglitz' cause.

As art critic for *Dial* (1920–29) Henry McBride could be counted on to be sympathetic to the point of view of the moderns. Although his writing was enormously important in creating a climate of interest in modernism and as a bastion of defense for the American modernists, McBride's was not an incisive critical mind. He will be remembered for the excellence of his taste and eye, the balance of his judgment, and the courage of his convictions, rather than for the depth of his criticism. As a member of the Arensberg circle, he favored Dada—a fellow critic once characterized McBride's writing as "Da," because he was only partially Dada—but he did not neglect to praise a wide range of modern art.

Important art journals of the late twenties and thirties included *Creative Art,* edited by Lee Simonson, and *American Magazine of Art,* later *Magazine of Art.* During the late thirties, European magazines such as *Cahiers d'Art* and *Plastique* were often scanned by American artists eager for more sophisticated material. In the forties and fifties, *Magazine of Art,* which ceased publication in 1953, and *Art Digest,* which became *Arts* in 1955, published criticism by art historians such as Robert Goldwater, Robert Rosenblum, and Leo Steinberg. Magazines published briefly by the Surrealist artists in exile during the war, *Tiger's Eye* and *View,* printed statements by Americans as well. In the late forties and fifties, *Art News,* a relatively stodgy journal with a historical bias, which had been published since 1902, became, under the editorship of Thomas B. Hess, the champion of the new American painting. Although the mass of enthusiastic chauvinistic outpourings in its pages will be forgotten, essays by Hess, Rosenberg, Greenberg,

and Meyer Schapiro in defense of Abstract Expressionism retain historical importance. In the late fifties, sculptor Philip Pavia published *It Is,* a magazine devoted exclusively to propagandizing for Abstract Expressionism, largely written by the artists themselves.

More recently, during the sixties, two new publications have gained importance. *Art International,* published in Switzerland by James Fitzsimmons, and *Artforum,* first in Los Angeles, later in New York, have emphasized post-Abstract Expressionist currents.

Besides artists, art historians, and assorted types of literati, collectors have also attempted art criticism. Since no credentials were needed, collectors often felt themselves to be—and in a few cases, indeed, were —as well equipped as any to enter the field. Beginning with two of the original buyers from the Armory Show, Arthur Jerome Eddy, who wrote the first book on Cubism to appear in English, and John Quinn, collectors have defended the points of view reflected in their collections. Duncan Phillips and Dr. Albert Barnes, the most sophisticated of the collector-critics, made substantial contributions to the literature on American art, and Katherine Dreier and A. E. Gallatin effectively evangelized for the recognition of modern art in America. In recent years, B. H. Friedman and Ben Heller, collectors of New York School painting, have defended their taste in writing.

The Issues

The history of American art criticism in this century may be reduced to a handful of controversial issues that have provided material for a series of lively, if vituperative, running battles, in which advocates and antagonists of a cause have lined up into viciously hostile enemy camps. Opening the century was the rather dusty matter of the battle of the ancients vs. the moderns, which had occupied the French art world some fifty years earlier. Supporters of academic art, the most articulate of whom were Royal Cortissoz, Kenyon Cox, and John Alexander, generally defended traditional art on the basis of its moral and technical superiority.

Besides the debate of academicism vs. modernism, there was the corollary issue of representation vs. abstraction. Whereas the first took fuel from the Armory Show and later declined as a serious issue, the second has occupied critics to the present. Sometimes, the discussion was carried out on a high philosophical plane, but, more often, ab-

straction was simply dismissed as socially useless because it carried no message, and undemocratic because it was unintelligible to the majority. The larger issue of art-for-art's sake vs. a socially useful art, which underlies a considerable amount of antimodernist opinion, was argued from the moment Henri took up the banner of life over art. It was still being debated in the sixties, with the young abstractionists avowing the autonomy and purity of art and its independence from life and with the pop artists and figure painters claiming that art separated from the concerns of life is sterile. On the other hand, some of the controversies of the thirties and forties, such as the relationship of American art to European art, seem to have died down. Others, such as the ability of art to change society, have become volatile again.

Although the battle lines were drawn even before the Armory Show made the issue of academic vs. modernist art topical, the Armory Show attracted participants into the conflict. Some critics, mainly the defenders of Henri and the Realists, such as James FitzGerald, F. J. Gregg, and James Huneker, tended to steer a middle course, neither totally embracing nor categorically dismissing modernism. Others were to change their opinions during the debate, sometimes in an abrupt about-face. Duncan Phillips, for example, was a late convert to modernism, whereas Guy Pène du Bois and Leo Stein ended by abandoning its defense. In the seventies, Hilton Kramer became more receptive to the American avant-garde, and Clement Greenberg began to attack pop and minimal art as inconsequential "novelty" art.

Among the most informed and least partisan early defenders of modernism were Christian Brinton and J. Nilson Laurvik, whose articles appeared regularly in *Century* and *International Studio*. Both posited the view that modernism was a continuation of traditional painting, although Laurvik felt that Fauvism and Cubism represented a decline from Post-Impressionism. Brinton, on the other hand, was one of the few critics familiar enough with developments in Europe to remark on the incompleteness of the Armory Show in its omission of the German and Austrian Expressionists and the Futurists.

But the real front-line fighters on the side of the modernists were Walter Pach, a painter, critic, and connoisseur, and Willard Huntington Wright, brother of the Synchromist Stanton Macdonald-Wright. The attacks against modernism they had to counter were largely based on the following grounds: (1) It was immoral and degenerate. (2) It

was technically incompetent. (3) It was dehumanizing and unintelligible. (4) It was a hoax and a fraud. (5) It was insane. (6) It was a foreign conspiracy. These were the usual charges modernism had encountered when it appeared, except for the last, which seems a peculiarly American idea. A typical response to the paintings in the Armory Show was the editorial "Lawlessness in Art," which appeared in the 1913 *Century* magazine. It stated, "What drew crowds were certain widely talked of eccentricities, whimsicalities, distortions, crudities, puerilities, and madness, by which, while a few were nonplussed, most of the spectators were vastly amused. . . . The exploitation of a theory of discords, puzzles, ugliness, and clinical details, is to art what anarchy is to society, and the practitioners need not so much a critic as an alienist."

From the academic point of view, beauty of subject meant an elevated theme. Royal Cortissoz criticized the moderns because of the ugliness of their subjects: "I disbelieve in modernism because it seems to me to flout fundamental laws and to repudiate what I take to be the function of art, the creation of beauty." To Cortissoz, modernism was symptomatic of the moral decay found in "a world full of jazz." Like the isolationists who feared contamination by foreigners, he raised charges of conspiracy:

> The United States is invaded by aliens, thousands of whom constitute so many acute perils to the health of the body politic. Modernism is of precisely the same heterogeneous alien origin and is imperilling the republic of art in the same way. . . . The French post-Impressionists—Cézanne, Van Gogh, Gauguin—retained just enough contact with the normal conventions of art for their subversive tendencies to be overlooked to a certain extent. . . . By the time the cubists came along there was an extensive body of flabby mindedness ready for the reception here. . . . These movements have been promoted by types not yet fitted for the first papers in aesthetic naturalization—the makers of true Ellis Island art.[13]

Such a passage is illustrative of what may be termed, to paraphrase Professor Richard Hofstadter's expression the "paranoid style in American politics," the "paranoid style in American art criticism."

Charles Buchanan, quoting Royal Cortissoz, in a review of the Forum exhibition of 1916, also objected to the international character

[13] Royal Cortissoz, *American Artists* (New York: Charles Scribner's Sons, 1923), p. 18.

of modernism, as well as to its unintelligibility: "If a work of art does not explain itself you may depend upon it that there is something wrong there. . . . Now the paintings in the Forum exhibition were not only no more characteristically American than they were Chinese, they were absolutely lacking in any national characteristics whatsoever."

A novel argument against modernism was presented by Duncan Phillips, before he became converted to at least some of its manifestations. In the 1918 essay "Fallacies of the New Dogmatism in Art," [14] Phillips echoed the opinion, held by a number of respectable critics, that modernism was not progressive but reactionary, because, from Cézanne onward, it preached the "cult of the archaic." This question—whether modern art was progressive or reactionary—was argued with great seriousness in the first quarter of the century; thereafter, it seems to have been found less interesting.

Frank J. Mather, Jr., found another unusual angle from which to attack the modernists. With a supercilious yawn, he condemned it as boring. Praising the National Academy show of 1916 over the Forum exhibition because of its greater variety, he concluded that "Monotony is the prerogative of the inwardly turned mind."

In all these debates, the most articulate advocate for the defense was Willard Huntington Wright. Against the charges of lunacy, he presented the evidence of a psychologist that there are no epidemics of pathological lunacy. "It is absurd," he said, "to accuse a large majority of the younger painters of the day and not a few among the elders of stark madness or perversity. One must, in all justice, recognize the sincerity of the new art and strive to comprehend its already considerable achievement." To the charge of unintelligibility, Wright countered in his Foreword to the Forum exhibition catalogue: "Not one man represented in this exhibition is either a charlatan or a maniac; and there is not a picture here which, in the light of the ideal, is not intelligible and logically constructed in accordance with the subtler and more complex creative spirit which is now animating the world of art." For Wright, modern art was not only progressive, it was steadily evolving new forms, keeping pace with the progress of science. As thought and philosophy become more abstract, so, he concluded, must modern art, "the authentic expression of modern thought."

[14] *American Magazine of Art,* IX (January, 1918).

Wright's goal was to legitimize modernism. He chose to accomplish this by providing substantial evidence that "modern painting is not a fad" but a tradition that "has progressed and developed logically for a century." From Wright's point of view, modernism represented not a step backward into the primitive past but an advance into the future. In order for modernism to gain acceptance in this country, it was essential that this premise be understood. Unfortunately, Wright's was a minority opinion; not until a sufficient body of literature tracing the internal development and roots of modern art appeared in America could he hope to be taken seriously. In his own history *Modern Painting,* he made one of the earliest attempts to provide such a historical context for modernism. Another early attempt was Sheldon Cheney's *A Primer of Modern Art,* published in 1924.

As a critic, Wright had a record that was creditable but not flawless. He immediately recognized the quality of the work of Maurer, Walkowitz, Marin, and Dove, but he thought Hartley and Sheeler only promising and found Bruce, Weber, and Demuth imitators of Cubism and Futurism, although he later recanted on Demuth. He had, as well, a few personal enthusiasms such as his high opinion of the mediocre landscape painter George Of. And, like many of the best American critics, he had a blind spot—the work of his brother Macdonald-Wright and the other Synchromists. At first, this took the form of special pleading, but, ultimately, his need to establish a rationale for Synchromism as the culminating moment in the history of Western painting led Wright to assume untenable positions. It led him, for example, to reject categorically painting in which flatness, rather than three-dimensionality, was stressed. In his last critical writings, he concluded that, since the art of painting had reached its maturity in Synchromism, no further advances could be made in the medium. He predicted that the disembodied art of color, the art of the future implied in Synchromism, would free itself of the canvas to become an autonomous medium, as it had in the clavilux (color organ) of Thomas Wilfred. Given Wright's initial hypothesis, that the tones of painting were analogous to the tones of music, this was a logical if fallacious conclusion. In this state of error, Wright retired from the field of art criticism to become the successful detective-story writer S. S. Van Dine.

The nature of Wright's fallacies and errors in judgment are illumi-

nating, because they are characteristic of the partial and mistaken understanding of modernism in the United States. He believed, first of all, that aesthetics was, or could be, a science and that criticism could be made scientific and exact. He believed as well that modern art could only be legitimized on the basis of its similarity to traditional art. Thus, like Dr. Barnes and innumerable others, Wright sought in older art consistent formal principles that would validate the new art. Searching for the authority of precedent, bewildered Americans for whom modernism, with its emphasis on the sensuous and the intuitive, was an alien experience cast about for sureness and solid ground. In criticism, such insecurity led to pseudo-scientific systems of analysis, and, in art, it led to abstract or semi-abstract paintings absurdly based on historical prototypes, which were merely academicism outside its usual context.

However, despite his limitations, Wright's contribution was impressive. He defended modernism with a sophistication equal to that of the academic critics; he insisted that the task of criticism was the separation of good from bad; and he refused to adopt a different set of standards for American art, constantly measuring it against advanced European art, thus forcing the realization that standards were still set in Europe and that American art would not come of age until it could conform to them. Berating the public, he claimed, "Modern art since Cézanne is the beginning of a new Renaissance; but the people in this country are unaware of its great significance." Wright took it upon himself to make them aware. If, in exasperation, he too became an eccentric, out of touch with the mainstream, his lot was not unlike that of many of the artists he championed.

The battle of abstract vs. representational art, hard fought throughout the second and third decades of this century, became, in the thirties, identified with the issue of European vs. American art. By this time, abstract art had come to be largely identified with European painting, whereas representational art was popularly considered the native mode of expression. Fostered by critics such as Thomas Craven, confusion between "modern" and "contemporary" helped to obstruct the development of modern American art, as it also protected Regionalists and American Scene painters from charges of academicism, to which they were certainly liable.

The leading apologist for abstraction in the thirties, George L. K.

The Practice, Theory, and Criticism of Art

Morris, maintained that "during an epoch in history such as this, when everywhere the mind seeks some order for its broken cultural fragments, the abstract art-work takes on fresh significance. It has the 'look' of its time, the ability to hold its place among the mechanisms that characterize the new civilization we are just beginning to know." But Morris' position was compromised by the fact that he seldom if ever praised anything but abstract art. Critics of the forties, fifties, sixties, and seventies would be less exclusive, and less prone to attempt to objectify personal taste into prescriptive dogma.

The major issues currently occupying criticism involve not only the position of the individual critic vis-à-vis the object under discussion or analysis but also the correct function, meaning, and role of art criticism as an autonomous discipline. Whether, as Royal Cortissoz insisted, "To say that a picture is bad in this or that respect is only incidentally to admonish the artist; the real purpose is to tell the lay reader what it is like" or whether, as John Dewey phrased it, "Criticism is judgment, ideally as well as etymologically" has yet to be resolved. Generally, serious critics side with Dewey. But, having decided that the evaluation of quality is the main task of the critics, they part company when it comes to determining on what basis this judgment is to be made.

The various attempts to make aesthetics or criticism scientific were undoubtedly naïve and mistaken; nevertheless, there arose from this concern with finding objective criteria of evaluation a type of criticism that endures as one of the strongest, perhaps *the* strongest, tradition of criticism in America. Although the roots of formalist criticism are usually traced to the English critics Clive Bell and Roger Fry, it is as much an American as an English tradition. Bell and Fry, as members of the Bloomsbury group, sought to put art criticism on an equal footing with literary criticism. Toward this end, they introduced some of the concepts of advanced literary criticism into art criticism, especially that which held form to be the expression of content. This was in contrast with the Americans who wished to eliminate the subjective factor entirely from criticism in order to provide systems of analysis that, transcending categories, personalities, and historical epochs, would prove their universality and general applicability.

Fry's attention was first focused on the problem of the analysis of form in art when, early in the century, he served as a young curator

in the European-painting department of the Metropolitan Museum, where he might have remained to illuminate the course of American art, had his talents not gone entirely unrecognized. During these years, he became acquainted with Denman Ross's *Theory of Pure Design,* which must have influenced his thinking enormously, since it was the only work he acknowledged in his 1909 "Essay in Aesthetics."

Fry's definition of art as the expression of emotion, and his separation of aesthetic beauty from the beauty of "a woman, a sunset, or a horse," was immediately accepted by the American critics Walter Pach, Willard Huntington Wright, and Christian Brinton. Clive Bell, as Fry pointed out, supported this formulation in observing, "however much the emotions of life might appear to play a part in the work of art, the artist was really not concerned with them, but only with the expression of a special and unique kind of emotion, the aesthetic emotion." The aesthetic emotion, for Bell, was communicated through "significant form."

Convinced of the rightness of Bell's and Fry's positions, Dr. Albert Barnes spent many years and devoted several books to the definition of "significant form." His search not only provided the basis for an extensive method of formal analysis, it influenced the thinking of some of our most important historians, critics, and aestheticians, including John Dewey, whose *Art as Experience* is dedicated to Dr. Barnes. Published in 1934, *Art as Experience* touched the thinking of a generation of American critics, and continues to be an important step in the development of American criticism.

During the thirties, under the rising tide of realism and illustrational painting, formalist criticism underwent a relative setback. It came under direct attack from critics who felt, as Virgil Barker did, that "the very conception of a 'pure' art, the very demand for a 'pure' aesthetic response could have arisen only in an unhealthy state of civilization." In a review of Fry's book on Cézanne, Barker summed up the humanists' arguments:

It is a mark of malease and incomplete living for the painter to want to escape from ordinary life and to attain in his art an unconditioned state of being. . . . art is reduced to an excrescence on life, something on the margin, a mere means of escaping from conditions there which have

proved too much for the subduing and harmonizing power of the personality. Its separation from life is fatal—to art and to life both.[15]

The most telling case against formalist criticism, however, was made by Meyer Schapiro, in a review of Alfred Barr's *Cubism and Abstract Art* ("Nature of Abstract Art," *Marxist Quarterly,* January–March, 1937). Schapiro criticized Barr's book, which still stands as the most lucid and thorough study of Cubism, on the grounds that it was unhistorical and separated art from its historical context. Objecting to Barr's presentation of art history as a cyclical process of exhaustion of forms and styles and reaction to this exhaustion, Schapiro stated that "the theory of immanent exhaustion and reaction is inadequate not only because it reduces human activity to a simple mechanical movement, like a bouncing ball, but because in neglecting the sources of energy and the condition of the field, it does not even do justice to its own limited mechanical conception."

This conception, that art history undergoes periodic cyclical reversals, was the view of the German art historian Heinrich Wölfflin, and it is one of the understood givens of a formalist interpretation of art history. Such an interpretation traces the evolution of forms in art independent of the personalities and conditions that generated them. To Schapiro, and other historians and critics opposed to this point of view, stylistic change is directly tied to social, cultural, and political change. In Schapiro's words: "The broad reaction against an existing art is possible only on the ground of its inadequacy to artists with new values and new ways of seeing . . . the banal divisions of the great historical styles in literature and art correspond to the momentous divisions in the history of society."

Attacked for being unhistorical, the formalist position has also been characterized as overly dependent on the judgments of history. Reviewing Clement Greenberg's collection of essays *Art and Culture,* published in 1961, Hilton Kramer accused Greenberg of taking the stand that "critical judgments if they are to carry the authority and force of something more than a merely personal taste, must be made in the name of history." Kramer interpreted Greenberg's attempt to construct

[15] Virgil Barker, "The Limitations of 'Pure' Art," *The Arts,* XIII, No. 1 (January, 1928).

an infra-logic of the relations among abstract forms as the presentation of "the impersonal process of history . . . in the guise of an inner logic."

A more serious criticism of the formalist position than that it is unhistorical or unduly historical—to the degree that it attaches positive value to "advanced" art—is the argument that it ignores the question of social context or content in art by concentrating exclusively on formal relationships. Many critics, ranging from partisans of representational art to moralists and social philosophers, have maintained that content—ethical, emotional, social, or political—takes precedence over form as the primary criterion of value in art. Harold Rosenberg continues to take such a stand, insisting that the validity of Abstract Expressionism resides in its "crisis content," rather than in its sense of pictorial form.

As a rule, formalist critics have stopped short of a discussion of content. Roger Fry, fearful such a discussion would plunge him into the "depths of mysticism," stopped "on the edge of that gulf." Greenberg is apparently equally wary of plumbing the ineffable. In neither case, at any rate, can the accusation of illogicality or muddled metaphysics be made as it can be of many critics of modern art. The issue becomes, instead, if the aesthetic emotion and significant form are ineffable, how much can the critic tell us about art?

If the contribution of Americans to twentieth-century art criticism has been undervalued, it has been so because often it was buried in an eccentric frame of reference. Thus, even so excellent a study as Milton Brown's *From the Armory Show to the Depression,* the basic source for any discussion such as the foregoing, dismisses the work of Denman Ross, W. H. Wright, and Dr. Barnes as "pseudo-scientific." Given the extent to which their findings have been incorporated, without acknowledgment, into current thinking, such an evaluation seems unjust. Like the advanced artists whose work was misunderstood, these thinkers worked in a situation where a lack of tradition or context for their work put them constantly on the defensive. As a result, Wright and Barnes, at any rate, became eccentric and offensive, and those whom they offended attributed to their work the shortcomings of their persons. At this point, it seems fitting to restore to them the credit due to pioneers.

Their pioneering work, however, seems of little interest to the

current crop of young critics reviewing for such journals as *Arts Magazine, Art News, Art in America,* and *Artforum* (which became in the sixties, under the editorship of Philip Leider and, later, John Coplans, the most influential journal on contemporary American art). Neither aesthetics nor the history of art criticism, which is only just beginning to exist as an independent discipline, but rather academic art history, is the background of most younger critics writing today. The result is that, increasingly as the seventies advance, art criticism comes to resemble a travesty of art-historical methodology; its aim often seems to be to provide long bibliographies for artists with short careers. Diatribes against "judgmental" criticism, i.e., criticism based on value judgments, have been directed against the school of formalist critics that took Clement Greenberg as its mentor. Greenberg's gradual retirement from the pages of art magazines has considerably weakened the position of formalist criticism, which seems unable to hold authority without a center. A lack of conviction in the future of painting as well as a disgust with the publicity function assigned to art criticism by an increasingly commercal milieu have caused a number of leading American art critics to defect to other pursuits. Philip Leider and Michael Fried, the most articulate and influential members of the Greenberg circle, have retired from contemporary art criticism to pursue academic studies. Annette Michelson writes mainly on film and performance, and Max Kozloff has been concentrating on photography and politics. Lucy Lippard has become a polemicist for feminism.

No single strong voice has asserted itself to take a position of sufficient conviction and clarity to force the critical dialogue to resume. Like the artists who speak only to people of their own persuasion or retire into lonely isolation, critics either move in cliques or remain completely out of touch with each other. In criticism as in art, media information has triumphed over communication: Raw, unprocessed data, statistical charts, and chronologies have replaced critical analysis and evaluation.

Fundamental questions have been raised but not answered. The notion of a "mainstream" has been attacked, the existence of an avant-garde challenged, and the possibility that painting is dead entertained. Such critics as Douglas Davis of *Newsweek* have taken up the standard of the multiple reproductive arts of film, video, and photo-

graphy, and museums are giving more and more exhibition space to such mass art forms. As the various channels of information broadcast conflicting signals, the public unfortunately becomes increasingly uncertain regarding the value of art in general. In this Tower of Babel situation, the question "Who is the true critic?" at this point seems no less relevant than the question "Who is the true artist?"

Chapter One

Apostles of Ugliness

ROBERT HENRI

Robert Henri's insistence on the connection between art and life announces one of the two main lines of thought in American art—that which holds that art is a reflection of life, a current traceable from the Ash Can School, through the American Scene painters of the thirties, to the Pop artists of the sixties and Photo-Realists of the seventies. Henri's notion that art is a vital process constantly in a state of organic growth reflects the extent to which the Vitalist philosophy of Henri Bergson had penetrated American art theory early in the century.

Henri's advice to his students and friends, mainly consisting of lecture notes compiled by students during his forty years as a teacher, provides a guide to his philosophy as teacher and liberal humanist. These aphorisms and observations document Henri's courageous and successful attempt to replace nineteenth-century academic conventions with practical attitudes more suitable to the conditions of the new century and to the conditions of American life.

[FROM an address to the students of the School of Design for Women, Philadelphia, 1901.]

The real study of an art student is generally missed in the pursuit of a copying technique.

I knew men who were students at the Académie Julian in Paris, where I studied this year and found some of the same students still there, repeating the same exercises, and doing work *nearly* as good as they did thirteen years ago.

37

At almost any time in these thirteen years they have had technical ability enough to produce masterpieces. Many of them are more facile in their trade of copying the model, and they make fewer mistakes and imperfections of literal drawing and proportion than do some of the greatest masters of art.

These students have become masters of the trade of drawing, as some others have become masters of their grammars. And like so many of the latter, brilliant jugglers of words, having nothing worth while to say, they remain little else than clever jugglers of the brush.

The real study of an art student is more a development of that sensitive nature and appreciative imagination with which he was so fully endowed when a child, and which, unfortunately in almost all cases, the contact with the grown-ups shames out of him before he has passed into what is understood as real life.

Persons and things are whatever we imagine them to be.

We have little interest in the material person or the material thing. All our valuation of them is based on the sensations their presence and existence arouse in us.

And when we study the subject of our pleasure it is to select and seize the salient characteristics which have been the cause of our emotion.

Thus two individuals looking at the same objects may both exclaim "Beautiful!"—both be right, and yet each have a different sensation— each seeing different characteristics as the salient ones, according to the prejudice of their sensations.

Beauty is no material thing.

Beauty cannot be copied.

Beauty is the sensation of pleasure on the mind of the seer.

No *thing* is beautiful. But all things await the sensitive and imaginative mind that may be aroused to pleasurable emotion at sight of them. This is beauty.

The art student that should be, and is so rare, is the one whose life is spent in the love and the culture of his personal sensations, the cherishing of his emotions, never undervaluing them, the pleasure of exclaiming them to others, and an eager search for their clearest expression. He never studies drawing because it will come in useful later when he is an artist. He has not time for that. He is an artist in the beginning and is busy finding the lines and forms to express the pleasures and emotions with which nature has already charged him. . . .

What you must express in your drawing is not "what model you had," but "what were your sensations," and you select from what is visual of the model the traits that best express you.

———

I do not want to see how skillful you are—I am not interested in your skill. What do you get out of nature? Why do you paint this subject? What is life to you? What reasons and what principles have you found? What are your deductions? What projections have you made? What excitement, what pleasure do you get out of it? Your skill is the thing of least interest to me.

———

The tramp sits on the edge of the curb. He is all huddled up. His body is thick. His underlip hangs. His eyes look fierce. I feel the coarseness of his clothes against his bare legs. He is not beautiful, but he could well be the motive for a great and beautiful work of art. The subject can be as it may, beautiful or ugly. The beauty of a work of art is in the work itself.

I love the tools made for mechanics. I stop at the windows of hardware stores. If I could only find an excuse to buy many more of them than I have already bought on the mere pretense that I might have use for them! They are so beautiful, so simple and plain and straight to their meaning. There is no "Art" about them, they have not been *made* beautiful, they *are* beautiful.

Some one has defined a work of art as a "thing beautifully done." I like it better if we cut away the adverb and preserve the word "done," and let it stand alone in its fullest meaning. Things are not done beautifully. The beauty is an integral part of their being done.

———

Low art is just telling things; as, There is the night. High art gives the feel of the night. The latter is nearer reality although the former is a copy. A painter should be interested not in the incident but in the essence of his subject.

Here is an emotional landscape. It is like something thought, something remembered.

Reveal the spirit you have about the thing, not the materials you are going to paint. Reality does not exist in material things. Rather paint the flying spirit of the bird than its feathers.

JOHN SLOAN

Along with Robert Henri, William Merritt Chase, Arthur Wesley Dow, and Hans Hofmann, John Sloan was one of the great teachers who shaped the art of America through their classes and lectures. In *The Gist of Art,* compiled mainly from notes taken by his students at the Art Students League, Sloan's tart, outspoken style is vividly preserved. Sloan's emphasis on "realization," a term Cézanne used to describe the artist's transformation of reality into something more durable and permanent, testifies to his consciousness of the importance of form and organization in art. In insisting that the function of art was to transform rather than to record the stuff of life, he was more clearly a twentieth-century artist than Henri. He counseled independence from formulas; and, like his former mentor, he was optimistic about the future of American art.

[FROM *The Gist of Art* (New York: American Artists Group, 1939).]

Art is the result of the creative consciousness of the order of existence. How can there be any ultimate solution of that? Art is the evidence of man's understanding, the evidence of civilization. Humanness is what counts. Man doesn't change much over the centuries, but there is some evidence that he is growing more human, very slowly, although it is his one great reason for being.

The artist has a song to sing. His creative mind is irritated by something he has to say graphically. You don't need to paint masterpieces or monumental subjects. Look out the window. Use your imagination. Get a kick out of that spatial adventure, the textures of things, the reality of the world. Find the design in things.

Seeing frogs and faces in clouds is not imagination. Imagination is

the courage to say what you think and not what you see. Max Eastman has said: "The scientist describes water as H₂O; the poet goes further and says 'it is wet.'" We want to describe things that way. An ideograph is better than the thing itself. A better work of art tries to say the thing rather than to be the thing. The image has greater realization than the thing itself. That is the great beauty of poetry—realization brought about by the use of images.

An artist is a product of life, a social creature. Of necessity he cannot mingle with people as much as he would like, but he reaches through his work. The artist is a spectator of life. He understands it without needing to have physical experiences. He doesn't need to participate in adventures. The artist is interested in life the way God is interested in the universe.

The artist has his own life to live; he has to pause and select and find something to say about it. The man of integrity works for himself alone, spurning all temptations to sell out his ability for commercial success. Any artist who paints to suit buyers and critics is what Walter Pach calls an Ananias, and unworthy of the name artist.

We live in a complex world in which we are mutually interdependent. But the artist must be independent. I think he always had to fight for his life, for freedom of expression, for the right to say what he believes. . . .

The great artist is the bloom on a plant, which is the art of the period. There may be more than one bloom. All the rest of us are the roots, shoots and branches of that plant or falling petals from the flower. The work we are doing today is a preparation for the great artists who are to come.

GUY PÈNE DU BOIS

• Although critics who were partisans of academic art reacted unfavorably to the realism of The Eight, The Eight also had their defenders in the press. James FitzGerald, James Huneker, and Frederick James Gregg supported their work from the outset, as did Guy Pène du Bois, a former Henri pupil who also wrote criticism. Later, Henri's friend Mary Fanton Roberts would devote considerable space to them in her magazine *The*

Touchstone. During the twenties, Forbes Watson, as editor of *The Arts,* often featured their work. And, as Davies had his special champions among critics who could not tolerate realism, Glackens and Prendergast found a friend in that redoubtable champion of modernism, Dr. Barnes, who not only bought their work, but subjected it to the same rigorous formal analysis with which he scrutinized Cézanne and Matisse.

[FROM "George B. Luks and Flamboyance," *The Arts,* III (February, 1923).]

Art is too generally confused with artisanship by the conception that it is made in three parts at least of good taste. In America good taste resides in the Eastern States—by the confession of these states—and is composed almost entirely of fear. In any case it is inconceivable that any flamboyance could exist within the confines of its precedential conservatism. Architects, as I have said perhaps too many times before, are the high priests of it. It may be that they have influenced American canvases. If they have, however, their way has been roundabout, their influence insidiously injected, for every artist will deny it. The fact is, anyway, that there is an enormous amount of willfulness, of intellectual direction, in the consistent good taste of most American canvases. This is true to a nearly intolerable extent in the prize-winning examples, and in their case is an evidence which cannot be taken lightly, for prizes are usually awarded by a consensus of opinion. Indeed, even when they are awarded through political machinations or favoritism of one kind or another there must still be some attention paid to the impression created upon those outside the ring and care taken to waylay or avoid their suspicion.

Good taste or the thought of it, as we know it in this country, is very largely a middle-class concern which begins at the manner of holding a fork, as an example, and ends at the pronunciation of a word or the decoration of a drawing room. It is considered so much a factor in the computation of social status that those persons who are uneasy upon the question of their position in the social scale, fortify it by the employment of instructors in fork holding and drawing room decoration. Indeed, taste is one of the most fearsome bugaboos in ordinarily comfortable lives.

George Luks, the flamboyant, has nothing to do with good taste of one kind or another. I do not know whether this makes him seem an especially honest or an especially ingenuous man, and do not think that it matters in the least. Nor does the fact that he is a Pennsylvanian and an Easterner make much difference. The fact that he was born under a republican form of government in the nineteenth century accounts for the nature of the flamboyance, but it does not account for the flamboyance. This is essentially his own, a natural gift of vitality just as in the instances of Rabelais and of Rubens. This vitality is the sort of power that will tear through fences and quite gaily pull at the pillars of established temples. It is not necessarily iconoclastic.

George Luks begins by having the bad taste of the braggard and goes on with a mad extravagance in untempered garrulousness and the impertinence, quite unconsidered on his part, to exhibit canvases fat in form and luscious in color to a people accustomed to the cramped works of painters with whom good taste is a dominating idol. . . . Luks will go to those whose strength almost carries an odor with it. The choice is quite often one of need and not of politeness or chance with Luks. He wants to make a record of the fullness of life, to render its rich flavor and warmth. This he does with a quality akin to mellowness and a sensuousness that is its counterpart. There are no static moments in a single one of his successful canvases. They do not flow with the swift urbanity of the lines of Rubens.

[FROM "William Glackens," *Arts and Decoration,* September, 1914.]

Had Glackens been a cerebralist he would have covered up his tracks. He would have formed a Renoiresque style such as we see in so many German pictures of the day. But Glackens took Renoir just as he took the bathers playing pranks on the beach, or the flowers in the fields. Renoir for him is part of the beauty of the world. He gladly acknowledges his obligations to Renoir. For Glackens doesn't have to try to be original.

Look for example at the reproduction of the young nude girl that was in the New Society exhibition this year. The form is pure Glackens. The Glackens' point of view remains an entity that can

easily be traced throughout his extensive production of drawings, pastels and paintings. That point of view is uncomplicated by the problems of the chess player. Men like Marcel Duchamp, for example, get their artistic pleasure from setting up intellectual problems for themselves and working them out. Instinct plays a very small part in such work. It is almost purely intellectual and has a strong appeal to the intellectuals.

Chapter Two

291: The Largest Small Room in the World

ALFRED STIEGLITZ

• Although poles apart in many ways, Robert Henri and Alfred Stieglitz shared certain basic assumptions: that art must be alive, not dead (i.e., academic); that "it is the spirit of the thing that is important"; that art cannot be labeled or compartmentalized. Stieglitz' statement, recorded by his friend Dorothy Norman, is characteristic of the salty, if not arrogant, tone that offended many, but earned the life-long devotion of others.

———

[FROM "Writings and Conversations of Alfred Stieglitz," edited by Dorothy Norman, *Twice a Year*, Nos. 14–15 (1947).]

I do not see why photography, water colors, oils, sculptures, drawings, prints . . . are not of equal potential value. I cannot see why one should differentiate between so-called "major" and "minor" media. I have refused so to differentiate in all the exhibitions that I have ever held.

People are constantly trying to compare, when the important thing is to see what is before one, in its own right. I refuse to label. . . . People are constantly asking if one likes this picture better than that; this medium better than that; the full-blown blossom better than the bud; Beethoven's Ninth Symphony better than the First. Had it not been for the First Symphony, Beethoven never would have developed to the point of being able to write the Ninth. It is the spirit of the thing that is important. If the spirit is alive, that is enough for me.

The Largest Small Room in the World

It is as if there were a great Noah's ark in which every species must be separated from the other species, so that finally, as they are all placed in their separate cells, they grow so self-conscious that finally, if one were to take them out and put them together they would all fall upon one another and kill each other.

CAMERA WORK: BENJAMIN DE CASSARES

• In the photography review *Camera Notes,* which soon expanded into *Camera Work,* a collection of criticism of photography and the visual arts published from 1903 to 1917, Stieglitz presented dissonant views of American culture and defenses of modernism in art and literature. The first American magazine to publish Gertrude Stein, *Camera Work* regularly published the criticism of Marius de Zayas, Benjamin de Cassares, Sadakichi Hartmann, and Charles Caffin, whose scathing attacks on the Academy made lively reading. De Zayas, a Mexican caricaturist, ultimately branched out on his own to open the Modern Gallery in 1915, with the financial aid of Marcel Duchamp's friend Walter Arensberg. Here he continued Stieglitz' tradition of showing the best European works, as well as examples of primitive art.

Cassares' pieces often had a *fin-de-siècle* air about them, and his sympathy was clearly with the nineteenth-century "decadents."

Insisting on the lack of true culture in the United States, the *Camera Work* critics set the stage for the more trenchant and systematic criticism of American culture that took place in the twenties. Other themes sounded were prophetic, too. Cassares' article on irony, excerpted below, was typical in that it discussed a radical subject that would crop up again and again in twentieth-century criticism of American culture.

[FROM "The Ironical in Art," *Camera Work,* No. 37 (1912).]

Irony in art is the expression of a lifelong vendetta of a penned-up, often impotent Ego against the commonplace and the limited; the cry for perfection *a rebours.* . . . The root of nihilism in art is spite. *Les Fleurs du Mal* is spite. *The World as Will and Idea* is spite. All Futurism, Post-Impressionism is spite. Great men are known by their

contempts. There have been geniuses who have never given their spite to the world; it was because they lacked the time, not the will.

All great movements begin with the gesture of hate, of irony, of revenge. This is as true of art as in social history. Irony is the perpetual heaven of escape. Nothing can follow the mind into that sanctuary. . . . Why should the dreamers and painters of the Other Plane despise this age we live in?—this age of sheds and pasteboard, of superficialities and stupidities, of inanities and material prosperity? Has it not given to us the divine ironists, the supreme haters, the mockers, the merry-andrews of art?

SADAKICHI HARTMANN

• Sadakichi Hartmann and Charles Caffin were two of the earliest apologists for modernism in America. Both published in *Camera Work,* as well as in more widely-read periodicals, such as *Forum* and *Century.* Hartmann's denunciation of Puritanism, excerpted below, presents an example of his writing for *Camera Work.* Caffin gained importance as an art critic for *Harper's Weekly, International Studio,* and later the *New York Sun,* and Hartmann was the author of an early history of modern art.

One of the regular contributors to *Camera Work,* Hartmann, like Henri, deplored the notion of art as a luxury commodity, outside the understanding or pocketbook of ordinary citizens. Reacting against the monopolization of art by the new rich and the "robber barons," who sought by buying art to buy themselves a pedigree, Hartmann analyzed the structure of the art world in order to expose its shams. Unfortunately, later critics of the American art audience would continue to find the same faults Hartmann uncovered in 1910.

———

[FROM "Puritanism, Its Grandeur and Shame," *Camera Work,* No. 32 (1910).]

[Puritanism is the] skeleton in the family closet, which saps the best life blood of our nation and makes it impossible for literature and art to expand in a free and wholesome manner. In the life of the Puritan all worship of the beautiful was wanting. . . . All we possess in the

domain of higher esthetics is the art of delicate transitions, of refinement, freshness of immediate observation and mechanical skill. And there can be no vital art of any sort until there has grown up an appreciation of the Rubens-Goya spirit; until we dare face our passions, until we are unashamed to be what we are, until we are frank enough to let wholesome egotism have its sway.

———

[FROM "The American Picture World, Its Shows and Shams," *Forum* (July–December, 1910).]

Foreigners of discernment, visiting this country, are astonished at the scarcity of American paintings on public exhibition. They wonder if the United States, so advanced in other things important to civilization, has as yet produced an art as distinctively American as the painters of the Barbizon School are distinctively French. America has no Luxembourg, no representative collection of pictures by American painters, and the chance of acquiring such a national treasure seems remote for years to come.

There is no doubt that we have done some big things in art, that we have produced some big men in painting, sculpture, illustration and other aesthetic pursuits, that the era of 1875–1900 has produced a group of men (as Inness, Homer Martin, Winslow Homer, A. P. Ryder, Abbott Thayer, St. Gaudens) of which any country could well be proud. But we Americans do not seem to value its significance or to be able to impress it on the European mind. We lack the graces of self-assertion in appreciation and enthusiasm. We consider aesthetic accomplishments inferior to attainments that directly benefit vital needs.

Americans have the reputation of being the most generous picture buyers in the world. Donations are readily made, and art museums crop up everywhere. This very year three huge buildings, involving an investment of millions of dollars, are under construction in Kansas City, Toledo, Ohio, and Worcester, Massachusetts. But the American collector has not yet learned to buy art for art's sake. He patronizes art for self-aggrandizement, for the sake of direct advertisement, of notoriety, of speculation, of crude and selfish reasons. It is with him

not a healthy demand for needed things, but just a gambling device. He treats art as a mere sport and delights in the reports of phenomenal prices that he paid for a single painting. And so the average citizen gets the erroneous idea that art is not for such as he, that the only pictures worthy [*sic*] the name are the few famous ones in the galleries of the rich, and that, like diamonds, automobiles, and race horses, they represent a luxury, a superfluity beyond the reach of an ordinary income. . . .

Picture buying depends almost entirely on individual trust and personal magnetism. The average collector, who has little knowledge of art and is often even doubtful as to what is best for him to buy, can do nothing but accept the word and blindly abide in the judgment of the salesman. The latter is all powerful. If he has once succeeded in securing the confidence of a customer, he has but himself to blame should he forfeit it.

The salesman of the large metropolitan establishments is shrewdness personified. Suave and self-possessed, he applies the kid-glove treatment to all prospective buyers. He is very dignified in deportment. He knows how to arouse the hush of expectancy. A vocabulary as picturesque as that of a poet accompanies the manners of a Chesterfield.

It is the credulity of the *nouveau riche* which has proved such a faithful source of revenue to the art dealer that, from small beginnings dating back to the civil war, he has risen to absolute control of the picture market. His methods show at times a striking similarity to the stock jobbing of Wall Street. Picture dealers work up an artificial demand for the productions of those artists they control. They "bear" prices on all pictures that lack the popular, salable quality, and "bull" those of which they control the supply. By misrepresentation and a nimble juggling of facts they unload worthless canvases upon confiding "lambs" after the fashion set by Wall Street with watered stocks. The ludicrous height to which the prices of Inness landscapes soared after the artist's death can only be compared to the shrewd operations in Spring wheat. . . .

In Europe, municipalities accumulate a collection before acquiring a suitable structure to shelter it. We, however, first erect a most expensive and elaborate building, and then try to fill it with donations. To walk through the empty exhibition halls of a museum in the Middle West is, indeed, a sad and melancholy pastime.

Art museums seem to have become necessary adjuncts to civilization. If people of ordinary means could afford to patronize art, there would be little use for museums. A certain educational value cannot be denied to them, although an actual influence like that of the Parthenon Frieze on modern English art is seldom noticeable. The only museum picture in America I know that can claim this distinction is Whistler's *Sarasate* at the Pittsburgh Carnegie Institute. The tendency for dark tonality and the triumphs of pictorial photography have received a considerable impetus from this canvas. The majority of these accumulations are so tentative, so incomplete, badly arranged and meaningless, that one might come to the conclusion that museums serve no purpose but that of a morgue—for dead pictures which nobody wants.

ARTHUR DOVE: THE MEANING OF 291

• In 1914, Stieglitz requested statements about the meaning of 291. The following is one of the responses he received.

[FROM *Camera Work*, No. 47 (1917).]

The question "What is 291?" leaves one in the same position in explaining it as the modern painter is in explaining his painting. The modern painting does not represent any definite object. Neither does "291" represent any definite movement in one direction, such as Socialism, suffrage, etc. Perhaps it is these movements having but one direction that make life at present so stuffy and full of discontent.

There could be no "291ism." "291" takes a step further and stands for orderly movement in all directions. In other words it is what the observer sees in it—an idea to the nth power.

One *means* used at "291" has been a process of elimination of the nonessential. This happens to be one of the important principles in modern art; there "291" is interested in modern art.

It was not created to promote modern art, photography, nor modern literature. That would be a business and "291" is not a shop.

It is not an organization that one may join. One either belongs or does not.

It has grown and outgrown in order to grow. It grew because there was a need for such a place, yet it is not a place.

Not being a movement, it moves. So do "race horses," and some people, and "there are all sorts of sports," but no betting. It is more interesting to find than to win.

MARCEL DUCHAMP

• Founded by emigré artists in New York at the same time as several short-lived publications associated with Dadaism, the magazine *291* joined *Camera Work* in printing the iconoclastic opinions of the avant-garde. Although the first *291*, published in 1915, bore as title the address of Stieglitz' gallery, its editors were Francis Picabia and Stieglitz' former associate, Marius de Zayas, who had recently opened his own gallery. Later, in 1917, Walter Arensberg, one of *291*'s backers, along with H. P. Roche, financed the publication of *Rongwrong* and *The Blind Man*. The following article was contributed to *The Blind Man* shortly after Marcel Duchamp resigned as an officer of the Society of Independent Artists over the issue of the society's refusal to exhibit the urinal titled "Fountain" by "Mr. R. Mutt." Testing the Americans' capacity to tolerate extremism, Duchamp quickly exposed the fallacy of the open exhibition; for, although all entries submitted were to be shown, Duchamp's found object was rejected, revealing that tacit considerations of taste and decorum still colored judgments.

[FROM "The Richard Mutt Case," *The Blind Man*, 1917.]

They say any artist paying six dollars may exhibit.

Mr. Richard Mutt sent in a fountain. Without discussion this article disappeared and never was exhibited.

What were the grounds for refusing Mr. Mutt's fountain:—

 1. Some contended it was immoral, vulgar.

 Others, it was plagiarism, a plain piece of plumbing.

Now Mr. Mutt's fountain is not immoral, that is absurd, no more

than a bath tub is immoral. It is a fixture that you see every day in plumbers' show windows.

Whether Mr. Mutt with his own hands made the fountain or not has no importance. He chose it. He took an ordinary article of life, placed it so that its useful significance disappeared under the new title and point of view—created a new thought for that object.

As for plumbing, that is absurd. The only works of art America has given are her plumbing and her bridges.

THE FORUM EXHIBITION

• The catalogue of the Forum Exhibition, organized in 1916 with the help of Stieglitz, Henri, and a group of critics, contains statements by a number of 291 artists. Below are those made by Dove, Abraham Walkowitz, and Alfred Maurer. Taking a consistently modernist stand, Stieglitz' protégés stressed that art was the expression of the unique, personal vision that allowed no compromise.

———

[FROM *The Forum Exhibition,* Anderson Gallery (New York: Hugh Kennerly, 1916).]

Arthur Dove

I should like to enjoy life by choosing all its highest instances, to give back in my means of expression all that it gives to me: to give in form and color the reaction that plastic objects and sensations of light from within and without have reflected from my inner consciousness. Theories have been outgrown, the means is disappearing, the reality of the sensation alone remains. It is that in its essence which I wish to set down. It should be a delightful adventure. My wish is to work so unassailably that one could let one's worst instincts go unanalyzed, not to revolutionize nor to reform, but to enjoy life out loud. That is what I need and indicates my direction.

Abraham Walkowitz

What one picks up in the course of years by contact with the world must in time incrust itself on one's personality. It stamps a man with the mark of his time. Yet it is, after all, only a dress put on a man's own nature. But if there be a personality at the core then it will mould the dress to its own forms and show its humanity beneath it.

In speaking of my art, I am referring to something that is beneath its dress, beneath objectivity, beneath abstraction, beneath organization. I am conscious of a personal relation to the things which I make the objects of my art. Out of this comes the feeling which I am trying to express graphically. I do not avoid objectivity nor seek subjectivity, but try to find an equivalent for whatever is the effect of my relation to such a thing, or to a part of a thing, or to an afterthought of it. I am seeking to attune my art to what I feel to be the keynote of an experience. If it brings to me a harmonious sensation, I then try to find the concrete elements that are likely to record the sensation in visual forms, in the medium of lines, of color shapes, of space division. When the line and color are sensitized, they seem to be alive with the rhythm which I felt in the thing that stimulated my imagination and my expression. If my art is true to its purpose, then it should convey to me in graphic terms the feeling which I received in imaginative terms. That is as far as the form of my expression is involved.

As to its content, it should satisfy my need of creating a record of an experience.

Alfred Maurer

My main concern in painting is the beautiful arrangement of color values—that is, harmonized masses of pigment, more or less pure.

For this reason, it is impossible to present an exact transcription of nature, for the color masses in nature are broken up by many minute color notes which tend to eliminate the mass effect. Consequently, I often use the dominating color in a natural object, and ignore the minor notes. By this process the natural *effect* is retained, and at the same time the picture becomes a color entity divorced from mere representation: and I have acquired a volume of color which will take its place in the conception of the picture. This, of course, would be

lost if all the details were truthfully set down: the many inconsequent aspects of an object would detract the eye from the final and pure effect of the work.

In order that I may express myself through the medium of color alone, I have eliminated, as far as possible, the sombre effect of black masses, and have keyed my pictures in a high articulation, so that the reaction to them will be immediate and at the same time joyous and understandable. Black, I believe, has a deadening effect in a pure color gamut, and I am trying to express the emotional significance of a scene without it, for pure colors are more moving than black, which is a negation of color.

It is necessary for art to differ from nature, or we would at once lose the *raison d'être* of painting. Perhaps art should be the intensification of nature; at least, it should express an inherent feeling which cannot be obtained from nature except through a process of association. Nature, as we all know, is not consciously composed; and therefore it cannot give us a pure aesthetic emotion. I believe that the artist who paints before nature should order his canvases; and in doing this he is unable to adhere exactly to the scene before him. The principles of organization and form, which animated the older painters, must not be ignored. They form the true basis for artistic appreciation. But the modern men can make use of these principles through a different medium. He can find a new method of presentation.

The artist must be free to paint his effects. Nature must not bind him, or he would have to become more interested in the subject-matter before him than in the thing he feels need expression. In my case, where I am interested in the harmonic relation of color volumes, I consider the tonal values first. This is why my pictures differ from the scene which they might seem to represent.

GEORGIA O'KEEFFE

Although Georgia O'Keeffe has denied that photography provided the example for her enlarged close-ups of flowers, there is an undeniable

similarity between certain of her compositions, both floral and abstract, and the photographs of her husband, Stieglitz, and his colleagues Paul Strand and Paul Haviland. The uniformity of texture and suave, simplified modeling, not only in O'Keeffe's flowers but in the paintings of Charles Demuth and Joseph Stella, suggest affinities to the transformations effected by the camera. The frequency with which the composition based on the cropped photograph, the rectangle selected out of a larger scene, appears in American art makes it clear that in many ways representational art in America is as closely tied to photography as it is to illustration. Given an already established taste for the factual and the concrete, it is not surprising that the documentary objectivity of the camera became something artists wished to emulate. Paradoxically, however, what they wished to borrow from the photograph was not its precise realism, but its ability to reduce a variety of objects and textures to a common denominator so as to treat them as equal elements in an abstract composition.

[FROM "Georgia O'Keeffe" in Katharine Kuh, *The Artist's Voice* (New York: Harper & Row, 1960). Copyright © 1960, 1961, 1962 by Katharine Kuh. Reprinted by permission of Harper & Row, Publishers, Inc.]

QUESTION: Why have you always been so interested in simplifying and eliminating detail?

O'KEEFFE: I can't live my life any other way. My house in Abiquiu is pretty empty; only what I need is in it. I like walls empty. I've only left up two Arthur Doves, some African sculpture and a little of my own stuff. I bought the place because it had that door in the patio, the one I've painted so often. . . . Those little squares in the door paintings are tiles in front of the door; they're really there, so you see the painting is not abstract. It's quite realistic. The patio is quite wonderful in itself. You're in a square box; you see the sky over you, the ground beneath. In the patio is a well with a large round top. It's wonderful at night—with the stars framed by the walls.

QUESTION: Do you always paint what you see? What about changing light?

O'KEEFFE: You paint *from* your subject, not what you see, so you can't be bothered with changes in light. I rarely paint anything I don't know very well.

The Largest Small Room in the World

JOSEPH STELLA

• Besides *Camera Work,* the little magazines, such as *Broom* and *Seven Arts,* would sometimes publish the statements of modern artists. The heights of fantasy reached in his late paintings are hinted at in this indictment of academic art by the avant-garde modernist Joseph Stella, whose equation of modern art with nonconformist individual freedom was typically American.

[FROM *Broom,* December, 1921.]

The motto of the modern artist is freedom—real freedom. We cannot have enuf [*sic*] of it because in art license doesn't exist. The modern painter knowing that his language deals with form and colour proclaims above all the purity of his own language and repudiates the assistance of all those red-cross societies which camouflage themselves: literature, philosophy, politics, religion, ethics. Although many prejudices still cling to him—and generations have to pass before he will reach the absolute freedom, he has lost that idiotic religious feeling which urges fanatics to nominate a leader, a pope. He recognizes personalities and not their derivations, the schools. But while he recognizes merit and he has respect for it, no-matter what period and what race it belongs to (it is to modern art the credit of having enriched the knowledge of beauty to be found in the most glorious forgotten periods) he is far from fetishism because his chief interest lies in the venture through the untrodden path knowing that he belongs to his own time, he does not only accept it but he loves it— and therefore he can't go back to any past to borrow material. He does not feel obliged to follow any tradition; only tradition lies in him. The only guide to follow is his own temperament and that's the reason why abstractions and representations in the strict sense of the word don't mean anything. Rules don't exist. If they did exist everybody would be [an] artist. Therefore he can't recognize as modern artists those who having left an old slavery are chained by a new one. In other words chinasism [*sic*], indianism, persianism, negro sculpture with Cézannism and Renoirism—which most prevail nowadays—cannot but disgust him. If Cubism has declared the independence of Painting, by

suppressing representation and in order to purify the vision is gone back, with abstractions, to geometry, the source of the graphic Arts, he feels that every declaration of Independence carries somewhat a declaration of a new slavery. And according to his credo he will always prefer the emotions as expressed by a child to the lucubrations of those warbling theorists who throw harlequin mantles on insipid soapy academic nudes or to those anatomical forms in wax chopped à sang froid by necrophiles. When we think that our epoch, like every other epoch, is nothing else but a point in the immensity of time, we have to laugh to those standards that people considered eternal. The masterpiece—a phrase of the infinite speech running through the centuries can't be the final word it is supposed to be. You cannot consider a phrase no matter how perfect it is, complete and final when the whole sentence is not finished.

MARSDEN HARTLEY

Both Hartley and John Marin expressed themselves poetically, and both wrote poetry whose subject was often the same as the lyric nature studies they chose to paint. Acerbic New Englanders, they condensed language as they condensed imagery in their paintings, in order to make the strongest statement in the fewest words. Hartley's faith in individualism and the importance of the subject is expressed below. In a later statement, Hartley explains his conversion to a severely simplified art, more intellectual than emotional.

[FROM *The Forum Exhibition,* Anderson Gallery (New York: Hugh Kennerly, 1916).]

Personal quality, separate, related to nothing so much as to itself, is a something coming to us with real freshness, not traversing a variety of fashionable formulas, but relying only upon itself. The artist adds something minor or major more by understanding his own medium of expression, than by his understanding of the medium or methods

of those utterly divergent from him. Characteristics are readily imitable; substances never; likeness cannot be actuality. Pictural notions have been supplanted by problem, expression by research. Artistry is valued only by intellectualism with which it has not much in common. A fixed loathing of the imaginative has taken place; a continual searching for, or hatred of, subject matter is habitual, as if presence or absence of subject were a criterion, or, from the technical point of view, as if the Cézannesque touch, for instance, were the key to the aesthetic of our time, or the method of Picasso the clew to modernity.

I am wondering why the autographic is so negligible, why the individual has ceased to register himself—what relates to him, what the problematic for itself counts. I wonder if the individual psychology of El Greco, Giotto and the bushmen had nothing to do with their idea of life, of nature, of that which is essential—whether the struggle in El Greco and Cézanne, for example, had not more to do in creating their peculiar individual aesthetic than any ideas they may have had as to the pictural problem. It is this specialized personal signature which certainly attracts us to a picture—the autographic aspect or the dictographic. That which is expressed in a drawing or a painting is certain to tell who is its creator. Who will not, or cannot, find that quality in those extraordinary and unexcelled watercolors of Cézanne, will find nothing whatsoever anywhere. There is not a trace anywhere in them of struggle to problem: they are expression itself. He has expressed, as he himself has said, what was his one ambition—that which exists between him and his subject. Every painter must traverse for himself that distance from Paris to Aix or from Venice to Toledo. Expression is for one knowing his own pivot. Every expressor relates solely to himself—that is the concern of the individualist.

It will be seen that my personal wishes lie in the strictly pictural notion, having observed much to this idea in the kinetic and the kaleidoscopic principles. Objects are incidents: an apple does not for long remain an apple if one has the concept. Anything is therefore pictural; it remains only to be observed and considered. All expression is illustration—of something.

[FROM "Art and the Personal Life," *Creative Art,* II, No. 46 (June, 1928).]

As soon as a real artist finds out what art is, the more he is likely to feel the need of keeping silent about it, and about himself in connection with it. There is almost these days, a kind of *petit scandale* in the thought of allying oneself with anything of a professional nature. And it is at this point that I shrink a little from asserting myself with regard to professional aspects of art. And here the quality of confession must break through. I have joined, once and for all, the ranks of the intellectual experimentalists. I can hardly bear the sound of the words "expressionism," "emotionalism," "personality," and such, because they imply the wish to express personal life, and I prefer to have no personal life. Personal art is for me a matter of spiritual indelicacy. Persons of refined feeling should keep themselves out of their painting, and this means, of course, that the accusation made in the form of a querulous statement to me recently "that you are a perfectionist" is in the main true. . . .

I have come to the conclusion that it is better to have two colors in right relation to each other than to have a vast confusion of emotional exuberance in the guise of ecstatic fullness or poetical revelation—both of which qualities have, generally speaking, long since become second-rate experience. I had rather be intellectually right than emotionally exuberant, and I could say this of any other aspect of my personal experience. . . .

I am satisfied that painting also is like nature, an intellectual idea, and that the laws of nature as presented to the mind through the eye—and the eye is the painter's first and last vehicle—are the means of transport to the real mode of thought; the only legitimate source of esthetic experience for the intelligent painter.

JOHN MARIN

• In his frequent letters to Stieglitz, Marin insisted, like Hartley, on individuality, intensity, freedom of expression, and quality. Like Stieglitz,

The Largest Small Room in the World

Marin was against simplification; he held that the attempt to explicate the unexplainable poetic core of the work of art was doomed to failure. Typical of the attitude of American artists, who tended to identify with the proletariat, rather than with a Bohemia, was Marin's contention that art is, above all, work.

[FROM *Selected Writings of John Marin*, edited with an introduction by Dorothy Norman (New York: Pellegrini & Cudahy, 1949).]

To Stieglitz, July 21, 1921

Freedom, what is it? Let's disobey the law. To first find out, to recognize, the elemental, the big laws then, one must perforce disobey the fool law, to keep the big law. But so many seek to break the big law. Well, nature has something to say about this.

To Stieglitz, Sept. 12, 1923

Yesterday I heard a bird singing. Well, I might go down in Africa and hear a lion roar down the street, the honk of an automobile down to the city, a jazz band. There was quality to the bird's singing, wonderful quality. So in the lion's roar, could be in the honk of the auto, could be in the jazz band. *Quality.* That's what the few of the world will always cry out for, till doomsday. I know it. That's one of my convictions if I have any.

To Hell with Walt Whitman's hymn to death, say I. He was already beginning to croak. No man is old until he begins those croakings. Some are born with it, they love to call the work of others *light, airy.* There is plenty of light if you can see it, away down deep in the uttermost depths. Go down and haul it up—no need to parade where you have been with the damned literature of romance. If you really have *been,* those who see will know, without smearing tatooing, skull, crossbones all over the body.

To Stieglitz, July 20, 1931

Out of doors painting as such is just a *Job*—to get down what's ahead of you—water you paint the way water moves—Rocks and soil

you paint the way they were worked for their formation—Trees you paint the way trees grow.

If you are more or less successful these paintings will look pretty well indoors for they have a certain rugged strength which will carry them off in a room—though they seemingly bear no relationship to the room

In *indoors* painting—as such—things should bear a close relationship to the room

And I find that now I am hovering close to a statement that in using the term *indoors* I am approaching a supposition of *inward travelling* which throws us back on our haunches again

But—I would like to sound myself to those—would like to roar at those

> Those critics
> Those feeble painters
> Those who gasp out "Interpret myself"
> Those—Art creatures
> Those—Art exponents

That painting after all—*is painting*—just that—and that if you'll paint and paint—and when you get through your paint builds itself up—moulds itself—piles itself up—as does that rock—this very set of things—why then you might call yourself a painter—you might have one or two of the *old boys*—could they come back—give you a deserved pat on the back

So I stand firm—I refused to be budged by the Spiritual crowd—the maybe so and maybe not—crowd

Yes I'll have it that painting is a *Job*—a *Job* in paint—and I am afraid that in the crazed desire to be modern—to have ideas—to be original—to belong to the tribe *intelligencia* [*sic*]—we have gotten away from the paint job which is a *lusty thing* . . . and I almost feel like saying "what you have to say don't amount to so much"—but the *lusty* desire to splash about—submerge oneself in a medium—you might come up to surface with something worth while—Oh there be phases and phases and still more—but at the present I sing to the LUSTY

Your

Marin

The Largest Small Room in the World

To Stieglitz, July, 1933

Also I know that when I quit this Expression in *Water Colors*—the which I am now playing with—and get to the dignified—the high micka muck medium Oils—I know that my clothes 'l' a'gin to have paint spots on em and that my wife 'l' a'gin to say things

I find that I begin to think about oil [paints] when the Wells begin to get low—which bears out Demuth's vision of Marin and his slopping water buckets

Once in a while, after a fellow has laid or is laying down some Solid Red Brick thoughts, or thinks or others think he has laid down these things of Grit and Color, building up, tearing down, often more tearing down than building up—thus bearing out the old saw, "What goes up must come down"—there happens along some one or ones: the curious, too the really interested, and they want to know what it's all about, this brick laying, or what calls for brick in the specifications. And there are those aplenty to tell them. Mostly loiterers. A few try hard and a fewer still with something to tell. But it has been in the past rather hard for those few to find place or space to tell.

It's getting better now. You can see the signs.

Quite a few people are getting nauseated with platitudes, the platitudes of those who write upon things about which they sense mighty little.

So that it's become the thing now to ask the worker himself about his carrying on.

There will be this, though. The worker is one rather given to observing, thinking and doing. It's not easy for him to talk about and explain his work, but as he and his work have been placed in false positions many times, I suppose that he owes it to himself and his world to say something.

To lay off for a while, which is not too difficult, to ponder over, to think on, to vision, what I have done, am doing, am to do, what I have seen, am seeing, am to see, in, of and on this world about me on which I am living, that impels the doing of my do—that's more difficult.

And too what others are doing. For the trend of the doing, from the seeing, must certainly bear out a sort of collective of today.

For the worker to carry on, to express his today, with the old instru-

ments, the old tools, is inexcusable, unless he is thoroughly alive to the relationships of things and works in relationships. Then he can express his today in any material, preserving that material's relationship; as the relationship of two electric bulbs of different strength can be the same as the relationship of two pieces of lead of different weights.

Considering the material sides of today with its insistence: glass, metals, lights, building of all kinds of all kinds of purposes with all kinds of material. Lights brilliant, noises startling and hard, pace setting in all directions, through wires, people movements, much hard matter.

The life of today so keyed up, so seen, so seeming unreal yet so real and the eye with so much to see and the ear to hear. Things happening most weirdly upside down, that it's all—what is it? But the seeing eye and the hearing ear become attuned. Then comes the expression:

> taut, taut
> loose and taut
> electric
> staccato.

The worker in parts, to create a whole, must have his parts, arrange his parts, his parts separate, his parts so placed that they are mobile (and though they don't interchange you must be made to feel that they can); have his lines of connection, his life arteries of connection. And there will be focussing points, focussing on, well, spots of eye arrest. And those spots sort of framed within themselves. Yes, there will be big parts and small parts and they will all work together, they will all have the feel, that of possible motion.

There will be the big quiet forms. There will be all sorts of movement and rhythm beats, one-two-three, two-two-three, three-one-one, all sorts, all seen and expressed in color weights. For color is life, the life Sun shining on our World revealing in color light all things.

In the seethe of things, in the interest of this, in the doing of this, terms, abstract, concrete, third or fourth dimension—bah. Don't bother us.

For the worker, the seer, is apt to damn all terms applied by the discussionists. But the glorious thing is that we cannot do, elementally

do, other than our ancestors did. That is, that a round conveys to all who see it a similar definite, a triangle a similar definite, solids of certain forms similar definites, that a line—what I am driving at is that a round remains, a triangle remains, a line remains and always was.

To get to my picture, or to come back, I must for myself insist that when finished, that is when all the parts are in place and are working, that now it has become an object and will therefore have its boundaries as definite as that the prow, the stern, the sides and bottom round a boat.

[FROM "John Marin, by Himself," *Creative Art,* October, 1928.]

Seems to me the true artist must perforce go from time to time to the elemental big forms—Sky, Sea, Plain—and those things pertaining thereto, to sort of re-true himself up, to recharge the battery. For these big forms have everything. But to express these, you have to love these, to be a part of these in sympathy. One doesn't get very far without this love, this love to enfold too the relatively little things that grow on the mountain's back. Which if you don't recognize, you don't recognize the mountain.

ARTHUR DOVE: ON HIS METHOD

• In a letter to Chicago collector Arthur Jerome Eddy, Dove attempts to answer Eddy's question as to what he was driving at in the painting *Based on Leaf Forms and Spaces,* which Eddy had bought in 1912 from Dove's Chicago show. Explaining that he will not make propaganda on modern art, Dove offers instead an "explanation of my own means."

[FROM Frederick S. Wight, *Arthur G. Dove* (Berkeley: University of California Press, 1958).]

Inasmuch as the means continually changes as one learns, perhaps the best way to make it understood would be to state the different steps which have been taken up to the present time. After having come to the conclusion that there were a few principles existent in all good art from the earliest examples we have, through the masters to the present, I set about it to analyze these principles as they occurred in works of art and in nature.

One of these principles which seemed the most evident was the choice of the simple motif. This same law held in nature, a few forms and a few colors sufficed for the creation of an object. Consequently I gave up my more disorderly methods [Impressionism]. In other words I gave up trying to express an idea by stating innumerable little facts, the statement of facts having no more to do with the art of painting than statistics with literature. . . .

The first step was to choose from nature a motif in color and with that motif to paint from nature, the forms still being objective.

The second step was to apply this same principle to form, the actual dependence upon the object (representation) disappearing, and the means of expression becoming purely subjective. After working for some time in this way, I no longer observed in the old way, and, not only began to think subjectively but also to remember certain sensations purely through their form and color, that is, by certain shapes, planes of light, or character lines determined by the meeting of such planes.

With the introduction of the line motif the expression grew more plastic and the struggle with the means became less evident.

Chapter Three

The Armory Show: Success by Scandal

WILLIAM GLACKENS

• The Armory Show touched off a prolonged series of critical debates on the validity of modernism, which lasted several years. To help gain an audience for the exhibition, Guy Pène du Bois devoted the entire March, 1913, issue of *Arts and Decoration* to the Armory Show. The following is an interview with William Glackens, chairman of the domestic committee, on the American Section of the Armory Show, which was ghost-written by Pène du Bois in that issue.

――――――

| FROM "Interview with William Glackens," *Arts and Decoration,* March, 1913. |

American art is above everything else skillful. American painters and sculptors are technical marvels. I mean the majority. They work with great fluency, manipulate the medium with an astonishing and almost sensational ease. Their painting is the kind of painting that wins prizes. But it is not the kind of painting in which one feels that the artist is actually enjoying himself. Indeed this skill in America is limited, limited by a lack of bravery—a fear of freedom or of honesty. It is skill enslaved by academies, skill answering to the dictates of a rigidly defined prescription—a prescription made general in order that it may fit everything, and, therefore, fitting nothing exactly.

We have had no innovators here. But I do know surely what is meant by innovators in art. American art is like every other art—a

matter of influence. Art, like humanity, every time has an ancestry. You have but to trace this ancestry with persistence and wisdom to be able to build the family tree. The cubes of the cubists that must inevitably give us a sense of weight and seem to be a marked departure from the much trodden paths of art are derived directly from Cézanne, who, in turn, is indebted to the impressionists and to the classicists—to the order-loving Ingres, for example.

Everything worth while in our art is due to the influence of French art. We have not yet arrived at a national art. The old idea that American art, that a national art, is to become a fact by the reproduction of local subjects, though a few still cling to it, has long since been put into the discard. This quite naturally and for very obvious reasons.

The early Americans were illustrative. They followed in the tracks of the writers, and that is out of the way that art should follow. It was France that showed them the error of their project. Even Winslow Homer so much lauded as a purely native product, was never good, never the power that he became, until he got under the influence of France. It was through France that Homer, with America, began to get a knowledge or, in fact, a first sight of actual values. That is true, too, in the instance of George Inness, who worked his way out of the rut of the Hudson River School only after he had secured the assistance of the art of France.

But the national art, the truly national art, must be the result of growth; it has never come as a meteor, it never will come as a meteor. Our own art is arid and bloodless. It is like nothing so much as dry bones. It shows that we are afraid to be impulsive, afraid to forget restraint, afraid above everything to appear ridiculous.

F. J. GREGG

• The apologetic tone of the critic F. J. Gregg, who examines the attitude of the Americans, is symptomatic of the second thoughts of the Armory Show's organizers.

———————

The Armory Show

[FROM "The Attitude of the Americans," *Arts and Decoration,* March, 1913.]

This is not by way of an apology but only in strict justice.

The American painters and sculptors who have arranged for the International Exhibition of Modern Art, and those of them who are co-operating as exhibitors, have reason to claim for themselves the credit of true disinterestedness. It may be that they will benefit as much, or more, than the general public, but, on the other hand, it must be remembered that they are running a risk with their eyes open, the risk of the deadly comparison which is sure to be made by the newly awakened and even by the casual spectator.

The Americans who have done this thing with their eyes open are of all sorts and conditions. Some of them are academicians, others are occasional exhibitors at the Academy; others, again, exhibit anywhere and don't care what side of the street they are found on; others are members of various groups in New York who have nothing whatever in common; others have given up exhibiting altogether, having become convinced of the futility of reaching the public in that way, and others believe only in "one man shows" under ordinary circumstances. It is something that individuals varying so on the subject of the display of art should have worked together harmoniously for what they regard as a great public purpose.

In the practice of their art the members of the Association and their fellow exhibitors present just as decisive contrasts as in the other matter. There is no doubt that in the case of a number of them it will be found that through their individual vitality they have been developing along their own lines, with the result that their works will hold their own even in the neighborhood of the innovators from aboard. This is no more than saying that a number of the Americans have been growing because they were alive and couldn't help it. But undoubtedly one thing the exhibition will show, as anybody might have imagined without it, these are the men who have had no or next to no influence on their fellow countrymen.

It is possible that, when the affair is over, the verdict will be that the vast mass of the American works exhibited represented simply arrested development, and had nothing in them to suggest anything like

the hope of posterity while, in the work brought here from Europe, and in that of the few Americans who have been dissatisfied and are struggling after something better was to be found all that was worth any serious attention. But if there was a great contrast and a discouraging one, that in itself will be but the clinching argument that the enterprise was necessary if the lethargy into which our painters and sculptors had fallen was to be put an end to.

We have had various exhibitions of so-called "Independents" and "Insurgents" and so on, but even in the case of the smallest of these it was hard for any man of sense to see what logical relation there was between the artists who showed their work together. There were always several of the associates who, you felt, ought not to have been there. Taking this fact into consideration it is not so surprising that there should be a great variety of importance, or lack of importance, in so large an exhibition as the present one.

What is undoubtedly to be found in the Frenchmen is a quality in their work which, however it may irritate, or puzzle, or disturb, never produces dullness. If it indicates nothing but what is embryonic, that very fact stands for growth into fulness of existence. On the other hand, American art, or that part of it with which the ordinary man is perfectly satisfied, is deadly dull and suggests decay instead of growth.

The manner in which Americans have regarded their own painters and sculptors has affected their purchases of foreign works. Of course there were some daring collectors who bought Post-Impressionists' paintings before they were accepted abroad, but the tendency here was to wait until the drift of fashion had made itself felt. . . .

Some persons who view the great exhibition in the 69th Regiment Armory, and even some artists, will have no idea of the amount of work performed by the members of the Association, at home and abroad, in getting the great show together. It is easy enough to collect pictures for an International Exposition. In such a case the result is a hodgepodge, each nation being represented by what is good, bad, or indifferent, but in the main by what is known as "official art." In this case a body of painters and sculptors set out to do a definite thing, to obtain a certain definite unity which was never lost sight of. The result is that as far as they were able to accomplish it, the exhibition has a positive unity.

Even if the American work in these rooms represents no such vigor as the European work, nothing was accepted or asked for which did not at any rate show a susceptibility on the part of the artist to the vital influences of his period.

Not only was it a difficult task to get the works together, but the exhibition and the preparation for it involved so many details, and such a mixture of details, that the members of the Association had to give up a great deal of their time in committees and otherwise to hard and continuous office work. It is true that they expect to benefit from the exhibition, but this is not the thing that they have kept in mind. The main thing was to get the foreign paintings and sculptures here, and each man made the question of how his own work would look under such trying circumstances quite a secondary consideration.

As one distinguished American painter put it: "I am just as anxious as you fellows are to see how bad my pictures look."

THEODORE ROOSEVELT

• Expressing the honest bewilderment of the man in the street, Theodore Roosevelt lashed out against the array of radical painting and sculpture on view at the Armory Show. His equation of modernism with the lunatic fringe has endured as a popular stereotype; so has his allegation that modern art is a hoax and a fake. Acknowledging the importance of the show, he nonetheless denied the value of the works exhibited.

———

[FROM "A Layman's Views of an Art Exhibition," *The Outlook,* XXIX (March 9, 1913).]

The exhibitors are quite right as to the need of showing to our people in this manner the art forces which of late have been at work in Europe, forces which cannot be ignored.

This does not mean that I in the least accept the view that these men take of the European extremists whose pictures are here ex-

hibited. It is true, as the champions of these extremists say, that there can be no life without change, no development without change, and that to be afraid of what is different or unfamiliar is to be afraid of life. It is no less true, however, that change may mean death and not life, and retrogression instead of development. Probably we err in treating most of these pictures seriously. It is likely that many of them represent in painters the astute appreciation of the power to make folly lucrative which the late P. T. Barnum showed with his faked mermaid. There are thousands of people who will pay small sums to look at a faked mermaid; and now and then one of this kind with enough money will buy a Cubist picture, or a picture of a misshapen nude woman, repellent from every standpoint.

KENYON COX

• The most intelligent rejection of modernism in the name of academic art came from Kenyon Cox, the articulate painter, critic, and member of the National Academy. Cox saw the breakdown of academic conventions in painting as an indication of the general breakdown of the moral structure. In many ways he was right: the Armory Show did signify the end of an age of cultural innocence in America, as World War I closed the Belle Époque in Europe. Both art and social moral structure were changing, if not crumbling, as Cox feared. But unlike his colleague Royal Cortissoz, Cox was not an hysterical reactionary condemning foreign art as "Ellis Island art"; rather, he was a highly rational conservative. Nevertheless, he could not refrain from charging the modern movement with charlatanism, decadence, and lunacy, the most popular of the indictments against the new art.

———

[FROM "The 'Modern' Spirit in Art," *Harper's Weekly,* March 15, 1913.]

It is proper to begin an account of the extraordinary exhibition of modern art recently held in New York with an acknowledgment that it is well such an exhibition should be held and that, therefore, the

thanks of the public are due to the gentlemen who got it together. We have heard a great deal about the Post-Impressionists and the Cubists; we have read expositions of their ideas and methods which have had a plausible sound in the absence of the works to be explained; we have had some denunciation and ridicule, some enthusiastic praise, and a great deal of half-frightened and wholly puzzled effort to understand what, it was taken for granted, must have some real significance; but we have not heretofore had an opportunity of seeing the things themselves—the paintings and sculpture actually produced by these men. Now the things are quite indescribable and unbelievable. Neither the praises of their admirers, the ridicule of their opponents, nor the soberest attempt at impartial description can give any idea of them. No reproduction can approach them. They must be seen to be believed possible, and therefore it is well that they should have been seen. From this point of view my only regret is that the Association of American Painters and Sculptors did not see fit to include some representation of the Futurists in their exhibition, that the whole thing might be done once for all. In a case of necessity one may be willing to take a drastic emetic and may even humbly thank the medical man for the efficacy of the dose. The more thorough it is the less chance is there that it may have to be repeated.

Of course I cannot pretend to have approached the exhibition entirely without prejudice. One cannot have studied and practised an art for forty years without the formation of some opinions—even of some convictions. But I remembered the condemnation of Corot and Millet by Gérôme and Cabanel; I remembered the natural conservatism of middle age; I took to heart the admonition of the preface to the catalogue, that "to be afraid of what is different or unfamiliar is to be afraid of life." I meant to make a genuine effort to sort out these people, to distinguish their different aims and doctrines, to take notes and to analyze, to treat them seriously if disapprovingly. I cannot do it. Nor can I laugh. This thing is not amusing; it is heartrending and sickening. I was quoted the other day as having said that the human race is rapidly approaching insanity. I never said it, but if I were convinced that this is really "modern art" and that these men are representative of our time, I should be constrained to believe it.

In recollecting the appalling morning I spent in this place certain personalities do, however, define themselves and certain tendencies

72

make themselves clear. It is no time for squeamishness or for standing upon "professional courtesy," and such persons as I may mention I shall treat quite frankly—in that respect, at least, I may follow their own example. Fortunately there is little necessity of dwelling upon the American part of the show. It contains some good work by artists who must wonder at the galley aboard which they find themselves, some work with real merit by men who have aided in the launching of the galley, and a great deal of bad work which, however, seldom reaches the depths of badness attainable by Frenchmen and Germans. But this work, good, bad, and indifferent, is either perfectly well known or is so paled by comparison that it needs no mention. Some of it is silly, but little of it is dangerous. There is one American, however, who must be spoken of because he has pushed the new doctrines to a conclusion in some respects more logical and complete than have any of the foreigners. In the wildest of productions of Picabia or Picasso there is usually discernible, upon sufficiently painstaking investigation, some faint trace of the natural objects which are supposed to have inspired them; and even when this disappears the title remains to show that such objects have existed. It has remained for Mr. Marsden Hartley to take the final step and to arrange his lines and spots purely for their own sake, abandoning all pretense of representation or even of suggestion. He exhibits certain rectangles of paper covered with a maze of charcoal lines which are catalogued simply as Drawing No. 1, Drawing No. 2, and so forth.

This, I say, is the logical end, for the real meaning of this Cubist movement is nothing else than the total destruction of the art of painting—that art of which the dictionary definition is "the art of representing, by means of figures and colors applied on a surface, objects presented to the eye or to the imagination." Two years ago I wrote: "We have reached the edge of the cliff and must turn back or fall into the abyss." Deliberately and determinedly these men have stepped over the edge. Now the total destruction of painting as a representative art is a thing which a lover of painting could hardly envisage with entire equanimity, yet one may admit that such a thing might take place and yet an art remain that should have its own value. A Turkish rug or a tile from the Alhambra is nearly without representative purpose, but it has intrinsic beauty and some conceivable human use. The important question is what it is proposed to substitute for this art of painting

which the world has cherished since there were men definitely differentiated from beasts. They have abolished the representation of nature and all forms of recognized and traditional decoration; what will they give us instead? And here is the difference between Mr. Hartley and his Parisian brothers. His "drawings" are purely nugatory. If one finds it impossible to imagine the kind of human being that could take any pleasure in them one is free to admit that there is nothing especially disgusting about them. But one cannot say as much for the works of the Frenchmen. In some strange way they have made their work revolting and defiling. To have looked at it is to have passed through a pathological museum where the layman has no right to go. One feels that one has seen not an exhibition, but an exposure.

Chapter Four

Cubism in America

ANDREW DASBURG

• Among the most successful of those who attempted to reconcile Cubism with older styles of representational art, Andrew Dasburg analyzed the impact of this school on American art. His criticism of the American understanding of Cubism was a remarkably incisive, contemporary account of its limitations, but his distaste for extremism reveals that he shared many of the prejudices that inhibited the development of American modernism and, incidentally, of his own art.

[FROM "Cubism—Its Rise and Influence," *The Arts,* IV (November, 1923).]

The influence of Cubism on American Art is apparent; yet in writing of Cubism in America one must hesitate to call anyone either its disciple or exponent, for "there are no Cubists"—none who call themselves so. *Isms* and classifications are "taboo." The illusion of individuality has cast its spell upon the artist. He resents being associated with any particular group. To him classification implies a loss of identity. This attitude is so general among our painters that one cannot write of "actual Cubism" in America, but only of the effort.

This ambition to achieve the distinctly personal would be admirable were it not accompanied by a self-deception which, admitting nothing, takes from many sources the formal material for our art. We fail to recognize that form arises in personality and bears the impress of its

origin. An idea can belong to all and become the way to individuality, whereas merely to adopt the results of another's use of the idea is essentially a negation of self. We lack the intellectual integrity to work logically within the limitations inherent in an idea. We want instead to gather what is best from many sources, forgetting that art is not compounded from extracts of different significant qualities found in great art. We have yet to learn that each development has a character of its own which remains forever intact. One cannot, for example, present simultaneously the quivering aspirational movement of El Greco and the gravitational weight of Cézanne; the absolute loss of both would result.

This idea of combining a variety of forms of perfection into one complete ideal realization prevents any creative work being done which possesses the contagious force of Cubism. Usually we weave into the fabric of a new conception enough of current traditions to destroy its integral character, a process of peaceful penetration wherein little is risked and much may be gained. Not until it is realized that originality never follows from this attitude of assimilation and refinement can we become innovators. Though we fail in this rôle there are, among American artists, men of unusual talent whose work compares favorably with the best being done in Europe, excepting that of a few great figures. Almost everyone that can be called "modern" has at some time or other shown an influence of Cubism in his work. Among these are Sheeler, Man Ray, Hartley, McFee, Wheelock, Demuth, Marin, Cramer, Burlin, Sterne, Wright, Haweis, H. F. Taylor, Dasburg, the Zorachs, A. Lohr, Baylinson, Judson Smith and lastly, Max Weber, who has worked more consistently within the discipline of Cubism and developed it further than any of these. . . .

Painting has a two-dimensional objective reality, a plane on which depth and modeling are illusional occurrences supplied through the process of association. In the non-illusional elements of painting, such as color, line, tone, and in the unlikeness of images, exists a separation which for the painter should be the key to plastic space. Qualities that are dissimilar, like contrasts of color, differences of tone and line, exist on the same plane only in a tactile sense, i.e., on the surface of the canvas; the difference of their appearance is a spatial interval.

Picasso with a fecundity of invention finally achieved the method in which the means he employs becomes the motive for his composition.

In this last phase of Cubism, so remote from the original conception, the emphasis is upon the material reality of the means involved, color existing for color, and all the other elements used accentuating their own reality through the fundamental aesthetic law of contrast. As aesthetic achievement which in its finest examples penetrates into a high region, having a quality akin to great Buddhistic art—one of ultimate poise wherein the conflict of elemental forces is transcended.

As in Europe, so in America; with a few distinguished exceptions, the idiosyncrasies of Cubism rather have permeated our art in varying degrees with a severity of line and acute angles just as Impressionism did before it with blue and orange. These, the essential symbols which remain intact always, will have to serve as an index for identifying those who come under its influence.

Among these, H. L. McFee combines a theme of planes, objects and cubical depth, which receive, through his sensitiveness, an appearance of poised solidity. Marin, in certain water colors, crystallizes exquisitely the spatial relation of things. Demuth, another artist of distinction, through a division of planes extending from his objects into their environment achieves an effect of displacement like the reflection of an image in a crystal. Haweis, Stella and Wheelock arrive at similar surprises in a distinctly personal manner. In contrast to the effect in the work of these men, that of Bluemner, Dickinson and the sculpture of Wolf and Nakian have a static simplicity, which in Hartley, Sheeler, and in recent improvisations of Paul Burlin, is especially fine.

Man Ray, in his Invention Dance, can be called a one-dimensional Cubist, carrying simplification to a point where his figures appear like paper patterns. The "Cubist-Futurist" settings designed by Robert Edmund Jones for the production of Macbeth were the most extraordinary of their kind by an American seen in America.

It is singular that "Synchromism," which Willard Huntington Wright calls "the last step in the evolution of present-day art materials," which "embraces every aesthetic aspiration from Delacroix and Turner to Cézanne and the Cubists," should have at one stage of its kaleidoscopic career borrowed from Cubism a scaffolding on which to support its color theories while at the same time denying its aesthetic validity.

Instead of finding Synchromism, as Apollinaire did in 1913, *"vaguement Orphist,"* New York in 1915 only recognized in it the influence

77

of Cubism. I refer to the figure composition of Macdonald-Wright based on the attitude of Michael Angelo's Slave, where the form is reduced to planes, distributed co-ordinately with the movement of the figure, dividing the color contrast and making an appearance like that of a gay Harlequin suit. I refer also to Morgan Russell's radiations of angular planes circulating spirally throughout his canvas.

Aside from the influence of 291, which stands unique, the work of these two Americans, with that of Max Weber, who undoubtedly was our first "extremist," together with the phenomenal success of the International Exhibition, tended more than any other influence to bring to notice the new formal element entering into French art. But the single novelty that broadcasted Cubism throughout America was Duchamp's Nude Descending the Stairs—the sensation of the hour, making the term "Cubism" become in the mind of the layman synonymous with "Modern Art."

STANTON MACDONALD-WRIGHT

• The two groups of American artists to have the firmest grasp of the principles of Cubism were the European-based Synchromists and the Precisionists, or Immaculates. As leader of the former, Stanton Macdonald-Wright formulated the color-oriented aesthetic of the Synchromists.

[FROM *The Forum Exhibition,* Anderson Gallery (New York: Hugh Kennerly, 1916).]

I strive to divest my art of all anecdote and illustration, and to purify it to the point where the emotions of the spectator will be wholly aesthetic, as when listening to good music.

Since plastic form is the basis of all enduring art, and since the creation of intense form is impossible without color, I first determined, by years of color experimentation, the relative spatial relation of the entire color gamut. By placing pure colors on recognizable forms (that is, by placing advancing colors on advancing objects, and retreating

colors on retreating objects), I found that such colors destroyed the sense of reality, and were in turn destroyed by the illustrative contour. Thus, I came to the conclusion that color, in order to function significantly, must be used as an abstract medium. Otherwise the picture appeared to me merely as a slight, lyrical decoration.

Having always been more profoundly moved by pure rhythmic form (as in music) than by associative process (such as poetry calls up), I cast aside as nugatory all natural representation in my art. However, I still adhered to the fundamental laws of composition (placements and displacements of mass as in the human body in movement), and created my pictures by means of color-form which, by its organization in three dimensions, resulted in rhythm.

Later, recognizing that painting may extend itself into time, as well as being a simultaneous presentation, I saw the necessity for a formal climax which, though being ever in mind as the final point of consummation, would serve as a *point d'appui* from which the eye would make its excursions into the ordered complexities of the picture's rhythms. Simultaneously my inspiration to create came from a visualization of abstract forces interpreted, through color juxtapositions, into terms of the visual. In them was always a goal of finality which perfectly accorded with my felt need in picture construction.

By the above one can see that I strive to make my art bear the same relation to painting that polyphony bears to music. Illustrative music is a thing of the past: it has become abstract and purely aesthetic, dependent for its effect upon rhythm and form. Painting, certainly, need not lay behind music.

CHARLES SHEELER

• In contrast to the Synchromist color-oriented aesthetic set forth by Stanton Macdonald-Wright, Charles Sheeler, as spokesman for the Precisionists, formulated more down-to-earth views of the "business of the artist," as in his statement from the Forum Exhibition catalogue.

Sheeler often took his themes from his own photographs; his attraction to the concrete and real made photography, at which he excelled, perhaps a more natural medium for him than painting. In subsequent statements,

he speaks of his rejection of brushwork, his interest in photography, and his search for subjects appropriate to the modern American experience. With this view, he photographed Chartres, but he painted factories.

[FROM *The Forum Exhibition,* Anderson Gallery (New York: Hugh Kennerly, 1916).]

I venture to define art as the perception through our sensibilities, more or less guided by intellect, of universal order and its expression in terms more directly appealing to some particular phase of our sensibilities.

The highest phase of spiritual life has always in one form or another implied a consciousness of, and, in its greatest moments, a contact with what we feel to be the profound scheme, system or order underlying the universe; call it harmonic rhythm, law, fact, God, or what you will.

In my definition I used the expression "through our sensibilities more or less guided by our intellects," and I here add "less rather than more," for I believe that human intellect is far less profound than human sensibility; that every thought is the mere shadow of some emotion which casts it.

Plastic art I feel to be the perception of order in the *visual* world (this point I do not insist upon) and its expression in purely plastic terms (this point I absolutely insist upon). So that whatever problem may be at any time any particular artist's point of departure for creative aesthetic endeavor, or whatever may be his means of solving his particular problem, there remains but one test of the aesthetic value of a work of plastic art, but one approach to its understanding and appreciation, but one way in which it can communicate its most profound significance. Once this has been established the observer will no longer be disturbed that at one time the artist may be interested in the relation of straight lines to curved, at another in the relation of yellow to blue or at another in the surface of brass to that of wood. One, two or three dimensional space, color, light and dark, dynamic power, gravitation or magnetic forces, the frictional resistance of surfaces and their absorptive qualities capable of visual communication, are material for the plastic artist; and he is free to use as many or as few as at the moment concern him. To oppose or relate these so as to communicate

his sensations of some particular manifestation of cosmic order—this I believe to be the business of the artist.

[FROM "A Brief Note on the Exhibition," first published in *Charles Sheeler, Paintings, Drawings, Photographs,* catalogue of an exhibition at the Museum of Modern Art, New York, 1939.]

On Technique and Photography

My theories about the technique of painting have changed in direct relation to my changed concept of the structure of a picture. In the days of the art school the degree of success in the employment of the slashing brushstroke was thought to be evidence of the success of the picture. Today it seems to me desirable to remove the method of painting as far as possible from being an obstacle in the way of consideration of the content of the picture. . . .

My interest in photography, paralleling that in painting, has been based on admiration for its possibility of accounting for the visual world with an exactitude not equaled by any other medium. The difference in the manner of arrival at their destination—the painting being the result of a composite image and the photograph being the result of a single image—prevents these media from being competitive.

[FROM Constance Rourke, *Charles Sheeler: Artist in the American Tradition* (New York: Harcourt, Brace, 1938).]

Cathedrals and Factories

Chartres is the flower of a time, having its roots in the deeper emotions of a people who were sharply focused upon religion and who sought the relief of outward expression. Religion was a great mass consciousness, and by the projection of the cathedral the welcome opportunity was given them. Every age manifests itself by some external evidence. In a period such as ours when only a comparatively few individuals seem to be given to religion, some form other than

the Gothic cathedral must be found. Industry concerns the greatest numbers—it may be true, as has been said, that our factories are our substitute for religious expression.

Even though I have so profound an admiration for the beauty of Chartres, I realize strongly that it belongs to a culture, a tradition, and a people of which I am not a part. I revere this supreme expression without having derived from the source which brought it into being. It seems to be a persistent necessity for me to feel a sense of derivation from that country in which I live and work.

FORBES WATSON

• The Synchromists had an apologist in the critic Willard Huntington Wright, brother of Macdonald-Wright, and, unfortunately, when Wright stopped producing art criticism, writing about their work virtually ceased. Others who wrote sympathetically of the American Cubists in the twenties were Henry McBride and Forbes Watson, editor of *The Arts,* whose essay on Demuth is exceptionally perceptive.

―――――――

[FROM "Charles Demuth," *The Arts,* III (January, 1923).]

Charles Demuth came in with the rush of "modernism" that made its tardy arrival in America after the famous Armory exhibition; which means that as an artist before the public, Mr. Demuth belongs to the past or passing decade. He is one of that group of aesthetic young Americans who specialized in the new movement imported from France, and decided that the opportunity to be saved from the obvious, which the new movement offered, together with its other advantages and disadvantages, was too good to be missed.

The disadvantages of the new movement were, that it called many who have turned out not to be chosen—heavy-minded young men (Demuth is the opposite of heavy-minded) who tramped into "modernism" to the accompaniment of a kind of fog-horn chorus of blah. Demuth has been tagged with the nickname modern, and he carries

this nickname as airily as Grace Christie balances the bubble in her bubble dance. For Demuth is mentally agile; he's the Whistler of his little circle, but he doesn't talk as much about it as Whistler did. I suspect that he often smiles at the demi-intellectual sentiments of the earnest members of the little circle, all that stuff about this being the age of machinery and the artist, in order to realize the dynamic forces, etc., etc. . . .

His art is light and floating. It moves through the air. It is agile, poised in a space above the world, but not out of reach of theatrical lights. And that certain skill of the acrobat, that sense of freedom and complete escape from rubber heels and office chairs . . . that all belongs to Demuth.

It is part of that excessive *finesse,* his most cherished attribute, which he protects behind a mask of disdain.

Fantasy, the light touch, the art quality (aesthetic), the whimsical, the ironic, the delicate (never the sweet), the biting—Charles Demuth.

Between himself and his spectators he likes to maintain a barrier of aloofness. He is *fin* in the French sense. He enjoys Duchamp's *blagues,* but he has more creative energy than Duchamp. Yet Duchamp has been his strongest influence of late years as Demuth himself says. From Duchamp he has gained an increased interest in good workmanship; but Demuth naturally has the sense of medium. Water color fits him like a glove. It belongs to and is a part of his expression. And in this medium he has done his finest work.

Oil is a medium for an exuberant nature. And Demuth despises exuberance. He is far too selective for that. His inventions are utterly intentional. He is not interested in fact for its own sake, and the display of much emotion would seem a little ridiculous to him, not to say vulgar. In this he makes me think of Jane Austen.

Many of his illustrations of vaudeville are among the American prizes in the Barnes collection.

His later art is Post-Cubist. It couldn't have been done before Cubism. It is only one of the manifestations that go to prove that Cubism as an art is far less important than Cubism as an influence. Every day makes this fact clearer.

But Demuth has not gone to work with Hebraic intensity and made a problem play of Cubism. Like a dainty canary he has picked seeds neatly here and there.

Chapter Five

The Thirties: Reaction and Rebellion

THOMAS CRAVEN

• The quarrel that rent the art world in the thirties began with a criticism of superficial imitations of European art and ended in a violent rejection of internationalism in art. That chauvinistic strain, which sought to make America safe for American art, was publicly announced when Royal Cortissoz dismissed the foreign sections of the Armory Show as "Ellis Island art." Henri's espousal of American subjects and the American scene was distorted in a manner he and his friends ultimately repudiated.

In the interest of creating a distinctively American art, Thomas Hart Benton and his friend the critic Thomas Craven launched diatribes against internationalists like Stieglitz ("a Hoboken Jew"), calling for an art based on regional themes, which would be intelligible to the common man. In the name of a democratic art, they proposed to abandon the genuinely democratic pleas of Henri and Sloan for a plurality of styles in favor of a prescription for the single style they considered suitable to express their nationalistic message.

Like earlier moralistic critics, Craven saw modernism as a degenerate style. He praised, instead, the American Regionalists who had rejected modernism and exalted "life" over art. Urging others to emulate Benton's abandonment of abstraction and return to realism, Craven attacked what were, to his mind, the inadequacies and weaknesses of abstract art and railed at the formalist approach to art.

84

The Modernists were men of the strongest antisocial propensities. They took pride in their aloofness and gloried in their refusal to traffic in bourgeois sentiments and vulgar emotions. "To hell with the public!" they cried. "There is no such thing as popular art! The public has always demanded trash and we will leave that to the academicians!" But these aristocrats of art, these aesthetic thoroughbreds, were not wholly above commerce with the rabble: they employed the most extraordinary tactics in order to persuade, cajole, and bully the public into buying their pictures. In such an atmosphere art turns inward, feeds upon itself, takes refuge in abstractions. It was only natural that men living in a little world of metaphysical disputations should have produced an art divorced from its human context; it was to be expected that the defence of this art should be the hopeless effort to separate social, moral, and sentimental activities from what was snobbishly labelled "pure aesthetics." This critical attitude, propped up by the tenets of an unstable psychology, sprang from two bases, the scientific and the emotional, but the machinery involved was identical.

It consisted in restricting the significant factors in the production and appreciation of art to those whose understanding rested upon special training or unusual experience. Thus technique, essentially a matter for painters and a few specialists, became the whole of art, a field completely isolated from vulgar understanding. Into this exclusive field the thoroughbreds dragged the values belonging to the profoundest art and annexed them to minor technical issues. Furthermore, by describing technical problems in the terms of physiological mechanics and psychology, painters made the simplest processes enormously impressive. The "purification of painting" was the fine name given to this dehumanizing tendency, and to be looked upon as in the know, one was forced to subscribe to the high-sounding chatter about abstraction, empathy, significant form, dynamic relationships, and so forth.

The purification of painting! An enchanting fallacy indeed! "Pure beauty," as Winckelmann said long ago, "is like pure water—it has no taste." Yet this tasteless art multiplied by leaps and bounds. The various purity cults founded on the technique of line and color organization raised mediocrity to a glorious eminence and provided the initiate with the regalia for personal distinction. Poor old Cézanne's little sensation was father to a thousand perversions. To be "highly sensitive" in the esoteric fashion was the supreme honor, and any

painter ingenious enough to erect a precious mythology round a few lines, or daubs of color, was assured of enviable notoriety. A tangle of lines, a swirl of tones, and he had produced a subjective cryptogram entitled *Psychic Portrait, Symphony in Blue-Green,* or *Centripetal Force.* Every little technical operation, every shade and detail, was magnified to epochal proportions. He was willing to die to make a table cloth pictorially interesting, willing to sacrifice his life to a pattern of spots and curves, the sole value of which lay in its "abstract beauty" —a theme for the humorist. He was so self-contained that he esteemed man as less valuable than a bowl of fruit or a congestion of cubes. The growth of humanity did not concern him—he was painting the growth of abstractions or the soul of pots and pans. Eventually he talked more about himself and his strange soul-states than about his art, and consulted the Freudian doctors to ascertain the full import of the psychic orgasms aroused within him by a piece of still life.

Increasing in purity, painting shrank proportionately in human values until, at last, it appealed to a few souls divinely endowed with the "aesthetic emotion." This emotion by means of which one responds purely to art, that is, to its abstract harmonics, has been regarded with suspicion by eminent investigators unable to separate it from other emotions and unable to admit that man, being what he is, a gross bundle of appetites, memories, and experiences all bound together into a single receiving system, can react purely to any stimulus. But the suspicion, I believe, is ill-founded. The aesthetic emotion is the unique property of those who love only art and not life; whose receptive apparatus, through disuse, has so shriveled that it is no longer capable of responding to anything but abstractions. Painters possessing this peculiar emotion are really convinced that they have symbolized the grace of the human body, and the dynamic power and movement of modern machines, by abstract combinations of lines and masses bearing no discoverable relation to the objects in question. They maintain that an abstract art is the reflex of a machine age, and that its technique is the organic expression of the scientific trend of the times, a theory echoed by many writers. It happens, however, that the Modernists, by their own confession, are aggressively hostile to our machine age, and that they live as far from it as possible, preferably in the more romantic quarters of Paris. In the ways of contemporary civilization, they are poorly educated, and their pseudo-scientific technique is an arbitrary

method deduced from Cézanne, a Provençal recluse for whom the machine age never existed.

THOMAS HART BENTON

• The careers of three of the leading artists in America during the thirties, Thomas Hart Benton, Edward Hopper, and Stuart Davis, provide dramatic contrasts in the variety of their responses toward the American Scene. Benton was only one of many American artists who abandoned abstraction to return to figurative art.

———

[FROM *An Artist in America* (rev. ed.; Kansas City: University of Kansas City Press, Twayne Publishers, 1951).]

John Steuart Curry and Grant Wood rose along with me to public attention in the thirties. They were very much a part of what I stood for and made it possible for me in my lectures and interviews to promote the idea that an indigenous art with its own aesthetics was a growing reality in America. . . .

We were different in our temperaments and many of our ideas but we were alike in that we were all in revolt against the unhappy effects which the Armory Show of 1913 had on American painting. We objected to the new Parisian aesthetics which was more and more turning art away from the living world of active men and women into an academic world of empty pattern. We wanted an American art which was not empty, and we believed that only by turning the formative processes of art back again to meaningful subject matter, in our cases specifically American subject matter, could we expect to get one.

The term [Regionalism] was, so to speak, wished upon us. Borrowed from a group of southern writers who were interested in their regional cultures, it was applied to us somewhat loosely, but with a fair degree of appropriateness. However, our interests were wider than the term suggests. They had their roots in that general and country-wide revival

of Americanism which followed the defeat of Woodrow Wilson's universal idealism at the end of World War One and which developed through the subsequent periods of boom and depression until the new internationalisms of the Second World War pushed it aside. This Americanist period had many facets, some dark, repressive, and suggestive of an ugly Neo-Fascism, but on the whole it was a time of general improvement in democratic idealism. After the break of 1929, a new and effective liberalism grew over the country and the battles between that liberalism and the entrenched moneyed groups, which had inherited our post Civil War sociology and were in defense of it, brought out a new and vigorous discussion of the intended nature of our society. This discussion and the political battles over its findings, plus a new flood of historical writing concentrated the thirties on our American image. It was this country-wide concentration more probably than any of our artistic efforts which raised Wood, Curry, and me to prominence in the national scene. We symbolized aesthetically what the majority of Americans had in mind—America itself. Our success was a popular success. Even where some American citizens did not agree with the nature of our images, instanced in the objections to my state-sponsored murals in Indiana and Missouri, they understood them. What ideological battles we had were in American terms and were generally comprehensible to Americans as a whole. This was exactly what we wanted. The fact that our art was arguable in the language of the street, whether or not it was liked, was proof to us that we had succeeded in separating it from the hothouse atmospheres of an imported and, for our country, functionless aesthetics. With that proof we felt that we were on the way to releasing American art from its subservience to borrowed forms. In a heyday of our success, we really believed we had at last succeeded in making a dent in American aesthetic colonialism.

However, as later occurrences have shown, we were well off the beam on that score. As soon as the Second World War began substituting in the public mind a world concern for the specifically American concerns which had prevailed during our rise, Wood, Curry, and I found the bottom knocked out from under us. In a day when the problems of America were mainly exterior, our interior images lost public significance. Losing that, they lost the only thing which could sustain them because the critical world of art had, by and large, as little

use for our group front as it had for me as an individual. The coteries of highbrows, of critics, college art professors, and museum boys, the tastes of which had been thoroughly conditioned by the new aesthetics of twentieth-century Paris, had sustained themselves in various subsidized ivory towers, and kept their grip on the journals of aesthetic opinion all during the Americanist period. These coteries, highly verbal but not always notably intelligent or able to see through momentarily fashionable thought patterns, could never accommodate our popularist leanings. . . .

Now all this anarchic idiocy of the current American art scene cannot be blamed solely on the importation of foreign ideas about art or on the existence in our midst of institutions which represent them. It is rather that our artists have not known how to deal with these. In other fields than art, foreign ideas have many times vastly benefited our culture. In fact, few American ideas are wholly indigenous, nor in fact are those of any other country, certainly not in our modern world. But most of the imported ideas which have proved of use to us were able to become so by intellectual assimilation. They were thoughts which could be thought of. The difficulty in the case of aesthetic ideas is that intellectual assimilation is not enough—for effective production. Effective aesthetic production depends on something beyond thought. The intellectual aspects of art are not art, nor does a comprehension of them enable art to be made. It is in fact the over-intellectualization of modern art and its separation from ordinary life intuitions which have permitted it, in this day of almost wholly collective action, to remain psychologically tied to the "public be damned" individualism of the last century and thus in spite of its novelties to represent a cultural lag.

Art has been treated by most American practitioners as if it were a form of science where like processes give like results all over the world. By learning to carry on the processes by which imported goods were made, the American artist assumed that he would be able to end with their expressive values. This is not perhaps wholly his fault because a large proportion of the contemporary imports he studied were themselves laboratory products, studio experiments in process, with primarily a process evolution. This put inventive method rather than a search for the meaning of one's life at the center of artistic endeavor and made it appear that aesthetic creation was a matter for intellectual

rather than intuitive insight. Actually this was only illusory, and art's modern flight from representation to technical invention has only left it empty and stranded in the backwaters of life. Without those old cultural ties which used to make the art of each country so expressive of national and regional character, it has lost not only its social purpose but its very techniques for expression.

EDWARD HOPPER

• In his essay on Burchfield, the American Scene painter Edward Hopper praised in his friend many of the picturesque qualities to be found in his own art. Later, he wrote on his interpretation of the relationship between art and life.

———————

[FROM "Charles Burchfield, American," *The Arts,* XIV (July, 1928).]

The work of Charles Burchfield is most decidedly founded, not on art, but on life, and the life that he knows and loves best. From what is to the mediocre artist and unseeing layman the boredom of everyday existence in a provincial community, he has extracted a quality that we may call poetic, romantic, lyric, or what you will. By sympathy with the particular he has made it epic and universal. No mood has been so mean as to seem unworthy of interpretation; the look of an asphalt road as it lies in the broiling sun at noon, cars and locomotives lying in God-forsaken railway yards, the steaming summer rain that can fill us with such hopeless boredom, the blank concrete walls and steel constructions of modern industry, midsummer streets with the acid green of close-cut lawns, the dusty Fords and gilded movies—all the sweltering, tawdry life of the American small town, and behind all, the sad desolation of our suburban landscape. He derives daily stimulus from these, that others flee from or pass with indifference.

Through many of these transcriptions are woven humorous anecdotes, which seem to be so firmly kneaded into the picture's plastic

qualities that they play only a minor role in one's enjoyment of the intense reality.

Our native architecture with its hideous beauty, its fantastic roofs, pseudo-Gothic, French Mansard, Colonial, mongrel or what not, with eye-searing color or delicate harmonies of faded paint, shouldering one another along interminable streets that taper off into swamps or dump heaps—these appear again and again, as they should in any honest delineation of the American scene. The great realists of European painting have never been too fastidious to depict the architecture of their native lands in their pictures.

[FROM "Art and Life," *Reality,* Spring, 1953.]

Great art is the outward expression of an inner life in the artist, and this inner life will result in his personal vision of the world. No amount of skillful invention can replace the essential element of imagination. One of the weaknesses of much abstract painting is the attempt to substitute the inventions of the intellect for a pristine imaginative concept.

The inner life of a human being is a vast and varied realm and does not concern itself alone with stimulating arrangements of color, form and design.

The term "life" as used in art is something not to be held in contempt, for it implies all of existence, and the province of art is to react to it and not to shun it. Painting will have to deal more fully and less obliquely with life and nature's phenomena before it can again become great.

[FROM "Notes on Painting," first published in *Edward Hopper Retrospective Exhibition,* catalogue of an exhibition at the Museum of Modern Art, New York, 1933, edited by Alfred H. Barr, Jr.]

My aim in painting has always been the most exact transcription possible of my most intimate impressions of nature. If this end is

unattainable, so, it can be said, is perfection in any other ideal of painting or in any other of man's activities. . . .

I have tried to present my sensations in what is the most congenial and impressive form possible to me. The technical obstacles of painting perhaps dictate this form. It derives also from the limitations of personality. Of such may be the simplifications that I have attempted. . . .

I believe that the great painters, with their intellect as master, have attempted to force this unwilling medium of paint and canvas into a record of their emotions. I find [that] any digression from this large aim leads me to boredom.

IVAN ALBRIGHT

• One of the leading Magic Realists, Ivan Albright had a fascination with the morbid that may date from the period when he made surgical drawings for a medical unit during World War I. With his twin brother, known professionally as Zsissly, he developed a bizarre mixture of the fantastic and the hyper-realistic. Like the Collier brothers, Albright represents a kind of extreme eccentricity that seems characteristically American—in the sense of individuality carried to the limits of a self-expression ultimately bordering on the obsessive. Later, in the assemblages of Bruce Conner and Edward Kienholz one sees a continuation of Albright's involvement with the more grotesque aspects of the American scene. West Coast "funk art," a kind of buckeye Surrealism, was also to continue in this direction.

[FROM *American Realists and Magic Realists*, edited by Dorothy C. Miller and Alfred H. Barr, Jr. With statements by the artists and an Introduction by Lincoln Kirstein. (New York: Museum of Modern Art, 1943).]

In the past I have painted herrings that changed from purple to an orange oxide, women whose torrid flesh folds resembled corrugated mush, lemons and imitation fur, purple glazed leaves that exuded a

funereal odor, and tawdry costume rings whose size all but covered actor-less hands. My models' idiosyncrasies have varied. Ida munched peanuts and threw the shelled husks on the floor for me to step on. The bearded one who sat on a town bench in the public square of San Diego chose to eat the lordly Judas bean and in so doing conceived himself an unsung Saint John. There was the long-haired flaxen Canadian, a Rosicrucian, in the electrically heated basement which he tended, who extolled his sliding Adam's apple as a mark of great spirituality. . . .

I have painted keys that were of brass and calla lilies that drooped from their overload of paraffin and showed inclinations to become tops to jelly jars. I have pumiced white-clean an old tombstone, eliminating its incised inscription, and used it in a painting for a threshold, when its proper place should have been at the head of the grave lichen-covered rather than under a door. But all things, whether a bluebottle fly or red flying hair, have had their points and counterpoints and it may be that in the wide future I will walk and amuse myself looking at this thing and at that thing through my ill-ground bifocal glasses that make an aberration next to the object I am looking at.

EDWARD BRUCE

• The first to suffer from the effects of the Depression, artists were also allowed to share in New Deal pump-priming measures, as employees of the federal government. Edward Bruce, chief of the Section of Fine Arts, Public Buildings Administration, evaluated the first WPA project in 1934.

[FROM "Implications of the Public Works Arts Project," *American Magazine of Art,* March, 1934.]

The reaction of the artists to the project . . . has been that while the economic relief afforded them by the project was enormously appre-

ciated and greatly needed, the spiritual stimulus to them in finding that they were recognized as useful and valuable members of the body politic and that the government desired their work, has been simply amazing. It has, as many of them expressed it, broken down the wall of isolation and brought them in touch and in line with the life of the nation. It has stimulated them to the maximum effort and aroused their excitement and imagination. . . .

The lady in an expensive fur coat who told me it was all right to feed the artists, but why make the public look at their stuff, is in for a shock. I think perhaps the outstanding feature of the work which has been produced so far is its honesty and fine quality of naturalness. It is a native product. While, of course, it shows signs of a definite art tradition and an art background, it is amazingly free from isms and fads and so-called modern influences. Ninety per cent of it is modern in the best sense. . . .

It has been a very exciting experience to discover vigorous local art movements all over the country and talent where we did not know talent existed. Artists who were thought of as having only a moderate talent are producing work far beyond and better than they have ever produced before, and artists who were absolutely unknown are producing some of the best work on the project.

If through the project there comes a demand for a beautiful America, the economic as well as the spiritual and esthetic possibilities are very great.

The backers of this project went into it with their eyes open. They didn't expect a hundred per cent quality and they won't get it, but it is quite apparent from the work already accomplished that this country is going to get a great many works of art of high quality which will show the investment to have been very profitable as well as very fine. Masterpieces and geniuses are not produced from isolated efforts: if the history of art is any criterion they come only from large art movements. A large body of work and a large number of artists are necessary to reproduce the Leonardos, the Piero della Francescas, and the Michelangelos.

REGINALD MARSH

• The American Scene painter Reginald Marsh describes his experience in painting a post office mural in Washington, D.C.

[FROM "Poverty, Politics, and Artists, 1930–45," *Art in America,* LIII, No. 4 (August–September, 1965).]

Having mounted the scaffold without a colored smock and a Tam o'Shanter resulted in many employees asking when the artist was coming along. This happened even after I had completed full length figures. In all the time I was there, no one asked me my name.

One or two had heard of Kent—three or four had heard of Grant Wood, and about a dozen of a Mexican who had trouble with Rockefeller Center. One had heard of Michelangelo.

Many volunteered to tell me that Cubism angered them.

Many wanted to know if there were new jobs in store for me and always looked at me in a pitying way.

Most of them ventured that I must have been born that way.

BURGOYNE DILLER

• Abstract artists, too, were given a chance to work on the Project. Burgoyne Diller, supervisor for the New York City Federal Art Project, was one of the leading American abstractionists of the thirties. In an interview made for the Archives of American Art in 1964, shortly before his death, he recalled the experience shared with many leading New York artists.

[FROM "Poverty, Politics, and Artists, 1930–45," *Art in America,* LIII, No. 4 (August–September, 1965).]

There's something that's unforgettable about that period. There was a sense of belonging to something, even if it was an underprivileged and downhearted time. It was exciting.

We worked day and night and weekends and believe me, we were not paid well for it, but we thought it was the most wonderful thing that could be happening. We were enthusiastic and we were ready and willing to do anything. It was a madhouse.

I was very much interested in abstract painting. They felt that there was no place for it at the time because they felt the project should be a popular program and while they didn't attempt to invalidate or question the validity of the work, abstract art had no place because you did have a great problem of building up public sympathy and understanding. . . .

We made a rather elaborate model of the work to be done for the [Arshile] Gorky mural in the Newark Airport. We did a rather good one for Gorky's presentation to the Art Commission of the City of Newark. The Commission was made up of rather elderly gentlemen. I'm sure they were of some prestige socially and economically. I'm sure they fit into the upper echelons of Newark society—rather cool, forbidding characters. They were the sort of people you would see sitting in the windows of the Princeton Club, or the Yale club. When we presented the mural I deliberately presented it as decoration so they wouldn't quibble about art. But one of them, probably brighter than the rest, said, "Well, that's abstract art, isn't it?" That unleashed the devil. They started, of course, a tirade of questions and cross-questions and accusations and statements about modern art. Beatrice Windsor, who is socially and economically their equal, shamed them into accepting it.

BALCOMB GREENE

• Despite the hostility of the American public toward the budding abstract art movement, there was a growing belief among artists that modernism, born in Europe, might flourish naturally in the United States, the world's most advanced and modern country. Even before the mass exodus of artists from Europe caused by the Nazi invasion, a number of abstract artists, such as Jean Hélion and Fernand Léger, came to New York, hoping to find a reception for their progressive ideas.

On the eve of World War II, Balcomb Greene, a member of the American Abstract Artists, wrote of the difficulties and the possible promise facing the advanced artist in America.

[FROM "American Perspective," *Plastique,* Spring, 1938.]

The stricture falls today upon the ambitious abstractionist that he cannot any longer provoke or scandalize by being Non-Objective. His amorphous and geometric forms cannot sing the tunes of home-soil nationalism or of proletarian discontent—much less combine them as present American "social realists" seem to. Therefore, perhaps in a new sense, our elimination of the subject offers a survival value.

The American abstractionist seems usually to understand that capitalist society hampers the development of his art. But he resents the professional revolutionist's demand for an art immediately comprehensible to the masses which will bolster up sales for a society which in turn is allowed a generation of dictators for its realization. The result in this country is a wary fraternalizing of artist with revolutionist. The "line" followed today by the Marxist is to end his Plekhanovistic attack on abstractionism by commending Hélion and Léger on their balance and their brushwork. Picasso, currently honored for his sadistic venture into Guernica, is honored not for his balance, his brushwork or his content, but for what is viewed as a lapse from individualism.

It is in this world of shaded pragmatisms that the artist as idealist must seek his values. He can hardly avoid visualizing himself laying cornerstones for the city of the future while other men—assisted by his alter ego—train their artillery on an enemy city now flying the Fascist flag. The argument as to how much construction should be suspended while destruction goes on is a tough one. And academic.

The central difficulty for the advanced artist may now be clear. Granted he has the tenacity to turn out his number of canvases, what besides his remote ideal has he to keep his work from becoming a mere brush service to his independence, automatic therefore, often imitative and always decorative? What stimulation?

In the United States he may lack the first essential, a certain public integrity however unenlightened. For a European it is difficult to

imagine what adroit agencies for publicity we have developed here, difficult to imagine with what gusto the sensationalist magazines may inflate the vulgar homosexual today, a living primitive tomorrow, a slick master of the streamlined woodblock the next day. The artist witnessing this may well be a cynic.

Certain facts complicate the picture. Largely it is the younger men and women who turn to our tradition. The teachers out of all proportion support and understand our effort. In an unspectacular way the mural division of the Federal Art Project is able to place many abstract murals, and without the expected indignation. And yet the general run of art magazines has fallen to a new low in selling the artist's personality and neglecting his work. That most influential New York museum of "modern art," by name and in its origin progressive, exhibits a craving for popularity which makes impossible any leadership. What abstract work is able to exhibit itself draws encouraging crowds, but seems to have built a following which makes its judgements privately. One might say the validity of the new tradition is established, but that the manipulators see no profit in assisting it.

JOHN GRAHAM

• In a prophetic but obscure treatise on aesthetics, John Graham, one of the most successful Cubist painters in America in the thirties, spoke of the artist's "handwriting," or *ecriture,* in a manner that would come to characterize the Abstract Expressionist use of gesture, and described the way his friend Gorky would begin to use line.

[FROM "What Is the Relationship of Art to Technique?," in *System and Dialectics of Art* (New York: Delphic Studios, 1937).]

—What is the relationship of art to technique?

Art is the authentic reaction of the artist to a phenomenon observed, set authoritatively to the operating plane. No technical perfection or elegance can produce a work of art. *A work of art* is neither the faithful nor distorted representation, it *is the immediate, unadorned record of an authentic intellecto-emotional REACTION of the artist set in space.*

Artist's reaction to a breast differs from his reaction to an iron rail or to hair or to a brick wall. *This authentic reaction recorded within the measurable space immediately and automatically in terms of brush pressure, saturation, velocity, caress or repulsion, anger or desire which changes and varies in unison with the flow of feeling at the moment, constitutes a work of art.*

Cold-blooded calculation and perfect technical execution do not constitute a work of art but a work of industry, and it is harmful and criminal before the public, artists, art students, and posterity to misrepresent such as works of art. Unfortunately about 90% of the holdings of all museums and collections are of this variety.

The difficulty in producing a work of art lies in the fact that artist has to unite at one and the same time three elements: thought, feeling, and *automatic "écriture."**

When a person talks about different objects which interest him his voice and gestures in their rise and fall and in their velocity, impetuously register his reaction to various aspects of these objects. Drawing or painting or writing is an immediate and organic accumulation of these *spontaneous* gestures set to the operating plane.

People who have never experienced anything deeply or had intense perception of any kind, have no means of differentiating between a work of art and a fraud (a work produced by sheer technique and nothing else).

People who are incapable of deep experiences are those whose emotional equipment is naturally poor as a result of inheritance or those whose emotional equipment has been weakened and stunted in childhood by mild and sterile rearing.

Art is essentially a creative process. Technique, therefore, plays but little part in it, namely the part of discipline and study. It is legitimate to keep on developing one's technique as long as one uses it to learn more and more about the *object* or about the *medium* itself, but the moment technique begins to be an aim in itself, it serves only the purpose of disguising ignorance and lack of ability. Then technique becomes an impediment to the artist and a dishonest camouflage to the public.

* By écriture is understood a personal technique—a result of training and improvisation in contradistinction to technique in general, which is an accumulation of professional methods.

The Thirties

The subject matter, representation, imitation of nature, technique, or trained skill have nothing to do with art. There are people who can paint Picasso's paintings with a greater technical perfection, there are people who can perform all [the] most difficult pirouette steps of Lifar or Nijinsky with greater technical perfection, etc., but the element of art is absent. All this is to say that any artist—painter, poet, dancer or singer—should have something to say first before bothering about technique. In fact, perfect technique makes the thing even more void if it is void, because the process of technique is impedimentary to free delivery of message unless the message is of such grandeur that nothing can impair it. Technique binds one's unconscious and if the messages of the unconscious are weak, the technique will kill them. Only genius can afford a perfect technique.

Children's drawings are frequently delightful by their fresh, unwise point of view and their direct response to space. A gifted child revalorizes the space-point element of the phenomenon observed so as to produce an equivalent of it. However children's drawings have no value because children cannot bring to consciousness their own unconscious understanding of space. The work of technically skilled craftsmen in art has no value because it has only a conscious attempt to understand space. Only the two combined produce a work of art.

STUART DAVIS

• The catalogue of the Whitney Museum's 1935 exhibition, *Abstract Painting in America,* included the following essay by Stuart Davis, the country's leading abstractionist, tracing the development of abstract art in America. Later, in 1941, Davis discussed his abstract interpretation of the American Scene in an article for *Parnassus* magazine.

—————

[FROM "On Abstract Art," in *Abstract Painting in America* (New York: Whitney Museum of American Art, 1935).]

I begin very, very broadly by saying that the American artist became conscious of abstract art by the impact of the Armory Show in 1913. Previous to this important event in the art education in the United States, there were several American artists working in Europe who were incorporating the abstract viewpoint in their canvases. But it was the Armory Show of 1913 with its huge panorama of the scene of art for the foregoing seventy-five years which brought to the American artist as a whole the realization of the existence of abstract art, along with its immediate artistic historical background.

The abstract portion of the exhibition which consisted of works by European artists, with few exceptions, created a real sensation. Argumentation and dispute were constantly carried on in front of these canvases by laymen as well as artists. Friendships were broken and new friends made in that heat induced by these daily congresses of opinion. There was no American artist who saw this show but was forced to revalue his artistic concepts. The final charge was touched off in the foundations of the Autocracy of the Academy in a blast which destroyed its strangle hold on critical art values forever. Henceforth the American artist realized his right to free expression and exercised that right. This was made very clear in the annual exhibitions of the Society of Independent Artists where all artists could show their works without submission to jury. Henceforth a more acute angularity was imparted to the divergence of approach of the different artist groups.

Among these groups the artists who followed the abstract attitude completely or in appreciable part were relatively small. Why this was so I do not know, I simply state it as a matter of fact for the record. But the function of this small group of abstract painters and sculptors continued to make more clear the special character of the aesthetic divergence among American painters as a whole. They were the leaven implanted in the mass body of the American artists which continued the revolution of aesthetic opinion instigated in February, 1913, by the abstract section of the International Exhibition of Modern Art commonly called the Armory Show.

What is Abstract art? The question will be answered differently by each artist to whom the question is put. This is so because the generative idea of abstract art is alive. It changes, moves, and grows like any other living organism. However, from the various individual answers some basic concordance could doubtless be abstracted. This basic con-

cordance of opinion would be very elementary and would probably run something like this. Art is not and never was a mirror reflection of nature. All efforts at imitation of nature are foredoomed to failure. Art is an understanding and interpretation of nature in various media. Therefore in our efforts to express our understanding of nature we will always bear in mind the limitations of our medium of expression. Our pictures will be expressions which are parallel to nature and parallel lines never meet. We will never try to copy the uncopiable but will seek to establish a material tangibility in our medium which will be a permanent record of an idea or emotion inspired by nature. This being so, we will never again ask the question of a painting, "Is it a good likeness, does it look like the thing it is supposed to represent?" Instead we will ask the question, "Does this painting, which is a defined two-dimensional surface, convey to me a direct emotional or ideological stimulus?" Since we forego all efforts to reflect optical illusions and concentrate on the reality of our canvas, we will now study the material reality of our medium, paint on canvas or whatever it may be. The approach has become scientifically experimental. A painting for example is a two-dimensional plane surface and the process of making a painting is the act of defining two-dimensional space on that surface. Any analogy which is drawn from our two-dimensional expression to three-dimensional nature will only be forceful in the degree to which our painting has achieved a two-dimensional clarity and logic.

[FROM "Abstract Art in the American Scene," *Parnassus,* March, 1941.]

I am an American, born in Philadelphia of American stock. I studied art in America. I paint what I see in America, in other words, I paint the American scene. . . . I don't want people to copy Matisse, or Picasso, although it is entirely proper to admit their influence. I don't make paintings like theirs. I make paintings like mine. I want to paint and do paint particular aspects of this country which interest me. But I use, as a great many others do, some of the methods of modern French painting which I consider to have universal validity.

Chapter Six

Art of This Century

HAROLD ROSENBERG AND ROBERT MOTHERWELL

• The decision to accept, as a condition of their art, the divorce of art from society was a difficult, sometimes agonizing one for American artists to make. In opposition to those who felt art should convey a social message, John Sloan issued this statement: "There is also much talk today about socially-conscious painting. My old work was unconsciously very much so, especially before I became a Socialist. After that I felt that such a thing should not be put into painting and I reserved it for my etching. They may say that I am now fiddling while Rome burns, but I question whether social propaganda is necessary to the life of a work of art."

The position of the New York School painters as the country emerged from World War II was articulated by Harold Rosenberg and Robert Motherwell on the title page of the review *Possibilities,* which they edited. It clearly indicates that the separation of art from politics that began in the thirties had become generally accepted.

———————

[FROM *Possibilities,* No. 1 (Winter, 1947–48).]

Naturally the deadly political situation exerts an enormous pressure.

The temptation is to conclude that organized social thinking is "more serious" than the act that sets free in contemporary experience forms which that experience has made possible.

One who yields to this temptation makes a choice among various theories of manipulating the known elements of the so-called objective state of affairs. Once the political choice has been made, art and literature ought of course to be given up.

Whoever genuinely believes he knows how to save humanity from catastrophe has a job before him which is certainly not a part-time one.

Political commitment in our times means logically—no art, no literature. A great many people, however, find it possible to hang around in the space between art and political action.

If one is to continue to paint or write as the political trap seems to close upon him he must perhaps have the extremest faith in sheer possibility.

In his extremism he shows that he has recognized how drastic the political presence is.

ROBERT MOTHERWELL

• The dilemma facing the avant-garde artist in America as he struggled to extract his art from a social context while preserving its radical content was put forth most succinctly by Robert Motherwell, youngest of the first-generation Abstract Expressionists, and often their scholarly spokesman.

———————

[FROM "The Modern Painter's World," *Dyn*, VI (1944).]

The term "modern" covers the last hundred years, more or less. Perhaps it was Eugène Delacroix who was the first modern artist. But the popular association with the phrase "modern art" like that of mediaeval art, is stronger than its historical denotation. The popular association with mediaeval art is religiousness. The popular association with modern art is its *remoteness* from the symbols and values of the majority of men. There is a break in modern times between artists and other men without historical precedent in depth and generality. Both sides are wounded by the break. There is even hate at times, though we all have a thirst for love.

The remoteness of modern art is not merely a question of language, of the increasing "abstractness" of modern art. Abstractness, it is true, exists, as the result of a long, specialized internal development in modern artistic structure.

But the crisis is the modern artists' rejection, almost *in toto*, of the

values of the bourgeois world. In this world modern artists form a
kind of *spiritual underground*.

Modern art is related to the problem of the modern individual's free-
dom. For this reason the history of modern art tends at certain mo-
ments to become the history of modern freedom. It is here that there
is a genuine rapport between the artist and the working class. At the
same time, modern artists have not a social, but an individualist
experience of freedom: this is the source of the irreconcilable conflict
between the Surrealists and the political parties of the working class.

The social condition of the modern world which gives every experi-
ence its form is the spiritual breakdown which followed the collapse
of religion. This condition has led to the isolation of the artist from the
rest of society. The modern artist's social history is that of a spiritual
being in a property-loving world.

No synthesized view of reality has replaced religion. Science is not
a view, but a method. The consequence is that the modern artist tends
to become the last active spiritual being in the great world. It is true
that each artist has his own religion. It is true that artists are constantly
excommunicating each other. It is true that artists are not always pure,
that sometimes they are concerned with their public standing or their
material circumstance. Yet for all that, it is the artists who guard the
spiritual in the modern world.

In the spiritual underground the modern artist tends to be reduced
to a single subject, his ego. . . . This situation tells us where to expect
the successes and failures of modern art. If the artist's conception, from
temperament and conditioning, of freedom is highly individualistic,
his egoism then takes a romantic form. Hence the Surrealists' love-at-
first-sight for the Romantic period, for disoriented and *minor* artists:
individualism limits *size*. If the artist, on the contrary, resents the
limitations of such subjectivism, he tries to objectify his ego. In the
modern world, the way open to the objectivization of the ego is through
form. This is the tendency of what we call, not quite accurately,
abstract art. Romanticism and formalism both are responses to the
modern world, a rejection, or at least a reduction, of modern social
values. Hence the relative failure of Picasso's public mural of the
Spanish Republic's pavilion in the Paris Exposition, *The Bombing of*

Guernica. Hence Picasso's great successes, given his great personal gifts, with the formal and emotional inventions in cubism, the *papier collé,* and even in many of the preliminary drawings for *Guernica:* here it is a question of Picasso's own genius. In the public mural, it is a question of his solidarity with other men. Picasso is cut off from the great social classes, by the decadence of the middle-class and the indifference of the working-class, by his own spirituality in a property-ridden world. *Guernica* is therefore a *tour de force.* It expresses Picasso's indignation, as an individual, at public events. In this it is akin to Goya's *Los Desastres de la Guerra.* The smaller format of etchings, or even of easel paintings is more appropriate. We see this in the greater effective horror of Picasso's *Girl with a Cock.* The mural form, by virtue of its size and public character, must speak for a whole society, or at the very least, a whole class. *Guernica* hangs in an uneasy equilibrium between now disappearing social values, i.e., moral indignation at the character of modern life—what Mondrian called the *tragic,* as opposed to the eternal and the formal, the aesthetics of the *papier collé.*

We admire Picasso for having created *Guernica.* We are moved by its intent. Yet how accurately, though intuitively, art measures the contradictions of life. Here a contradiction exists. So long as the artist does not belong, in the concrete sense, to one of the great historical classes of humanity, so long he cannot realize a social expression in all its public fullness. Which is to say, an expression for, and not against. The artist is greatest in affirmation. This isolation spiritually cripples the artist, and sometimes gives him, at present, a certain resemblance to Dostoyevsky's *idiot.*

The artist's problem is *with what to identify himself.* The middle-class is decaying, and as a conscious entity the working-class does not exist. Hence the tendency of modern painters to paint for each other. . . .

The preponderance of modern artists come from the middle-class. To this class modern art is always hostile by implication, and sometimes directly so. Even before the socialists, the artists recognized the enemy in the middle-class. But being themselves of middle-class origin, and leading middle-class lives—certainly not the lives of the proletariat—the artist in a certain sense attacks himself. He undermines

his own concrete foundation. He is then led to abstract eternal goods from reality. Here begins the rise of abstract art. All art is abstract in character. But it is especially in modern times that after the operation of abstraction so little remains.

The artist's hostility for the middle-class is reciprocated. This period, more than others, has detested its greatest creations, even when made by extremely conventional beings, like Cézanne. In the face of this hostility, there have been three possible attitudes of which the artist was not always conscious; to ignore the middle-class and seek the eternal, like Delacroix, Seurat, Cézanne, the cubists, and their heirs; to support the middle-class by restricting oneself to the decorative, like Ingres, Corot, the Impressionists in general, and the fauves; or to oppose the middle-class, like Courbet, Daumier, Pissarro, Van Gogh, and the Dadaists. The last class tends to be destroyed by the struggle. Some artists like Picasso, have had all three relations to the middle-class.

ARSHILE GORKY

• Arshile Gorky's murals of the thirties were perhaps the first indication that American art could fully assimilate, in order to recast in its own terms, the fundamentals of European modernism. Here Gorky describes his goals in the creation of these large-scale public works. In his use of stylized airplane parts as "plastic symbols" he imitated Stuart Davis' manner of transforming symbolic objects into stylized flat shapes, although in his emphasis on fantasy, Gorky reveals himself, like his contemporaries, to be moving away from the impersonal world of Cubism toward Surrealism's private world of the dream.

A study for *Aviation: Evolution of Forms Under Aerodynamic Limitations,* the mural in the Administration Building at Newark Airport, Newark, New Jersey, which is the subject of the following essay, is illustrated in the editor's *American Art Since 1900.*

[FROM "Aviation: Evolution of Forms under Aerodynamic Limitations," in Ethel K. Schwabacher, *Arshile Gorky* (New York: Macmillan Co. for the Whitney Museum of American Art, 1957).]

The architectonic two-dimensional surface plane of walls must be retained in mural painting. How was I to overcome this plastic problem when the subject of my murals was that of the unbounded space of the sky-world of aviation? How keep the walls from flying away or else crushing together as they would be sure to do in a pictorial narrative? The problem resolved itself when I considered the new vision that flight has given to the eyes of man. The isle of Manhattan with all its skyscrapers from the view of an aeroplane five miles up becomes but a geographical map, a two-dimensional surface plane. This new perception simplifies the form and shapes of earth objects. The thickness of objects is lost and only the space occupied by the object remains. Such simplification removes all decorative details and leaves the artist with limitations which become a style, a plastic invention, particular to our time. How was I to utilize this new concept for my murals?

In the popular idea of art, an aeroplane is painted as it might look in a photograph. But such a hackneyed concept has no architectural unity in the space that it is to occupy nor does it truthfully represent an aeroplane with all its ramifications. An operation was imperative, and that is why in the first panel of *Activities on the Field,* I had to dissect an aeroplane into its constituent parts. An aeroplane is composed of a variety of shapes and forms and I have used such elemental forms as a rudder, a wing, a wheel, a searchlight, etc., to create not only numerical interest, but also to include within a given wall space, plastic symbols of aviation. These plastic symbols are the permanent elements of aeroplanes that will change with the change of design. These symbols, these forms, I have used in paralyzing disproportions in order to impress upon the spectator the miraculous new vision of our time. To add to the intensity of these shapes, I have used such local colors as are to be seen on the aviation field, red, blue, yellow, black, gray, brown, because these colors were used originally to sharpen the objects against neutral backgrounds so that they could be seen clearly and quickly.

The second panel of the same wall contains objects commonly used around a hangar, such as a ladder, a fire extinguisher, a gasoline truck, scales, etc. These objects I have dissected and reorganized in the same homogeneous arrangement as in the previous panel.

In the panel, *Early Aviation,* I sought to bring into elemental terms the sensation of the passengers in the first balloon to the wonder of the

sky around them and the earth beneath. Obviously this conception entails a different problem than those previously cited. In fact each of the walls presents a different problem concerning aviation and to solve each one, I had to use different concepts, different plastic qualities, different colors. Thus, to appreciate my panel of the first balloon, the spectator must seek to imaginatively enter into the miraculous sense of wonder experienced by the first balloonists. In the shock of surprise everything changes. The sky becomes green. The sun is black with astonishment on beholding an invention never before created by the hand of God. And the earth is spotted with such elliptical brown forms as had never been seen before.

The image of wonder I continued in the second panel. From the first balloon of Montgolfier, aviation developed until the wings of the modern aeroplane, figuratively speaking, stretch across the United States. The sky is still green for the wonders of the sky never cease, and the map of the United States takes on a new geographical outline because of the illusion of change brought about by the change in speed.

The first three panels of *Modern Aviation* contain the anatomical parts of autogyros in the process of soaring into space, and yet with the immobility of suspension. The fourth panel is a modern aeroplane simplified to its essential form and so spaced as to give a sense of flight.

In the last three panels I have used arbitrary colors and shapes; the wing is black, the rudder yellow, so as to convey the sense that these modern gigantic toys of men are decorated with the same fanciful play as children have in coloring their kites. In the same spirit the engine becomes in one place like the wings of a dragon, and in another the wheels, propeller, and motor take on the demonic speed of a meteor cleaving the atmosphere.

In *Mechanics of Flying* I have used morphic shapes. The objects portrayed, a thermometer, hygrometer, anemometer, an aeroplane map of the United States, all have a definitely important usage in aviation, and to emphasize this, I have given them importance by detaching them from their environment.

Art of This Century

• Like his contemporaries, first-generation New York School painters Adolph Gottlieb, Barnett Newman, and Jackson Pollock, Gorky was interested in the symbolic content of art. Not primitive forms, but the capacity of the primitive mind to symbolize natural forces and such abstract concepts the vital energy of movement, intrigued Gorky.

[FROM Ethel K. Schwabacher, *Arshile Gorky* (New York: Macmillan Co. for the Whitney Museum of American Art, 1957).]

Letter from Gorky to his wife, May 31, 1941

Men do not move in one movement as with primitives: the movement is composed, and different parts of the body may move in opposed directions and with diverse speeds. Movement is the translation of life, and, if art depicts life, movement should come into art, since we are only aware of living because it moves. Our expressions belong to this same big movement and they show the most interesting aspects of the individual; his character, his personality. What kept me in doubt was, I think, the very simplicity of the early primitives in rendering movement, their conception of things in general being very simple, that of the modern being more complex. Today it all seems to me the other way around—the movement of the primitive is a misconception of true movement, is a fabrication of his mind, an automatic creation which corresponds in no way with the natural movement of living beings. In one word, it is complicated because he does not take the trouble to probe deeply, but invents, creates for himself. The movement of the modern seems to me to be simple because, putting aside all his natural capacity as a human automation, he uses his energy to see well, in order to render well what he has felt well in seeing well. . . . To conclude, in order not to inflict Mougouch's * ears too much, I am in entire sympathy with the modern European movement to the exclusion of those moderns who belong to the other class, those who invent things instead of translating them.

* Mougouch was Gorky's nickname for his wife.

MARK ROTHKO

• The wish to find a universally meaningful subject often led American painters in the forties to look to ancient myths for inspiration. In the passages by Rothko, Newman, and Gottlieb that follow, some of the attitudes of leading Abstract Expressionists toward content in art are set forth.

[FROM *Possibilities,* No. 1 (Winter, 1947–48).]

The romantics were prompted to seek exotic subjects and to travel to far off places. They failed to realise that, though the transcendental must involve the strange and unfamiliar, not everything strange or unfamiliar is transcendental.

The unfriendliness of society to his activity is difficult for the artist to accept. Yet this very hostility can act as a lever for true liberation. Freed from a false sense of security and community, the artist can abandon his plastic bankbook, just as he has abandoned other forms of security. Both the sense of community and of security depend on the familiar. Free of them, transcendental experiences become possible.

I think of my pictures as dramas; the shapes in the pictures are the performers. They have been created from the need for a group of actors who are able to move dramatically without embarrassment and execute gestures without shame.

Neither the action nor the actors can be anticipated or described in advance. They begin as an unknown adventure in an unknown space. It is at the moment of completion that in a flash of recognition, they are seen to have the quantity and function which was intended. Ideas and plans that existed in the mind at the start were simply the doorway through which one left the world in which they occur.

The great Cubist pictures thus transcend and belie the implications of the Cubist program.

The most important tool the artist fashions through constant practice is faith in his ability to produce miracles when they are needed. Pictures must be miraculous: the instant one is completed, the intimacy between the creation and the creator is ended. He is an outsider. The picture must be for him, as for anyone experiencing it later, a revela-

tion, an unexpected and unprecedented resolution of an eternally familiar need.

On shapes:

They are unique elements in a unique situation.

They are organisms with volition and a passion for self-assertion.

They move with internal freedom, and without need to conform with or to violate what is probable in the familiar world.

They have no direct association with any particular visible experience, but in them one recognizes the principle and passion of organisms.

The presentation of this drama in the familiar world was never possible, unless everyday acts belonged to a ritual accepted as referring to a transcendent realm.

Even the archaic artist, who had an uncanny virtuosity found it necessary to create a group of intermediaries, monsters, hybrids, gods and demigods. The difference is that, since the archaic artist was living in a more practical society than ours, the urgency for transcendent experience was understood, and given an official status. As a consequence, the human figure and other elements from the familiar world could be combined with, or participate as a whole in, the enactment of the excesses which characterize this improbable hierarchy. With us the disguise must be complete. The familiar identity of things has to be pulverized in order to destroy the finite associations with which our society increasingly enshrouds every aspect of our environment.

Without monsters and gods, art cannot enact our drama: art's most profound moments express this frustration. When they were abandoned as untenable superstitions, art sank into melancholy. It became fond of the dark, and enveloped its objects in the nostalgic intimations of a half-lit world. For me the great achievements of the centuries in which the artist accepted the probable and familiar as his subjects were the pictures of the single human figure—alone in a moment of utter immobility.

But the solitary figure could not raise its limbs in a single gesture that might indicate its concern with the fact of mortality and an insatiable appetite for ubiquitous experience in face of this fact. Nor could the solitude be overcome. It could gather on beaches and streets

and in parks only through coincidence, and, with its companions, form a *tableau vivant* of human incommunicability.

I do not believe that there was ever a question of being abstract or representational. It is really a matter of ending this silence and solitude, of breathing and stretching one's arms again.

BARNETT NEWMAN

[FROM *The Ideographic Picture,* Betty Parsons Gallery, January 20–February 8, 1947.]

The Kwakiutl artist painting on a hide did not concern himself with the inconsequentials that made up the opulent social rivalries of the Northwest Coast Indian scene, nor did he, in the name of a higher purity, renounce the living world for the meaningless materialism of design. The abstract shape he used, his entire plastic language, was directed by a ritualistic will towards metaphysical understanding. The everyday realities he left to the toymakers; the pleasant play of non-objective pattern to the women basket weavers. To him a shape was a living thing, a vehicle for an abstract thought-complex, a carrier of the awesome feelings he felt before the terror of the unknowable. The abstract shape was, therefore, real rather than a formal "abstraction" of a visual fact, with its overtone of an already-known nature. Nor was it a purist illusion with its overload of pseudo-scientific truths.

The basis of an aesthetic act is the pure idea. But the pure idea is, of necessity, an aesthetic act. Here then is the epistemological paradox that is the artist's problem. Not space cutting nor space building, not construction nor Fauvist destruction; not the pure line, straight and narrow, nor the tortured line, distorted and humiliating; not the accurate eye, all fingers, nor the wild eye of dream, winking; but the idea-complex that makes contact with mystery—of life, of men, of nature, of the hard, black chaos that is death, or the grayer, softer chaos that is tragedy. Everything else has everything else.

Spontaneous, and emerging from several points, there has arisen during the war years a new force in American painting that is the modern counterpart of the primitive art impulse. As early as 1942, Mr.

Edward Alden Jewell was the first publicly to report it. Since then, various critics and dealers have tried to label it, to describe it. It is now time for the artist himself, by showing the dictionary, to make clear the community of intention that motivates him and his colleagues. For here is a group of artists who are not abstract painters, although working in what is known as the abstract-style.

ADOLPH GOTTLIEB

[FROM "The Ides of Art," *Tiger's Eye,* No. 2 (December, 1947).]

Certain people always say we should go back to nature. I notice they never say we should go forward to nature. It seems to me they are more concerned that we should go back, than about nature.

If the models we use are the apparitions seen in a dream, or the recollection of our prehistoric past, is this less part of nature or realism, than a cow in a field? I think not.

The role of the artist, of course, has always been that of image maker. Different times require different images. Today when our aspirations have been reduced to a desperate attempt to escape from evil, and times are out of joint, our obsessive, subterranean, and pictographic images are the expression of the neurosis which is our reality. To my mind, certain so-called abstraction is not abstraction at all. On the contrary, it is the realism of our time.

———

• The question of symbolic content was uppermost in the minds of the Abstract Expressionists. Gottlieb rejected the geometric specificity of Synthetic Cubism for images that were more generally evocative.

[FROM Jeanne Siegel, "Adolph Gottlieb: Two Views," *Arts Magazine,* XLII (February, 1968).]

On Pictographs and Symbols

I would start by having an arbitrary division of the canvas into rough rectangular areas, and with the process of free association I would put various images and symbols within these compartments. And it was irrational. There was no logical or rational design in the placing of these. It was purely following an impulse, which was irrational, trying to use the method of free association. And then when all of these images and symbols were combined, they could not be read like a rebus. There was no direct connection one to the other. And [yet], however, by the strange juxtapositions that occurred, a new kind of significance stemmed from this juxtaposition.

I don't want to give the impression that I was trying to convey some kind of literary message. I wasn't a writer, I was a painter. I was really trying to make paintings. Actually, I was involved with pictorial problems, such as the type of an article written in a magazine at the time that said "Gottlieb kills space." Well, I was trying to kill space. That is, I was trying to kill the old three-dimensional deep space, which may have been valid for the representation of actual objects and figures, but for what I was painting, that kind of space wasn't the right space. So I had to try to invent some other kind of pictorial space, which I did with this method of using lines that went out at the edges of the canvas and that formed these rectangular frames. So that it was a continuous space and the paintings had no definite focal point. If there was a focal point, there were, I would say, numerous focal points, which were distributed as I chose. And this was, I think, a painterly problem primarily. It was not an attempt to translate a literary message into a pictorial form.

I did have certain symbols that were repeated and carried over from one painting to another. But my favorite symbols were those which I didn't understand. If I knew too well what the symbol signified, then I would eliminate it because then it got to be boring. I wanted these symbols to have, in juxtaposition, a certain kind of ambiguity and mystery. . . .

There's tremendous difference between my recent things and the pictographs. The pictographs were all-over paintings. There was no beginning, and no end, no definite focal point. However, when I broke away from that aspect of my work and got into the imaginary

landscapes and into what people call the bursts, I was working with definite focal points. By focal point I mean a point within the rectangle of the canvas to which one's eye is drawn. In portraits, for example, the focal point is the head. So instead of numerous focal points as in my pictographs I used only one or two. And that's the great difference in what I was doing before and what I have been doing since the late fifties. It's a different spatial concept, and naturally, the forms are different. Well, the space was determined by the forms. The character of the forms required a different kind of space, pictorial space, which is to say a flat space.

HANS HOFMANN

• Of the artists who emigrated to New York during the thirties and forties, none was more important than Hans Hofmann. Bringing with him one of the most sophisticated minds and painting techniques in Europe, Hofmann played a role in elevating the painting culture of America that cannot be overestimated. Stressing both instinct and awareness, he was able to strike a balance between spontaneity and formal coherence that would serve as a model for several generations of American painters. His emphasis on the primacy of color was later adopted by the abstractionists of the sixties.

———

[FROM *Catalogue of the Hans Hofmann Exhibition*, Kootz Gallery, New York, 1955.]

The genuine value of a painting is greatly determined through its basic concept.

In painting we differentiate between "pure painting" and "tonal painting." Pure painting is the antithesis of tonal painting.

We deal with tonal painting where color is degraded to a tonal gradation from the highest light down into the deepest tonal shades. Tonal gradation can be produced by any kind of color mixture.

In pure painting color serves simultaneously a plastic and a psychological purpose. We deal, in the achievement of this purpose, with a

formal problem and with a color problem in parallel occurrence, the synchronization of which constitutes the pictorial synthesis of the work. Color has in itself a sovereign function on the basis of its intrinsic qualities. Color in itself is Light. *In nature, light creates the color; in the picture, color creates light.* Every color shade emanates a very characteristic light—no substitute is possible.

The luminous quality of a work depends not only upon the light-emanating quality of every color but predominantly upon the relation of these qualities. *Relation is the product of a hypersensitive creative mind. Relation produces a new quality of a higher order through a created actuality*, either in the form of tension, when we deal with the compositional demand of integrated form, or in the form of intervals, when we deal with color relations. *We must always distinguish between form in a physical sense (nature) and form in an aesthetical sense (the form of the work itself as a creation of the mind).*

Color undergoes in this process still another metamorphosis, in the textural progression of the work. Texture is the consequence of the general pigmentary development of the work, and becomes in this way an additional light-producing factor, capable of altering the luminosity of the colors in the pace of their development towards a color-totality.

Basically and technically the color problem is dual conditioned: it is a formal problem in its inevitable structural relation to the pictorial surface, and it is—*per se*—a problem of color development which must respect its own inherent laws. Since each of these laws operates in a rhythm entirely its own, their interplay leads to a pictorial consonance comparable to harmony and counterpoint in music.

The magic of painting, however, can never be fully, rationally explained. It is the harmony of heart and mind in the capacity of *feeling into things* that plays the instrument. The instrument answers the throb of the heart in every instance. Painting is always intuitively conditioned. Theoretically it is a process of metabolism, whereby color transubstantiates into vital forces that *become the real sources of painterly life.* These sources are not of a physical but rather of a hyper-physical nature—the product of a sensitive mind. . . .

Whereas in tonal painting neighborhood relations are achieved through dark-and-light transitions, in pure painting the rhythmic interweaving of the color scales brings the color into an "open" neigh-

borhood relationship in which colors are compositionally in accordance with a color development upon which their formal grouping ultimately depends. The colors meet now in neighborly relation in the sense of *tensional difference*—that is to say, in the sense of *simultaneous contrast*. The finest difference in color shades can achieve powerful contrasts. Although tonal development may lead to an overall pictorial harmony, it sacrifices simultaneous contrast, which is the predominant quality of pure painting.

A painting has an immediate impact, but is conceived sequentially. The process of development is made invisible in the synthesis of the completed work.

Looking at a picture is a spontaneous act that reveals at once the quality or non-quality of the work.

But what is quality? Quality is the essence resulting from convincingly established felt-relationships. It can only be produced through an act of empathy, that is, the power to feel *into* the nature of things. . . .

Pictorial life is a created reality. Without it, pictorial communication —the appeal to the sense and the mind—is nonexistent. Color, in nature as well as in the picture, is an agent to give the highest aesthetic enjoyment. The emotion-releasing faculty of the color related to the formal aspect of the work becomes a means to awaken in us the feelings to which the medium of expression responds analogously when we attempt to realize our experiences creatively. Upon it will depend the formal and psychic appeal of the created image which is finally achieved through an absolute synchronization, in which a multitude of seemingly incompatible developments have been firmly interwoven— molded in the synthesis of the work.

[FROM "Statement by Hans Hofmann," *IT IS,* Winter–Spring, 1959.]

America is at present in a state of cultural blossoming. I am supposed to have contributed my share as teacher and artist by the offering of a multiple awareness. This awareness I consider to constitute a visual experience and a pictorial creation.

"Seeing" without awareness, as a visual art, is just short of blindness. "Seeing" with awareness is a visual experience; it is an art.

We must learn to see. The interpretation in pictorial terms of what we see is "another" art.

Every act of pictorial creation has, therefore, a dual conceptual approach.

The origin of creation is, therefore, a reflection of nature on a creative mind:

We are nature
What surrounds us is nature
Our creative means are nature
Nothing, however, will happen without the creative faculties of our conscious-and-unconscious mind.

One of these faculties is an awareness of space in every form of manifestation: either

a) in the form of movement and counter-movement, with the consequence of rhythm and counter-rhythm; or
b) in the form of force and counter-force in a two-dimensional play in every direction; or
c) in the form of tension as a result of these forces.

The pictorial life as a pictorial reality results from the aggregate of two-and-three-dimensional tensions: a combination of the effect of simultaneous expansion and contraction with that of push and pull.

The nature of the light-and-color problem in the plastic arts cannot be fully understood without an awareness of the foregoing considerations. Color and light are to a very great extent subjected to the formal problems of the picture surface.

The color problem follows a development that makes it a life-and-light-emanating plastic means of first order. Like the picture surface, color has an inherent life of its own. A picture comes into existence on the basis of the interplay of this dual life. In the act of predominance and assimilation, colors love or hate each other, thereby helping to make the creative intention of the artist possible.

Talent is, in general, common—original talent is rare. A teacher can only accompany a talent over a certain period of time—he can never

make one. As a teacher, I approach my students purely with the human desire to free them from all scholarly inhibitions. And I tell them, "Painters must speak through paint—not through words."

[FROM Irma B. Jaffe, "A Conversation with Hans Hoffman," *Artforum*, January, 1971.]

It's a tremendous experience, teaching. . . . I think there is not another man in this world who has the experience as a teacher that I have. So as a result of my long, long period of teaching, I have come to the conclusion that you cannot actually teach art; *you cannot.* You can let everyone paint, let him have his enjoyment, but you cannot teach him the sixth sense. You cannot. Everyone, more or less, has talent, a little bit. It then depends on the teacher *how* the talent is developed. It must develop through work, not through a teacher, not through influences from the outside. You cannot help it, you belong to a certain time. You are yourself the result of this time. You are also the creator of this time. That all goes hand in hand to make your work significant.

The child is really an artist, and the artist should be like a child, but he should not stay a child. He must become an artist. That means he cannot permit himself to become sentimental or something like that. He must know what he is doing.

I start out with no preconception from the very start. I let things develop according to my sensing and feeling, to my moods, especially those in which I find myself when I get up in the morning.

Sometimes I'm in extremely gay moods, sometimes I'm not so gay. When that's already come to expression on the first spot I see on my my canvas, from then on, it goes on and on and the painting, my paintings—I say it once more, my paintings—go through tens of thousands of developments, tens of thousands of developments in which the different values have been brought up to the creation of an immense volume with the expression of universality, with space, and so on.

That is not accident. That is all created. That is also the control from a certain momentum, see? But at the same time there develops in me a relationship to my own paintings, and this is mostly a poetic relationship, because my painting itself is poetry. I consider this poetry expressed in color, and according to the outcome, I give my title.

[My] push and pull [theory] is not so simple as people think it is. It is actually the secret of three dimensionality, of a flat surface . . . creating space, deep, deep space without destroying the surface, without drilling a hole in the surface. That's my great discovery, which I discovered through my very rich teachings here.

It is all wrong with Italian perspective—it has only one direction in the depth, but nothing comes back. But in my pictures it goes back and comes—it goes in and it comes back.

Chapter Seven

The New American Painting

• The following statements by Jackson Pollock, Willem de Kooning, and Franz Kline provide information on their working methods and attitudes toward their own art, and art in general, which may be taken as typical of those painters who used gesture as their primary expressive means.

JACKSON POLLOCK

[FROM *Arts and Architecture*, February, 1944.]

Living is keener, more demanding, more intense and expansive in New York than in the West; the stimulating influences are more numerous and rewarding. At the same time, I have a definite feeling for the West: the vast horizontality of the land, for instance; here only the Atlantic gives you that.

I have always been very impressed with the plastic qualities of American Indian art. The Indians have the true painter's approach in their capacity to get hold of appropriate images, and in their understanding of what constitutes painterly subject-matter. Their color is essentially Western, their vision has the basic universality of all real art. Some people find references to American Indian art and calligraphy in parts of my pictures. That wasn't intentional; probably it was the result of early memories and enthusiasms.

I accept the fact that the important painting of the last hundred years was done in France. American painters have generally missed the point of modern painting from beginning to end. (The only American

master who interests me is Ryder.) Thus the fact that good European moderns are now here is very important, for they bring with them an understanding of the problems of modern painting. I am particularly impressed with their concept of the source of art being the unconscious. This idea interests me more than these specific painters do, for the two artists I admire most, Picasso and Miró, are still abroad. . . .

The idea of an isolated American painting, so popular in this country during the thirties, seems absurd to me, just as the idea of creating a purely American mathematics or physics would seem absurd. . . . And in another sense, the problem doesn't exist at all; or, if it did, would solve itself. An American is an American and his painting would naturally be qualified by that fact, whether he wills it or not. But the basic problems of contemporary painting are independent of any one country.

[FROM "My Painting," *Possibilities,* No. 1 (Winter, 1947–48).]

My painting does not come from the easel. I hardly ever stretch my canvas before painting. I prefer to tack the unstretched canvas to the hard wall or the floor. I need the resistance of a hard surface. On the floor I am more at ease. I feel nearer, more a part of the painting, since this way I can walk around it, work from the four sides and literally be *in* the painting. This is akin to the method of the Indian sand painters of the West.

I continue to get further way from the usual painter's tools such as easel, palette, brushes, etc. I prefer sticks, trowels, knives, and dripping fluid paint or a heavy impasto with sand, broken glass, and other foreign matter added.

When I am *in* my painting, I'm not aware of what I am doing. It is only after a sort of "get acquainted" period that I see what I have been about. I have no fears about making changes, destroying the image, etc., because the painting has a life of its own. I try to let it come through. It is only when I lose contact with the painting that the result is a mess. Otherwise there is pure harmony, an easy give and take, and the painting comes out well.

The New American Painting

[FROM B. H. Friedman, *Jackson Pollock: Energy Made Visible* (New York: McGraw-Hill, 1972).]

Modern art . . . is nothing more than the expression of contemporary aims. . . . All cultures have had means and techniques of expressing their immediate aims—the Chinese, the Renaissance, all cultures. The thing that interests me is that today painters do not have to go to a subject matter outside of themselves. Most modern painters work from a different source. They work from within.

. . . new needs need new techniques. And the modern artists have found new ways and new means of making their statements. It seems to me that the modern painter cannot express this age, the airplane, the atom bomb, the radio, in the old forms of the Renaissance or of any other past culture. Each age finds its own technique . . . the strangeness will wear off and I think we will discover the deeper meanings in modern art. . . . [Laymen looking at a Pollock or other modern painting] should not look *for*, but look passively—and try to receive what the painting has to offer and not bring a subject matter or preconceived idea of what they are looking for. . . . The unconscious is a very important side of modern art and I think the unconscious drives do mean a lot in looking at paintings. . . . [Abstract art] should be enjoyed just as music is enjoyed—after a while you may like it or you may not. . . . I like some flowers and others, other flowers I don't like. . . . I think at least give it a chance.

. . . the modern artist is living in a mechanical age and we have . . . mechanical means of representing objects in nature such as the camera and photograph. The modern artist, it seems to me, is working and expressing an inner world—in other words, expressing the energy, the motion, and other inner forces . . . the modern artist is working with space and time, and expressing his feelings rather than illustrating. . . . [Modern art] didn't drop out of the blue; it's part of a long tradition dating back with Cézanne, up through the Cubists, the post-Cubists, to the painting being done today. . . . Well, method is, it seems to me, a natural growth out of a need, and from a need the modern artist has found new ways of expressing the world about him. I happen to find ways that are different from the usual techniques of painting, which seems a little strange at the moment, but I

don't think there's anything very different about it. I paint on the floor and this isn't unusual—the Orientals did that. . . .

Most of the paint I use is a liquid, flowing kind of paint. The brushes I use are used more as sticks . . . than [as] brushes—the brush doesn't touch the surface of the canvas, it's just above. . . . I'm able to be more free and to have greater freedom and move about the canvas with greater ease . . . with experience it seems to be possible to control the flow of the paint to a great extent, and I don't use . . . the accident . . . I deny the accident.

[A preconceived image] hasn't been created. . . . Something new —it's quite different from working, say, from a still life where you set up objects and work directly from them. I do have a general notion of what I'm about and what the results will be. . . . I approach painting in the same sense as one approaches drawing—that is, it's direct. I don't work from drawings, I don't make sketches and drawings and color sketches into a final painting.

WILLEM DE KOONING

[FROM "What Abstract Art Means to Me," *Museum of Modern Art Bulletin,* XVIII, No. 3 (Spring, 1951).]

The word "abstract" comes from the lighttower of philosophers, and it seems to be one of their spotlights that they have particularly focussed on "Art." So the artist is always lighted up by it. As soon as it— I mean the "abstract"—comes into painting, it ceases to be what it is as it is written. It changes into a feeling which could be explained by some other words, probably. But one day, some painter used "Abstraction" as a title for one of his paintings. It was a still life. And it was a very tricky title. And it wasn't really a very good one. From then on the idea of abstraction became something extra. Immediately it gave some people the idea that they could free art from itself. Until then, Art meant everything that was in it—not what you could take out of it sometime. There was only one thing you could take out of

it sometime when you were in the right mood—that abstract and indefinable sensation, the aesthetic part—and still leave it where it was. For the painter to come to the "abstract" or the "nothing," he needed many things. Those things were always things in life—a horse, a flower, a milkmaid, the light in a room through a window made of diamond shapes maybe, tables, chairs, and so forth. The painter, it is true, was not always completely free. The things were not always of his own choice, but because of that he often got some new ideas.

The aesthetics of painting were always in a state of development parallel to the development of painting itself. They influenced each other and vice versa. But all of a sudden, in that famous turn of the century, a few people thought they could take the bull by the horns and invent an aesthetic beforehand. After immediately disagreeing with each other, they began to form all kinds of groups, each with the idea of freeing art, and each demanding that you should obey them. Most of these theories have finally dwindled away into politics or strange forms of spiritualism. The question, as they saw it, was not so much what you *could* paint but rather what you could *not* paint. You could *not* paint a house or a tree or a mountain. It was then that subject matter came into existence as something you ought *not* to have. . . .

This pure form of comfort became the comfort of "pure form." . . .

Kandinsky understood "Form" as *a* form, like an object in the real world; and an object, he said, was a narrative—and so of course, he disapproved of it. He wanted his "music without words." He wanted to be "simple as a child." He intended, with his "inner self," to rid himself of "philosophical barricades" (he sat down and wrote something about all this). But in turn his own writing has become a philosophical barricade, even if it is a barricade full of holes. It offers a kind of Middle-European idea of Buddhism or, anyhow, something too theosophic for me.

The sentiments of the Futurists were simpler. No space. Everything ought to keep on going! That's probably the reason they went themselves. Either a man was a machine or else a sacrifice to make machines with.

The moral attitude of Neo-Plasticism is very much like that of Constructivism, except that the Constructivists wanted to bring things out in the open and the Neo-Plasticists didn't want anything left over.

I have learned a lot from all of them and they have confused me

plenty too. One thing is certain, they didn't give me my natural aptitude for drawing. I am completely weary of their ideas now.

The only way I still think of these ideas is in terms of the individual artists who came from them or invented them.

The point they all had in common was to be both inside and outside at the same time. A new kind of likeness! The likeness of the group instinct.

Personally, I do not need a movement. What was given to me, I take for granted. Of all movements, I like Cubism the most. It had that wonderful unsure atmosphere of reflection—a poetic frame where something could be possible, where an artist could practise his intuition. It didn't want to get rid of what went before. Instead it added something to it. The parts that I can appreciate in other movements came out of Cubism. Cubism *became* a movement, it didn't set out to be one. It has force in it, but it was no "force-movement." And then there is that one-man movement, Marcel Duchamp—for me a truly modern movement because it implies that each artist can do what he thinks he ought to—a movement for each person and open for everybody.

——————

[FROM an interview by David Sylvester with Willem de Kooning, BBC, December 30, 1960. First published in "Content Is a Glimpse," *Location*, I, No. 1 (Spring, 1963).]

The "women" [a series of female nudes by the artist] had to do with the female painted through all the ages, all those idols, and maybe I was stuck to a certain extent; I couldn't go on. It did one thing for me: it eliminated composition, arrangement, relationships, light—all this silly talk about line, color and form—because that was the thing I wanted to get hold of. I put it in the center of the canvas because there was no reason to put it a bit to the side. So I thought I might as well stick to the idea that it's got two eyes, a nose and mouth and neck. I got to the anatomy and I felt myself almost getting flustered. I could never get hold of it. I almost petered out. I never could complete it and when I think of it now, it wasn't such a bright idea. But I don't think artists have particularly bright

ideas. Matisse's *Woman in Red Blouse*—what an idea that is! Or the Cubists—when you think about it now, it is so silly to look at an object from many angles. Constructivism—open, not closed. It's very silly. It's good that they got those ideas because it was enough to make some of them great artists.

[FROM "Is Today's Artist with or Against the Past?" an interview by Thomas B. Hess, with Willem de Kooning, *Art News*, Summer, 1958.]

Being a painter I naturally see things, outdoors, on the streets; maybe I see things more naturally in museums. The history of art is separate from all history but connected, it meets with everything else, but it has its own constants. For instance, every period has its group of important artists, but over five or six hundred years, only a few will seem outstanding. I don't think any modern artist—Cézanne, Matisse, Picasso and the rest—has been as great as the great of the past—Rubens or Velásquez or Rembrandt.

[FROM "The Renaissance and Order," *Transformation, Arts, Communication, Environment: A World Review*, I, No. 2 (1951).]

In the Renaissance, when people—outside of being hung or crucified—couldn't die in the sky yet, the ideas a painter had always took place on earth. He had this large marvelous floor that he worked on. So if blood was on a sword, it was no accident. It meant that someone was dying or dead.

It was up to the artist to measure out the exact space for that person to die in or be dead already. The exactness of the space was determined or, rather, inspired by whatever reason the person was dying or being killed for. The space thus measured out on the original plane of the canvas surface became a "place" somewhere on that floor. If he were a good painter, he did not make the center of the end of that floor—the vanishing point on the horizon—the "content" (as the philosophers and educators of commercial art want to convince us nowadays that they did). The "content" was his way

of making the happening on the floor measurable from as many angles as possible instead. The main interest was how deep the happening—and the floor itself—could be or ought to be. The concept he had about the so-called subject established the depth; and with that he eventually found how high it was and how wide. It was not the other way around. He wasn't Alice looking into the Looking Glass. The scene wasn't there yet. He still had to make it.

Perspective, then, to a competent painter, did not mean an illusionary trick. It wasn't as if he were standing in front of his canvas and needed to imagine how deep the world could be. The world was deep already. As a matter-of-fact, it was depth which made it possible for the world to be there altogether. He wasn't so abstract as to take the hypotenuse of a two-dimensional universe. Painting was more intellectual than that. It was more intriguing to imagine himself busy on that floor of his—to *be,* so to speak, on the inside of his picture. He took it for granted that he could only measure things subjectively, and it was logical therefore that the best way was from the inside. It was the only way he could eventually project all the happenings on the frontmost plane. He became, in a way, the idea, the center, and the vanishing point himself—and all at the same time. He shifted, pushed, and arranged things in accordance with the way he felt about them. Sure they were not all the same to him. His idea of balance was a "wrought" one or a "woven" one. He loved something in one corner as much as he hated something in another. But he never became the things himself, as is usually said since Freud. If he wanted to, he could become one or two sometimes, but he was the one that made the decision. As long as he kept the original idea in mind, he could both invent the phenomena and inspect them critically at the same time. Michelangelo invented Adam that way, and even God. In those days, you were subjective to yourself, not to somebody else. If the artist was painting St. Sebastian, he knew very well he wasn't St. Sebastian—nor was he one of the torturers. He didn't understand the other fellow's face because he was painting his own; he understood it better because he himself had a face. He could never become completely detached. He could not get man out of his mind.

———

The New American Painting

[FROM an interview by Harold Rosenberg with Willem de Kooning, *Art News*, September, 1972.]

On Easel Painting

If I make a big painting I want it to be intimate. I want to separate it from the mural. I want it to stay an easel painting. It has to be a painting, not something made for a special place. The squarish aspect gives me the feeling of an ordinary size. I like a big painting to get so involved that it becomes intimate, that it really starts to lose its measurements, so that it looks smaller. To make a small painting look big is very difficult, but to make a big painting look small is also very difficult.

I'm crazy about Mondrian. I'm always spellbound by him. Something happens in the painting that I cannot take my eyes off. It shakes itself there. It has terrific tension. It's hermetic. The optical illusion in Mondrian is that where the lines cross they make a little light. Mondrian didn't like that, but he couldn't prevent it. The eye couldn't take it, and when the black lines cross they flicker. What I'm trying to bring out is that from the point of view of eyes it's really not optical illusion. That's the way you see it.

In a book on optical illusion there was an illustration with many lines drawn in a certain way. There were two parallel lines, then little lines like this and little lines like that from the other side. The figure looked narrower in the center than on the top and bottom. I don't call that an optical illusion. That's the way you see it. It looks narrower in the center.

FRANZ KLINE

[FROM David Sylvester, "Interview with Franz Kline," *Living Arts*, Spring, 1963.]

On Black and White Paintings

It wasn't a question of deciding to do a black-and-white painting. I think there was a time when the original forms that finally came out

in black and white were in color, say, and then as time went on I painted them out and made them black and white. And then, when they got that way, I just liked them, you know. . . .

I didn't have a particularly strong desire to use color, say, in the lights or darks of a black-and-white painting, although what happened is that accidentally they look that way. Sometimes a black, because of the quantity of it or the mass or the volume, looks as though it may be a blue-black, as if there were blue mixed in with the black, or as though it were a brown-black or a red-black. The whites the same way; the whites of course turned yellow, and many people call your attention to that, you know; they want white to stay white forever. It doesn't bother me whether it does or not. It's still white compared to the black.

On Calligraphy

You don't make the letter "C" and then fill the white in the circle. When people describe forms of painting in the calligraphic sense they really mean the linear, that painting was the equalization of the proportions of black, or the design of black against a form of white; but, in a lot of cases, apparently it does look that way. I rather imagine as people have come from the tradition of looking at drawing, they look at the lines, until you go to art school and then some drawing teacher tells you to look at the white spaces in it; but I didn't think about the black-and-white paintings as coming that way. I thought about it in a certain sense of the awkwardness of "not-balance," the tentative reality of lack of balance in it. The unknown reason why a form would be there and look just like that and not meaning anything particularly, would, in some haphazard way, be related to something else that you didn't plan either.

On Paint Handling

I don't like to manipulate the paint in any way in which it doesn't normally happen. In other words, I wouldn't paint an area to make texture, you see? And I wouldn't decide to scumble an area to make it more interesting to meet another area which isn't interesting enough. I love the idea of the thing happening that way and through the paint-

ing of it, the form of the black or the white comes about in exactly that way, plastically.

On Composition as Process

Paint never seems to behave the same. Even the same paint doesn't, you know. In other words, if you use the same white or black or red, through the use of it, it never seems to be the same. It doesn't dry the same. It doesn't stay there and look at you the same way. Other things seem to affect it. There seems to be something that you can do so much with paint and after that you start murdering it. There are moments or periods when it would be wonderful to plan something and do it and have the thing only do what you planned to do, and then, there are other times when the destruction of those planned things becomes interesting to you. So then, it becomes a question of destroying— of destroying the planned form; it's like an escape, it's something to do; something to begin the situation. You yourself, you don't decide, but if you want to paint you have to find out some way to start this thing off, whether it's painting it out or putting it in, and so on.

It can at times become like the immediate experience of beginning it; in other words, I can begin a painting if I decide it would be nice to have a large triangle come up and meet something that goes across like this. Now, on other occasions, I can think the whole thing through. The triangle needs an area that goes this way and then at the top something falls down and hits about here and then goes over there. So I try and rid my mind of anything else and attack it immediately from that complete situation. Other times, I can begin it with just the triangle meeting a large form that goes over that way, and when I do it, it doesn't seem like anything. When this series of relationships that go on in the painting relate—I don't particularly know what they relate to—I, in some way, try to form them in the original conception of what I rather imagined they would look like. Well then, at times, it's a question of maybe making them more than that. You see what I mean. It'd be a question of, say, eliminating the top or the bottom. Well, I can go through and destroy the whole painting completely without even going back to this original situation of a triangle and a long line, which seems to appear somewhere else in the painting. When it appears the way I originally thought it should, boy, then it's wonderful.

On Seeing Images in His Work

If someone says, "That looks like a bridge," it doesn't bother me really. Naturally, if you title them something associated with that, then when someone looks at it in the literary sense, he says, "He's a bridge painter." . . .

There are forms that are figurative to me, and if they develop into a figurative image it's all right if they do. I don't have the feeling that something has to be completely non-associative as far as figure form is concerned.

I think that if you use long lines, they become—what could they be? The only thing they could be is either highways or architecture or bridges.

On Emotional Content

It is nice to paint a happy picture after a sad one. I think that there is a kind of loneliness in a lot of them which I don't think about as the fact that I'm lonely and therefore I paint lonely pictures, but I like kind of lonely things anyhow; so if the forms express that to me, there is a certain excitement that I have about that. Any composition—you know, the overall reality of that does have something to do with it; the impending forms of something, do maybe have a brooding quality, whereas in other forms, they would be called or considered happier.

On Painting as Drawing

I rather feel that painting is a form of drawing and the painting that I like has a form of drawing to it. I don't see how it could be dissociated from the nature of drawing. I find that in many cases a drawing has been the subject of the painting—that would be a preliminary stage to that particular painting.

BARNETT NEWMAN

• "Abstract sublime" was the phrase critic Robert Rosenblum chose to denote the simplified, reduced, static abstractions of Barnett Newman and

The New American Painting

Mark Rothko. In this passage Newman states his views on the sublime in art, and, in the one following, Rothko gives his reasons for painting environmental, mural-sized pictures.

| FROM *Tiger's Eye,* No. 6 (December, 1948).]

The invention of beauty by the Greeks, that is, their postulate of beauty as an ideal, has been the bugbear of European art and European aesthetic philosophies. Man's natural desire in the arts to express his relation to the Absolute became identified and confused with the absolutisms of perfect creations—with the fetish of quality—so that the European artist has been continually involved in the moral struggle between notions of beauty and the desire for sublimity. . . .

Michelangelo ↘ knew that the meaning of the Greek humanities for his time involved making Christ — who is God; that his plastic problem was neither the medieval one, to make a cathedral, nor the Greek one, to make a man like a god, but to make a cathedral out of man. In doing so, he set a standard for sublimity that the painting of his time could not reach. Instead, painting continued on its merry quest for a voluptuous art until in modern times, the Impressionists, disgusted with its inadequacy, began the movement to destroy the established rhetoric of beauty by the Impressionist insistence on a surface of ugly strokes.

The impulse of modern art was this desire to destroy beauty. However, in discarding Renaissance notions of beauty, and without an adequate substitute for a sublime message, the Impressionists were compelled to preoccupy themselves, in their struggle, with the culture values of their plastic history so that instead of evoking a new way of experiencing life they were able only to make a transfer of values. . . .

So strong is the grip of the *rhetoric* of exaltation as an attitude in the large context of the European culture pattern that the elements of sublimity in the revolution we know as modern art, exist in its effort and energy to escape the pattern rather than in the realization of a new experience. Picasso's effort may be sublime but there is no doubt that his work is a preoccupation with the question of what is the nature of beauty. Even Mondrian, in his attempt to destroy the Renaissance picture by his insistence on pure subject matter, succeeded only in raising

the white plane and the right angle into a realm of sublimity, where the sublime paradoxically becomes an absolute of perfect sensations. The geometry (perfection) swallowed up his metaphysics (his exaltation).

The failure of European art to achieve the sublime is due to this blind desire to exist inside the reality of sensation (the objective world, whether distorted or pure) and to build an art within a framework of pure plasticity (the Greek ideal of beauty, whether that plasticity be a romantic active surface, or a classic stable one). In other words, modern art, caught without a sublime content, was incapable of creating a new sublime image, and unable to move away from the Renaissance imagery of figures and objects except by distortion or by denying it completely for an empty world of geometric formalisms—a pure rhetoric of abstract mathematical relationships, and became enmeshed in a struggle over the nature of beauty; whether beauty was in nature or could be found without nature.

I believe that here in America, some of us, free from the weight of European culture, are finding the answer, by completely denying that art has any concern with the problem of beauty and where to find it. The question that now arises is how, if we are living in a time without a legend or mythos that can be called sublime, if we refuse to admit any exaltation in pure relations, if we refuse to live in the abstract, how can we be creating a sublime art?

We are reasserting man's natural desire for the exalted, for a concern with our relationship to the absolute emotions. We do not need the obsolete props of an outmoded and antiquated legend. We are creating images whose reality is self-evident and which are devoid of the props and crutches that evoke associations with outmoded images, both sublime and beautiful. We are freeing ourselves of the impediments of memory, association, nostalgia, legend, myth, or what have you, that have been the devices of Western European painting. Instead of making *cathedrals* out of Christ, man, or "life," we are making it out of ourselves, out of our own feelings. The image we produce is the self-evident one of revelation, real and concrete, that can be understood by anyone who will look at it without the nostalgic glasses of history.

The New American Painting

MARK ROTHKO

[FROM *Interiors,* May, 1951.]

I paint very large pictures. I realize that historically the function of painting large pictures is painting something very grandiose and pompous. The reason I paint them, however—I think it applies to other painters I know—is precisely because I want to be very intimate and human. To paint a small picture is to place yourself outside your experience, to look upon an experience as a stereopticon view or with a reducing glass. However you paint the larger picture, you are in it. It isn't something you command.

• Although he gradually expunged Surrealist elements from his work, Rothko continued to keep his paintings resonating with a fuller content than that of purely abstract, that is, geometric, painting. In this and the following statement, Rothko pledges his dedication to a spiritual art intended to transcend the material world.

[FROM *Personal Statement,* David Porter Gallery, Washington, D.C., 1945.]

I adhere to the material reality of the world and the substance of things. I merely enlarge the extent of this reality, extending to it coequal attributes with experiences in our more familiar environment. I insist upon the equal existence of the world engendered in the mind and the world engendered by God outside of it. If I have faltered in the use of familiar objects, it is because I refuse to mutilate their appearance for the sake of an action which they are too old to serve; or for which, perhaps, they had never been intended.

I quarrel with surrealist and abstract art only as one quarrels with his father and mother, recognizing the inevitability and function of my roots, but insistent upon my dissension: I being both they and an integral completely independent of them.

The surrealist has uncovered the glossary of the myth and has established a congruity between the phantasmagoria of the unconscious and the objects of everyday life. This congruity constitutes the

exhilarated tragic experience which for me is the only source book for art. But I love both the object and the dream far too much to have them effervesced into the insubstantiality of memory and hallucination. The abstract artist has given material existence to many unseen worlds and tempi. But I repudiate his denial of the anecdote just as I repudiate the denial of the material existence of the whole of reality. For art to me is an anecdote of the spirit, and the only means of making concrete the purpose of its varied quickness and stillness.

Rather be prodigal than niggardly. I would sooner confer anthropomorphic attributes upon a stone than dehumanize the slightest possibility of consciousness.

[FROM *Tiger's Eye,* No. 9 (October, 1949).]

The progression of a painter's work, as it travels in time from point to point, will be toward clarity: toward the elimination of all obstacles between the painter and the idea, and between the idea and the observer. As examples of such obstacles, I give (among others) memory, history or geometry, which are swamps of generalization from which one might pull out parodies of ideas (which are ghosts) but never an idea in itself. To achieve this clarity is, inevitably, to be understood.

AD REINHARDT

• Although a member of the first generation of Abstract Expressionists, Ad Reinhardt was often referred to as the "black monk" of the movement because of his constant refusal to interest himself in either Expressionist paint handling or emotional content. Yet his calls for impersonality, aloofness, and asceticism have been heeded by many of the younger American artists. Reinhardt's insistence on the separation of art from life led him to propagandize from the thirties onward for a pure art-for-art's sake in a

most persuasive, if dogmatic manner. A source for the recent cool reductive abstraction, Reinhardt has influenced both painters and the "minimal" sculptors.

———

[FROM "Art-as-Art," *Art International,* VI, No. 10 (December 20, 1962).]

The one thing to say about art and life is that art is not life and life is not art. A "slice-of-life" art is no better or worse than a "slice-of-art" life. Fine art is not a "means of making a living" or a "way of living a life," and an artist who dedicates his life to his art, or his art to his life, burdens his art with his life and his life with his art. Art that is a matter of life and death is neither fine nor free.

The one assault on fine art is the ceaseless attempt to subserve it as a means to some other end or value. The one fight in art is not between art and non-art but between true art and false art, between pure art and Action-Assemblage art, between abstract art and Surrealist-Expressionist–anti-art, between free art and servile art. Abstract art has its own integrity, not some other "integration" with something else. Any combining, mixing, adding, diluting, exploiting, vulgarizing or popularizing abstract art deprives art of its essence and depraves the artist's artistic consciousness. Art is free, but it is not a free-for-all.

The one struggle in art is the struggle of artists against artists, of artist against artist, of the artist-as-artist within and against the artist-as-man, -animal, or -vegetable. Artists who claim that their art-work comes from nature, life, reality, earth, or heaven, are subjectively and objectively rascals or rustics. The art of "figuring" or "picturing" is not a fine art. "New images of man"—figures and "nature-in-abstraction" —pictures are fakes. An artist who is lobbying as a "creature of circumstances" or logrolling as a "victim of fate" is not a fine master-artist. No one ever forces an artist to be pure.

The one meaning in art comes from art-working and the more an artist works, the more there is to do. Artists come from artists, art-forms come from art-forms, painting comes from painting. The one direction in fine or abstract art today is in the painting of the same one form over and over again. The one intensity and the one perfection

comes only from long and lonely routine attention and repetition. The one originality exists only where all artists work in the same tradition and master the same convention. The one freedom is realized only through the most conscious art-discipline and through the most regular studio ritual. Only a standardized, prescribed form can be imageless, only a stereotyped image can be formless, only a formula-ized art can be formula-less. A painter who does not know what or how or where to paint is not a fine artist.

The one work for the fine artist, the one painting, is the painting of the one-size canvas—the single-scheme, one formal device, one color-monochrome, one linear-division in each direction, one symmetry, one texture, one free-hand-brushing, one rhythm, one working everything into one dissolution and one indivisibility, each painting into one over-all uniformity and non-irregularity. Everything into irreducibility, un-reproducibility, imperceptibility. Nothing "usable," "manipulatable," "salable," "dealable," "collectable," "graspable." No art as a commodity or a jobbery. Art is not the spiritual side of business.

CLYFFORD STILL

• In a rare statement, Clyfford Still acknowledges his debt to earlier modern art movements while maintaining his own independence from group efforts. A manifesto of individualism, the following statement explains Still's decision to retire from the New York art world and live in seclusion.

———

[FROM *Clyfford Still: Paintings in the Albright-Knox Art Gallery, Buffalo* (Buffalo, N.Y.: The Buffalo Fine Arts Academy, 1966).]

To supplement the reproductions of paintings shown in this catalogue with written comment by the painter represents not only the extreme of temerity on my part—it is patently presumptuous. At least that is what I have been told by some of those who write about pictures. In a culture where the written word is commonly re-

garded as synonymous with God, the gesture suggests an arrogance pregnant with blasphemy. Having been instructed in the degrees of my apostasy I am left no choice but to confirm their long repeated convictions—add weight to their thesauri of my crimes.

By the end of my twenty-fifth year, having seen and studied deeply the works and acts of those men of art presented in museums and books as masters, I was brought to the conclusion that very few of them merited the admiration they received and those few most often achieved true worth after they had defied their means and mores. The galleries held almost exclusively a collection of works selected to reflect the quality of minds dedicated to aesthetic puerilities and cultural pretentions. And few writers revealed in their analyses or criticisms more than a very obvious desire to be authorities in the social milieu, and were as completely ignorant of the whole of painting which they befouled and presumed to direct as they were inept in the art of writing.

To me it became an imperative that if this instrument—this extension of one's mind and heart and hand—were to be given its potential, a fresh start must be made. My conclusion was born of knowledge of the past, but my understanding of the past and its influence, right up to the present moment, made it clear that it could not be escaped by will alone. The manifestos and gestures of the Cubists, the Fauves, the Dadaists, Surrealists, Futurists or Expressionists were only evidence that the Black Mass was but a pathetic homage to that which it often presumed to mock. And the Bauhaus herded them briskly into a cool, universal Buchenwald. All the devices were at hand, and all the devices had failed to emancipate.

I had not overlooked the organic lesson; ontogeny suggested that the way through the maze of sterility required recapitulation of my phylogenic inheritance. Neither verbalizings nor aesthetic accretions would suffice. I had to accomplish my purpose, my emancipation and the exalting responsibility which I trusted would follow, totally and directly through my own life and hands. Time would have to wait. Years of labor would be required, but each work would bring its quanta of release and add the strength needed to realize the step which must ensue.

Through the years of the 1930's the work of clarifying, excising, extending and reviewing was pressed during all the time and with

all the energy I could order. Until those symbols of obeisance to—or illustration of—vested social structures, from antiquity through Cubism and Surrealism to my then immediate contemporaries, were impaled and their sycophancy exposed on the blade of my identity.

Of course, trouble began when my paintings were first publicly seen. The professionals complained that they were without precedent; or that they gave evidence of traditional things misunderstood. Aesthetic, political, even religious offense was apparent: To make assault plausible, crypto-Christian moralities were applied to me in terms brashly devised to misinterpret every facet of my life and meaning. Judgment was given and published.

The compliment was returned. Because now I had proof that my years of painting and deliberation had not been wasted. Only, the work had to be carried on in aloneness and with ruthless purpose. I had learned as a youth the price one pays for a father, a master, a Yahweh, or his contemporary substitute—an Institutional Culture. But my crime was compounded. To sin against the Order in the lighted arena was no deep offense; one could be dealt with—analyzed, neutralized, or encysted. But for one to defy the laws of Control, in the silence of the catacombs, with the canon instrument of their aggrandizement—for this more than correction was needed —this was treason!

Here was I free and here was I betrayed by my failure to withdraw completely from those who know me. Surely that which they found of interest should be shared with others. That the "others" responded with resentment or fear only stimulated their desire to justify their interest. Always in terms that would convince. Rational, artistically adequate, socially acceptable terms. Reminding my defenders that their efforts bore the germs of negation of all that gave these canvases meaning and purpose for me, I was made aware that the professionals *had* caught the odor of a latent power, smelled qualities that could be exploited.

For these conceptions could be perverted into pretentious exercises in design, parodied as socio-aesthetic devotions, or mauled into psychotic alibis expedient for ambition or intellectual impotence. The elements of my paintings, ineluctably co-ordinated, confirmed for me the liberation of the spirit. In the hands of unscrupulous and calculating men it was readily apparent that these elements could be

segregated and evacuated to intimidate the mind, blast the eyes with hatred, or seduce with insipid deceit.

Meanwhile, literary frustrates, and political aficionados posing as painters, leapt forth to affirm their dedication to Progress, People, Peace, Purity, Love, or the *avant-garde*. Examples purporting to be my antecedents were hauled out and indiscriminately compared with my work. Fatuous generalizations obscured every particular. Thus the genesis of a liberating absolute was buried under a blanket of historical inanities.

I have been told, to my considerable amusement, that my personal departure from New York City was hailed by many remaining there as "a victory for their Establishment." Certainly, acquiescent replacements from coast to coast—ex-students and perennial imitators alike—were happily hustled forth to deny that I had ever existed. So was authority restored to the institution of Art; and the crafting of histories resumed by those who would starve should their hoax be exposed. A Pyrrhic charade.

Let it be clearly understood that my relation to that contemporary Moloch, the Culture State, has not been altered. In its smothering omnipresence there is no *place,* ideologically or practically, for anyone who assumes the aspiration by which birth was given to the paintings reproduced in this catalogue. Few institutions that would survive among the power structures of our culture can afford the presence of an individual who would challenge the merit of their rules, nor dare they embrace a code of conduct or administration that does not seek, and yield to, the collectivist denominators of this time. . . .

To all who would know the meaning and the responsibilities of freedom, intrinsic and absolute, these works are dedicated.

STUDIO 35

• Round-table discussions at the Artist's Club and elsewhere gave the Abstract Expressionists an opportunity to clarify mutual concerns. At the third

meeting of Studio 35, the discussion group that met in the spring of 1950, preceding the Club's formation, the following remarks were made on finishing a painting and on the relationship of the artist to tradition—crucial issues to the participants.

[FROM *Modern Artists in America,* edited by Robert Motherwell and Ad Reinhardt (New York: Wittenborn, Schultz, 1952).]

MODERATOR MOTHERWELL: The question then is, *"How do you know when a work is finished?*

BAZIOTES: I consider my painting finished when my eye goes to a particular spot on the canvas. But if I put the picture away about thirty feet on the wall and the movements keep returning to me and the eye seems to be responding to something living, then it is finished.

NEWMAN: I think the idea of a "finished" picture is a fiction. I think a man spends his whole lifetime painting one picture or working on one piece of sculpture. The question of stopping is really a decision of moral considerations. To what extent are you intoxicated by the actual act, so that you are beguiled by it. To what extent are you charmed by its inner life? And to what extent do you then really approach the intention or desire that is really outside of it? The decision is always made when the piece has something in it that you wanted.

DE KOONING: I refrain from "finishing" it. I paint myself out of the picture, and when I have done that, I either throw it away or keep it. I am always in the picture somewhere. The amount of space I use I am always in, I seem to move around in it, and there seems to be a time when I lose sight of what I wanted to do, and then I am out of it. If the picture has a countenance, I keep it. If it hasn't, I throw it away. I am not really very much interested in the question.

REINHARDT: It has always been a problem for me—about "finishing" a painting. Among modern artists there is a value placed upon "unfinished" work. Disturbances arise when you have to treat the work as a finished and complete object, so that the only time I think I "finish" a painting is when I have a deadline. If you are going to present it as an "unfinished" object, how do you "finish" it?

HOFMANN: To me a work is finished when all parts involved communicate themselves, so that they don't need me.

The New American Painting

MOTHERWELL: I dislike a picture that is too suave or too skilfully done. But, contrariwise, I also dislike a picture that looks too inept or blundering. I noticed in looking at the [Cercle et] Carré exhibition of young French painters who are supposed to be close to this group, that in "finishing" a picture they assume traditional criteria to a much greater degree than we do. They have a real "finish" in that the picture is a real object, a beautifully made object. We are involved in "process" and what is a "finished" object is not so certain.

HOFMANN: Yes, it seems to me all the time there is the question of a heritage. The American painter of today approaches things without a basis. The French approach things on the basis of a cultural heritage—one feels that in all their work. It is a working towards a refinement and quality rather than working toward new experiences, and painting out these experiences that may finally become tradition. The French have it easier. They have it in the beginning.

DE KOONING: I am glad you brought up this point. It seems to me that in Europe every time something new needed to be done it was because of traditional culture. Ours has been a striving to come to the same point that they had—not to be iconoclasts.

GOTTLIEB: There is a general assumption that European—specifically French—painters have a heritage which enables them to have the benefits of tradition, and therefore they can produce a certain type of painting. It seems to me that in the last fifty years the whole meaning of painting has been made international. I think Americans share that heritage just as much, and that if they deviate from tradition it is just as difficult for an American as for a Frenchman. It is a mistaken assumption in some quarters that any departure from tradition stems from ignorance. I think that what Motherwell describes is the problem of knowing what tradition is, and being willing to reject it in part. This requires familiarity with his past. I think we have this familiarity, and if we depart from tradition, it is out of knowledge, not innocence.

DE KOONING: I agree that tradition is part of the whole world now. The point that was brought up was that the French artists have some "touch" in making an object. They have a particular something that makes them look like a "finished" painting. They have a touch which I am glad not to have.

BAZIOTES: We are getting mixed up with the French tradition. In talking about the necessity to "finish" a thing, we then said American

painters "finish" a thing that looks "unfinished," and the French, they "finish" it. I have seen Matisses that were more "unfinished" and yet more "finished" than any American painter. Matisse was obviously in a terrific emotion at the time, and it was more "unfinished" than "finished."

Chapter Eight

After Abstract Expressionism

•While recent abstraction has separated art from life, pop art has been interested in reintroducing the stuff of life into art. Statements by Jasper Johns and Robert Rauschenberg, whose early use of mass-culture images helped other artists break with Abstract Expressionism, as well as statements from pop artists Claes Oldenburg, Roy Lichtenstein, and Andy Warhol, indicate a set of common attitudes toward art and life and their possible reintegration in an imagistic, representational style.

JASPER JOHNS

[FROM *Sixteen Americans*, edited by Dorothy C. Miller (New York: Museum of Modern Art, 1959).]

Sometimes I see it and then paint it. Other times I paint it and then see it. Both are impure situations, and I prefer neither.

At every point in nature there is something to see. My work contains similar possibilities for the changing focus of the eye.

Three academic ideas which have been of interest to me are what a teacher of mine (speaking of Cézanne and Cubism) called "the rotating point of view" (Larry Rivers recently pointed to a black rectangle, two or three feet away from where he had been looking in a painting, and said ". . . like there's something happening over there too."); Marcel Duchamp's suggestion "to reach the Impossibility of sufficient visual memory to transfer from one like object to another the memory imprint"; and Leonardo's idea ("Therefore, O painter, do not surround your bodies with lines . . .") that the boundary of a body is

neither a part of the enclosed body nor a part of the surrounding atmosphere.

Generally, I am opposed to painting which is concerned with conceptions of simplicity. Everything looks very busy to me.

———

[FROM "What Is Pop Art?" an interview by G. Swenson with Jasper Johns, *Art News,* February, 1964.]

JOHNS: I'm not a Pop artist! Once a term is set, everybody tries to relate anybody they can to it because there are so few terms in the art world. Labeling is a popular way of dealing with things. . . .

I've taken different attitudes at different times. That allows different kinds of actions. In focusing your eye or your mind, if you focus in one way, your actions will tend to be of one nature; if you focus another way, they will be different. I prefer work that appears to come out of a changing focus—not just one relationship or even a number of them but constantly changing and shifting relationships to things in terms of focus. Often, however, one is very single-minded and pursues one particular point; often one is blind to the fact that there is another way to see what is there.

SWENSON: Are you aspiring to objectivity?

JOHNS: My paintings are not simply expressive gestures. Some of them I have thought of as facts, or at any rate there has been some attempt to say that a thing has a certain nature. Saying that, one hopes to avoid saying I feel this way about this thing; one says this thing is this thing, and one responds to what one thinks is so.

I am concerned with a thing's not being what it was, with its becoming something other than what it is, with any moment in which one identifies a thing precisely and with the slippng away of that moment, with any moment seeing or saying and letting it go at that.

SWENSON: What would you consider the difference between subject matter and content, between what is depicted and what it means?

JOHNS: Meaning implies that something is happening; you can say meaning is determined by the use of the thing, the way an audience uses a painting once it is put in public. When you speak of what is

depicted, I tend to think in terms of an intention. But the intention is usually with the artist. "Subject matter?" Where would you focus to determine subject matter?

SWENSON: What a thing is. In your Device paintings it would be the ruler.

JOHNS: Why do you pick ruler rather than wood or varnish or any other element? What it is—subject matter, then—is simply determined by what you're willing to say it is. What it means is simply a question of what you're willing to let it do.

There is a great deal of intention in painting; it's rather unavoidable. But when a work is let out by the artist and said to be complete, the intention loosens. Then it's subject to all kinds of use and misuse and pun. Occasionally someone will see the work in a way that even changes its significance for the person who made it; the work is no longer "intention," but the thing being seen and someone responding to it. They will see it in a way that makes you think, that is a possible way of seeing it. Then you, as the artist, can enjoy it—that's possible—or you can lament it. If you like, you can try to express the intention more clearly in another work. But what is interesting is anyone having the experiences he has. . . .

SWENSON: If you cast a beer can, is that a comment?

JOHNS: On what?

SWENSON: On beer cans or society. When you deal with things in the world, social attitudes are connected with them—aren't they?

JOHNS: Basically, artists work out of rather stupid kinds of impulses and then the work is done. After that the work is used. In terms of comment, the work probably has it, some aspect which resembles language. Publicly a work becomes not just intention, but the way it is used. If an artist makes something—or if you make chewing gum and everybody ends up using it as glue, whoever made it is given the responsibility of making glue, even if what he really intends is chewing gum. You can't control that kind of thing. As far as beginning to make a work, one can do it for any reason.

SWENSON: If you cast a beer can, you don't have to have a social attitude to beer cans or art?

JOHNS: No. It occurs to me you're talking about *my* beer cans, which have a story behind them. I was doing at that time sculptures of small objects—flashlights and light bulbs. Then I heard a story about

Willem de Kooning. He was annoyed with my dealer, Leo Castelli, for some reason, and said something like, "That son-of-a-bitch; you could give him two beer cans and he could sell them." I heard this and thought, "What a sculpture—two beer cans." It seemed to me to fit in perfectly with what I was doing, so I did them—and Leo sold them.

SWENSON: Should an artist accept suggestions—or his environment—so easily?

JOHNS: I think basically that's a false way of thinking. Accept or reject, where's the ease or the difficulty? I don't put any value on a kind of thinking that puts limits on things. I prefer that the artist does what he does [rather] than that, after he's done it, someone says he shouldn't have done it. I would encourage everybody to do more [rather] than less.

ROBERT RAUSCHENBERG

[FROM *Sixteen Americans,* edited by Dorothy C. Miller (New York: Museum of Modern Art, 1959).]

Any incentive to paint is as good as any other. There is no poor subject.

Painting is always strongest when in spite of composition, color, etc., it appears as a fact, or an inevitability, as opposed to a souvenir or arrangement.

Painting relates to both art and life. Neither can be made. (I try to act in that gap between the two.)

A pair of socks is no less suitable to make a painting with than wood, nails, turpentine, oil and fabric.

A canvas is never empty.

[FROM Calvin Tomkins, *The Bride and the Bachelors* (New York: Viking, 1965). Copyright © 1962, 1964, 1965, 1968 by Calvin Tomkins.]

Painting relates to both art and life. Neither can be made. I try to act in the gap between the two . . . I don't want a picture to look like something it isn't . . . I want it to look like something it is. And I think a picture is more like the real world when it is made out of the real world.

I really feel sorry for people who think things like soap dishes or mirrors or Coke bottles are ugly, because they're surrounded by things like that all day long, and it must make them miserable.

I don't want a painting to be just an expression of my personality . . . I feel it ought to be much better than that. And I'm opposed to the whole idea of conception—execution—of getting an idea for a picture and then carrying it out. I've always felt as though, whatever I've used and whatever I've done, the method was always closer to a *collaboration* with the materials than to any kind of conscious manipulation and control.

It has never bothered me a bit when people say that what I'm doing is not art. I don't think of myself as making art. I do what I do because I want to, because painting is the best way I've found to get along with myself. And it's always the moment of doing it that counts. When a painting is finished it's already something I've done, no longer something I'm doing, and it's not so interesting any more. I think I can keep on playing this game indefinitely. And it is a game—everything I do seems to have some of that in it. The point is, I just paint in order to learn something new about painting, and everything I learn always resolves itself into two or three pictures.

[FROM "The Artist Speaks: Robert Rauschenberg," an interview by Dorothy Gees Seckler, *Art in America,* LIV, No. 3 (May–June, 1966).]

Someone asked me yesterday: "Do you really see modern life as all made up of hell?" Of course not. But if one is illustrating hell one usually uses the properties of hell. I've never thought that problems were so simple politically that they could be tackled directly in art works, not by me anyway, although in my personal life I do take stands on atrocities of all kinds. But every day, by doing consistently what you do with the attitude you have, if you have strong feelings,

these things are expressed over a period of time as opposed to, say, one *Guernica*. That's just a different attitude. . . . When you just illustrate your feeling about something self-consciously—that is for me almost a commercial attitude. If you feel strongly it's going to show. That's the only way the political scene can come into my work—and I believe it's there. Consistently there has been an attempt to use the very last minute in my life and the particular location as a source of energy and inspiration rather than retiring into some other time or dream or idealism. I think that cultivated protest is just as dream-like as idealism.

CLAES OLDENBURG

[FROM Claes Oldenburg, *Environments Situations Spaces,* catalogue of an exhibition at the Martha Jackson Gallery, New York, 1961.]

I am for an art that takes its form from the lines of life, that twists and extends impossibly and accumulates and spits and drips, and is sweet and stupid as life itself. I am for an artist who vanishes, turning up in a white cap, painting signs or hallways.

I am for an art that comes out of a chimney like black hair and scatters in the sky. I am for an art that spills out of an old man's purse when he is bounced off a passing fender. I am for the art out [of] a doggy's mouth, falling five floors from the roof. I am for the art that a kid licks, after peeling away the wrapper. I am for an art that is smoked, like a cigarette, smells, like a pair of shoes. I am for art that flaps like a flag, or helps blow noses, like a handkerchief. I am for art that is put on and taken off, like pants, which develops holes, like socks, which is eaten, like a piece of pie. . . .

I am for art you can sit on. . . . I am for art that is flipped on and off with a switch. I am for art that unfolds like a map, that you can squeeze, like you your sweety's arm, or kiss, like a pet dog. Which expands and squeaks, like an accordion, which you can spill your dinner on, like an old tablecloth. I am for an art you can hammer with, stitch with, sew with, paste with, file with. I am for an art that tells you the time of day and which helps old ladies across the street.

I am for the art of red and white gasoline pumps and blinking bis-

cuit signs. I am for the art of old plaster and new enamel. I am for the art of slag and black coal and dead birds. I am for the art of scratchings 'in the asphalt. I am for the art of bending and kicking things and breaking them and by pulling on them making them fall down. I am for the art of sat-on bananas.

I am for the art of underwear and the art of taxicabs. I am for the art of ice cream cones dropped on concrete. I am for the blinking arts, lighting up the night. I am for falling, splashing, wiggling, jumping, going on and off. I am for the art of fat truck-tires and black eyes. I am for Kool Art, 7-Up Art, Pepsi Art, Sunkist Art, Dro-bomp Art, Vam Art, Pamryl Art, San-O-Med Art, 39 cents Art and 9.99 Art.

I am for the white art of refrigerators and their muscular openings and closings. . . . I am for the art of decapitated teddy bears, exploded umbrellas, chairs with their brown bones broken, burning Xmas trees, firecracker ends, pigeon bones, and boxes with men sleeping in them. I am for the art of hung, bloody rabbits and wrinkly chickens, tambourines and plastic phonographs, and abandoned boxes tied like pharaohs.

ROY LICHTENSTEIN

[FROM "What Is Pop Art?" an interview by G. Swenson with Roy Lichtenstein, *Art News*, November, 1963.]

SWENSON: What is Pop art?

LICHTENSTEIN: I don't know—the use of commerical art as subject matter in painting, I suppose. It was hard to get a painting that was despicable enough so that no one would hang it—everybody was hanging everything. It was almost acceptable to hang a dripping paint rag, everyone was accustomed to this. The one thing everyone hated was commerical art; apparently they didn't hate that enough either. . . .

SWENSON: Are you anti-experimental?

LICHTENSTEIN: I think so, and anti-contemplative, anti-nuance, anti-getting-away-from-the-tyranny-of-the-rectangle, anti-movement-and-light, anti-mystery, anti-paint-quality, anti-Zen, and anti all of those

brilliant ideas of preceding movements which everyone understands so thoroughly.

We like to think of industrialization as being despicable. I don't really know what to make of it. There's something terribly brittle about it. I suppose I would still prefer to sit under a tree with a picnic basket rather than under a gas pump, but signs and comic strips are interesting as subject matter. There are certain things that are usable, forceful and vital about commercial art. We're using those things—but we're not really advocating stupidity, international teenagerism and terrorism.

[FROM "Talking with Roy Lichtenstein," an interview by John Coplans, *Artforum,* May, 1967.]

COPLANS: What about the various common objects you painted, for example, the ball of twine, etc.?

LICHTENSTEIN: I think that in these objects, the golf ball, the frankfurter, and so on, there is an anti-Cubist composition. You pick an object and put it on a blank ground. I was interested in non-Cubist composition. The idea is contrary to the major direction of art since the early Renaissance which has more and more symbolized the integration of "figure with ground."

COPLANS: What led you to the landscapes which, incidentally, seem to be very optical?

LICHTENSTEIN: Well, partly it was a play on Optical Art. But optical materials might be used in commercial art, or in display, you use an optical material to make a sky, because the sky has no actual position—it's best represented by optical effects.

COPLANS: And the sunsets?

LICHTENSTEIN: Well, there is something humorous about doing a sunset in a solidified way, especially the rays, because a sunset has little or no specific form. It is like the explosions. It's true that they may have some kind of form at any particular moment but they are never really perceived as defined shape. Cartoonists have developed explosions into specific forms. That's why I also like to do them in three-dimensions and in enamels on steel. It makes something ephemeral completely concrete.

COPLANS: Where did you get the image for the engagement ring?

LICHTENSTEIN: It was actually a box in a comic book. It looked like an explosion.

COPLANS: Did you find or invent the brush stroke image?

LICHTENSTEIN: Although I had played with the idea before, it started with a comic book image of a mad artist crossing out, with a large brush stroke "X," the face of a fiend that was haunting him. I did a painting of this. The painting included the brush stroke "X," the brush, and the artist's hand. Then I went on to do paintings of brush strokes alone. I was very interested in characterizing or caricaturing a brush stroke. The very nature of a brush stroke is anathema to outlining and filling in as used in cartoons. So I developed a form for it, which is what I am trying to do in the explosions, airplanes, and people—that is, to get a standardized thing—a stamp or image. The brush stroke was particularly difficult. I got the idea very early because of the Mondrian and Picasso paintings, which inevitably led to the idea of a de Kooning. The brush strokes obviously refer to Abstract Expressionism. . . .

COPLANS: How much difference is there in the drawing, placement, etc., between the real Picasso and yours?

LICHTENSTEIN: Quite a bit. Usually I just simplify the whole thing in color as well as in shape. Anything slightly red becomes red, anything slightly yellow becomes yellow, and the shapes become simplified, although in some paintings Picasso simplified to a greater extent than I often do. I don't think simplification is good or bad—it is just what I want to do just now. Picasso made the *Femme d'Algiers* from Delacroix's painting and then I did my painting from his.

COPLANS: Why didn't you ever do a Léger?

LICHTENSTEIN: It's funny, Léger is someone I didn't understand. I used to think he was just doing clichés. Later I understood the sensibility. I realized that he did it for reasons that have to do with industrialization, and "hardness." Recently I have been tempted to do a Léger; it's something I may yet do. I like the idea. He really isn't someone I think I am like yet everyone else thinks I am like him. I can see a superficial relationship, for obviously there is the same kind of simplification and the same kind of industrial overtones and clichés. My work relates to Léger's but I admire Picasso more than I do Léger.

ANDY WARHOL

[FROM "What Is Pop Art?" an interview by G. Swenson with Andy Warhol, *Art News,* November, 1963.]

WARHOL: Someone said that Brecht wanted everybody to think alike. I want everybody to think alike. But Brecht wanted to do it through Communism, in a way. Russia is doing it under government. It's happening here all by itself without being under a strict government; so if it's working without trying, why can't it work without being Communist? Everybody looks alike and acts alike, and we're getting more and more that way.

I think everybody should be a machine.

I think everybody should like everybody.

SWENSON: Is that what Pop Art is all about?

WARHOL: Yes. It's liking things.

SWENSON: And liking things is like being a machine?

WARHOL: Yes, because you do the same thing every time. You do it over and over again.

SWENSON: And you approve of that?

WARHOL: Yes, because it's all fantasy. It's hard to be creative and it's also hard not to think what you do is creative or hard not to be called creative because everybody is always talking about that and individuality. Everybody's always being creative. And it's so funny when you say things aren't, like the shoe I would draw for an advertisement was called a "creation" but the drawing of it was not. But I guess I believe in both ways. All these people who aren't very good should be really good. Everybody is too good now, really. Like, how many actors are there? There are millions of actors. They're all pretty good. And how many painters are there? Millions of painters and all pretty good. How can you say one style is better than another? You ought to be able to be an Abstract-Expressionist next week, or a Pop artist, or a realist, without feeling you've given up something. I think the artists who aren't very good should become like everybody else so that people would like things that aren't very good. It's already happening. All you have to do is read the magazines and the catalogues. It's this style or that style, this or that image of man—but that really doesn't make any difference. Some artists get left out that way, and why should they?

SWENSON: Is Pop Art a fad?

WARHOL: Yes, it's a fad, but I don't see what difference it makes. I just heard a rumor that G. quit working, that she's given up art altogether. And everyone is saying how awful it is that A. gave up his style and is doing it in a different way. I don't think so at all. If an artist can't do any more, then he should just quit; and an artist ought to be able to change his style without feeling bad. I heard that Lichtenstein said he might not be painting comic strips a year or two from now—I think that would be so great, to be able to change styles. And I think that's what's going to happen, that's going to be the whole new scene. That's probably one reason I'm using silk screens now. I think somebody should be able to do all my paintings for me. I haven't been able to make every image clear and simple and the same as the first one. I think it would be so great if more people took up silk screens so that no one would know whether my picture was mine or somebody else's.

SWENSON: It would turn art history upside down?

WARHOL: Yes.

SWENSON: Is that your aim?

WARHOL: No. The reason I'm painting this way is that I want to be a machine, and I feel that whatever I do and do machine-like is what I want to do. . . .

SWENSON: When did you start with the "Death" series?

WARHOL: I guess it was the big plane crash picture, the front page of a newspaper: 129 DIE. I was also painting the Marilyns. I realized that everything I was doing must have been Death. It was Christmas or Labor Day—a holiday—and every time you turned on the radio they said something like, "4 million are going to die." That started it. But when you see a gruesome picture over and over again, it doesn't really have any effect.

JAMES ROSENQUIST

• Originally a sign painter of giant billboards, James Rosenquist coupled unlikely images from contemporary sources, enlarging them to the mythic dimensions of the movie screen or the highway billboard.

Clement Greenberg

[FROM "What Is Pop Art?" an interview by G. Swenson with James Rosenquist, *Art News,* February, 1964.]

I'm amazed and excited and fascinated about the way things are thrust at us, the way this invisible screen that's a couple of feet in front of our mind and our senses is attacked by radio and television and visual communications, through things larger than life, the impact of things thrown at us, at such a speed and with such a force that painting and the attitudes toward painting and communication through doing a painting now seem very old-fashioned. . . .

I think we have a free society, and the action that goes on in this free society allows encroachments, as a commercial society. So I geared myself, like an advertiser or a large company, to this visual inflation —in commercial advertising, which is one of the foundations of our society. I'm living in it, and it has such impact and excitement in its means of imagery. Painting is probably more exciting than advertising —so why shouldn't it be done with that power and gusto, with that impact? I see very few paintings with the impact I've felt, that I feel and try to do in my work. . . . My metaphor, if that is what you can call it, is my relations to the power of commercial advertising, which is in turn related to our free society, the visual inflation which accompanies the money that produces box tops and space cadets. . . .

When I use a combination of fragments of things, the fragments or objects or real things are caustic to one another, and the title is also caustic to the fragments. . . . The images are expendable, and the images are in the painting and therefore the painting is also expendable. I only hope for a colorful shoe-horn to get the person off, to turn him on to his own feelings.

CLEMENT GREENBERG

• Organized by Clement Greenberg in 1963 for the Los Angeles County Museum, the exhibition "Post-Painterly Abstraction" included thirty-one artists. Among them were Helen Frankenthaler, Kenneth Noland, Morris Louis, Ray Parker, Jules Olitski, Sam Francis, Ellsworth Kelly, Paul Feeley, John Ferren, Frank Stella, and Nicolas Krushenick. Mr. Greenberg's cata-

logue essay, excerpted below, gave his reasons for feeling that a reaction against the painterly aspects of Abstract Expressionism had set in.

[FROM *Post-Painterly Abstraction,* catalogue of an exhibition at the Los Angeles County Museum, 1964.]

The great Swiss art historian, Heinrich Woelfflin, used the German word, *malerisch,* which his English translators render as "painterly," to designate the formal qualities of Baroque art that separate it from High Renaissance or Classical art. Painterly means, among other things, the blurred, broken, loose definition of color and contour. The opposite of painterly is clear, unbroken, and sharp definition, which Woelfflin called "linear." The dividing line between the painterly and the linear is by no means a hard and fast one. There are many artists whose work combines elements of both, and painterly handling can go with linear design, and vice versa. This still does not diminish the usefulness of these terms or categories. With their help—and keeping in mind that they have nothing to do with value judgments—we are able to notice all sorts of continuities and significant differences, in the art of the present as well as of the past, that we might not notice otherwise.

The kind of painting that has become known as Abstract Expressionism is both abstract and painterly. Twenty years ago this proved a rather unexpected combination. Abstract art itself may have been born amid the painterliness of Analytical Cubism, Léger, Delaunay, and Kandinsky thirty years earlier, but there are all kinds of painterliness, and even Kandinsky's seemed restrained by comparison with Hofmann's and Pollock's. The painterly beginnings of abstract and near-abstract art would appear, anyhow, to have been somewhat forgotten, and during the 1920's and 1930's abstract art had become almost wholly identified with the flat silhouettes and firm contours of Synthetic Cubism, Mondrian, the Bauhaus, and Miró. (Klee's art was an exception, but the smallness of his works made their painterly handling relatively unobtrusive; one became really aware of Klee's painterliness only when it was "blown up" later on by artists like Wols, Tobey, and Dubuffet.) Thus the notion of abstract art as some-

thing neatly drawn and smoothly painted, something with clean out-lines and flat, clear colors, had become pretty well ingrained. To see this all disappear under a flurry of strokes, blotches, and trickles of paint was a bewildering experience at first. It looked as though all form, all order, all discipline, had been cast off. Some of the labels that became attached to Abstract Expressionism, like the *"informel"* and "Action Painting," definitely implied this; one was given to under-stand that what was involved was an utterly new kind of art that was no longer art in any accepted sense.

This was, of course, absurd. What was mostly involved was the dis-concerting effect produced by wide-open painterliness in an abstract context. That context still derived from Cubism—as does the context of every variety of sophisticated abstract art since Cubism, despite all appearances to the contrary. The painterliness itself derived from the tradition of form going back to the Venetians. Abstract Expressionism —or Painterly Abstraction, as I prefer to call it—was very much art, and rooted in the past of art. People should have recognized this the moment they began to be able to recognize differences of *quality* in Abstract Expressionism. . . .

Abstract Expressionism was, and is, a certain style of art, and like other styles of art, having had its ups, it had its downs. Having pro-duced art of major importance, it turned into a school, then into a manner, and finally into a set of mannerisms. Its leaders attracted imitators, many of them, and then some of these leaders took to imi-tating themselves. Painterly Abstraction became a fashion, and now it has fallen out of fashion, to be replaced by another fashion—Pop Art— but also to be continued, as well as replaced, by something as genuinely new and independent as Painterly Abstraction itself was ten or twenty years ago.

The most conspicuous of the mannerisms into which Painterly Ab-straction has degenerated is what I call the "Tenth Street touch" (after East Tenth Street in New York), which spread through abstract paint-ing like a blight during the 1950's. The stroke left by a loaded brush or knife frays out, when the stroke is long enough, into streaks, ripples, and specks of paint. These create variations of light and dark by means of which juxtaposed strokes can be graded into one another without abrupt contrasts. (This was an automatic solution for one of the cru-cial technical problems of abstract painting: that of asserting the con-

tinuity of the picture plane when working more or less "in the flat"—
and it's one of the reasons why the "Tenth Street touch" caught on
the way it did.) Out of these close-knit variations or gradations of light
and dark, the typical Abstract Expressionist picture came to be built,
with its density of accents and its packed, agitated look.

In all this there was nothing bad in itself, nothing necessarily bad as
art. What turned this constellation of stylistic features into something
bad as art was its standardization, its reduction to a set of mannerisms,
as a dozen, and then a thousand, artists proceeded to maul the same
viscosities of paint, in more or less the same ranges of color, and with
the same "gestures," into the same kind of picture. And that part of
the reaction against Painterly Abstraction which this show tries to
document is a reaction more against an attitude than against Painterly
Abstraction as such.

As far as style is concerned, the reaction presented here is largely
against the mannered drawing and the mannered design of Painterly
Abstraction, but above all against the last. By contrast with the inter-
weaving of light and dark gradations in the typical Abstract Ex-
pressionist picture, all the artists in this show move towards a physical
openness of design, or towards linear clarity, or towards both. They
continue, in this respect, a tendency that began well inside Painterly
Abstraction itself, in the work of artists like Still, Newman, Rothko,
Motherwell, Gottlieb, Mathieu, the 1950–1954 Kline, and even Pollock.
A good part of the reaction against Abstract Expressionism is, as I've
already suggested, a continuation of it. There is no question, in any
case, of repudiating its best achievements. . . .

Some of the artists in this exhibition look "hard-edged," but this by
itself does not account for their inclusion. They are included because
they have won their "hardness" from the "softness" of Painterly Ab-
straction; they have not inherited it from Mondrian, the Bauhaus,
Suprematism, or anything else that came before.

Another thing the artists in this show, with two or three exceptions,
have in common is the high keying as well as lucidity of their color.
They have a tendency, many of them, to stress contrasts of pure hue,
rather than contrasts of light and dark. For the sake of these, as well
as in the interests of optical clarity, they shun thick paint and tactile

effects. Some of them dilute their paint to an extreme and soak it into unsized and unprimed canvas (following Pollock's lead in his black and white paintings of 1951). In their reaction against the "hand-writing" and "gestures" of Painterly Abstraction, these artists also favor a relatively anonymous execution. This is perhaps the most important motive behind the geometrical regularity of drawing in most of the pictures in this show. It certainly has nothing to do with doctrine, with geometrical form for its own sake. These artists prefer trued and faired edges simply because these call less attention to themselves as drawing—and by doing that they also get out of the way of color.

HELEN FRANKENTHALER

• The first to develop Jackson Pollock's method of painting directly on raw canvas, Helen Frankenthaler describes her working process in the excerpt that follows.

[FROM an interview by Henry Geldzahler with Helen Frankenthaler, *Artforum*, October, 1965.]

I think there is something now I am still working out in paint; it is a struggle for me to both discard and retain what is gestural and personal, "signature." I have been trying, and the process began without my knowing it, to stop relying on gesture, but it is a struggle. "Gesture" must appear out of a necessity, not a habit. I don't start with a color order, but find the color as I go.

I'd rather risk an ugly surprise than rely on things I know I can do. The whole business of spotting; the small areas of color in the big canvas; how edges meet; how accidents are controlled—all this fascinates me, though it is often where I am most facile and most seducible by my own talent. . . .

When a picture needs blank canvas to breathe a certain way I leave it. If you look at my pictures over the years, the first breakthrough in leaving blank canvas left a lot of it "blank"; progressively it was covered up, until now my best pictures are sometimes totally covered.

After Abstract Expressionism

When I order stretchers for pictures with unsized canvas, nine out of ten times I cut off the blank areas because the picture doesn't need them. This is an aspect of giving up one's mark. The unsized area doesn't have to do the work. That doesn't mean I couldn't—don't—do pictures that need unsized areas. Often what I seem to fight is the idea that I'm onto something and going to drive it into the ground. I tend to side-develop—that's the way I really show my mark and continuity.

ROBERT ROSENBLUM

• An authority on Romantic art, historian Robert Rosenblum was among the first to recognize the quality of Louis's paintings and their relationship to Mark Rothko's and Barnett Newman's fields of color.

[FROM *Toward a New Abstraction,* catalogue of an exhibition at The Jewish Museum, New York, 1963.]

Morris Louis's best paintings, like those of Matisse, tend to silence their commentator. The directness of their optical assault at first stuns the intellect and permits only a tonic exhilaration of the senses. . . .

The direction he chose to explore rejected the labyrinthine spatial complexities of de Kooning and Pollock as well as the palpability of their paint surfaces. Rather than overlays of frothing brushwork or tangled skeins of pigment, Louis's paint seems to be saturated into the very fabric of his unsized canvases. With this, he began to achieve a luminosity allied to the radiant color stains of Rothko, Newman, and Frankenthaler.

Like so many modern masters, Louis followed impulses toward a rigorous pictorial economy, a pruning of non-essentials that dares all to win all. In his last years, the exquisite hothouse atmosphere of the early paintings, with their thinly spreading veils of color, is distilled to taut rainbow sequences that are no more adequately described as stripes than are the glowing horizontal articulations between Rothko's fields of color or the vibrant vertical divisions that cleave Newman's expansive spaces. Without drawn contours, these straight paths of

color sing across the open plane of the canvas. At times, their parallel edges overlap (a glowing yellow over a burning vermillion), an effect that enriches further the atmospheric density generated; elsewhere, they run exactly contiguous courses, like two bullets speeding together through space without colliding. Indeed, the velocity of these paintings can be breathtaking. In the upright verticals, these streaks of color speed toward, but seldom attain, the lower edge of the canvas, as if we were just catching a patch of movement that will continue; and in those aligned diagonally, we likewise seize the fragment of a trajectory that implies swift energies beyond the lateral edges of the canvas. The dazzling rightness of these final works makes Louis's untimely death in 1962 all the greater a loss for abstract painting today.

ALAN R. SOLOMON

• The late Alan Solomon, who was among the few critics of the period to appreciate pop art and sixties abstraction, organized many influential exhibitions of both while he was director of the Jewish Museum. In his discussion of Kenneth Noland's stained paintings, Solomon examined Noland's preoccupation with centered images and subtle but clear colors and edges.

[FROM *Toward A New Abstraction,* catalogue of an exhibition at The Jewish Museum, New York, 1963.]

The target became a starting point for Kenneth Noland . . . because it is a kind of ultimate image, the final possibility of focus, and yet with limitless possibilities of diffusion.

Concentricity implies focus on the center, on the bull's-eye, and the contrasts in a target zero in on the spot at the center which is as precisely determined and emphatically stressed as anything imaginable in the whole range of visual experience. At the same time, the flatness of the target and its repetitions and alternations of color and value resolve themselves statically and finitely at the bull's-eye. On the other hand, the stone thrown into the water sets up centrifugal forces which constantly destroy themselves at the center and radiate their energy to

the perimeter, which is never fixed and constantly renews its edge. Against the concentric severity, against the monotony and centripetal idiocy of the target, stand the infinite possibilities of elaboration of the device, of expansion outward, of dynamic buoyancy, of richness and complexity.

The circle motifs, then, provide an absolute, rigidly disciplined scheme which emphasizes all the more the spirit of free inventive play which underlies their manipulation, so that Noland's solutions, from painting to painting, are always surprising and fresh. At the same time, each painting implies a struggle against easy resolution of the tonal, textural and spatial situation; this in part explains the ability of the image to renew itself constantly in his work. He plainly uses the targets, as well as the unrelenting lozenges and the most recent chevrons, because these devices prevent the intrusion of design considerations which might lead to artfulness on the one hand or figurative associations on the other.

Noland's paintings do not give up their secrets easily. Their spareness and blandness mask their true voluptuosity, and they often depend on ambiguities which enforce a deliberative contemplation more exacting than the simplicity of the forms would seem to require. The tightest and most rigorous of his images are often virtually incapable of visual and psychological resolution. Their ambivalence must be regarded not as resistance to the encounter with the beholder, but as an affirmation of complexity and enrichment as a mode of experience as well as of art. Noland's paintings become for him, then, a statement of his positive feelings about experience and about life, and about art as a vehicle for these feelings. His absorption in edges, which may be feathery and indeterminate, despite their circular reference, or crisp and positive, but never hard; the spatial complexity and planimetric sonority generated by his color, which may be opaque or stained into the canvas; the hypnotic precision of concentration or the echoing resonance toward the limits of the field; the ponderosities or the soaring effects; the sobriety or the lyricism—all these embrace the whole range of paradoxical richness.

ELLSWORTH KELLY

• Although Ellsworth Kelly is honored as the foremost hard-edge painter, he disclaims any special interest in edges, calling attention instead to his preoccupation with color as mass and form.

———————

[FROM an interview by Henry Geldzahler with Ellsworth Kelly, *Art International,* VIII, No. 1 (February, 1964).]

. . . I don't like most Hard Edge paintings. I'm not interested in edges. I'm interested in the mass and color, the black and white. The edges happen because the forms get as quiet as they can be. I want the masses to perform. When I work with forms and colors, I get the edge. In a [John] Chamberlain, the edges of the forms are hard but you don't think about the edges. In my work, it is impossible to separate the edges from the mass and color.

I like to work from things that I see whether they're man-made or natural or a combination of the two. Once in a while I work directly from something I've seen, like a window, or a fragment of a piece of architecture, or someone's legs; or sometimes the space between things, or just how the shadows of an object would look. The things I'm interested in have always been there. The idea of the shadow of a natural object that has existed, like the shadow and the separation of the rock and the shadow; I'm not interested in the texture of the rock, or that it is a rock, but in the mass of it, and its shadow.

JULES OLITSKI

• The following statement by Jules Olitski illustrates the degree to which the sixties' abstractionists were equally absorbed by the problems of color and those of structure.

———————

[FROM *Catalogue of the International Biennial Exhibition of Art,* Venice, 1966.]

After Abstract Expressionism

Painting is made from inside out. I think of painting as possessed by a structure—i.e. shape and size, support and edge—but a structure born of the flow of color feeling. Color *in* color is felt at any and every place of the pictorial organization; in its immediacy—its particularity. Color is felt throughout.

What is of importance in painting is paint. Paint can be color. Paint becomes painting when color establishes surface. Where edge exists within the structure, it must be felt as an integral and necessary outcome of the color structure. Outer edge cannot be thought of as being in some way within—it is the outermost extension of the color structure. The decision as to *where* the outer edge is, is final, not initial. The focus in recent painting has been on the lateral—a flat and frontal view of the surface. This has tended toward the use of flat color areas bounded, inevitably, by edges. Edge is drawing and drawing is *on* the surface. The color areas take on the appearance of overlay, and if the conception of form is governed by edge—no matter how successfully it possesses the surface—paint, even when stained into raw canvas remains on or above the surface. I think, on the contrary, of color as being seen *in*, not *on*, the surface.

JOSEF ALBERS

• The theoretical work and experiments in color contrast of Josef Albers, one of the outstanding abstract painters of the century, have provided the basis for much of the research in optical art. In addition, his simple geometric compositions and use of high-intensity color must be considered as part of the context in which the "new abstraction" was developed.

———————

[FROM Kynaston L. McShine, *Homage to the Square* (New York: Museum of Modern Art, 1964).]

The colors in my paintings are juxtaposed for various and changing effects. They are to challenge or to echo each other, to support or oppose one another. The contrasts, respectively boundaries, between them may vary from soft to hard touches, may mean pull and push besides clashes, but also embracing, intersecting, penetrating.

Despite an even and mostly opaque application, the colors will appear above or below each other, in front or behind, or side by side on the same level. They correspond in concord as well as in discord, which happens between both, groups and singles.

Such action, reaction, interaction—or interdependence—is sought in order to make obvious how colors influence and change each other: that the same color, for instance—with different grounds or neighbors —looks different. But also, that different colors can be made to look alike. It is to show that 3 colors can be read as 4, and similarly as 2, and also 4 as 2.

Such color deceptions prove that we see colors almost never related to each other and therefore unchanged; that color is changing continually: with changing light, with changing shape and placement, and with quantity which denotes either amount (a real extension) or number (recurrence). And just as influential are changes in perception depending on changes of mood, and consequently of receptiveness.

All this will make [one] aware of an exciting discrepancy between physical fact and psychic effect of color.

But besides relatedness and influence I should like to see that my colors remain, as much as possible, a "face"—their own "face," as it was achieved—uniquely—and I believe consciously—in Pompeian wall paintings—by admitting coexistence of such polarities as being dependent and independent—being dividual and individual.

Often, with paintings, more attention is drawn to the outer, physical, structure of the color means than to the inner, functional, structure of the color action as described above. Here now follow a few details of the technical manipulation of the colorants which in my painting usually are oil paints and only rarely casein paints.

Compared with the use of paint in most painting today, here the technique is kept unusually simple, or more precisely, as uncomplicated as possible.

[FROM "Josef Albers" in Katharine Kuh, *The Artist's Voice* (New York: Harper & Row, 1960). Copyright © 1960, 1961, 1962 by Katharine Kuh. Reprinted by permission of Harper & Row, Publishers, Inc.]

I think art parallels life; it is not a report on nature or an intimate disclosure of inner secrets. Color, in my opinion, behaves like man—in two distinct ways: first in self-realization and then in the realization of relationships with others. In my paintings I have tried to make two polarities meet—independence and interdependence, as for instance, in Pompeian art. There's a certain red the Pompeians used that speaks in both these ways, first in its relation to other colors around it, and then as it appears alone, keeping its own face. In other words, one must combine both being an individual and being a member of society. That's the parallel. I've handled color as man should behave. With trained and sensitive eyes, you can recognize this double behavior of color. And for all this, you may conclude that I consider ethics and aesthetics as one.

QUESTION: When your colors vibrate, are you trying to suggest movement?

ALBERS: I don't accept your term "vibrate," because in my understanding, vibration of color happens only rarely. What I'm after, in a broader term, is interaction. If I can refer again to the parallel with life, the job is to make the unbearable, bearable, or to make that which doesn't behave, behave. This means a different organization of conditions for every color and every situation. A color can be placed among other colors so that it loses its identity. Red looks green or looks like a gas—dematerialized. Gray can look black, depending on what surrounds it. This I call "acting color." I work with the same painting, the same colors over and over—innumerable times. As a rule, I use either three or four colors in a painting. Merely by changing one color, a totally different climate is produced, though all the other colors in the work remain identical in area and hue. With two separate colors in no way overlapping, three are produced through interaction. Each borrows from and gives to the other. Where they meet, where they intersect, a new color results. In science, one plus one is two, but in art it can be three. Often I have to paint ten different times before I reach a realization. I usually start with a very small sketch; then comes painting after painting until I realize what I'm after. What I want is to play staccato and legato—and all the other musical terms, but not for the purpose of expressing myself.

QUESTION: If you're not expressing yourself, what are you doing?

ALBERS: I'm pleasing myself and educating others to see. If these

paintings are me, this is an unavoidable result—not calculated. What I'm calculating is the interaction of color. . . . In my paintings, line doesn't amount to much, but in my linear constructions I use line for the purpose of interaction. According to most color systems, harmony depends on the constellation of colors with a system. I go further in saying that, first, harmony is not the main aim of color. Disharmony is just as important in color as in music. And second, I say that every color goes with every other color if the quantities are right. This, of course, leads to a new seeing of color.

SIDNEY TILLIM

• In a review of *The Responsive Eye* exhibition at the Museum of Modern Art, which introduced optical art, Sidney Tillim clarified the relationship of "optical art" to the European tradition of geometric art and to American post-painterly abstraction.

––––––––

[FROM "Optical Art: Pending or Ending?" *Arts Magazine,* XXXIX (January, 1965).]

The general tendency of Post-Abstract Expressionist art in the United States, exclusive of the painterly Neo-Dadaists Rauschenberg and Johns and the assemblage school, has been toward hard-edged forms, a corresponding simplicity of structure and a greater emphasis on color. These "hard" qualities are present not only in abstractionist art but in Pop art and some realism as well, though far less self-evidently. And while it now seems that Ellsworth Kelly has failed to move very far off the bridge he represents between hard-edge art and a convincingly Post-Abstract Expressionism abstraction, Louis and Noland, staining liquid bars of color across huge canvases, and, in an even less painterly idiom, Stella, with his shaped canvases have extended the "new" American painting into the sixties. . . .

European abstractionist art, on the other hand, has not had, at least until now, an equivalent "hard-edge" reaction of such clarity partly because that need has been partially filled by the greater tolerance

on the Continent for traditional geometric art, partly because painterly abstraction never achieved the violence and the pervasive influence there that it achieved here and consequently did not require as clean-cut a reaction, and, finally, partly because of the persistence of doctrinaire habits implied in the first two reasons. . . .

To the extent that it is optical at all, the American style is far more color-oriented than percept-oriented—which implies structual differences as well. American-type "opticality" is conscious of a field which expands rather than contracts from the deposition of dry waves, lines and spots of translucent hues. A distinguishing feature of the paintings by Noland, Louis, and Poons is that traditional dark-and-light contrasts have been exchanged for the contrasts of hues which are usually of equal value and intensity. Thus the entire field becomes a chiaroscuro-less "positive" form, "bulked space" as it were, rather than space that has been carved into traditional, structured figure-ground relationships.

FRANK STELLA AND DON JUDD

• Critic Sidney Tillim was the first to single out Frank Stella and Don Judd as the leading figures of a "new avant-garde." Reacting against the metaphysical *angst* of Abstract Expressionism, they produced an apodictic, impersonal abstraction that remained, nonetheless, derived from Abstract Expressionism rather than from European geometric art, as the interview with the initiators of "minimal art" illustrates.

[FROM Bruce Glaser, "Questions to Stella and Judd," *Art News,* September, 1966.]

STELLA: The European geometric painters really strive for what I call relational painting. The basis of their whole idea is balance. You do something in one corner and you balance it with something in the other corner. Now the "new painting" is being characterized as symmetrical. Ken Noland has put things in the center and I'll use a symmetrical pattern, but we use symmetry in a different way. It's non-relational. In the newer American painting we strive to get the thing in

the middle, and symmetrical, but just to get a kind of force, just to get the thing on the canvas. The balance factor isn't important. We're not trying to jockey everything around.

GLASER: What is the "thing" you're getting on the canvas?

STELLA: I guess you'd have to describe it as the image, either the image or the scheme. Ken Noland would use concentric circles; he'd want to get them in the middle because it's the easiest way to get them there, and he wants them there in the front, on the surface of the canvas. If you're that much involved with the surface of anything you're bound to find symmetry the most natural means. As soon as you use any kind of relational placement for symmetry, you get into a terrible kind of fussiness which is the one thing that most of the painters now want to avoid. When you're always making these delicate balances, it seems to present too many problems; it becomes sort of arch.

GLASER: An artist who works in your vein has said he finds symmetry extraordinarily sensuous; on the other hand, I've heard the comment that symmetry is very austere. Are you trying to create a sensuous or an austere effect? Is this relevant to your surfaces?

JUDD: No, I don't think my work is either one. I'm interested in spareness, but I don't think it has any connection to symmetry. . . . I don't have any ideas as to symmetry. My things are symmetrical because, as you said, I wanted to get rid of any compositional effects, and the obvious way to do it is to be symmetrical.

GLASER: Why do you want to avoid compositional effects?

JUDD: Well, those effects tend to carry with them all the structures, values, feelings of the whole European tradition. It suits me fine if that's all down the drain. When Vasarely has optical effects within the squares, they're never enough, and he has to have at least three or four squares, slanted, tilted inside each other, and all arranged. That is about five times more composition and juggling than he needs.

———

GLASER: You've written about the predominance of chance in Robert Morris' work. Is this element in your pieces too?

JUDD: Yes. Pollock and those people represent actual chance; by now it's better to make that a foregone conclusion—you don't have to mimic

chance. You use a simple form that doesn't look like either order or disorder. We recognize that the world is ninety per cent chance and accident. Earlier painting was saying that there's more order in the scheme of things than we admit now, like Poussin saying order under- lies nature. Poussin's order is anthropomorphic. Now there are no preconceived notions. Take a simple form—say a box—and it does have an order, but it's not so ordered that that's the dominant quality. The more parts a thing has, the more important order becomes, and finally order becomes more important than anything else.

STELLA: The artist's tools or the traditional artist's brush and maybe even oil paint are all disappearing very quickly. We use mostly com- mercial paint, and we generally tend toward larger brushes. In a way, Abstract-Expressionism started all this. De Kooning used house painter's brushes and house painter's techniques.

GLASER: Pollock used commercial paint.

STELLA: Yes, the aluminum paint. What happened, at least for me, is that when I first started painting I would see Pollock, de Kooning, and the one thing they all had that I didn't have was an art school background. They were brought up on drawing and they all ended up painting or drawing with the brush. They got away from the smaller brushes and, in an attempt to free themselves, they got involved in commercial paint and house-painting brushes. Still it was basically drawing with paint, which has characterized almost all twentieth-cen- tury painting. The way my painting was going, drawing was less and less necessary. It was the one thing I wasn't going to do. I wasn't going to draw with the brush.

GLASER: What induced this conclusion that drawing wasn't necessary any more?

STELLA: Well, you have a brush and you've got paint on the brush, and you ask yourself why you're doing whatever it is you're doing, what inflection you're actually going to make with the brush and with the paint that's on the end of the brush. It's like handwriting. And I found out that I just didn't have anything to say in those terms. I didn't want to make variations; I didn't want to record a path. I wanted to get the paint out of the can and onto the canvas. I knew a wise guy who used to make fun of my painting, but he didn't like

the Abstract-Expressionists either. He said they would be good painters if they could only keep the paint as good as it is in the can. And that's what I tried to do. I tried to keep the paint as good as it was in the can.

GLASER: Are you implying that you are trying to destroy painting?

STELLA: It's just that you can't go back. It's not a question of destroying anything. If something's used up, something's done, something's over with, what's the point of getting involved with it?

GLASER: Are you suggesting that there are no more solutions to, or no more problems that exist in painting?

STELLA: I always get into arguments with people who want to retain the old values in painting—the humanistic values that they always find on the canvas. My painting is based on the fact that only what can be seen there *is* there. It really is an object. Any painting is an object and anyone who gets involved enough in this finally has to face up to the objectness of whatever it is that he's doing. He is making a thing. All that should be taken for granted. If the painting were lean enough, accurate enough or right enough, you would just be able to look at it. All I want anyone to get out of my paintings, and all I ever get out of them, is the fact that you can see the whole idea without any confusion. . . . What you see is what you see.

GLASER: But some would claim that the visual effect is minimal, that you're just giving us one color or a symmetrical grouping of lines. A nineteenth-century landscape painting would presumably offer more pleasure, simply because it's more complicated.

JUDD: I don't think it's more complicated.

STELLA: No, because what you're saying essentially is that a nineteenth-century landscape is more complicated because there are two things working—deep space and the way it's painted. You can see how it's done and read the figures in the space. Then take Ken Noland's painting, for example, which is just a few stains on the ground. If you want to look at the depths, there are just as many problematic spaces. And some of them are extremely complicated technically; you can worry and wonder how he painted the way he did.

JUDD: Old master painting has a great reputation for being profound, universal and all that, and it isn't, necessarily.

STELLA: But I don't know how to get around the part that they just wanted to make something pleasurable to look at, because even if that's what I want, I also want my painting to be so you can't *avoid* the fact that it's supposed to be entirely visual.

GLASER: You've been quoted, Frank, as saying that you want to get sentimentality out of painting.

STELLA: I hope I didn't say that. I think what I said is that sentiment wasn't necessary. I didn't think then, and I don't now, that it's necessary to make paintings that will interest people in the sense that they can keep going back to explore painterly detail. One could stand in front of any Abstract-Expressionist work for a long time, and walk back and forth, and inspect the depths of the pigment and the inflection and all the painterly brushwork for hours. But I wouldn't particularly want to do that and also I wouldn't ask anyone to do that in front of my paintings. To go further, I would like to prohibit them from doing that in front of my painting. That's why I make the paintings the way they are, more or less. . . . I don't go out of my way to be economical. It's hard to explain what exactly it is I'm motivated by, but I don't think people are motivated by reduction. It would be nice if we were, but actually, I'm motivated by the desire to make something, and I go about it in the way that seems best. . . .

I make the canvas deeper than ordinarily, but I began accidentally. I turned one-by-threes on edge to make a quick frame, and then I liked it. When you stand directly in front of the painting it gives it just enough depth to hold it off the wall; you're conscious of this sort of shadow, just enough depth to emphasize the surface. In other words, it makes it more like a painting and less like an object, by stressing the surface.

Chapter Nine

The Single Image: Minimal, Literal, and Object Art

LARRY BELL

• One of the most original of the younger artists to emerge in recent years on the West Coast, Larry Bell, known for his mirrored boxes and environments, was quick to recognize the radical nature of Andy Warhol's work, which was especially appreciated in Los Angeles because of its apparent lack of connection to earlier traditions in art history.

[FROM "Andy Warhol," *Artforum,* February, 1965.]

It is quite unique to these past few years that a generation of artists should have its influence on a second generation before it has even resolved its own philosophy. Modern means of communication and Pop Art are a romance that must have been made in heaven. It is my opinion that Andy Warhol is an incredibly important artist; he has been able to take painting as we know it, and completely change the frame of reference of painting as we know it, and do it successfully in his own terms. These terms are also terms that we may not understand.

Warhol has successfully been able to remove the artist's touch from the art. He has not tried to make a science out of it as Seurat did, but made an anti-science, anti-aesthetic, anti-"artistic" art totally devoid of all considerations that we may have thought of as necessary. He has taken a super-sophisticated attitude and made it the art, and made the paintings an expression of complete boredom for aesthetics as we know it.

The Single Image

It has always been my opinion that the only art that is really important is the art that changes. Warhol is important and his paintings are art. In the past artists have been involved with making art as an object, alone, relating only to itself; these paintings are objects without reference and without relationship even to themselves. They even have very little to do with Andy Warhol, maybe nothing, because it is dubious whether he had anything to do with the act of painting them. It is painting in the most absolute and abstract sense; it is Pop Art and probably the first true, pure honest example of it. The paintings are visual proof that the "thought" is sincere, considered and deliberate, with absolutely no guesswork, second guessing, or naïve accidents. It is absolute; it is painting; most of all, it is art. In any event, and no matter what is finally decided about it, nothing can take away from it the important changes that the work itself has made in the considerations of other artists.

JASPER JOHNS

• Beginning in 1964, Jasper Johns began to add new elements of complexity and ambiguity to his already highly charged images. Easily recognizable pop subjects like the flag were replaced by less legible images, combining painted surfaces, reproductions, impressions of objects, and casts of real objects, including fragments of the human body. An encyclopedic survey of the varieties of representation, depicted and reproduced as well as mirrored and replicated, Johns's masterpiece of the mid-sixties, *According to What?* contains many references to *Tu m'*, the last painting by Marcel Duchamp, who had become a great inspiration for Johns during this period. In "Notes on *According to What?*" the sketchbook notations made before the composition of the painting, Johns's multivalent process of mentation is exposed, and his debt to Duchamp's notes contained in the *Green Box,* which prepared.the way for the creation of *The Bride Stripped Bare by Her Bachelors, Even,* is recalled.

[FROM "Notes on *According to What?*" *Art and Literature,* Spring, 1965.]

Make neg. of part of figure & chair. Fill in these layers—encaustic (flesh?), linen, Celastic. One thing made of another. One thing used

as another. An arrogant object. Something to be folded or bent or stretched. (SKIN?) Beware of the body and the mind. Avoid a polar situation. Think of the edge of the city and the traffic there. Some clear souvenir—A photograph (a newspaper clipping caught in the frame of a mirror) or a fisherman's den or a dried corsage. Lead section? Bronze junk? Glove? Glass? Ruler? Brush? Title? Neg. female fig.? Dog? Make a newspaper of lead or Sculpmetal? Impressions? Metal paper bag? Profile? Duchamp (?). Distorted as a shadow. Perhaps on falling hinged section. Something which can be erased or shifted. (Magnetic area.) In WHAT use a light and a mirror. The mirror will throw the light to some other part of the painting. Put a lot of paint & a wooden ball or other object on a board. Use this in a painting. Dish with photo & color names. Japanese phonetic "NO" (possessive, "of") stencilled behind plate? Determine painting size from plate size—Objects should be loose in space. Fill(?) the space loosely. RITZ(?) CRACKERS, "if the contents of this package have settled," etc. Space everywhere (objects, no objects), MOVEMENT. Take flashlight apart? Leave batteries exposed? Break orange area with 2 overlaps of different colors. Orange will be "underneath" or "behind." Watch the imitation of the shape of the body.

The watchman falls "into" the "trap" of looking. The "spy" is a different person. "Looking" is and is not "eating" and "being eaten"? (Cézanne—each object reflecting the other.) That is, there is continuity of some sort among the watchman, the space, the objects. The spy must be ready to "move," must be aware of his entrances and exits. The watchman leaves his job & takes away no information. The spy must remember and must remember himself and his remembering. The spy designs himself to be overlooked. The watchman "serves" as a warning. Will the spy and the watchman ever meet? In painting named SPY, will he be present? The spy stations himself to observe the watchman. If the spy is a foreign object, why is the eye not irritated? Is he invisible? When the spy irritates, we try to remove him. "Not spying, just looking"—Watchman.

Color chart, rectangles or circles. (Circles on black to white rectangles.) Metal stencil attached and bent away. OCCUPATION—Take up space with "what you do." Cut into a canvas & use the canvas to reinforce a cast of a section of a figure. The figure will have one edge coming out of the canvas "plane" & the other edge will overlap cut

or will show the wall behind. A chain of objects (with half nega-
tive?). Cast RED, YELLOW, BLUE or cut them from metal. Bend
or crush them. String them up. (OR) Hinge them as in FIELD
PAINTING. Bend them. Measurements or objects which have
changed their "directions." Something which has a name. Something
which has no name. Processes of which one "knows the results." Avoid
them. City planning, etc.

> One thing working one way
> Another thing working another way.
> One thing working different ways
> at different times.
>
> Take an object.
> Do something to it.
> Do something else to it.
> " " " " "
>
> Take a canvas.
> Put a mark on it.
> Put another mark on it.
> " " " " "
>
> Make something.
> Find a use for it.
> AND/OR
> Invent a function.
> Find an object.

DON JUDD

• During the sixties, artists themselves became prolific writers, defending
their works with sophisticated written polemic that defined issues with
precision. Trained in either art history or aesthetics, or both, sculptors
like Don Judd, Robert Morris, and Robert Smithson, conceptualists like
Mel Bochner, and painters like Walter Darby Bannard had the university
background that American artists of previous generations had usually
lacked. Several of their texts, such as Judd's "Specific Objects" and
Morris's "Notes on Sculpture," became key documents for critical dis-
course as well as for understanding the intentions of artists in the sixties.

Don Judd

[FROM "Specific Objects," *Contemporary Sculpture* (New York: The Art Digest [Arts Yearbook 8], 1965).]

Three dimensions are real space. That gets rid of the problem of illusionism and of literal space, space in and around marks and colors —which is riddance of one of the salient and most objectionable relics of European art. The several limits of painting are no longer present. A work can be as powerful as it can be thought to be. Actual space is intrinsically more powerful and specific than paint on a flat surface. Obviously, anything in three dimensions can be any shape, regular or irregular, and can have any relation to the wall, floor, ceiling, room, rooms or exterior or none at all. Any material can be used, as is or painted.

A work needs only to be interesting. Most works finally have one quality. In earlier art the complexity was displayed and built the quality. In recent painting the complexity was in the format and the few main shapes, which had been made according to various interests and problems. A painting by Newman is finally no simpler than one by Cézanne. In the three-dimensional work the whole thing is made according to complex purposes, and these are not scattered but asserted by one form. It isn't necessary for a work to have a lot of things to look at, to compare, to analyze one by one, to contemplate. The thing as a whole, its quality as a whole, is what is interesting. The main things are alone and are more intense, clear and powerful. They are not diluted by an inherited format, variations of a form, mild contrasts and connecting parts and areas. European art had to represent a space and its contents as well as have sufficient unity and aesthetic interest. Abstract painting before 1946 and most subsequent painting kept the representational subordination of the whole to its parts. Sculpture still does. In the new work the shape, image, color and surface are single and not partial and scattered. There aren't any neutral or moderate areas or parts, any connections or transitional areas. The difference between the new work and earlier painting and present sculpture is like that between one of Brunelleschi's windows in the Badia di Fiesole and the façade of the Palazzo Rucellai, which is only an undeveloped rectangle as a whole and is mainly a collection of highly ordered parts.

The Single Image

ROBERT MORRIS

[FROM "Notes on Sculpture," Parts I and II, *Artforum,* February and October, 1966.]

Mondrian went so far as to claim that "Sensations are not transmissible, or rather, their purely qualitative properties are not transmissible. The same, however, does not apply to *relations* between sensations. . . . Consequently only *relations* between sensations can have an objective value. . . ." This may be ambiguous in terms of perceptual facts but in terms of looking at art it is descriptive of the condition which obtains. It obtains because art objects have clearly divisible parts which set up the relationships. Such a condition suggests the alternative question: Could a work exist which has only one property? Obviously not, since nothing exists which has only one property. A single, pure sensation cannot be transmissible precisely because one perceives simultaneously more than one as parts in any given situation: if color, then also dimension; if flatness, then texture, etc. However, certain forms do exist which, if they do not negate the numerous relative sensations of color to texture, scale to mass, etc., . . . do not present clearly separated parts for these kinds of relations to be established in terms of shapes. Such are the simpler forms which create strong gestalt sensations. Their parts are bound together in such a way that they offer a maximum resistance to perceptual separation. . . .

The simpler regular and irregular (polyhedrons) maintain the maximum resistance to being confronted as objects with separate parts. They seem to present no lines of fracture by which they could divide for easy part-to-part relationships to be established. I term these simple rectangular and irregular polyhedrons "unitary" forms. Sculpture involving unitary forms, being bound together as it is with a kind of energy provided by the gestalt, often elicits the complaint among critics that such works are beyond analysis.

Characteristic of a gestalt is that once it is established all the information about it, qua gestalt, is exhausted. (One does not, for example, seek the gestalt of a gestalt.) Furthermore, once it is established it does not disintegrate. One is then both free of the shape and bound to it. Free or released because of the exhaustion of information about it, as shape, and bound to it because it remains constant and indivisible.

Simplicity of shape does not necessarily equate with simplicity of experience. Unitary forms do not reduce relationships. They order them. If the predominant, hieratic nature of the unitary form functions as a constant, all those particularizing relations of scale, proportion, etc., are not thereby canceled. Rather they are bound more cohesively and indivisibly together. The magnification of this single most important sculptural value, shape, together with greater unification and integration of every other essential sculptural value, makes, on the one hand, the multipart, inflected formats of past sculpture extraneous, and, on the other, establishes both a new limit and a new freedom for sculpture.

The object is but one of the terms in the newer esthetic. It is in some way more reflexive because one's awareness of oneself existing in the same space as the work is stronger than in previous work, with its many internal relationships. One is more aware than before that he himself is establishing relationships as he apprehends the object from various positions and under varying conditions of light and spatial context. Every internal relationship, whether it be set up by a structural division, a rich surface, or what have you, reduces the public, external quality of the object and tends to eliminate the viewer to the degree that these details pull him into an intimate relation with the work and out of the space in which the object exists. . . .

While the work must be autonomous in the sense of being a self-contained unit for the formation of the gestalt, the indivisible and undissolvable whole, the major esthetic terms are not in but dependent upon this autonomous object and exist as unfixed variables which find their specific definition in the particular space and light and physical viewpoint of the spectator. Only one aspect of the work is immediate: the apprehension of the gestalt. The experience of the work necessarily exists in time. *The intention is diametrically opposed to Cubism with its concern for simultaneous views in one plane.* Some of the new work has expanded the terms of sculpture by a more emphatic focusing on the very conditions under which certain kinds of objects are seen. The object itself is carefully placed in these new conditions to be but one of the terms. The sensuous object, resplendent with compressed internal relations, has had to be rejected. That many considerations must be taken into account in order that the work keep

its place as a term in the expanded situation hardly indicates a lack of interest in the object itself. But the concerns now are for more control of and/or cooperation of the entire situation. Control is necessary if the variables of object, light, space, body, are to function. The object itself has not become less important. It has merely become less *self* important.

DAN FLAVIN

• Dan Flavin was among the first to renounce discrete single objects to focus on art as environment. Influenced, as were many artists of the sixties, by Marcel Duchamp's appropriation of manufactured objects to the context of art, Flavin used standard industrial fluorescent light to divide and illuminate space.

[FROM ". . . in daylight or cool white," in Brydon Smith, *Fluorescent Light, etc., from Dan Flavin,* catalogue of an exhibition at the National Gallery of Canada, Ottawa, and the Vancouver Art Gallery, Vancouver, 1969. Copyright © 1969 National Museums of Canada.]

By 1961, I was tired of my three-year-old romance with art mainly as tragic practice. I found that all of my small constructions, with the exception of "mira, mira" were memorial plaques and that the numerous pages and folding books of water-color and poetry which I had made were dominated by black ink.

My four-room flat had shrunk to a mental closet. . . . It had to be abandoned. . . .

In time, I came to these conclusions about what I had found with fluorescent light, and about what might be accomplished plastically: now the entire spatial container and its components—wall, floor and ceiling, could support this strip of light but would not restrict its act of light except to enfold it. Regard the light and you are fascinated— practically inhibited from grasping its limits at each end. While the tube itself has an actual length of eight feet, its shadow, cast by the supporting pan, has but illusively dissolving ends. This waning cannot really be measured without resisting consummate visual effects.

Realizing this, I knew that the actual space of a room could be disrupted and played with by careful, thorough composition of the illuminating equipment.

———————

[FROM "Some Remarks," *Artforum,* December, 1966.]

Electric light is just another instrument. I have no desire to contrive fantasies mediumistically or sociologically over it or beyond it. Future art and the lack of that would surely reduce such squandered speculations to silly trivia anyhow.

The lamps will go out (as they should, no doubt). Somehow I believe that the changing standard lighting system should support my idea within it. I will try to maintain myself this way. It may work out. The medium bears the artist.

LUCY R. LIPPARD

• Writing on the new category of hybrid produced in the sixties, critic Lucy Lippard traces the pictorial antecedents of recent sculpture.

———————

[FROM *American Sculpture of the Sixties,* catalogue of an exhibition at the Los Angeles County Museum, 1967.]

The notion of the painting as object has two interpretations. First as a specific surface, but without connotations of volume and physicality, second as an actual three-dimensional thing. Both contributed to the idea of a non-sculptural sculpture, that is, a sculpture which rejects the history of sculpture as precedent in favor of the history of painting, and at times, of architecture and engineering. The notion of the sculpture as object is equally equivocal. Until recently, the "object" implied an additive, Dada or Surrealist or assemblage work made of non-traditional materials or found items. Structures—or, as Don Judd has called a broader grouping, "specific objects"—are, on the other hand, simple, single or strictly repetitive, serial or modular, with a

quality of inertia and apparent (superficial) abdication of the transforming powers of art. In this context, the object or objectness is directly opposed to the additive premise on which most post-Cubist works are founded. But its connotations, like those of the Dada object, are non-sculptural and even anti-sculptural. In that many of the artists are former painters who have rejected painting, this is also an anti-painting idiom, though most of these artists are far more interested in recent painting than in recent sculpture. . . .

Around 1963, the structurists and structural painters actually paralleled each other's efforts to advance formally with their chosen means. Frank Stella's use of a very deep stretcher and "deductively" shaped supports, Dan Flavin's lighted "icon" boxes, Ronald Bladen's flat forms projecting from panels, Donald Judd's ribbed and striated reliefs and Richard Smith's canvas constructions all demonstrated a preoccupation with expanding the dimensions and formal possibilities of painting, or wall-hung pieces. The fact that all but Stella further approached or moved into free-standing structures and all but Stella and Smith are now considered sculptors is significant. Perhaps the most important aspect of the increasing attraction of sculpture today is its apparent potential as a vehicle of advance—both formal and evocative, or sensuous. This comprises its most crucial relationship to painting, for it is only with the avant-garde's decreasing interest in painting that sculpture has come to the fore. This is a very literal period. Sculpture, existing in real space and physically autonomous, is *realer* than painting. Yet sculpture also has its own peculiar kinds of illusionism which it has not, like painting, had to give up in the interest of fidelity to medium. For instance, a lacquered wooden surface disguises the color and texture of wood, but retains a mellowness characteristic of wood, whereas a hard, shiny, enameled wooden surface disguises wood to the point of making it an illusion of metal. A shiny, reflecting metal surface gives the illusion of insubstantiality or transparency by reflecting its surroundings, and a burnished metal surface like that of David Smith's *Cubis* can give the illusion of several atmospheric depths as well as asserting the surface. By painting their materials, whether masonite, wood, steel, plaster, most abstract and some figurative sculptors are trying to avoid the connotations of the materials—naturalistic or industrial or academic—and give the illusion

of something autonomous and new in itself without reference to its antecedents—physical or historical.

Smith himself was not averse to painting his sculpture in much the same manner that one might paint a canvas. His *Zigs* often combine strong sculptural form with a frontal, centralized image, polychromy, and even brushwork that was frankly allied to painting. It was only Smith's knowledge of sculpture which kept some of them from looking like one-image painting peeled off the wall. One-image painting, in turn, could be said to imitate (unconsciously) the singleness and self-sufficiency of sculpture; when Barnett Newman made an exaggeratedly tall, thin monochrome painting as well as bronze sculptures out of the stripe which divides all his canvases, he was admitting in effect that the stripe was the unit by which his painting existed, denying, at least temporarily, the importance of that stripe's placement on the supporting surface. There has been other single-image planar sculpture (structures are generally imageless), such as Ellsworth Kelly's flat monochrome shapes which, like Newman's stripes, seem to have been freed from their canvas grounds to exist rather precariously in three dimensions. The "thin" idiom itself, in more hierarchical form, can be traced to Calder's stabiles and perhaps to Matisse's late cut-outs. Such works could be said to mimic and even parody the necessary flatness of a painted image by their own unnecessary flatness. The kind of color Kelly uses, for instance, so sharp and positive in a painting when juxtaposed against another color or the white of a wall, becomes far more ambiguous when isolated in actual space.

For that matter, very little of the new sculpture—from assemblage to "space sculpture" to structures—is anything but ambiguous as a vehicle for color, though the effectiveness of color should not be underrated. Color in sculpture is more difficult to work with than color in painting because so many factors must be taken into consideration. It is also more difficult to assess from a critical point of view. Whereas color in painting can be judged within a relatively understood system of theory or experience, such a system, fortunately, is not yet established for sculpture. No matter how large a painting is, the surface can be taken at a glance, and while the form and color action may be extremely subtle and engender different effects after different viewing times, it can be perceived initially as a unity. A sculpture must hold

its own in space and from different angles; color must be so thoroughly controlled that it is both absorbed by and heightens the purpose (formal or psychological) of the sculpture itself. Because of this, and because color had largely disappeared from sculpture for so long, its development is in a much earlier stage.

As new materials are tested and found viable, the kind of color open to sculpture expands and is in turn often picked up by painting. Metal-flecked, day-glo and other commercial paints, sprayed color, professional "fabrication" and color application, garish Pop derived hues, are examples of this feedback. [New] materials liberate forms previously "used up" in painting and traditional sculpture. A vinyl biomorph is an entirely different sight and experience than approximately the same biomorph in marble by Arp, or in paint by Gorky. Every object employing labyrinthine wires, threads, ropes, all-over linear patterns can be tenuously traced to Pollock and therefore accused of being unoriginal. However, this attitude seems unnecessarily exclusive, and finally invalid. Exact use of color alone, as evidenced in Kenneth Price's work, transforms shapes previously used by Brancusi and Arp into something new, just as Sol LeWitt's structural frameworks of a square within a square bear no visual resemblance to Albers' *Homage to the Square* paintings, nor Bruce Nauman's random, rubbery shapes to Masson's automatism. Three-dimensional objects can, I believe, return to the vocabulary of previous painting and sculpture and, by changing the syntax and accents, more fully explore avenues exhausted in two dimensions or conventional materials and scale, without risk of being unoriginal or reactionary.

THE SENSIBILITY OF THE SIXTIES

• In an attempt to define the "sensibility of the sixties," Irving Sandler and I compiled a detailed questionnaire that focused on the differences in attitude between American artists of the sixties and those of the earlier New York School. The results indicated that at least some artists believed, by the end of the past decade, that the spirit of the avant-garde was dead and that commercialism had taken its place. The acceptance of art by the general public was condemned as superficial, and American attitudes toward art were analyzed for their contemporary meaning.

[FROM "The Sensibility of the Sixties," compiled by Irving Sandler and Barbara Rose, *Art in America,* LV, No. 1 (January–February, 1967).]

Roy Lichtenstein: A Friendlier Climate

The sensibility of the sixties: Meanings other than formal (abstruse meanings); apparent impersonality; predetermined end-product; and factory surfaces.

There is no avant-garde today.

To a great extent the sensibility of the sixties has hardened into an academy. It takes the form of repetition of, rather than creation of, the already understood sensibilities.

The condition of the artist has changed. There is a friendlier climate for adventurous work. Mass media, etc., do not change avant-garde into academy, but, through their attentions, obviate the "underground" necessary for an avant-garde. The universities have followed current activity, not affected it.

There has always been a small group—with varying degrees of insight—interested in art. There may now be a greater and more sophisticated art audience than before, but this audience is very small; and the great public for art probably compares in number with the public for chemistry.

Allan Kaprow: The Newest Energies

The last half-dozen years has been a period of cool detachment, irony and what we may call the flip-hip. "Object's" blank, empty expanses and silences were hyped up in the psychedelic dissolves of op, with both sharing in a quasi-technological sensibility that excluded handwork and individualized personality. Pop, while parodying the "faulty" technology of cheap commercial reproduction and revealing a faint nostalgia for the past whose styles or themes it used, also kept the artist at a distance by shifting the emphasis away from *engagement* and urgent commitment to style and high camp. Most of the other modes such as color field painting, hard-edge, the various clean forms of assemblage, as well as the new music and dance, also tended to eliminate emotionalism and crisis in favor of craft, technical exploration, wit, or "classical realization."

The Single Image

Yes, there is an avant-garde today. Although there is good work being done in the conventionalist arts—painting, sculpture, music, dance, poetry, etc.—the newest energies are gathering in the crossovers, the areas of impurity, the blurs which remain after the usual boundaries have been erased. This zone is increasingly referred to as the "intermedia" (Dick Higgins' term for the media between media). And within this zone, I see the most critical point of oscillation occurring between the intermedia and life. Here, the identity of "art" becomes uncertain and the artist can no longer take refuge in its superiority to life, as he was once accustomed to do. This is where, suddenly, decisions regarding *human* values become imperative. . . .

Yes, the sensibility of the sixties has hardened into an academy. As the movements of the early sixties quickly became famous, they revealed the symptoms of a progressive academicism almost immediately. The evidence, in countless exhibitions of nearly similar material and in repetitive, over-stylized work by individual artists, was simply the ritual of rise and fall built into the "movement" concept by recent history. That is to say that the achievement of academic status is ironically an appropriate goal of modern art.

In America the ritual is only hastened and intensified in its pathos; here artists die in absurd martyrdom very young. It is natural that this is so, because the American economy and life-style are dedicated to planned obsolescence on many levels (not the least being the cult of youth which grants prime time to fewer and fewer years of our lengthening life span). The changeover from style to style, from fashion to fashion, is just another form of a widespread need for continuous "movements." . . .

Art movements, conceived by one or at most a few individuals, have always been parallels to the one-man, or family, shop. Just as the small grocery and neighborhood atmosphere have given way to the supermarket and shopping center, I would guess that in order to beat the game of dying for a brief hour of life in art, the artist may have to begin thinking in modern, i.e., corporate, terms. He may have to explore not only the nature of technological processes, but the effect these have upon human life.

Participating in and even initiating many movements would then become almost a formula for continuous self-renewal. Diversification and efficient distribution—characteristics of a successful economy—

would become operations leading to freedom, rather than to the stigma of commercialism and sell-out. I am beginning to suspect that on the level of self, most modern artists have become men of the past.

Carl Andre: Art Is What We Do/Culture Is What Is Done to Us

The same fat surplus which burns in Vietnam feeds us. Let the art armies be disbanded. In the wake of the anarch, all marches are up. There is no art in these questions. These are culture questions. Art is what we do. Culture is what is done to us. A photograph of an art object is not the art object. An essay about an artist's work is not the artist's work. Art schools are not art objects. Whatever happened to the art object? Each man has a public of one; that's how it is, always has been.

Larry Zox: Removing the Camouflage and Exposing the Foundation

The capacity for being affected is obviously the same now as it's been in the past. The artists of the fifties (abstract expressionists) seemed to operate at a closed level. That is to say . . . they had a particular awareness in thought and in making art. Their problems were the result of European artists dominating them, which in turn made the various attitudes that followed. At the end of the fifties the younger artists found themselves with a dilemma: the anxiety now evident created a period of isolation and expansion of what art was about. Responding to this problem has developed a sensibility of removing the camouflage and exposing the foundation.

Philip Pearlstein: The Romantic Self-Image Is Gone

Yes, there is a sensibility of the sixties. It is roughly a 60-degree deflection in angle from that of the improvised expressionism of the fifties. It is objective rather than subjective, constructed (planned, predetermined) rather than improvised, but also less based on external logic, a bit more surreal.

There is an avant-garde always as long as some artists are doing what their immediate predecessors haven't done. The nature of today's avant-garde is perhaps conditioned by the fact that an artist of the

"avant-garde" of any stylistic persuasion—realism to dumb form—can expect to have almost immediate and public, even institutional, reaction and evaluation of his work. . . .

Pop art, constructions of all kinds, hard-edge abstraction and my own kind of hard realism—it's all "hard"—sharp, clear, unambiguous. In the fifties everything was ambiguous.

The artist's condition has changed. One now owns a brownstone in the West 80s, or on Park Slope, or one buys into a cooperative loft building or a dairy farm somewhere. And some artists are now earning enough (through sales, teaching, etc.—not family-inherited money) to *buy*. What is more important, though, is the change in attitude from that of the thirties and forties that lets serious, dedicated, totally committed artists buy, own property and have children—often two and three children—and not feel themselves destroyed. The romantic self-image is gone. As Kaprow said in a recent article, artists today are men of the world.

Al Held: Art Did Not Begin in 1945

The surrealist sensibility has been rejected by the artists I'm interested in today. The artists who interested me in the fifties considered themselves alone, tormented, tortured. Their emphasis was on an internal monologue (surrealist). Now, there's a different emphasis, more on the formal and esthetic aspects of art. The slogan of the fifties was the old art slogan: art and life. The slogan of the sixties is the old art slogan: art out of art. I like both slogans.

If by avant-garde one means a reaction against action painting, O.K. Most of the ideas advanced in the sixties are based on the premise that art began in 1945. This kind of thinking is provincial. Post-painterly abstraction (no hand) is simply a rejection of De Kooning. The notion that work should be sent out to be made is radical only if one forgets Moholy-Nagy, Max Bill, etc. The shaped-canvas and the painting-sculpture combine are avant-garde concepts only if one conveniently ignores a centuries-long medieval tradition. The idea of avant-garde today has to do with process, method and materials. But these have always been given in twentieth-century art.

Robert Mangold: Popular Art Cannot Be Avant-Garde

I don't believe that there is a single sensibility at work now, in fact there seem to be many different attitudes, with nothing in common. The following is an attempt to characterize in general terms only what might be called the new abstract art: Common properties—loss of identification with the process of making art, rather a stronger emphasis on the piece; frustration with painting as a medium for advanced art; adaptation of industrial-commercial techniques and materials.

Art that is popular, sought-after, publicized in a broad sense, cannot be considered avant-garde. Advanced art challenges concepts of present art, presents a certain statement, and contains within it questions as to its own validity. The result is a chancy experience-position for spectator and artist.

No, there is not an academy today, but perhaps many academies.

The desire on the part of artists, critics, dealers, curators and collectors to inflate reputations, promote, publish and distribute current ideas and attitudes in an attempt to prove their legitimacy has a crippling effect on advanced art.

Paul Brach: It's Still Lonely in the Studio

The sensibility of the sixties is tough, deadpan, ironic, anti-confessional, anti-individual, aware of its audience (playing games with the audience) and of the conventions of art (playing games with art); in short, it is *mannerist*.

There is no avant-garde today. Everything gets known too quickly for there to be any space between the scouting party and the main body of troops. Perhaps there is an avant-garde of quality—but there is no particular look or unifying style that embraces the few works that have real quality. . . .

Things have changed. There are more artists, more collectors, more dealers, more critics, more money, more action! It's still lonely in the studio. The rest is diversion, tempting but debilitating. The cohesion of the artists to each other has loosened so that many ideas seem to come from the outside. The universities keep their eyes on the ball (it must strain them) and accept, sometimes a bit late, the taste dictated from the message center.

The Single Image

Walter Darby Bannard: The Mainstream and the Avant-Garde

Avant-garde could be a useful critical term if properly defined. It presumes a "mainstream," a directional historical flow of a series of stylistic changes. Someone should write a thorough essay on this. It is enough to say here that there is always an avant-garde within any vital environment such as we now have, that its character is always the same, and that it consists of artists who are making works containing new or apparently new characteristics which will influence other artists. For example: Picasso in 1912, De Kooning in 1945, Noland in 1960.

The avant-garde artist usually makes good works of art, but avant-garde characteristics and high quality cannot be perfectly correlated. At this time Pollock seems to have been a less avant-garde though more original and better painter than De Kooning. The same goes for Matisse relative to Picasso. In 1960, Rauschenberg may have been more avant-garde than Noland, though by far the inferior artist. David Smith was probably the best sculptor of his time, but he was not very avant-garde. In the future he may appear to have been more so. I believe the avant-garde in painting today consists of painters who are dealing with color problems. . . . I also feel that abstract art is in the primitive stage of an era of new clarity and that the paintings done in the latter sixties will lay a basis for more beautiful and intellectual art than we have seen since impressionism.

George Segal: Everyone Shares a Stew of Ideas

There is an avant-garde today, healthily shooting down different extreme directions. Everyone shares a huge stew of ideas. Some of the ideas are pushed to logical extremes or strained through unique personalities, and unexpected jumps are made. I think we're in the middle of an explosion of vitality that has affected all the areas of art: painting, sculpture, music, dance, poetry, film, architecture, theater; we've seen only the beginning of hybrid forms and mutations that can and will be invented.

Despite the unabashed derivative work shown, evidence of agile bandwagon-hopping, regular weekly obituary notices on the death of pop, the calm dismissal of op as last season's flash, the start of mild

interest at primary structures being the fashion for next season, the handwringing over the future of art, I think there is no academy of the sixties and that other factors are operating. Many people seem to forget that different ideas flowing have subterranean currents and connections. A new hard-edge painter can have affinity with both Mondrian and a musical score by Cage. A shaped canvas can become fully three-dimensional. If a real object is placed in a room, it's called pop. The same object, abstracted into a geometric shape three-dimensionally, is called a primary structure. . . .

Serious art will always have an intense minority audience in relation, say, to the audience for a Doris Day movie. The changed nature of the U.S.A. after World War II, with its new power, prosperity and leisure, has rocketed interest in fine art. When I was a kid from a poor family in the Bronx, I could take a nickel subway ride to the Met and see free the things formerly reserved for kings. I'm hoping the culture boom, along with everything else it does, will increase the ranks of the intense minority.

CLAES OLDENBURG

• The following statement by Claes Oldenburg, an artist whose work has always commented on social realities, is a bitter indictment of American violence in the late sixties, a period of widespread unrest that was, in part, due to the impact of the Vietnam war on American culture. Writing baby-talk jargon, Oldenburg comments on infantile American attitudes.

[FROM "America: War and Sex, Etc." *Arts Magazine,* XLI (Summer, 1967).]

These be evil times. What hurt, the work must show it. To use red, suddenly, after so much red denial. This show is about bending, circulating, having yr. fingras cut off (the Fan).

Why must we go thru another hole in the skull?

Vulgar USA civilization now beginning to interfere my art. I only intended a bedwatch with generous drinks from the clock.

The Single Image

Make Useay* depend on Canaday.† Leave the colonies breathless! Roy explosions, ‡ I spots—consequentials fum explosions. In the studio I am quite in sane. Billy Lugosi in his Lab. § Ape Man plays Moonlite Sonata. What did you do today? I cut off twentytwo lipsticks. World is *not* a drawing. Artists the curse of the world. They know how to start things, but not know how to stop them. When Ray Gun shoots, noone dies. Art childs play. Art as life is murder.

Hitler, he erased half of Europe, but the world is *not* a drawing. Flagging of belief in Reality 'low art to enter life. There is morality to scale. Drop a bomb violates scale. As the numbers increase, I hug my wife closer. Nature hates us. Every day we eat half of her. Tomorrow she is whole again. Life is—difficult to say—this multiple. . . .

I have begun to keep, among the notes I turn to, scattered, unpredictably located, faces of the mutilated, or the polaroid of my granduncle at the last living point of death. These throw me off my search. I stumble round the studio as result, forgetting what simple and efficient thing I wanted. We are so poorly educated in Death. We can only dish it out, as they say. Provide Ice Cream. If I hadn't tried out as reporter (out of my love of fire), I might never have acquainted a corpse—or a cunt for that matter. Both these are secrets in USA. . . .

Raze Harlem. Erect in its place, painstakingly accurate replica, Chicago fire, near the end, or San Francisco earthquake.

For Welfare Id., propose a famous park. Disneyland of Death, for Sunday, family visit. Like the War Mouse. Page-antic of Uceay. Technological contribs to Death: subs in act, planes in strafe, wiggling replics of the Monitor and M. Variety of wounds. Culminate in colossal, concrete Mr. Clean, at the rocky point of the south end, threatening the N. Inside—planetariums, spectacles of the After Life. How Heroes Live Then. But also afterlife of the losers, cowics. Alternating and intermingling—detailed projects for the coming war on Stellar Dust. Also, Soldier Fare Thru the Ages (in the rest). A Worlds Fair of Death. Now Heart deliciously slips into the cool bottoms, watching

* U.S.A.

† John Canaday, *New York Times* art critic, considered by many to have philistine, anti-avant-garde views.

‡ Roy Lichtenstein, pop art painter.

§ Billy Klüver, physicist and president of EAT (Experiments in Art and Technology).

the ship depart. Steve whips his horses in the New Jersey highlands. Make up thee mind Mr. US, thee want wet or hot. Mr. Ray Gun, he commend gas.

We Promethised Land. We home fire. We Red Man. We run torch to Plato, stumbling angmond za fagends. Lipstick here is bullet. Paint drop here she punching bag.

WALTER DARBY BANNARD

• Although critics like Lucy Lippard and Robert Pincus-Witten argued for a permissive attitude toward hybridization of forms, painter Walter Darby Bannard took the formalist, Kantian position of the circle of younger critics influenced by Clement Greenberg and denounced the new forms as "novelty art."

[FROM "Notes on American Painting of the Sixties," *Artforum,* January, 1970.]

History has told us that good art looks new, except for a family resemblance to the art it "outdates," and that it *influences* artists. This gives rise to trends and full-fledged art-making styles. We have learned our lesson well, and now, as we say goodbye to the sixties, we see newness and importance securely fixed as safe taste. But the use of clues and signs always catches up to those who will not see art properly. The mediocre ambitious artist is always a few jumps ahead; he has a keen nose for what's "in the air" and he wastes no time bringing it into his art. It is still true that good art is new and important. What is unique to the sixties is that *bad* art is now new and important. As always, bad art takes aim at assimilated taste. But it has taken until now for assimilated taste to demand these qualities. This has produced something else peculiar to the sixties: the co-existence of many very different-looking styles of art-making, each claiming to be as much "high art" as the others, each with its defenders and detractors. It was not like that in the fifties. There were a few individualists then as now, but Abstract Expressionism was a mammoth tidal wave unlike anything we have today. These recent co-existing styles are symptomatic

of the demand for newness and importance; to be new is to be different and to be important is to be generative—therefore, many styles going along parallel lines in time. The fear of being "wrong" fosters acceptance of bad art as long as the art public is not sure it is actually bad. History has told them to go along with whatever seems to persist. And their own indecision sustains the very persistence they seek. And so we have the spectacle of mighty art institutions like the Museum of Modern Art loaded to the hatches with chichi junk, like Marisol sculpture, hideous Wesselmann paintings, the grim idiocy of Lucas Samaras, all kinds of bobbling, clicking, flashing and wiggling things, and exhibitions of photographs of gigantic earth and sky "works" which are as destructive as they are silly. Everything has its place in this hysterical anarchy. And now, just as 10, 50 or 100 years ago, 99 percent of it is worthless. Only the superficial modes of selection have changed.

It is not possible to rightly condemn a style of art-making, just as it is not possible to rightly condemn any material for art, because it cannot be shown that a good work of art will not come up in that style. Conversely, there is no style which guarantees good art, though there have been some, like Cubism and Impressionism and perhaps Fauvism, which at the temporal center of their effective lifetimes have allowed rather mediocre artists to paint very good paintings. . . .

I do think that all the really good painting of the past ten years has a direct and specific link to the great art of the recent past, will in time look much less discontinuous than it does now, and is related more by a basic sameness of process and intent than by evident visual similarity. The most striking characteristic of the best paintings of the sixties, the factor of design which will let the art historian of the future pinpoint a work of the sixties, is the extreme spatial manipulation of the shape of the painting or of the elements of the picture surface to give color a visually plausible place on the two-dimensional abstract picture plane. Furthermore, with the exception of some painters who persist in previous styles, I am of the opinion that *all* the best painting of the sixties has been made by artists who have done this.

The two fundamental problems the serious abstract painter faces are those of edge and isolation; the edge must be accommodated by design because it is the strongest single factor of design of the surface,

and the elements of the surface tend to become isolated across the resistant flatness of two dimensions. Realist painting has it easier than abstract painting, and the Impressionists had it the best. Every illusion, every color, every brush stroke was fully and naturally rationalized by the character of their style. It seems that all of their problems were solved before they started painting. The problem of relating bits of colored paint across a closed-up flat surface was solved by the illusion of realist depth, which allows the pieces to "reach" each other across the apparent void; the problem of the edge, the strongest element of design of a painting, was solved by the naturally occurring elements of landscape—horizons, trees, waterlines, bridges, houses—all of which reflect the edge and bring it into the painting; the problem of ordering a vast and subtle variation of colors was solved by the strict adherence to what was "seen"; the problem of the subjection of paint to the service of imitation of materials not "natural" to paint was solved by making the paintings actually consist of separate touches of paint distinct enough to stand as paint, though they made up an illusion of another thing. Furthermore, Impressionism may have been the only painting style to fuse the usually antagonistic approaches to art-making: constructive painting, built up from the inside, and "effect" painting, in which the paint is worked to achieve something preconceived. Impressionism gave its practitioners a firmer, stronger base for painting than any style before or since.

The great continuing problem of abstract painting has been to build a basis for painting as strong as that of Impressionism without the illusion of reality.

Cubism got painting into abstraction by using the Impressionist stroke to hack away at depicted subjects until the subjects were submerged under the varied inflections of relief with vestiges of the subject functioning decoratively. . . . When color came back to Cubist painting, in the teens, it was no longer the affective color of the Impressionists and the Fauves, but a color at the service of space, color which served to identify planes and distinguish areas. Thus it was that our first powerful abstract style sacrificed one of the natural elements of painting (color) for an element it had to fake (illusion in space). With a few great exceptions like Matisse, that is the way it has been ever since, or perhaps it is more accurate to say that Cubism, free of affective color, has been far and away the most *dominant* style.

Color has been forced to work itself back into the "mainstream" of painting by innovation. . . .

No high-minded artist of the past 50 years has started out and matured without coming to terms with Cubism. Some, like Rothko, Newman and Still, found their own way around it, and some day it may be seen that they carried high art through Abstract Expressionism. But the evident "mainstream," the great wave of the *accepted* art, the expanded Cubism which is typified by the painting of de Kooning, came down on the maturing, serious artist of 1960 like the proverbial ton of bricks. The most sensitive and ambitious of them knew something was wrong, but artists are only human, and it took a lot of nerve to turn against a style so much in power. It seemed as though every step of art-making had to be referred back to the canons of Abstract Expressionism for approval; if not, it was necessary to take another stand, more violent and rebellious: to accommodate Cubism with illustration (Rauschenberg), to mock Cubism on its own terms by arranging the interior *strictly* in terms of its edge (Stella) or to go to post-Cubist symmetry to open up space for color (Noland). The only artist of the sixties to *convert* Cubism into color painting and make great art of it was Hofmann. Some of the reason for the eventual "take-over" of expressive color may be that it is a positive, evolutionary way to break the yoke of Cubism; certainly the erosion of Cubist picture-making by floods of color is a most interesting process of the painting of the sixties. . . .

Though the "shaped canvas" is one of the clichés of the sixties, Frank Stella, who was the first to make a big issue of it, remains the only one to handle it convincingly. He alone of the canvas-shapers keeps the inside of his picture carefully adjusted in terms of edge and size, so that the shape of the canvas seems to be generated from within rather than applied as an element of design. In recent years he has combined his glowing colors in an illusion of shallow space by letting the colored bands surround and run in front of and behind each other.

The paintings of Kenneth Noland, unlike all those above, stay resolutely flat, though an occasional unsuccessful work will "buckle." His best work, the recent horizontal "stripe" or "band" paintings, make[s] no concession by means of illusion to the problems of piece-isolation. Noland's is an interesting case, probably the only one in which pure pressure of color dictates size and shape. Once committed

to horizontal bands of color on a horizontally extended surface, No-
land has a number of overall options open to him, besides the adjust-
ment and variation of hue which finally "makes" the picture. He can
change the proportion of the canvas, the width of the bands and the
value of the colors. . . .

By "atomizing" his paint, Jules Olitski has reduced the painted
shape so much that it no longer figures as shape. This is a solution for
color painting similar to that of Pollock's for space painting. As I
have said, color must have surface, must spread out to present itself
fully, and covering closes off the surface and isolates shapes. By atomiz-
ing his paint Olitski has given his surface opaque color and trans-
parency at the same time. If you spatter red paint on a white piece of
paper the result will be a surface *occupied* by red but not *covered* by it.
If a similar shot of green is applied the same effect will be gained. The
result is that the two colors extend across the surface, are visible and
contrasting all over that surface, but do not literally cover it. It is not
possible for two colors to each completely cover a surface and remain
visible. Furthermore, the colors *get at* one another in proportion to
the degree of fragmentation because there is more edge-per-color avail-
able the more divided the color is. This ration of available surface of
equivalent volumes according to the degree of disintegration is a
well-known fact in physics, and it works for art as well. Oltiski plays
these clouds of powdered color over his surfaces just as Pollock strung
out his net of painted line, varying the concentration here and there.
Though he usually keeps values close, the value differences which do
exist take over through the fog, and the colors can take their place in
the various shadowy depths induced by those value differences or sit
opaquely on the surface. Because of the compensations made by the
other factors of his style Olitski has not chosen to go to explicit depth
illusion; it is enough for him to *suggest* it, softly, here and there, so
that we know it is there, kept in reserve, backing up the painting.

Olitski is obliged to do something about the edge because the pale,
close-value surface can close up and turn the painting into a big flat
object very easily, and this would force visual consideration away from
the painting. Internal repetition of the edge would quite evidently
interfere with the quality and mechanics of his surface. But the
atomized shape is so subdued as shape, the colors so delicately uni-
form across the surface, that strong edge-repetition is not needed;

there is nothing inside the painting which calls for it. Olitski simply brings the edge in along one side, or goes around a corner, by masking off a value difference or by drawing a rough and often highly colored line. This declares the painting as a painting, stays out of its "body" and carries in other colors. . . .

Despite all the "new" materials brought into art and the consequent silly talk about the decline and imminent death of painting, I think we are just getting started, that in the sixties we have taken the first moves of the first great burst of real abstract painting. The new art, its roots deep in the great art of the recent past, will leave behind it the frivolity and fussiness of the fad styles of the sixties and the puritan restrictions of Old Mother Cubism. It will be as bright as it is balanced, as permissive as it is secure, a natural art embracing all the natural materials of painting, an American analogue to the beautiful painting of the French Impressionists a hundred years behind us.

Since writing this essay I have seen that I made one wrong conclusion. Noland's wide horizontal stripe paintings work, in part, not because the edges are held away from our vision but because the painting is extended until the elements are esthetically integrated.

WDB

January, 1975

AD REINHARDT

• Called the "conscience of the art world," Ad Reinhardt, whose monochrome black paintings presaged the imagelessness of minimal art, was the first to speak out against many of the fashionable notions introduced during the permissive anti-elitist sixties. In the following moralizing address given at the College Art Association meeting on January 28, 1960, and again at one of the last meetings of the Artists' Club later that year, Reinhardt criticized the idea of democracy in art, debasement of taste, mixtures of art and real life, hybrid forms, and absence of value judgments—all of which gained increasing prominence after Reinhardt's death in 1967.

Ad Reinhardt

[FROM an address to the College Art Association and to the Artists' Club in New York City, 1960.]

What is the "Failure of Art-Conscience" at present? How is our time out of joint these days? Do we have a history of art morality? A moral art history? Is there a code of art ethics? What are the unconscionable crimes of artists?

Is the art-"sink of corruption" like any other ordinary sink? Can it be condoned with "that's life" or "to err is human" or "even the air. we breathe in is polluted"? The everyday world has Law, Order, Justice, fines, fit punishments, and a Commissioner of Air Pollution. Everything all together may be beyond good and evil, right and wrong, but art is not.

Corruption in art cycles moves forward always in the name of life, fate, nature, humanity, animality, society, cosmic-anxiety, reality, surreality, automatism, organicism, vitalism, existentialism, primitivism, irrationality, unconsciousness, spontaneity, visions, images, impulses, sensations, impressions, expression, business, romance, "silent poetry," "frozen music," etc. The reform movement and atonement occurs always as a return to the strong neo-classic virtues of detachment, honesty, rationality, clarity, coldness, emptiness, sterility, formalism, intellectuality, idealism, meaninglessness, and contentlessness.

The cockles of the hearts of our plebian curators and critics must have been warmed considerably in the middle forties when after several "waves" of cold, dry, empty abstraction, some mythic-poetic artists made public their divination that "there is no such thing as a good painting about nothing," presaging a wave of hot, loaded, compromised art that was to flood the markets and wash away, by the fifties, all lines of distinction, and make a quiet, dignified profession into a rabble-rousing profit-making where "anything goes," "anything can be art," "everyone is an artist," and "an artist is like everyone else."

But everyone is not an artist. Some artists are better than others. Some artists have less clear consciences. Some artists get no chances to become corrupt. No artist is guiltless. Some artists are no good any way. The moral argument in art always focuses on the "artist as artist," not on the "artist's artist," or the (American) people's artist, or on the artist as a human, or super- or sub-human being, or on the artist as anything else.

The Single Image

Naturally it's difficult for an artist to draw a line, but an open, indulgent, demoralized art situation presents too many temptations for art-immorality and art-rascality, too many opportunities for conscienceless artists.

In the absence of a lawfully constituted art authority, then, these Thirteen Rules of Ethical Conduct for Professional Fine Artists is hereby respectfully submitted for everyone's approval.

(1) It is not right for an artist to make believe that he doesn't know what he's doing, when everyone else knows what he's doing, or to say that there is no wrong, or that it's "a matter of personal opinion," or that "time will tell" what's not right. Artists who leave decisions of what is not right to someone else, especially to those who don't know, should be put to the rack and given the brush. Artists who write that art is "Voyaging into the night, one knows not where, on an unknown vessel . . . , etc. ," should be put in irons and chained to galley-oars.

(2) It is not right for artists to "overprofessionalize" or "over-amateurize" their profession in the practice or teaching of it. An artist who thinks that a good social conscience will fix up a bad artistic conscience, or who believes that what helps "Business Buy American Art" helps him, or that "Art Is Education and Communication for Everybody," should be taken into custody and booked for suspicion.

(3) It is not right for artists to palm off their brush-stroke marks for grass as "a feeling for Nature" or to keep alive the idiotic idea that they see some "structure underlying the surface appearances of reality." Artists who think that art is not a hot-house product but an out-house byproduct, and who participate in "New Nature" or "nature in Abstraction" ideas should be sentenced to a term of hard labor in the fields.

(4) It is not right for artists to act as if "abstraction" and "representation" do not make any difference. Artists who do not remember Clive Bell's sentence, forty-seven years ago, that "every sacrifice made to representation is something stolen from art," and who paint "abstract expressionist" flames, girders, grasses, and sunsets, should be apprehended for fencing hot merchandise. Artists who portray naked old ladies, young undressed boys, beauties (Marilyn Monroe), and beasts ("New Images of Man") should be put into solitary.

(5) It is not right for artists to mix their art up with other arts,

with the idea that the arts augment each other, or to claim that their paintings beautify architecture or that their church and synagogue decorations are an "integration of art and religion." Artists who consort with poets and musicians should be accused of contributing to the delinquency of minor arts.

(6) It is not right for artists to plug their paintings as a valuable report or record of World Wars and Peace, or to pass themselves off as visionaries of cosmic orders or seismographs of universal disorders. Artists who claim they symbolized "Victory" in the Pepsi-Cola forties or the "Voice of America" in the post–Pepsi-Cola period or "the Atomic Age" should be found guilty of having given aid and comfort to the enemy.

(7) It is not right for an artist to make his bag of tricks a matter of life and death. Artists who send chills, however delicious, up curators' spines with warnings like "Let no man undervalue the implications of this work, or its power for life, or for death, if it is misused," should be charged with arson and false alarm.

(8) It is not right for artists to make themselves out "characters," bumpkins, or "ordinary chaps" and to instill in young and old followers the faith that "If this shmo can do it, so can I." Artists who cook up short art careers for friends and supporters, and are in turn confronted with "If these guys can do it, I can do it better," and finally with, "I'm the champ, they're the spoilers," should be disbarred for committing a public nuisance.

(9) It is not right for artists to spend their daytimes, on stage, playing "Good-time-Charlies" and "Hard-to-get-Gerties," and their nighttimes, behind the art scenes, being "Jack-the-Rippers." Artists who believe that it is just as easy to fall in love with a rich curator as it is with a poor critic, or that murder in art or artist-slaughter will not out, should have their entertainment licences revoked and their premises closed.

(10) It is not right for artists to encourage critics to think that sloppy impasto is Dionysian and that neat scumbling is Apollonian. Artists who peddle wiggly lines and colors as representing emotion should be run off the streets. Bad artists who, after years of hard pulling, finally make good paintings, and good artists who start pushing bad paintings for easy money, deserve the same punishment.

(11) It is not right for artists to think that painting is like prosti-

tution, that "first you do it for love, then you do it for others, and finally you do it for money." An artist who makes a living from his art should be registered as a "Lumpen-Artist," issued an identity card, and dismissed with a suspended sentence.

(12) It is not right for artists to feel it's all right to be "irascible" when young and without means, and "docile" when doddering and well-paid-off. Artists stricken with "fall-out" or "sell-out" should be institutionalized, pensioned, and enabled to lead a comfortable hand-out-to-mealy-mouth existence for the rest of their natural lives.

(13) It is not right for an artist who knows what's not right, and especially who is without sin, not to tell artists who don't know what's not right, what not to do, and not to cast the first stone.

Chapter Ten

Into the Seventies: Beyond the Object

JAMES MONTE

• The first public sign that a major change in artistic sensibility had taken place was an exhibition held late in 1968 in a warehouse in upper west-side Manhattan. The show, *Nine at Castelli,* introduced new talents and defined the direction of "post-minimal" art as, according to critic Max Kozloff, "an attack on the status of the object." The show stimulated an exhibition at the Whitney Museum in May–July, 1969, which further clarified the reaction against the hard gestalt shapes and volumes of minimal art. In the following catalogue essay, James Monte, a curator of the museum, discusses the nature of the new anti-formal art, characterized by dematerialization, chance, and arbitrary arrangements.

[FROM *Anti-Illusion: Procedures/Materials,* catalogue of an exhibition at the Whitney Museum of American Art, New York, 1969.]

The radical nature of many works in this exhibition depends less on the fact that new materials are being used by the artists than on the fact that the acts of conceiving and placing the pieces take precedence over the object quality of the works. It matters even less, for example, that Barry Le Va, Robert Morris, Rafael Ferrer or Michael Asher use such materials as felt, hay, ice, chalk, graphite, air or tissue; these materials have, after all, been used in the past by a significant minority of vanguard artists. The simple fact of their inclusion in art works is much less interesting than the way in which they are used. The notion that materials alone possess some shamanistic artistic prop-

erties, which, because of their new or exotic nature, can guarantee the quality of painting or sculpture has been consistently disproven by the offerings of many artists over the past few years. That fewer and fewer sculptors carve in granite, limestone, and marble and fewer painters use egg tempera in combination with oil glazes says nothing about the goodness or badness of those materials, but rather something about the changing ideas animating much of twentieth-century art. So one is reminded that changes in form and materials *may* result in truly interesting new works although not necessarily.

The painters and sculptors in this exhibition do not share a common philosophy or aesthetic. None is part of an artistic commune. What they do share became clearer as Marcia Tucker [Associate Curator, Whitney Museum] and I came to closer grips with the specific problems of this exhibition. During its organization, we discovered that the normal curatorial procedures of seeing and then selecting or rejecting works to be included could not be followed. After visiting numerous studios and galleries, as well as viewing slides and photographs, we discovered that the bulk of the exhibition would be comprised of painting and sculpture which we had not seen and would not see until perhaps one week before the opening date of the show. That this method of putting together an exhibition is risky for the artist as well as the Museum goes without saying. The artist must rely on his act, outside his studio, in a strange environment, within a short period of time, to carry the weight of his aesthetic position. In effect, what I'm saying is no more "Series." A picture in a series can look more or less good in a particular place, but it isn't crucial. Here the very nature of the piece may be determined by its location in a particular place in a particular museum. The piece may turn out to be one that could be re-shown elsewhere, and it may not.

For example, in the sculptures by William Bollinger, Barry Le Va, Robert Morris, Bruce Nauman, Richard Serra, Joel Shapiro, Keith Sonnier, Robert Rohm and the painting by Robert Ryman, each exists in either a de-objectified or scattered or dislocated state and in some instances the three conditions simultaneously. Another condition often found is the dependence on location, not merely as a site for the work, but as an integral, inextricable armature, necessary for the existence of the work. Robert Ryman's picture is painted on a standard, movable museum wall; the painting, one must conclude, exists for the

duration of the exhibition. Richard Serra's lead sculpture is a displayed act as much as it is an exhibited sculpture. Serra brought material, lead, and a saw with which to manipulate the dense metal, and set about transforming a location as well as leaving a sculpture. The transformation of site and material are visual coefficients in Serra's work. Joel Shapiro's convoluted nylon twine is loosely woven and stapled to a wall. The resultant object exists as an art work until it is removed from the wall site. It then becomes an art corpse set to rest in a plastic bag in a corner of the artist's studio. Keith Sonnier's sculpture uses the wall as a ground and in some instances as a trompe l'oeil pictorial plane. His sculpture is usually comprised of flocking material, impregnated cloth, and slender rope or cloth strands combined to form a low relief surface. The work alludes to a flatness, flatter than it actually us. A curiously muted reversal of illusion occurs in the following manner: a given section of flocking substance, overlaid by a hanging section of cloth or rope, appears to revert to a painted facsimile of itself rather than aggressively pushing toward the viewer as a bulging relief. An inverse trompe l'oeil action undermines the already evanescent character of the materials Sonnier chooses to use.

Barry Le Va has said that he is not necessarily concerned with the specific language of certain materials, but more with the materials as the language of a specific idea or concept. His earlier pieces, made during 1966–67, reflected the working-out or application of material in the service of a predetermined idea about form. The newer works completed in 1968–69 are conceptual as well, but with an additional emphasis, that of time. Rather than distributing and relating felt fragments in small or large agglomerates on a floor, Le Va uses combinations of materials such as bulk chalk and mineral oil in conjunction with paper or cloth elements. The process which occurs when the materials are mixed allows the work to change over a period of hours or days, depending on the degree of dryness or dampness, absorption or saturation, which depends in turn on the mix ratio of the materials. Le Va is able to use time as a substantial element in the recent pieces; he can project the sequential development of the work in a way analogous to that in which a biologist estimates the growth of micro-organisms developed in a laboratory. The analogy is perhaps apt in another way as well. The biologist confirms the growth rate

of his culture by examining and recording its change. Among other tests to be made on the culture, its growth rate is presumably important to the scientist. It is important for Le Va as well; once he knows how various substances interact, he can then use the elements as they act with and on each other after he has, in a sense, given himself to them for a period of apprenticeship. He must empathize with their cycle as well as with their materiality, as the scientist must with his micro-organisms. Le Va views his discoveries objectively and, unlike the traditional painter or sculptor, has little interest in manipulating those materials in order to produce a series of works based on a single set of confluences. Le Va, like many of the other artists in this exhibition, willfully changes the circumstances in which he works the moment the possibility of extending those circumstances ceases to exist.

Carl André, Lynda Benglis, John Duff, Eva Hesse, Robert Lobe and Richard Tuttle continue to produce objects which might be termed discreet and in most cases recessive. André does, as Philip Leider pointed out, "make sculpture." But Leider adds, "Somewhat like Dan Flavin, the order which André imposes on materials is not designed so much to create an object as to create a set of conditions which we experience as art. . . ."

Therein lies the difficulty of talking about André's sculpture: sometimes it is firmly tied to sculptural tradition, no matter that it hugs the ground; at other moments it seems to be an environmental episode, some sort of architectural subversion that exhales an art quality while at the same moment criticizing the environment which cannot contain it in a conclusive manner.

It is this inconclusive quality which André's sculpture shares with works as formally diverse as those by Benglis, Duff, [Neil] Jenney, Lobe and Tuttle. There exists in the sculpture made primarily of joined wood and wire by Lobe and Duff a suggested possibility of environmental extension. One cannot disregard a reading of their pieces which includes an architectural ambition to build some form of habitation. Jarring if inconclusive functional references are likely to occur in Neil Jenney's sprawling pieces. His environmental sets can be likened to a mixed metaphor which traps and bemuses the onlooker.

What at first appeared to be an aesthetic of impoverishment, frozen

between layers of latex or plastic in Eva Hesse's sculptures, is simply not that on continued viewing. Whether her works are diminutive and intended to be hand-held or made on a grand scale, her finest sculpture has a unique animus which is anthropomorphic in quality if not intent. Her work alludes to human characteristics such as the softness of skin, the swell of a muscle or the indeterminate color of flesh fading under clothing after exposure to a summer sun.

The air sculpture by Michael Asher reveals a sensibility quite opposite to that possessed by Eva Hesse. Asher's sculpture is literally a curtain of air defining the height, width and depth of an entrance from one gallery to the adjacent gallery. The piece is a cubic volume of space, circumscribed by an activated air mass within the confines of that space. The space is acknowledged by the pressure felt when moving into or out of its confines. The disembodied literalism of the piece neatly alludes to a slab form without carpentry. Feeling and therefore knowing replaces the cycle of seeing and hence knowing the sculptural presence.

The fact that so many artists were willing to risk challenging the terms within which they have operated in the past in so direct a manner became one of the primary reasons for holding the exhibition. Connoisseurship became a secondary issue—how can an artist make a sculpture or paint a picture without opportunity to reflect on its perfectability? Whether it is good or isn't depends entirely on seeing it in place, which isn't possible in a museum. So the answer is that the artist *cannot* reflect on his work in the usual manner under the conditions I have described. And since serious artists care very much about what they can and cannot do, it became apparent that these artists cared about a set of ideas which included responses to materials, time and creative acts which absolved them from other more traditional responses to their work.

One of the most conservative or traditional properties of modern art is its reliance on style. The signature of virtually every modern painter and sculptor has been his style, or series of styles. Style replaced illusion while at the same moment it gave the individual artist the area within which he could develop his art. Most of the artists in this exhibition have chosen to slip around style (it's difficult to ignore or defeat) by concentrating on their individual acts. One could properly ask how an artist eludes style if one of his art acts

follows another. One sure-fire method is by constantly changing materials or even media. Another is to conceive each work in terms of the freedoms and limitations of a particular time and place. Many of the artists in this exhibition do just that. It is, of course, absurd to deny that there are not internal links from one work to the next, no matter if one is "sculpture," the other "dance" and the next "film"; what I am proposing is that there exists a lack of interest in stylistic consistency.

Since it can be argued with some effectiveness that artists are of necessity extremely practical people whose adjustment to their living conditions is often audacious, the following remarks are perhaps pertinent. Artists, particularly sculptors, are faced with enormous problems, such as procurement and storage of materials, storage of unsold works, transportation costs, not to mention the time and cost of completing large works. Those who teach are fortunate enough to have the use of student help and often the facilities of the university or art school where they teach. Most are not so fortunate and as a result much of their early work does not survive intact. Bitter as this may be, even more bitter are the crippling effects of not being able to produce on the development of these artists. The most obvious way to develop is by working through as many problems as ambition, time and money will allow. The effects of being able to work through a series of problems quickly, in full scale, was remarked on by Richard Serra who commented, ". . . so I was able to discard a lot of ideas while working through ten or twelve pieces in Europe and I also discovered what I wanted to do for a particular piece to be shown here. . . ."

What I have attempted to show is the basically healthy attitude shared by the artists in this exhibition toward their working methods, materials and environment. Healthy not as in "mental health" but as descriptive of their relations to tradition; these artists have assimilated an array of complex formal and social problems within the art world and have offered solutions which are often startlingly original.

One of the most interesting characteristics of post-war American art is the speed with which it reveals itself. No matter what happens, it seems to happen fast. It's as if the *furor poeticus* of the Futurist Manifesto had become the guiding principle of all activity. One becomes acutely aware of time as an independent element as one becomes

aware of human energy as an element in time. A revelation of art energy made visible in a short period of time seems to be the very basis upon which major post-war American art rests. Illusion is a key factor in arresting or slowing the energy flow from the art object to the onlooker; the instant response, wherein the spectator must of necessity be arrested by the aesthetic experience for a moment, is given over to examination and perhaps delectation. Most major post-war American art rigorously denies that particular kind of delectation time to the viewer by treating illusion in a very measured way. The viewer who is disappointed by a Jackson Pollock painted in 1947 or by a Kenneth Noland painted twenty years later is probably disappointed because he misunderstands the context within which he is forced to confront these works. The rigor with which these artists (and others) deny a viewing of their works outside the non-illusionistic limits they have prescribed leads directly to the anti-illusionist paintings and sculptures in the present exhibition.

With the American abstract-expresisonist artists providing an historical scrim at the back of a hypothetical stage, the figures of Marcel Duchamp, Jasper Johns, Robert Rauschenberg, Claes Oldenburg and finally Robert Morris fill out a kind of cast of influences for many of the artists included in the exhibition. It is Robert Morris who provided a significant minority of the artists with intellectual stimulation, attention and help through his writing about their art, teaching, and organizing an exhibition of their works. It was Morris who established, in his writing, the links between Pollock's concern for the innate property of semi-viscous paint and the current close examination of the properties of various materials.

The very tough logic underlying the best post-war American abstract art combined with a kind of art systems analysis, brilliantly conceived by Claes Oldenburg, seems to account for at least a portion of the history behind these artists' works. Oldenburg's superior rationalism in dealing with sculptural form, his carrying over of form from one material to the next, his environmental concerns, all contributed to a kind of climate of open possibilities.

It becomes apparent as one walks through the exhibition that each of the artists presumes very little about the procedures or materials with which he makes his art. Nor is there presumption about where and how the objects should be seen. In many cases, the artists control

the very life-span of their individual works. Factors such as material disintegration or physical change are integrally contained within a number of objects. Taken singly or in combination, the procedural factors alone seriously call into question how art should be seen, what should be done with it and finally, what is an art experience.

ROBERT MORRIS

• The leading apologist for "auto-form," distributional, and ephemeral art, Robert Morris exhorted artists to renounce the object because of its commercial commodity value.

———————

[FROM "Notes on Sculpture," Part III, *Artforum*, April, 1969.]

Beyond Objects

What was relevant to the sixties was the necessity of reconstituting the object as art. Objects were an obvious first step away from illusionism, allusion and metaphor. They are the clearest type of artificial independent entity, obviously removed and separate from the anthropomorphic. It is not especially surprising that art driving toward greater concreteness and away from the illusory would fasten on the essentially idealistic imagery of the geometric. Of all the conceivable or experienced things, the symmetrical and geometric are most easily held in the mind as forms. The demand for images that could be mentally controlled, manipulated, and above all, isolated was on the one hand an esthetic preconception and on the other a methodological necessity. Objects provided the imagistic ground out of which sixties art was materialized. And to construct objects demands preconception of a whole image. Art of the sixties was an art of depicting images. But depiction as a mode seems primitive because it involves implicitly asserting forms as being prior to substances. If there is no esthetic investment in the priority of total images then projection or depiction of form is not a necessary mode. And if the method of working does not demand pre-thought images, then geometry, and consequently

objects, is not a preferential form and certainly not a necessary one to any method except construction.

Certain art is now using as its beginning and as its means, stuff, substances in many states—from chunks, to particles, to slime, to whatever—and pre-thought images are neither necessary nor possible.

Alongside this approach is chance, contingency, indeterminacy— in short, the entire area of process. Ends and means are brought to- gether in a way that never existed before in art. In a very qualified way, Abstract Expressionism brought the two together. But with the exception of a few artists, notably Pollock and Louis, the formal struc- ture of Cubism functioned as an end toward which the activity in- variably converged and in this sense was a separate end, image, or form prior to the activity. Any activity, with perhaps the exception of un- focused play, projects some more or less specific end and in this sense separates the process from the achievement. But images need not be identified with ends in art. Although priorities do exist in the work under discussion, they are not preconceived imagistic ones. The priori- ties have to do with acknowledging and even predicting perceptual conditions for the work's existence. Such conditions are neither forms nor ends nor part of the process. Yet they are priorities and can be in- tentions. The work illustrated here involves itself with these considera- tions—that which is studio-produced as well as that which deals with existing exterior zones of the world. The total separation of ends and means in the production of objects, as well as the concern to make manifest idealized mental images, throws extreme doubt on the claim that the Pragmatic attitude informs Minimal art of the sixties. To be- gin with the concrete physicality of matter rather than images allows for a change in the entire profile of three-dimensional art: from particular forms, to ways of ordering, to methods of production and, finally, to perceptual relevance.

So far all art has made manifest images whether it arrived at them (as the art in question) or began with them. The open, lateral, random aspect of the present work does in fact provide a general sort of image. Even more than this, it recalls an aspect of Pollock's imagery by these characteristics. Elsewhere I have made mention of methodological ties to Pollock through emphasis in the work on gravity and a direct use of materials. But to identify its resultant "field" aspect very closely with Pollock's work is to focus on too narrow a formalistic reading.

Similar claims were made when Minimal art was identified with the forms found in previous Constructivism.

One aspect of the work worth mentioning is the implied attack on the iconic character of how art has always existed. In a broad sense art has always been an object, static and final, even though structurally it may have been a depiction or existed as a fragment. What is being attacked, however, is something more than art as icon. Under attack is the rationalistic notion that art is a form of work that results in a finished product. Duchamp, of course, attacked the Marxist notion that labor was an index of value, but Readymades are traditionally iconic art objects. What art now has in its hands is mutable stuff which need not arrive at the point of being finalized with respect to either time or space. The notion that work is an irreversible process ending in a static icon-object no longer has much relevance.

The detachment of art's energy from the craft of tedious object production has further implications. This reclamation of process refocuses art as an energy driving to change perception. (From such a point of view the concern with "quality" in art can only be another form of consumer research—a conservative concern involved with comparisons between static, similar objects within closed sets.) The attention given to both matter and its inseparableness from the process of change is not an emphasis on the phenomenon of means. What is revealed is that art itself is an activity of change, of disorientation and shift, of violent discontinuity and mutability, of the willingness for confusion even in the service of discovering new perceptual modes.

At the present time the culture is engaged in the hostile and deadly act of immediate acceptance of all new perceptual art moves, absorbing through institutionalized recognition every art act. The work discussed has not been excepted.

EVA HESSE

• Although she did not live to experience the international success of her vision of an art both poetic and absurd, Eva Hesse produced a substantial oeuvre that focused on the expressive property of materials and nongeometric structures.

Eva Hesse

[FROM Cindy Nemser, "An Interview with Eva Hesse," *Artforum,* May, 1970. The interview was published in its entirety in Cindy Nemser, *Art Talk: Conversations with Twelve Women Artists* (New York: Scribner's, 1975).]

I do think there is a state of quality that is necessary, but it is not based on correctness. It has to do with the quality of the piece itself and nothing to do with neatness or edges. It's not the artisan quality of the work, but the integrity of the piece. . . . I'm not conscious of materials as a beautiful essence. . . . For me the great involvement is for purpose—to arrive at an end—not that much of a thing in itself. . . . I am interested in finding out through working on the piece some of the potential and not the preconceived. . . . As you work, the piece itself can define or redefine the next step, or the next step combined with some vague idea. . . . I want to allow myself to get involved in what is happening and what can happen and be completely free to let that go and change. . . . I do, however, have a very strong feeling about honesty—and in the process, I like to be, it sounds corny, true to whatever I use, and use it in the least pretentious and most direct way. . . . If the material is liquid, I don't just leave it or pour it. I can control it, but I don't really want to change it. I don't want to add color or make it thicker or thinner. There isn't a rule. I don't want to keep any rules. That's why my art might be so good, because I have no fear. I could take risks. . . . My attitude toward art is most open. It is totally unconservative—just freedom and willingness to work. I really walk on the edge. . . .

It's not a simple question for me. . . . First, when I work it's only the abstract that I'm working with, which is the material, the form it's going to take, the size, the scale, the positioning, where it comes from, the ceiling, the floor. . . . However I don't value the totality of the image on these abstract or esthetic points. For me, as I said before, art and life are inseparable. If I can name the content, then maybe on that level, it's the total absurdity of life. If I am related to certain artists it is not so much from having studied their works or writings, but from feeling the total absurdity in their work. . . .

Absurdity is the key word . . . it has to do with contradictions, and oppositions. In the forms I use in my work the contradictions are certainly there. I was always aware that I should take order versus chaos, stringy versus mass, huge versus small, and I would try to find

the most absurd opposites or extreme opposites. . . . I was always aware of their absurdity and also their formal contradictions and it was always more interesting than making something average, normal, right size, right proportion. . . .

I think that there is a time element in my use of the circle. It was a sequence of change and maturation. I think I am less involved in it now . . . in the last works I did, just about a year ago, I was less interested in a specific form like the circle or square or rectangle . . . I was really working to get to a non-anthropomorphic, non-geometric, non-non. . . .

When I came back from Europe, about 1965–66, I did a piece called *Hangup.* It was the most important early statement I made. It was the first time my idea of absurdity or extreme feeling came through. It was a huge piece, six feet by seven feet. The construction is really very naïve. If I now were to make it, I'd construct it differently. It is a frame, ostensibly, and it sits on the wall with a very thin, strong but easily bent rod that comes out of it. The frame is all cord and rope. It's all tied up like a hospital bandage—as if someone broke an arm. The whole thing is absolutely rigid, neat cord around the entire thing. . . . It is extreme and that is why I like it and don't like it. It's so absurd to have that long thin metal rod coming out of that structure. And it comes out a lot, about ten or eleven feet out, and what is it coming out of? It is coming out of this frame, something and yet nothing and—oh, more absurdity?—is very, very finely done. The colors on the frame were carefully gradated from light to dark—the whole thing is ludicrous. It is the most ridiculous structure that I ever made and that is why it is really good. It has a kind of depth I don't always achieve and that is the kind of depth or soul or absurdity or life or meaning or feeling or intellect that I want to get. . . . I know there is nothing unconnected in this world, but if art can stand by itself, these really were alone.

JACK BURNHAM

• One of the leading defenders of conceptual art, Jack Burnham describes its linguistic and philosophical sources, as well as its debt to Marcel

Duchamp, who believed in an art of ideas. Burnham's insistence that art is a game reflected the art-game strategy of many younger artists in the seventies.

[FROM "Problems of Criticism," IX, *Artforum,* January, 1971.]

Joseph Kosuth, a young artist eminently disliked by Formalists, Antiformalists, and even a number of his Conceptualist colleagues, has performed a valuable service for the art world, one which has been mainly lost on the art establishment. When, fifty-five years ago, Ludwig Wittgenstein recognized that the bankruptcy of German Neo-Idealism and British Logical Empiricism lay in an inability to cope with or use ordinary language, the philosopher saw his mission as a kind of psychotherapist. Much of his therapy involved explicating the absurdities resulting from the misuse of language, or as he would say, "converting concealed nonsense into overt nonsense." He saw that neither applying metaphysics nor science to language could work, but only using language as it is meant to be used, *i.e.,* understanding the natural limitations and logic of ordinary language. Acting in a similar capacity, Kosuth—like Daniel Buren and a few others—has partially revealed the bankruptcy of historical avant-gardism mainly by demonstrating that avant-garde art operates according to transparently logical mechanisms. Merely by understanding and using some of these, the artist reveals their inherently linguistical nature at the same time that he becomes enmeshed in their historical superstructure. The illogicality of every mythic assumption is exposed by a simple test: do not act out the myth; rather act out the wishful thinking motivating mythmakers.

But what about excellence or individualism? Are they dead, or, more likely, is the framework which proscribes certain acts by certain individuals as excellent under reconsideration? Remember that every critic ties him- or herself to a stable of artist superstars. The tacit assumption is that whoever keeps his or her superstars visible for the longest time becomes, in effect, a meta-superstart. Individualism does not die, just the convenient notion that it is invested in certain glamorous individuals. . . .

Into the Seventies

The sudden transference of some avant-garde artists to politics stems from a desire to find a viable revolution, one providing the needed psychological surrogate. Presently avant-gardism can only mean revival, unacceptable inconoclasm, or the deliberate presentation of nonart. This, of course, is bad news to the critics who have enjoyed the major portion of their careers amplifying praise for avant-garde heroes while damning various purveyors of "bad art" and esthetic license. While Harold Rosenberg fits this description, he is a critic who continues to make intelligent and insightful commentary on an art world which he finds less and less to his liking. In regard to recent conceptually oriented exhibitions Rosenberg writes:

> The dilemma of the museum is that it takes its esthetic stand on the basis of art history, which it is helping to liquidate. The blending of painting and sculpture into decorative media, the adulteration of styles, the mixing of genres in order to create an "environment" for the spectator have completed the erosion of values derived exclusively from the art of the past which was begun by the avant-garde movements. What is needed to replace those values is a critical outlook towards history and the part of creation in contemporary culture, politics, and technology. Esthetics does not exist in a vacuum. The museum seems unaware [of] how precarious it is to go as far out from art as it has on no other foundation than its simple-minded avant-gardism. In the direction it has taken, nothing awaits it but transformation into a low-rating mass medium.*

This is the old story of the revolution that revolutionizes itself out of existence. On the scenes are mediators who attempt to hold the center by welding feuding factions together or by excommunicating the "bad apples" who are incapable of recognizing the boundaries of approved revolt. Most ironic is the art world's rejection of science and technology without realizing that the same ethos of "progress" that characterized technological change in the nineteenth and twentieth centuries is equally responsible for the illusion of avant-garde art. Such critics are caught in an even tighter dilemma. How can they understand the history of modern art—that rationale that has led to the apparent dangers of technological art and Conceptualism—if they cannot comprehend that these trends represent a *reductio ad absurdum* of the entire notion of artistic change?

* "Dilemmas of a New Season," *The New Yorker,* October 10, 1970, p. 154.

Given the circumstances, the stifling sensation among avant-garde artists of being able to go neither backwards nor forwards is to be expected. By challenging the illusion of perpetual change in modern art, we strike at the heart of the myth. Being linguistical, art cannot evolve or progress; it can only define the parameters of linguistic expression allotted to it. Thus it is my guess that within five years many of the following hypotheses will be verified and generally accepted by at least some younger art historians:

(1) Examples of high art contain unconsciously perceived structural relationships; the notion that high art evolves is the result of code changes that adhere to certain myths with diachronic features.

(2) Stylistic changes in modernist art closely adhere to a progression sometimes referred to as "[Roman] Jakobson's Law"; this linguist has shown an inverse relationship between deterioration of an aphasic's speech concurrently on the phonological level (signifier in art) and the semantic-syntactical level (signified in art) *and* the development of speech competency for young children.

(3) Art is a sign system that adheres to Louis Hjelmslev's double system of articulation; normal art is defined *both* by a plane of content and a plane of expression; where one or the other is lacking, the omission is explained by the convention of dropped signifiers or signifieds which appears in a higher level system of the semilogical analysis.

(4) All works of art conform to a basic linguistic unit, the sentence; furthermore works of art obey grammatical forms found in four sentence types; these consist of (a) simple sentences; (b) compound-complex sentences including those with both deep and surface ambiguities; (c) a sentence with some disagreement between subject and predicate; (d) "elliptical" sentences or expressions completed contextually (*i.e.*, within the framework of art history); and (e) "phatic" expressions (also called "ready-made utterances" according to Ferdinand de Saussure's term *"locutions toutes faites"*).

(5) In essence all varieties of art conform to simple but fundamental procedures rooted in rituals many thousands of years old.

(6) By 1912 to 1914 Marcel Duchamp generally understood all the above hypotheses.

If the above hypotheses prove to be true, then the artist would appear to be left with little if anything to do—aside perhaps from

political Agitprop functions. In other words, *the driving force of avant-gardism has been its mystique as an undetected syntactical structure.* Once detected, art becomes an elaborate and beautiful game.

RUDOLPH ARNHEIM

• Opposed to Burnham's enthusiastic defense of conceptual art as non-art, Rudolf Arnheim criticized its intellectual pretensions.

[FROM ". . . And This Is About Conceptual Art," *The New York Times,* July 13, 1974.]

When I was lonely I used to look at the moon and tell myself that the same moon could be seen at the same moment across the sea by the persons I loved. In that comforting thought there was a germ of poetry, good enough perhaps for the notebook of a writer; but it was no poem.

Had I asked my friends abroad to take a photograph of the moon at the same time that I was taking one myself, and had I then pasted the snapshots on a piece of paper together with a short description of the procedure and offered the whole thing to a gallery for sale at $1,000, I would have created a work of conceptual art.

Much too long have we played the fruitless game of trying to decide which objects are art and which are not. This has left us wholly unprepared when anyone choosing to be an artist presents any object or action for exhibition. Criteria derived from painting and sculpture have been applied although they have not fit. The discrepancy is startling enough to keep the undernourished thing alive.

How about trying the opposite approach for a change: Instead of carrying the discards of daily behavior to the exhibition rooms of art, how about looking for art around us and within us?

Artists have become alarmed about art having to subsist in a diving bell. They are expected to breathe art in their studios, and their public has tried to do the same in museums. But outside the studio and the museum there is no art. This state of affairs cannot continue because

art has never grown from anything but the poetical overtones of all daily living.

What is needed is a revival of that pervasive symbolism so common in unimpaired cultures. Not long ago in Grand Central Station I noticed an elderly woman lugging a suitcase. "Heavy, isn't it?" I said. And she, with an Old World accent, "The whole life is heavy!"

In this woman the poetical basis of art still existed. For her, the depth of wisdom still resided in the surface of appearance. Without this basic coincidence there can be no art; and some artists have undertaken to restore it. But how are they going about it? They are rejecting one kind of art object, only to replace it with another. They are not willing to issue a decree: "The production of art objects is suspended while our minds are being reconditioned."

They believe that they are replacing percepts with concepts; but that is bad psychology. What these artists are really doing is replacing paintings and sculptures with mental images. And they forget that mental images are nothing new. In fact, art has never been anything else: not canvas or wood or stone, but mental images created by those objects. And art remains mental imagery, even if one calls it conceptual and pretends to have given up the world of the senses.

The basic tie to the senses can be camouflaged with the tough language of exact science, which supposedly deals with concepts. In their statements, conceptual artists sport precise measurements and specifications: "On Jan. 9, 1969, a clear plastic box measuring $1'' \times 1'' \times \frac{3}{4}''$ enclosed within a slightly larger cardboard container was sent by registered mail . . ." When such precision is irrelevant, it parodies science, as Rabelais and Sterne did so long ago, or it attempts to profit from the authority of impersonal matter-of-factness. A box was mailed. The data speak. At best, the artist conjures up those beautiful, unconceptual reveries that sprout from scientific descriptions.

The thought experiments proposed by conceptual artists are no more alien to the senses than the imagery of traditional art. They are useful exercises of the imagination. They should not be called "works" because that term conceals the modesty of the accomplishment, and they are not works but scores, records, instructions.

They should be published in newspapers, next to the columns on physical fitness and good eating habits. They are not gallery material

but simple lessons to be practiced by everybody until our minds can listen again to the symbolic speech of things around us. Once we profit from the training, art objects may make sense again.

BRUCE NAUMAN

• Among the younger artists experimenting with new forms such as "body art," Bruce Nauman explains his interest in documentary images. In his post-abstract work, reproductive media are used to revive representation of the human face and figure.

[FROM "The Way Out West: Interviews with Four San Francisco Artists," an interview by Joe Raffaele and Elizabeth Baker with Bruce Nauman, *Art News*, Summer, 1967.]

[It's called] *A Wax Mold of the Knees of Five Famous Artists*, although it's made out of fiberglass, and they are my knees. I couldn't decide who to get for artists, so I used my own knees. Making the impressions of the knees in a wax block was a way of having a large rectangular solid with marks in it. I didn't want just to make marks in it, so I had to follow another kind of reasoning. It also had to do with trying to make the thing itself less important to look at. . . . I suppose my work must have to do with some of the things the Dadaists and Surrealists did. I like to give the pieces elaborate titles the way they did, although I've only been titling them recently.

[FROM an interview by Willoughby Sharp with Bruce Nauman, *Arts Magazine*, XLIV (March, 1970).]

I've always been interested in graphics, prints, drawings and paintings and I was a painter before I started making sculpture. I guess I first started using photographs to record *Flour Arrangements*. Then I started thinking about the *Fountain* and similar things. I didn't know how to present them. I suppose I might have made them as paintings at that time. In fact, I think I did get some canvas and

paint but I had no idea of how to go about making a painting anymore. I didn't know what to do. Perhaps if I had been a good enough painter I could have made realistic paintings. I don't know, it just seemed easier to make the works as photographs. . . . The problems involving figures are about the figure as an object, or at least the figure as a person and the things that happen to a person in various situations—to most people rather than just to me or one particular person. . . .

I think of . . . going into the studio and being involved in some activity. Sometimes it works out that the activity involves naming something, and sometimes that the activity is the piece.

RICHARD SERRA

• Although videotape is a favored medium for process- and performance-oriented artists like Nauman, Keith Sonnier, and Lynda Benglis, a number of artists involved in transcending the limits of making static objects are working on film. But, as Richard Serra comments, their interest is not with literary narrative, but with a self-referential, perceptual experience.

————————

[FROM "Play It Again, Sam," *Arts Magazine,* XLIV (February, 1970).]

A shift in interest in recent films is from subject matter, qua literature which utilizes a narrative time, to that of those films in which time can be equated with "live time" or with procedural time: the time of the film in its making. This refocus of time is not merely a subject matter allusion; *i.e.,* the viewer does not simply become the subject in relation to the object (the form of most on-going theatre) but instead experiences the time and place of subject and object simultaneously.

The potential of the camera as an active device (*tool*) is being considered not only for its perceptual possibilities, but as an element in the structure. Means and ends are being made explicit.

Into the Seventies

NANCY GRAVES

• Although the abstract art of the sixties had neglected subject matter to concentrate on formal problems, the subject of art once more became pressing for artists in the seventies as it had been in the fifties. Now, however, rather than searching for subjects in Freudian dream imagery or Jungian archetypes, younger artists took a more factual, scientific, objective, and documentary approach to subject matter. Photographs served many younger artists like Nancy Graves and Chuck Close as points of departure for paintings, although Graves uses the cosmic image of meteorological maps and Close paints banal portraits of friends and acquaintances enlarged to mythic movie-screen dimensions.

[FROM *Nancy Graves,* catalogue of an exhibition at the La Jolla Museum of Contemporary Art, La Jolla, California, 1973.]

Lexicon of Mapping

The map is a systematic presentation on a surface of the nature and distribution of phenomen[a] in space.

The main properties of mapping are shape, area, distance and direction.

A good map has mastered the complexities of nature and idea and resolved them as to form a necessary—utilitarian—design.

Maps and charts visualize what is abstract in nature as well as what is too immense to be seen. . . .

The science of measuring by photography is photogrammetry. What the airborne camera brings down from the sky is a load of field notes in the form of spatial relationships between images that as such are intrinsically accurate but that as abstract information are only more or less complete.

[FROM a press release for *Nancy Graves,* an exhibition of drawings at the Albright-Knox Art Gallery, Buffalo, New York, 1974.]

Statements by the Artist

One of the reasons I have chosen specific images is that it leaves me freer to investigate the boundaries of art-making. If you know what it is you must do you can forget it and get on with the business of seeing.

What is the boundary between time and the mind: philosophical, archaeological, paleontological, morphological, genealogical, spatial-scientific; and perception: the way the work of mine is to be read/seen?

Variability and repetition of similar forms in relationship to the shifting evaluation of idea and execution is an attitude that occurs in the sculpture, film and painting.

To devise a visual schema which plays upon the identity and usage of an image through illusionist/philosophical permutation is to question the object.

CHUCK CLOSE

[FROM Linda Chase, Nancy Foote, and Ted McBurnett, "Photo-Realists: Twelve Interviews," *Art in America*, LX, No. 6 (November–December, 1972). Interview with Chuck Close by Linda Chase and Ted McBurnett.]

I go to a great deal of trouble to get the specific kind of photograph that is going to have the kind of information that's interesting to me: texture, elaborate depth of field—and the distance I shoot them from is important. I don't want the eyes to follow you like in a traditional portrait, but I also don't want them to be staring through people. If the camera is about six feet away from the subject, it turns out about right.

Yes, I think sometimes people think that just because you use a photograph there is only one kind of painting that could be made. Just as many different kinds of paintings can be made from a photograph as from life. You look at certain things rather than others, and some people prefer a greater degree of fidelity to the information on the photograph than others.

I am trying to make it very clear that I am making paintings from photographs and that this is not the way the human eye sees it. If I stare at this it's sharp, and if I stare at that it's sharp too. The eye is very flexible, but the camera is a one-eye view of the world, and I think we know what a blur looks like only because of photography. It really nailed down blur. It's this elusive thing, and the camera gives you information that was too difficult to deal with otherwise.

At first I just had everything from the nose back to the cheeks sharp, and that defined the back edge of the focus. Then I decided that I wanted to make it a much shallower depth of field, and have the tip of the nose begin to blur, and I would have a sandwich. I would establish both dimensions of the focus. In the first one it obviously happened by accident, but I liked what happened. I liked the fact that I wasn't thinking of the cheek in relation to the ear and trying to decide which was closer and which farther away—a kind of traditional "things in front, things in the middle, things in the back" kind of reading—that if a person were simply panning across or scanning the cheek and some informational change took place, he would realize that he was moving back and forth in space. To the degree that something is out of focus, other areas that are similarly out of focus are on the same level in space. It gives me different constants to deal with. It's different to make a blurry soft thing than it is to make a hard thing.

I have nailed down the size; my black-and-white paintings are all the same size, and the color paintings are all the same, and I have a system for how the head is going to fit into the rectangle. The head is going to be so big, it's going to come so close to the top edge, and it's going to be centered left and right. I just didn't want to worry about composition as I had for so long. One of the reasons I wanted to make these paintings originally was that I had worried for so long about pulling paintings off. I would have good days and bad days. The painting would be up, it would be down. I would be fixing one corner and the whole other corner would go to pieces. I was thinking about painting as "first aid," and when I got the painting patched up I would call it quits. I decided to determine what the attitude was and try to maintain it and just go through the painting. Every day

Robert Hughes

I got more done, and eventually it would be completed. If it wasn't good it was the whole painting that was not good.

After a while with the black-and-white paintings I began to get the cliché marks again, so I decided to change the problem. But I didn't want to change everything, so I decided I would alter one variable and try color. The minimum number of colors to get full color is three, so I had the transfers made and started trying color. I used to have five or six favorite colors that I would use. Now I use three colors and I have to use all three. I can't prefer one to the other. Every square inch has some of all three. One result is that I'm mixing colors I never made in my life. I find it very liberating to accept things from the start as the eventual issues in the painting.

Every limitation I have made has just opened things up and made it much more possible to make decisions. When everything in the world was a possibility I only tried three things or four things over and over. It's true. It's incredible. I didn't take advantage of that supposed freedom, and once I decided I was going to have relatively severe limitations, everything opened up: I have the possibility of making decisions about things other than how I feel on a certain day, etc. I was never happy inventing interesting shapes and interesting color combinations because all I could think of was how other people had done it. I couldn't get other people out of my paintings because the only solutions were the ones that were already nailed down. Now there is no invention at all; I simply accept the subject matter. I accept the situation. There is still invention. It's a different kind of invention. It's "how to do it," and I find that, as a kind of invention, much more interesting. I do think approaching a painting that way —with any kind of self-imposed discipline—ultimately affects the subject matter. That's what sustains me. I'm not concerned with painting people or with making humanist paintings.

ROBERT HUGHES

• In a critique of enormously popular Photo-Realism, Robert Hughes compares the new style with nineteenth-century academic realism, which also tried to rival photography in factual accuracy.

Into the Seventies

[FROM "An Omnivorous and Literal Dependence," *Arts Magazine,* XLVIII (June, 1974).]

In a sense, Photo-Realism is the last of the imperial Yankee art styles, the end product of the dubious infatuation with Masscult which has been propelled forward in the New York art-world for the last dozen years: a manner of painting from photographs (generally 35 mm. color slides, whether "found" or purposely made) in a state of extreme and non-committed cool. A plethora of highly-finished detail is substituted for the iconic generalizations of Pop Art, but the stance is otherwise similar. Photo-Realism forms a limited but energetically promoted enclave within the general realist "revival" in American art—a revival formed not so much by the sudden blossoming of a thousand unexpected flowers, but rather due to a tardy recognition that culture is pluralistic, and that a rigidly formalist party line that excludes an enormous range of figurative painters, from Philip Pearlstein and William Bailey to Fairfield Porter, Sylvia Mangold or Joseph Raffaele cannot, however convenient it may seem, work as a contemporary description. There is no sense in which Photo-Realist art can be called the spearhead of this realist movement (or revival); in fact, it is comporatively *retardataire.* But it has the merit (for promotional purposes) of being highly recognizable—a stylistic package which has been made to serve the nostalgia for "movements," for that linear and exclusivist habit of thought which believes that, at any given time, there *must* be a dominant art style. . . .

All Photo-Realist art now provides is a replay of the *mechanical* uses of photography that were standard small change of salon art in the last quarter of the nineteenth century; these, even in their time, were recognized as a step down from the brilliant exploration of the creative relationship between photograph and painted image which had been conducted by a succession of nineteenth-century artists, from Delacroix and Courbet to Degas and Caillebotte. By 1890, as Aaron Scharf points out in *Art and Photography,* the hegemony of the photo-derived and painted image in the annual Salons and Royal Academy exhibitions was complete. And like Photo-Realism today, it struck its critics then as degenerate: a matter, wrote one, of "mere colored photographs without grace, pathos, awe, life or imagination . . . as ugly, as crude, as unpleasant, as photographic as canvas and dull paint can

make them." "It is impossible to deny," ran an article in the June 1893 issue of *The Studio,* "that many modern schools of painting appear to have taken a view of nature as the camera depicts it. The academic composition of landscape or figure subjects is for the moment set aside in favor of more or less haphazard arrangements that show the apparently careless grouping which a snapshot from a Kodak presents." This, the author lamented, signified a considerable change of taste: "The masses now prize statistics, measurements, and textures more than abstract beauty, color harmonies, or decorative composition." . . .

Politicians don't ignore the polls. For an artist to ignore public taste would be like a politician ignoring the attitudes of his constituents. Thus painters like [Ralph] Goings, [Richard] McLean, [Robert] Bechtle and [Don] Eddy are elevated, at a stroke of the pen, from artists scrambling like most other artists as best they can for some kind of media success into the elected representatives of The People. It is a dazzling apotheosis: democracy in action, at last transcending that tedious and bloody scramble of juntas or "movements" for historical supremacy which, in the caricaturing terms of routine art-pedagogy, is so often presented as the story of twentieth-century culture.

Moreover, once you have striven to expunge all "humanist" or "subjective" or "personal" traces from representational art, giving it the aggressively value-free character of an inventory, you are apt to be stranded in a body of work that looks intimidatingly clear and didactic but, in reality, has nothing whatever left to do. Photo-Realism, like conceptual art, is obsessed with "information." Information, of course, is the party word of the seventies, as flatness was in the sixties and gesture in the fifties. But applied as it is to these painstaking manual enlargements of photographs, it is a misnomer. What the paintings actually offer—whether the subject is the wreathed pipes and glittering cylinder-heads of a Tom Blackwell car, or the spotted hide of a Richard McLean quarter-horse, or one of Audrey Flack's gaudy and congested tabletops—is an accretion of impacted data, set down in a spirit of indifferent enumeration like a very long laundry-list. The informational content is as stingy as the factual content is fulsome. Information consists of relations between facts; and in the Photo-Realist canon there is barely any room for such a relationship, except on the kitschy level of biographical metaphor which Audrey

Flack's large still-lives, those lollipop-tinted reworkings of the familiar *Vanitas* theme, contain. The main thing Photo-Realism got from Pop was an interest in the couplings and uncouplings of available signs and media: most Photo-Realist work is not a projection of the real world, using photography as an *aide-mémoire,* but a painting of a photograph in which common allusion to reality provides its identifiable balance. But the Photo-Realist enterprise is in itself a drastic simplification of the play between signs and symbols in Pop; so that one is left with a trivialized mix of deadpan description and gobbets of "modernism"—the picture-plane wistfully trying to be flat despite its illusionist loading.

Admittedly, we do not seem to inhabit a Renaissance space any more; the pressure and jostle of objects in Photo-Realism conforms to a truth of experience, namely that the hierarchically-ordered sequence of foreground, middle ground, and background in the one-point perspective of classical *disegno* has become questionable as a descriptive convention for the chaotic mix of signs and forms and messages that starts at the window. But the problem remains to find a way of drawing (and of representation in general) that enables us not just to see, but to see how we see. "The camera," Ralph Goings observed in an interview, "sees monocularly. It has only one eye and I have two . . . and when I'm looking at something directly, by shifting my head just a little bit, relationships change. If there's an awkward juxtaposition, say, of two forms, the natural tendency, when drawing directly from the subject, would be to shift your head so that that—in terms of traditional ideas about composition—would be corrected. The camera doesn't make those kinds of distinctions and corrections . . . you really get a chance to see reality in all its awkwardness, and all of its randomness." But, then, why bother with the labor of manual enlargement in another medium? Monocular flatness pertains to the camera lens, binocular scanning to the human eye. Authentic and intelligent drawing has aims other than simple enumeration. Its target is not the object itself, but an exposition of *process*: what goes on, what decisions and apprehensions occur, between the first glimpse of this stone, this Big Mac stand, this shoe or buttock, and its solidified presence in the mind as a coded, recognizable image. The formal adjustments that rise from binocular vision are perhaps only a metaphor of that unceasing, rich and always provisional feedback between object and

mind—a feedback which is stopped dead by Photo-Realist techniques. To draw reality is still to examine thought itself, and what remains most intriguing in drawing is the spectacle of eye and brain struggling to agree. This, in turn, involves the recognition that seeing is an event that unfolds in time and is never wholly to be fixed, as well as the excruciating awareness of how provisional sight is and how rarely final in its deductions. If Photo-Realism's relation to photography is boringly simple, its potential as drawing is frequently null. All that remains is the technique: that elaborate, deadpan *verismo* which has propelled Photo-Realism into its popularity among those collectors who, wearied or intimidated by the ideological conflicts of the sixties, have no appetite left for "difficult" art. For those who are not automatically thunderstruck by eye-fooling illustration, the Photo-Realist project has, it must be admitted, its longueurs. Airbrushes are good for glitter but bad for flesh, it seems; for every painter like Chuck Close, whose enormous three-color separation portraits do possess an imposing and hermetic veracity, there are a dozen like Hilo Chen, whose bikini-clad women have all the natural consistency of rubber; time and again, Photo-Realism recalls Degas's vicious apothegm on some salon battlepiece which had displeased him, that "everything is metal except the cuirasses." But then, the work of Bechtle, McLean, Goings, and their ilk is not about tactile involvement. It is not fundamentally about reality at all, only about signs. And perhaps it is this distance that gives Photo-Realism (now that the linguistic glamour has shredded away from Pop) its tedium. So much acreage of canvas for so little result; so much ballyhoo for what is, in the end, only indifferent abstraction plus grocery.

MARTIN FRIEDMAN

• A pioneer in identifying new directions in art, Walker Art Center director Martin Friedman assembled an exhibition in 1974 entitled *Projected Images*—representational forms projected with technological aids—that represented the turn the art and technology movement took in the seventies toward a more personal art, less involved with gadgetry, and increasingly oriented toward perceptual phenomena, formal structuralism, and spectator participation.

Into the Seventies

[FROM *Projected Images,* catalogue of an exhibition at the Walker Art Center, Minneapolis, 1974.]

The term "projected images" describes a group of environmental works that depend upon specific light sources for their existence. The perception of these transitory images in darkened spaces is affected by the character and scale of such spaces. Many artists who work with projections have come to this hybrid form through dissatisfaction with traditional painting and sculpture techniques. While filmmaking and video production attract an increasing number of artists, most of these converts observe the technical conventions of the new media; their films are intended for viewing under standard projection conditions and their videotapes are made to be seen on television monitors. By contrast, the artists represented in this exhibition conceive of film and video images essentially in environmental terms—as dominant elements of interior spaces—and they are as much concerned with the changing spatial and psychological relationships between observer and image as with the character of the image itself.

For some artists, the projected pieces are variations on stylistic ideas that appeared earlier in their paintings, sculptures or performances, and although technological processes are utilized to realize new objectives, their basic concerns remain artistic. For example, Peter Campus, now established as a serious master of video art, regards himself primarily as an artist who happens to utilize this medium. His attitudes about form are those of a painter, and his large video screen projection, a work that involves the observer as participant, is a changing surface of dramatically illuminated images of figures and shadows, curiously reminiscent of a baroque tableau. While highly regarded as independent filmmakers, Michael Snow and Paul Sharits use film here to create situations that subvert the basic premise of the observer-image relationship. The observer is not in a fixed position before the screen; rather, he is encouraged to move about, and to sense the image as irradiated atmosphere. Sharits explores the purely abstract character of film, and Snow, in a large, double-faced screen work, comments on its illusionistic properties. Their basic subject matter is the cinematic process.

Aside from cinema and video criticism, the projected image has yet to generate its specialized literature, but a few writers, sensing the

importance of this phenomenon and its role in current artistic thought deal with it. . . .

Placed in open gallery spaces, with no special architectural housing, the projection equipment is subordinate to the bright images it casts. There is none of the flashing light syndrome of the mid-sixties, a period of limitless optimism about the imminent marriage of art and technology. That brief utopian episode was inspired, in large measure, by the seemingly limitless possibilities of incorporating in the art-making process the sophisticated know-how associated with outer space exploration and high speed communication. Complexity became a virtue in itself and the laboratory of *Doctor No* moved into the museum; too often the result was a smoking ruin, artistically and literally. Now the art and technology movement of the sixties has all but vanished, largely because the objectives of artists and engineers almost never coincided.

Robert Whitman and Rockne Krebs are among the handful of honorable survivors of that heady period, and continue to produce important works in which technology serves an artistic purpose. During the sixties Whitman utilized the resources of E.A.T. (Experiments in Art and Technology, a New York–based cooperative involving the combined talents of artists and engineers) in order to realize his ambitious Happenings and live action events. Krebs has trained himself to be expert in the use of lasers and has also become proficient in optics. He has produced an impressive series of interior and exterior laser-beam "sculptures," some of which extend and vibrate across great distances. At M.I.T. he is finishing a stint as a research fellow in a program established by Gyorgy Kepes to enable artists to work on projects involving technology. For this exhibition, Krebs has created a piece that combines ancient and modern projection techniques: by means of a special lens mounted in an exterior wall, he has produced a *camera obscura* mirage of the urbanscape of freeways and buildings to the north of the museum. The space containing this improbable image is activated by vibrant red laser lines reflected in its mirrored-wall surfaces.

Relationships to painting persist throughout the exhibition. Like those Renaissance masters whose landscapes recede into infinite distance, the artists who make illusionistic projected images penetrate space. The ideal perception of such imaginary depth occurs when the

observer is directly in front and at the center of the work, but the sensation of depth quickly dissipates as one moves from this optimal position. Depth perception gives way to a heightened awareness of light, color and motion and the impression of volume is succeeded by a subliminal awareness of the indeterminate space created by the projection and its reflections on walls, floor and ceiling. Thus, one reality overl[ie]s another. The atmospheric projection becomes part of the new reality of the room.

The affirmation of the two-dimensionality of the picture plane has been a central concern in the evolution of modern painting, and forms within the plane act as units of energy in a continuous "field." We are conscious of the flat picture plane, even as it accommodates itself to a curved surface. Paul Sharits has produced his art on the thesis that a frame of film is a flat object, as is its focused projection. Although Sharits's vibrating triptych of pure color strongly relates to recent non-figurative painting, it is equally expressive of the movement and rapidly shifting imagery peculiar to film. His work in this exhibition, SYNCHRONOUSOUNDTRACKS, consists of actual film frames, printed to show sprocket holes that move through the projectors at varying speeds, and these three contiguous rectangles of abstract design and pure color, the result of brilliant dye applied to the film stock, become a visual simile of the filmmaking and projecting processes. The amplified sound of film moving through the projector radiates from speakers placed near the images, and the observer is invited to circulate through this complex of image and sound.

Those artists who use realistic subject matter—only Sharits works with a non-realistic theme—concentrate on everyday images and situations. Their subjects are dramatically enlarged, omnipresent forms such as light bulbs, safety matches, the landscape, and, of course, the spectator as the prime elements. In several works, familiar objects assume iconic significance through their illuminated transformations. The real world becomes mysterious and the Surrealist phrase, "the shock of the familiar," takes on immediacy. Indeed, a surreal quality permeates those works in which ubiquitous forms are magnified as objects in a dream. These images are disorienting and blur our notions of reality. The mesmeric quality of the isolated object is especially strong in the pieces by Robert Whitman and Ted Victoria. Both artists dwell on the symbolic qualities of daily objects, which in this case, are them-

selves sources of illumination. On a wet surface—a continuous, controlled waterfall that flows over a platform of planks placed on edge —Whitman projects a film loop of a safety match that is ignited, consumed by its flame, then re-ignited. The piece derives from Whitman's earlier use of film as an element in his live event environmental pieces. The slowly rotating light bulbs in Victoria's illuminated "series" piece are glowing hermetic shapes suspended in airless space.

Even a simple act, by repetition, can assume formal, ritualistic character and, in Snow's double-sided film event, the moving figures express his interest in spatial tensions rather than narrative. The "action" is seen from two vantages, filmed by two motion picture cameras placed equidistant[ly] from a center point. In the gallery, this situation is "recreated" by two film projectors placed on either side of a double-faced screen at a ratio equaling that used during the filming. The illusion is of a continuous event that the observer can walk around at will. He can see its "front" and "back."

The projected images are metaphysical environments illuminated by light beams and floating picture planes. Although the art and technology movement of the mid-sixties and the elevation of the banal subject through Pop art helped shape the attitudes of many artists in this exhibition, another significant influence is present: the anti-formalism of the late sixties, a movement as involved with socio-political statement as with aesthetic issues. Conceptual art, for example, was more concerned with sensory experience than durable form, and in this spirit, the projected image is weightless and, during its manifestation, transforms the space it occupies.

BARBARA ROSE

• Enormous changes characterized the expanded art world of the seventies. New York was firmly established as the world art capital, and a vast influx of artists from all over the world was drawn to its marketplace. The loft galleries of SoHo competed with uptown Fifty-seventh Street and Madison Avenue galleries to introduce new faces. In the following article, this author traces the shift in emphasis from the work of art to the personality of the artist. The most extreme manifestation of this shift was "body art," a performance documented with journals, photographs,

film or video, in which the artist treated his own body as an alien object, sometimes deliberately mutilating himself in acts of public masochism that insured attention when attention became, simply because of the sheer quantity of artists demanding it, more and more difficult to attract.

[A revised version of this essay appeared in *Partisan Review*, No. 4, 1974.]

Twilight of the Superstars

I am using the term "star" to describe artists catapulted to eminence through the pages and images of the media because the word "star" appropriately characterizes the growth of a cult of personality. This promotional approach is rapidly replacing earlier criticism that established reputations on the basis of comparative quality, or even on the shakier grounds of significant innovation—the criterion used to justify the elevation of some reputations in the sixties. As the art world has extended more and more into the world of business and entertainment, suddenly art is noticeable to a public clearly not interested in aesthetic values, but in the sensation created by the huge sums of money attached to art now.

It is just as well that the appetite of this enlarged public is not for new art, but for new personalities, because finally there is little to differentiate one conceptual artist's work from another. One pale grid on the wall is pretty much like any other; one page of compulsive calligraphy is hardly distinguishable from another. Thus the shift in focus from art work to the persona of the artist is necessary in a greatly expanded art world. In an overcrowded and undercapitalized milieu, only media attention can single out the happy few from the madding crowd. This cynicism is supported by attitudes toward success inculcated in art schools and promulgated by a new type of literature devoted to advising artists how to market their careers, manage their images, find galleries, collectors, etc., which, along with books by accountants and lawyers about art, is the largest new category of art literature.

The rejection of "judgmental" criticism by the new critics of the seventies can be seen as part of the general rejection of authoritarian attitudes that characterized the collapse of leadership in all areas at

the end of the sixties. The relativity of aesthetic judgment is an obvious analogue to the relativity of moral judgments. Possibly this development was inevitable, but it has been exacerbated by the exposure of the excesses of authoritarian personalities. That the leaders have clay feet decimates the ranks of followers. For example, the recent documented revelation that Clement Greenberg wilfully changed the color of David Smith's sculptures after the artist's death has diverted focus from the contribution of Greenberg's evaluative criticism to his shortcomings as an authoritarian personality, adding to the skepticism regarding any criticism based on distinctions in quality. Without Greenberg as a figurehead, the circle of critics who unquestioningly accepted his premises has been eclipsed, to be replaced by another group of critics whose point of departure seems to be that no further distinctions can be made between good art and bad art and that, as Don Judd put it, a work need only be "interesting."

At this point, a word should be said about the evolution of the concept of the "Superstar." The term was invented by Andy Warhol, who learned how to manipulate media for his own purposes from the original Great Imposter, Duchamp himself. A Superstar is anybody Warhol happens to notice, whose image and/or voice is recorded by his indiscriminate camera or cassette. The gag originally was that Superstars were just ordinary people, with no particular attributes of distinction. Having introduced the ideas that art has no quality and that the artist needs no special technical skill or training (so anyone can make art), Warhol has seen his worldview triumphant, not among the masses, whom in fact he might be seeking to liberate from the oppression of burgeois culture, but [among] the priests of high culture itself. In his devastating equation of Liz Taylor and the Mona Lisa in similar silk-screen replicas, Warhol exposed the leveling process of the media. Reduced to the photographic reproduction, Liz is a star, and the Mona Lisa is a star, too. This confusion has by now infiltrated museology and criticism sufficiently to produce an atmosphere of chaotic insecurity and uncertainty.

The creation of such an atmosphere was undoubtedly Warhol's intention; his goal was nothing less radical than the obliteration of traditional culture, not through direct attacks, but through the guerrilla tactics of subversion and infiltration—the gradual erosion of values through the equation of diverse images once categorically antithetical.

No head-on confrontation, no aggressive assaults, just a progressive take-over of the apparatus of culture by Smiling Andy, the Exploding Plastic Inevitable. Warhol has succeeded by appealing to base curiosity, the mass taste for sensationalism, novelty and entertainment. And his success in creating a cult of personality has greatly impressed a younger generation of artists, some of whom, more interested in careers as artists than in making art, have imitated his tactics with a shameless lack of originality. Not long after Andy had plastered the art world with multiple images of himself, exhibition announcements and art press advertisements were as likely to bear the photograph of the artist as a reproduction of his work. For example, in the case of Joseph Beuys's widely circulated enlarged photograph of his own melancholic countenance, the poster, reminiscent of the old Hollywood broadsides and mail-order autographed photos, became the art.

This is not the place to speculate on why artists are styling themselves after movie stars; suffice it to say that the impotence and irrelevance of seriousness of any kind in a democratic mass culture every day demonstrated by the election of movie stars to public office is demoralizing generally. The latest and most blatant bid for attention by an artist determined to promote a Superstar career is Lynda Benglis's double-page advertisement for herself in the November *Artforum,* in which the artist is seen nude, oiled, and masturbating an over-size penis, apparently extending from her own body, that is convincingly flesh-colored but rather unconvincingly enlarged. Shades of Linda Lovelace and Alice Cooper.

In the same issue of *Artforum* is an article on Benglis by Robert Pincus-Witten, a senior editor of the magazine. Commenting on Benglis's last exhibition poster, a rear view of the artist bending over, blue jeans dropped to her ankles, coyly peering over one shoulder, Pincus-Witten writes, "The cheesecake shot—in part homage to Betty Grable pinups—recalls for me a late version of Odilon Redon's *Birth of Venus.* Though this work can hardly have been in her mind, Benglis is strongly interested in Classical myth. Among her most recent works are pornographic polaroids rendered ambiguous by their cultural context—they are parodies of Mannerist and Hellenistic postures. Il Rosso Fiorentino and ithyphallic kraters, a Leda without a swan." Mr. Pincus-Witten's erudition notwithstanding, the Benglis poster is

less reminiscent of Redon than . . . of the October cover of a Times Square porno magazine ironically called *Gallery*.

Superstardom is accomplished by means of establishing greatness by association. This requires the development of a pseudo-art-historical approach to self-serving trivia once reserved for the iconography of the great masters.

Paradoxically, the age of the artist-Superstar coincides with the actual waning of artistic individualism, and the visible similarities of one work with another accompany a diminution of quality. For years, artists found it possible to conceive of themselves privately as individuals, working with their own community of outsiders. Now the rewards of art seem insufficiently gratifying and the artist competes with the porno star or the sado-masochistic rock entertainer for attention. Of course Warhol initiated this direction, but one has a sense that his actions and words are still commentaries on a situation, not merely extensions of it. Sex, as Duchamp once again was the first to notice, will inevitably excite a public, any public. Warhol maintained his distance from his subject matter by managing to make pornography boring. The new art pornography of Photo-Realism or the promotional advertisements of would-be Superstars no longer have any such distancing mechanisms. They have become what they presume to be about: pornography and sado-masochism.

If there is a conscious aim in such publicly degraded behavior, then it must be the degradation of art. For some time I have felt that the radicalism of minimal and conceptual art is fundamentally political, that its implicit aim is to thoroughly discredit the forms and institutions of dominant bourgeois culture, to demoralize the public, preparing it to renounce the official culture, which is shown to be meaningless and consequently not worth perpetuating. This is certainly revolutionary strategy—a kind of abstract Warholism—although one cannot see how it prepares the way for the triumph of proletarian culture. On the other hand, weakening public trust in art may as easily pave the way for fascist counterrevolution, for a mass culture in the service of totalitarian ideals.

Chapter Eleven

Sculpture for the Space Age

GASTON LACHAISE

• Born in France, Gaston Lachaise, creator of voluptuous nudes and intricately locked couples, was among the first artists in America openly to defy Puritanism in all its aspects, shamelessly proclaiming the sovereignty of the erotic. In the following reminiscence, he describes his meeting with the young Boston matron, his future wife, Isabel Dutard Nagle, who was to inspire his art for the next thirty years.

———

| FROM "A Comment on My Sculpture," *Creative Art,* III (August, 1928).|

At twenty, in Paris, I met a young American person who immediately became the primary inspiration which awakened my vision and the leading influence that had directed my force. Throughout my career as an artist, I refer to this person by the word "Woman." . . .

"Woman," as a vision sculptured, began to move, vigorously, robustly, walking, alert, lightly, radiating sex and soul. Soon she came to forceful repose, serene, massive as earth, soul turned towards heaven. "La Montagne"! The feet almost disappeared. Mountains neither jump nor walk, but have fertile rolling pastures, broad and soft as fecund breasts.

Then "Woman" rose again, upstanding, noble, bountiful, poised on her toes, with closed self-absorbed eyes, nearly detached from earth. Still later, after communion with the universe and cosmic realization, "Woman,"—spheroid, planetary, radiative—was entirely projected be-

yond the earth, as protoplasm, haunted by the infinite, thrust forth man, by means of art, towards the eternal.

On certain occasions I have made use of animals, sea gulls, sea lions, dolphins, peacocks, penguins, to translate spiritual forces. I have enjoyed doing portraits. My interest in portraiture has always been keen, for a portrait of an individual is synthesis of the prevalent forces within the individual, and in this process there is expansion for the creator. Of late a vision of the form of "Man" is growing more clear and precise to me. I must begin to attempt to realize it. Undoubtedly he will be the son of "Woman."

Whenever an American artist is led to speak of his achievement in art he is, necessarily, on account of the violent intensity and fabulous wealth of this land, anchored to certain cold facts which in the United States are stressed, fantastically, beyond the reality of art.

The path to achievement, though cleared of a few stumps and morasses, is as bare and dangerous as the trail over the plains, across the Rockies, to the Far West in 1828. Financial strain from all sides, no genuine support for the better part of a lifetime are yours. Will power, tenacity, pride that can disregard all humiliations conceivable, aggressiveness, essential on occasions, long stretches of labor—day and night—twenty hours out of twenty-four, are your only assets. Hardships for all concerned. Artists' wives are assuredly the pioneer women of this era. Artists' wives will go to heaven, let me tell you....

Yet it cannot be overlooked, that at present, even though neglected, the American artist "living and true"—creative and bearer of fruit, has begun to grow roots and function in the rocky soil of America. At wide intervals artists do meet individuals who possess the ability to render vital support to them in addition to holding tremendous enthusiasm for them. This is marvelously refreshing. Response from the artists is never lacking. Curiously, in the United States, this individual of discernment, taste and character strong enough to both appreciate and cooperate with an artist is rare, whereas artists who contain untold potentialities increase rapidly whatever the hardships their choice of life offers. . . .

What some twelve years ago I declared, I repeat emphatically, "The most favorable ground for the continuity of art is here."

Sculpture for the Space Age

JOHN FLANNAGAN

• Applying for a Guggenheim Fellowship in 1939, John Flannagan made the statement below, in which he shows his aims to be close to Brancusi's. Later, in a letter to his dealer, Curt Valentin, Flannagan gave clues to the meaning of his work. Like the early Abstract Expressionists, Flannagan searched for the archetypes Jung had located in the collective unconscious.

———

[FROM *Art in America*, LIII, No. 4 (August–September, 1965).]

My aim is to continue the purpose of twenty years of working in sculpture—to create a plastic idiom alive as the spoken word; sculpture as direct and swift in feeling as a drawing, sculpture with such ease, freedom and simplicity that it hardly seems carved but to have endured always. Fulfilled, it should mean the development of an instrument so sensitive as to record the human psyche in all its various moods and reactions to life instead of the usual banal platitudes and worn clichés.

This is an austere art which compels a clear perception of its scope and limitations. Therefore it seems that it should be of a generalized universal symbolic nature . . . man, woman, child, animal. The fusion of abstract design with feeling and representational values is one of the major problems of art expression. The design, the sculptural form is of course fundamental but it is necessary to vitalize this through emotion and verisimilitude, else the work becomes cold and remote. Over and above the tactile organization of lines, planes and masses should brood the mystery of a living thing.

———

[FROM *Letters of John B. Flannagan* (New York: Curt Valentin, 1942).]

"The Stone-Cutter" is timeless and *haunted* by the *old human* dreams so old-prehistoric; yet the Artist does *remember*. The Alligator called the "Dragon Motif" carved by a chisel that *thinks* and *feels* fascinated by the *wonder* and terror that must have made the fearsome phantasy

that was the *"Monster Motif Phantasy."* The great longing of the *wishful-rebirth phantasy* that is in "Jonah." These things are not *conscious,* may be *unconscious,* thought only *by hand* and just now I realize the *fish* (as in Jonah) is the very ancient symbol of the Female Principle so "Jonah and the Whale the Rebirth Motif."

ALEXANDER CALDER

• In an interview, Alexander Calder, a pioneer of Kinetic Sculpture, explains the origin and significance of his mobiles.

[FROM "Alexander Calder" in Katharine Kuh, *The Artist's Voice* (New York: Harper & Row, 1960). Copyright © 1960, 1961, 1962 by Katharine Kuh. Reprinted by permission of Harper & Row, Publishers, Inc.]

QUESTION: Which has influenced you more, nature or modern machinery?

CALDER: Nature. I haven't really touched machinery except for a few elementary mechanisms like levers and balances. You see nature and then you try to emulate it. But, of course, when I met Mondrian I went home and tried to paint. The basis of everything for me is the universe. The simplest forms in the universe are the sphere and the circle. I represent them by disks and then I vary them. My whole theory about art is the disparity that exists between form, masses and movements. . . . Even my triangles and spheres, but they are spheres of a different shape.

QUESTION: How do you get that subtle balance in your work?

CALDER: You put a disk here and then you put another disk that is a triangle at the other end and then you balance them on your finger and keep on adding. I don't use rectangles—they stop. You can use them; I have at times but only when I want to block, to constipate movement.

QUESTION: How did the mobiles start?

CALDER: The mobiles started when I went to see Mondrian. I was

impressed by several colored rectangles he had on the wall. Shortly after that I made some mobiles; Mondrian claimed his paintings were faster than my mobiles.

QUESTION: What role does color play in your sculpture?

CALDER: Well, it's really secondary. I want things to be differentiated. Black and white are first—then red is next—and then I get sort of vague. It's really just for differentiation, but I love red so much that I almost want to paint everything red. I often wish that I'd been a *fauve* in 1905.

QUESTION: Do you think that your early training as an engineer has affected your work?

CALDER: It's made things simple for me that seem to confound other people, like the mechanics of the mobiles. I know this, because I've had contact with one or two engineers who understood my methods. I don't think the engineering really has much to do with my work; it's merely the means of attaining an aesthetic end.

QUESTION: How do your mobiles differ from your stabiles in intention?

CALDER: Well, the mobile has actual movement in itself, while the stabile is back at the old painting idea of implied movement. You have to walk around a stabile or through it—a mobile dances in front of you. You can walk through my stabile in the Basle museum. It's a bunch of triangles leaning against each other with several large arches flying from the mass of triangles.

QUESTION: How did you begin to use sound in your work?

CALDER: It was accidental at first. Then I made a sculpture called Dogwood with three heavy plates that gave off quite a clangor. Here sound was just another variation. You see, you have weight, form, size, color, motion, and then you have noise.

DAVID SMITH

• Nonconformist in both his art and his opinions, America's greatest sculptor, David Smith, spoke eloquently of his own art and of the place of sculpture in modern culture.

[FROM "A Symposium on Art and Religion," *Art Digest,* December 15, 1953.]

It is a little late even to toy with the idea that art has any chance with ideologies better served by plaster saints, television, radio and Tin Pan Alley. Whole segments of Christianity still shun art which was part of the aggrandizement, pomp, and corruption of the Roman church before the Reformation. The association of art with the graven and golden image likewise makes art taboo.

The truly creative art of our time cannot play an important part in organized religion because the traditions are diametrically opposed. The artist is not involved with translation. He is not dedicated to a program or a faith other than his work, which for him is a different kind of faith from religious faith. His profundities and philosophy are himself, delicately hidden from verbalizers and proselytizers. His freedom to conceive in visual terms is greater than any other freedom of our time. To produce at his highest, he cannot be harnessed to any doctrine.

There is a particular sense of rightness which inspiration and conviction give to the work of art, wholly personal and individual, which organized religion does not understand.

The artist's tradition antedates Christianity by 30,000 years and encompasses pagan cultures which Christianity has attempted to destroy.

[FROM "Thoughts on Sculpture," *College Art Journal,* Winter, 1954.]

I do not believe that any two people see the same sculpture, simply because no two people see each other.

In the same way, no two people see the same apple. The reality of an apple is not a mono image of stopped action, nor a photo view. The reality is actually all apples and all views; it is an associative image. The red apple may be green, or yellow, or black, spotted or striped. It may be halved with the core, or against the core, or segmented. It may be sweet, sour, rotten, sensuously felt, hanging, rolling, crushed to juice, the blossom flower or a bud. The recording of the apple image can go on indefinitely, interlocked with associations until it becomes personal history.

In sculpture or painting, if the artist chooses to depict the image denoting apple, the eye sees and the spirit knows, but the knowing is not all the same. The artist has presented the form for perceptual response. The definition is selected from the experience of the beholder. The apple and its mode of presentation are only the spark to fire the viewer's imagination.

There were no words in the artist's creation; no words are involved in understanding. No judgment, no logic, no conclusion, no set of values outside of man's world, no form involved which the eye of man has not seen. The mind records everything the eye sees. In spirit, or more technically, in perception, all men are potentially equal. Man's lack of visual perception does not represent a lack of ability. Instead, it may be a case of censoring, originating in the doubt that that which cannot be verbally explained, cannot be perceived.

Perception through vision is a highly accelerated response, so fast, so free that it is too complex to tabulate, but nevertheless a natural reaction since the origin of man. The comparatively recent mode of word communication cannot act as a substitute for the perception of form. There are not enough words in the language, nor can the relatively slow conscious mind keep up to record the vision.

As an example, based on the most simple element in use by both sculptor and painter, let me pose a question to black. Is it white? Is it day or night? Good or evil? Positive or negative? Is it life or death? Is it the superficial scientific explanation about the absence of light? Is it a solid wall or is it space? Is it paint, a man, a father? Or does black mean nothing? Did it come out blank having been censored out by some unknown or unrecognizable association? There is no one answer. Black is no one thing. It is many things. The answer depends upon individual reaction. The importance of black depends upon the conviction and the artistic projection of black, the mytho-poetic view, the myth of black. And to the creative mind, the dream and the myth of black is the truth of black, not the scientific theory or dictionary explanation or the philosopher's account of black. Black, as a word, or as an image recall, flashes in the mind as a dream, too fast for any rational word record. But its imagery is all involved by the artist when he uses black on a brush.

From the artist there is little accent on moral judgment, no conscious involvement with his historic position, no conscious effort to find uni-

versal truth or beauty, no analyzing of other men's minds in order to speak for them. His act in art is an act of personal conviction and identity. If there is truth in art, it is his own truth.

It is doubtful if aesthetics has any value to the creative artist, except as reading matter. It is doubtful if it has any value to his historic understanding of art, because his history of art is built upon the visual record of art and not written accounts made on a basis of speculation.

From the philosophic-aesthetic point of view, at the time of creation the contemporary work of art is a vulgarization. By vulgar I mean the Oxford definition, "offending against refinement of good taste." This describes where the advance schools of art rate with most critical opinion now, and how Van Gogh, Cézanne and Cubism were regarded by the critics of their time. The work of art does not change. The mellow of time, the pedant's talk, only legitimize it in the minds of the audience who may wish to hear, but refuse to see.

The influential majority of aestheticians are at present a quarter of a century or more behind art. Thus the contemporary artist cannot be impressed by the written directives on art. His directives are emotional and intuitive, arising from contemporary life. To make art the artist must deal with unconscious controls, the intuitive forces which are his own convictions. Those especial and individual convictions that set his art apart from that of other men are what permit him to project beyond the given art history. This takes blind conviction, for if his contribution is original, it stands little chance of acceptance from the reactionary or status quo authorities.

Aesthetics usually represent the judgments which lesser minds hold as rules to keep the creative artist inside the verbal realm and away from his visual world. Actually the philosophy of art and the history of art have nothing to do with creative artist's point of view. Both are in entirely different fields. But the layman is apt to become confused if he is not able to make this differentiation. He often expects the artist to perform according to the philosopher's truth theorems or the didactic historian's speculations.

When we speak of the creative artist we must speak of affection— intense affection which the artist has for his work. An affection, along with belligerent vitality and conviction. Can the critics, the audience, the art philosophers ever possess the intensity of affection which the creator possessed? Do they extend affection and vitality into the effort

of understanding? Can they project this intense affection to the work of art? Or do they miss it?

In his regard for nature the contemporary artist stands in much the same position as primitive man. He accepts nature, intuitively. He becomes a part of nature. He is not the superman, the pseudo-scientist in nature. He accepts it for its own statement as existence. He marvels. Nature is beauty. Beauty becomes the point of departure—for celebration to produce the work of art. The work of art can have subject to any degree of abstracting or the artist himself is the subject for celebration or identification.

Often the artist is asked to explain his work. Naturally he cannot, but in one instance I have recalled a few motivations in the procedure of a sculpture. This work, later called *Hudson River Landscape,* has been exhibited at the University of Illinois and elsewhere.

This sculpture came in part from dozens of drawings made on a train between Albany and Poughkeepsie, a synthesis of ten trips over a 75 mile stretch. Later, while drawing, I shook a quart bottle of India ink and it flew over my hand. It looked like my river landscape. I placed my hand on paper. From the image that remained, I travelled with the landscape, drawing other landscapes and their objects, with additions, deductions, directives, which flashed unrecognized into the drawing, elements of which are in the sculpture. Is my sculpture the Hudson River? Or is it the travel and the vision? Or does it matter? The sculpture exists on its own; it is an entity. The name is an affectionate designation of the point prior to travel. My object was not a word justification or the Hudson River but it may travel on any river—rivers are much the same—or on a higher level, the viewer may travel through his own form response arrived at through his own recall.

I have identified only part of the related clues. The sculpture possesses nothing unknown to any man. I want the viewer to travel by perception the path I travelled in creating it. The viewer always has the privilege of rejecting it. He can like it, or almost like it. He may feel hostile toward it, if it demands more than he is capable of extending. But its understanding can only come by affection and visual perception, which were the elements in its making. My own words cannot make it understood and least of all, the words of others.

David Smith

[FROM "Second Thoughts on Sculpture," *College Art Journal,* Spring, 1954.]

When the artist starts to make his own statement, he must recognize that he is a product of his time, that what has gone before is his heritage, and from his particular vantage point, his purpose is to project beyond. He will identify himself with his filial epoch, which is only his present history, probably not many decades back, possibly only as far back as the oldest artists of his time. But whatever distance back he accepts as his filial heritage, his concept must press beyond the art of his time and in this sense he must always work towards that which he doesn't know. Many artists of my generation feel that Cézanne is the beginning of their filial epoch.

In the 20th century, Cézanne used the room still life ratio of viewing for the distant landscape. The Cubist views were from all distances— the room, far away, in equal stature and in actual identification with the artist. It may have been Kandinsky during Cubism's first decade, who moved farthest, paralleled by Mondrian, but here the move was not only in distance but in identity. Both painters were moving independently farther from the object identity.

The contemporary artist has not only inherited the feeling of moving and distance on the earth plane but also possesses the newly found distance element of viewing vertically down, from which view the current mode of travel gives him the working tenet.

Poetically he has known that pattern is form. That chiaroscuro is not his age. That no area can be indicated without man's intuitive vision projecting the dimension. Practically he sees the fallacy of any two-dimensional supposition. This two-dimensional reference which critics have used to distinguish painting from sculpture seems to be the most abstract kind of thought. Especially when he reflects that the thicknesses of some of Van Gogh and Cézanne's paintings have been equal or greater than the dimensional contrasts of Han dynasty tomb carving.

And yet the work of the advanced artist is not influenced so much by his physical position in distance or the contradictions in rationale but by the poetic position, that irrational creative state upon which his whole approach depends.

Most important in this poetic point of viewing has been his moving and the lengthening of distance between the artist and the object. He has moved so far away from the object that he meets it from the other side, consumes it, and becomes the object himself, leaving only two factions involved, the artist and his work. The artist is now his own nature, the work is the total art. There is no intermediary object. The artist has now become the point of departure. Like many changes in art critically termed revolutions, this position is not wholly new, it has occurred in art before to some degree. This represents a closer position to the total or ultimate degree. His new position is somewhat that of primitive man. He is not the scientific viewer of nature. He is a part of nature. He is the nature in the work of art.

Art history is one thing to the art historian and another to the creative artist. Art history to the artist is visual. His art is not made up of historian's words of judgments. His choices are made the same way he makes the work of art—by the visual, irrational, creative. His history is a selection of his own preferences. His visionary reconstruction goes farther back in the history of man than the evidence. His history may even leave a few openings for mythical reconstruction or epochs destroyed or lying still buried. Actually the artist by his working reference to art of the past is often the discoverer of new value, in historically unimportant epochs, and the first to pick out the art value in work which was previously viewed as ethnographic only.

The artist sees a wholly different set of masterpieces than those the art historians have chosen to acclaim. He first sees the forms of the Venus of Willendorf before those of Melos. He sees the structures of Braccelli before the ripples of Michelangelo. A Cameroon head, a sepik mask before a Mona Lisa. Using his visual art references he will go to an earlier and perhaps neglected period and pick out an approach that is sympathetic to his own time. In Chinese Rei Sho character writing, the graphic aim was to show force as if carved or engraved in steel. In Japanese painting the power intent was suggested by conceiving a stroke outside the paper, continuing through the drawing space to project beyond, so that the included part possessed both power origin and projection. Even accident—which is never accident but intuitive fortune—was explained. If drops fall, they become acts of providence. If the brush flows dry into hairmarks, such may be greater in energy. And that in the painting certain objects possessing force, the

sentiment of strength must be evoked and felt [*sic*]. I do not cite these tenets to show that we are direcly influenced by oriental art. The forces involved have occurred in art without declaration. The visual aesthetic the artist retains by memory of an Assyrian wounded lion frieze is still more his aesthetic on the power stroke than the oriental statement.

In contemporary work, force, power, ecstasy, structure, intuitive accident, statements of action dominate the object. Or they power the object with belligerent vitality. Probably the fact that man the artist can make works of art direct without the object meets opposition by its newness. Possibly this direct approach is a gesture of revolt representing the new freedom, unique in our time. Possibly there is a current ecstasy in the artist's new position much like that of 1910–12 Cubism.

From the artist there is no conscious effort to find universal truth or beauty, no effort to analyze other men's minds in order to speak for them. His act in art is an act of personal conviction and identity. If there is truth in art, it is his own truth. If beauty is involved, it is only the metaphor of imagination.

BARNETT NEWMAN

• In the sixties, veteran Abstract Expressionist Barnett Newman translated the reductive imagery of his color-field paintings into large-scale sculpture. Inspired by classical monuments, Newman used simplified forms in sculptures like *Broken Obelisk*, which shares the gestalt quality of minimal art, for which Newman's own paintings were a primary source.

[FROM "Chartres and Jericho," *Art News*, April, 1969.]

In the spring of 1967, when the steel was being cut for the four triangles that make up the pyramidal half of my *Broken Obelisk*, I became intrigued—intrigued is a better word than inspired—with the triangle as a possible format for painting. It was at that moment that I "saw" paintings on the huge sheets of steel. Later that year I had

some stretchers made for two triangles and the challenge of the triangular format began for me.

I must explain that the triangle had no interest for me either as a shape in itself or because it has become stylish to use shaped canvas. After all, I had done the so-called shaped canvases or what is more correct in my case, no-shape canvases, as far back as 1950. What I wanted to do was find out whether or not the triangle could function for me pragmatically as an object and whether it could also act as a vehicle for a subject. Could I do a painting on the triangle that would overcome the format and at the same time assert it? Could it become a work of art and not a thing?

I knew if I conformed to the triangle I would end up with either a graphic design or an ornamental image. I had to transform the shape into a new kind of totality.

In a sense this was no different a problem than the rectangle except that the triangle brings back into painting physical perspective with its three vanishing points. How to do a painting without getting trapped by its shape or by the perspective was the challenge here.

It was only when I realized that the triangle is just a truncated rectangle that I was able to get away from its vanishing points. I knew that I must assert its shape, but in doing so I must make the shape invisible or shape-less. I realized that after all it is nothing more than a slice of space, a "space vehicle," which the painter gets into and then has to get out of. It was this drama, my involvement in the existence of the triangle as an object and my need to destroy it as an object, that made it possible for me to begin painting them. After all, format as format can be a trap.

RICHARD SERRA

• During the late sixties, the simple geometric forms of minimal sculpture suddenly gave way to a genre of three-dimensional arrangements of unaltered materials. Such casual, "dematerialized," antiformal arrangements were pioneered by Carl Andre, whose floor-hugging squares of common metals were placed adjacent to one another as casually as a bricklayer might stack bricks. Other artists such as the late Eva Hesse had more eccentric interpretations of "post-minimal" sculpture combining randomness and order. Among the most articulate members of this younger

generation of environment- and precess-oriented sculptors, Richard Serra has written about some current concerns regarding new modes of spatial perception.

———————

[FROM "Play It Again, Sam," *Arts Magazine,* LXIV (February, 1970).]

A recent problem with the lateral spread of materials, elements on the floor, in the visual field is the inability of this landscape mode to avoid arrangement *qua* figure ground: the pictorial convention. The rationale for this investigation is a plea for perceptual wholeness or a willingness to allow the definition of the place to control the priority of relations. In part this is a misinterpretation of Anton Ehrenzweig's concept of differentiation. The mystique of loosening up remains no more than a justification for Allan Kaprow.

One way of coming to terms with this problem is to reveal the fact of the operative rationale that allows the work to find its place. Lawrence Weiner and Carl Andre point out the polarities: Andre's place, Weiner's residue.

Solving the problem of the base has been crucial to the development of sculpture. Some recent work attempts to circumvent or camouflage this dilemma by constructing a series of points (surrogate bases) within the work which can support the lateral members splayed out above them. This is redundant, for if the floor actually functions as a base, there is no need to construct such surrogate bases within the work to make the floor *appear* to function structurally. The debt of such solutions to pictorial conventions is obvious. When pieces are viewed from above, the floor functions as a field or ground for the deployment of decorative linear and planar elements. The concern with horizontality is not so much a concern for lateral extension as it is a concern with painting. Lateral extension in this case allows sculpture to be viewed pictorially—that is, as if the floor were the canvas plane. It is no coincidence that most earth works are photographed from the air. The crucial problems confronting sculpture today are the avoidance of the concerns properly belonging to architecture and painting which, as Barbara Rose has indicated, have produced in the name of sculpture so much failed architecture and three-dimensional painting.

The perception of the work in its state of suspended animation, arrested motion, does not give one calculatable truths like geometry, but a sense of a presence, an isolated time. The apparent potential for disorder for movement endows the structure with a quality outside of its physical or relational definition.

As forces tend toward equilibrium the weight in part is negated.

MEL BOCHNER

• In this early appreciation of minimal art, conceptual artist Mel Bochner explores similarities and differences in the works of Carl Andre, Dan Flavin, and Sol LeWitt, whose stringent intellectualism encouraged the emergence of conceptual art.

————

[FROM "Serial Art, Systems, Solipsism," *Arts Magazine,* XLI (Summer, 1967.)]

Everything that exists is three-dimensional and "takes up" space (space considered as the medium in which the observer lives and moves). Art objects are qualitatively different from natural life yet are co-extensive with it. This results in the unnaturalness of all art (a factor of its intrusion).

The above is relevant to an examination of certain three-dimensional art being done today, especially the works of Carl Andre, Dan Flavin and Sol LeWitt. Their works cannot be discussed on either stylistic or metaphoric grounds. What they can be said to have in common, though, is a heightened artificiality due to the clearly visible and simply ordered structure they use. These orders and *how* the resultant pieces exist in their environments are what I would like to examine.

Carl Andre uses convenient, commercially available objects such as bricks, styrofoam planks, ceramic magnets, cement blocks, wooden beams. Their common denominators are density, rigidity, opacity, uniformity of composition, and roughly geometric shape. A number of *a priori* decisions govern his various pieces. One and only one kind of object is used in each. Individual pieces are specifically conceived for

the conditions of the place in which they are to occur. (Although in no way connected with environment art, both Andre and Flavin exhibit an acute awareness of the phenomenology of rooms.) The arrangement of the designated units is made on an orthogonal grid by use of simple arithmetic means. (The word "arrangement" is preferable to "composition" in the case of all three of these artists. Composition usually means the adjustment of the parts, i.e., their size, shape, color or placement to arrive at the finished work whose exact nature is not known beforehand. Arrangement implies a fixed nature to the parts and a pre-conceived notion of the whole.) The principle means of cohesion in Andre's pieces is weight (gravity), the results of another *a priori*, the use of no adhesives or complicated joints. This necessitates their appearance on the floor in horizontal configurations such as rows or slabs. Although earlier pieces made of styrofoam planks were large and space-consuming (a principle quality of styrofoam being its "bloatedness"), recently Andre's work has tended to be more unassuming. Height is the negligible dimension in these recent pieces, which is probably due somewhat to the instabilty of unadhered stacks. At any rate this causes the pieces to exist below the observer's eye-level. They are made to be "looked down upon," impinging very slightly on common space. However, it is just this persistent slightness which is essentially unavoidable and their bald matter-of-factness that makes them in a multiple sense *present*.

These artists are further differentiated (as all artists are) by their individual methodology which in relation to the methodology of the past can only be termed serial. Serial or systematic thinking has generally been considered the antithesis of artistic thinking. Systems are characterized by regularity, thoroughness, and repetition in execution. They are methodical. It is their consistency and the continuity of application that characterizes them. Individual parts of a system are not in themselves important but are relevant only in how they are used in the enclosed logic of the whole series.

One of the first artists to make use of a basically progressional procedure was Dan Flavin. A salient example of this is his 1964 *Nominal Three—to Wm. of Ockham* ("Posit no more entities than are necessary."—Wm. of Ockham). The simple series involved can be graphically visualized as $[1 + (1 + 1) + (1 + 1 + 1)]$.

Flavin, however, is difficult to come to terms with in even a quasi-

objective discussion. For, although his placement of fluorescent lamps parallel and adjacent to one another in varying numbers or sizes is "flat-footed" and obvious, the results are anything but. It is just these "brilliant" results that confound and compound the difficulties.

In his most recent exhibition he restricted his units to cool-white lamps in 8″, 6″ and 2″ lengths. Two sets 8″/8″ were placed in diagonally opposite corners (one pair "mitred," the other "butted" together); one set 8″/2″ was put in the corner made by a wall and fireplace; two sets 8″/6″ and 8″/6″/2″ were in the centers of perpendicularly adjoining walls; one set 8″/6″ was at the end of a false wall directly in front of the window. The system was as uncomplicated as the hanging and placement (Dan Graham has commented on the "re-placeability" of fluorescents). Otherwise nothing else happened and many considered it a pseudo-event. The fixtures themselves, which amount to only a low relief projection from the wall, were obliterated by their own light and cross shadows. But they intensely accentuate all the phenomena of the room . . . the tilted floor, false wall, leaning door, excessively baroque fireplace. The room was brought into an equilibrium in which any implication of possible action or change was excluded. The gaseous light (perhaps they are lit only because they can be lit) is indescribable except as space if, once again, we consider space as a medium. Flavin "fills" the space in direct proportion to his illumination of it. The vacancy of the room is as much part of the pieces as the arrangement of the lamps. (When Flavin uses colored lamps the effect is of quality divorced from substance, color existent as color and nothing else. In a recent piece in Washington, D.C., the "redness" was particularly dematerialized.) . . .

Sol LeWitt's work takes a particularly flat, non-emphatic position. His complex, multi-part structures are the consequence of a rigid logic system which excludes individual personality factors as much as possible. As a system it serves to enforce the boundaries of his work as "things-in-the-world" separate from both maker and observer. . . .

When one encounters a LeWitt, although an order is immediately intuited, how to apprehend or penetrate it is nowhere revealed. Instead one is overwhelmed with a mass of data—lines, joints, angles. The pieces situate in centers usurping most of the common space, yet their total volume (the volume of the bar itself) is negligible. Their immediate presence in reality as separate and unrelated things is asserted

by the demand that we go around them. What is most remarkable is that they are seen moment to moment spatially (due to a mental tabulation of the entirety of other views) yet do not cease at every moment to be flat.

Some may say, and justifiably, that there is a "poetry" or "power" or some other quality to this work which an approach such as the above misses. But, aspects such as those exist for individuals and are difficult to deal with using conventional meanings for words. Others may claim that given this they are still bored. If this is the case, their boredom may be the product of being forced to view things not as sacred but as they probably are—autonomous and indifferent.

CLEMENT GREENBERG

• Founder of a school of formalist criticism that dominated the art writing of the sixties, Clement Greenberg dismissed both minimal and pop art as passing fads.

[FROM *American Sculpture of the Sixties,* catalogue of an exhibition at the Los Angeles County Museum of Art, 1967.]

Recentness of Sculpture

In the Sixties it has been as though art—at least the kind that gets the most attention—set itself as a problem the task of extricating the far-out "in itself" from the merely odd, the incongruous, and the socially shocking. Assemblage, Pop, Environment, Op, Kinetic, Erotic, and all the other varieties of Novelty art look like so many logical moments in the working out of this problem, whose solution now seems to have arrived in the form of what is called Primary Structures, ABC, or Minimal art. The Minimalists appear to have realized, finally, that the far-out in itself has to be the far-out as end in itself, and that this means the furthest-out and nothing short of that. They appear also to have realized that the most original and furthest-out art of the last hundred years always arrived looking at first as though it had parted company with everything previously known as art. In other words, the furthest-out usually lay on the borderline between

art and non-art. The Minimalists have not really discovered anything new through this realization, but they have drawn conclusions from it with a new consistency that owes some of its newness to the shrinking of the area in which things can now safely be non-art. Given that the initial look of non-art was no longer available to painting, since even an unpainted canvas now stated itself as a picture, the borderline between art and non-art had to be sought in the three-dimensional, where sculpture was, and where everything material that was not art also was. Painting had lost the lead because it was so ineluctably art, and it now devolved on sculpture or something like it to head art's advance. (I don't pretend to be giving the actual train of thought by which Minimal art was arrived at, but I think this is the essential logic of it.)

Proto-Pop (Johns and Rauschenberg) and Pop did a lot of flirting with the third dimension. Assemblage did more than that, but seldom escaped a stubbornly pictorial context. The Shaped Canvas school has used the third dimension mainly in order to hold on to light-and-dark or "profiled" drawing: painters whose canvases depart from the rectangle or tondo emphasize that kind of drawing in determining just what other inclosing shapes or frames their pictures are to have. In idea, mixing the mediums, straddling the line between painting and sculpture, seemed the far-out thing to do; in actual aesthetic experience it has proven almost the opposite—at least in the context of painting, where even literal references to the third dimension seem inevitably, nowadays if not twenty-five years ago, to invoke traditional sculptural drawing.

Whether or not the Minimalists themselves have really escaped the pictorial context can be left aside for the moment. What seems definite is that they commit themselves to the third dimension because it is, among other things, a co-ordinate that art has to share with non-art (as Dada, Duchamp, and others already saw). The ostensible aim of the Minimalists is to "project" objects and ensembles of objects that are just nudgeable into art. Everything is rigorously rectilinear or spherical. Development within the given piece is usually by repetition of the same modular shape, which may or may not be varied in size. The look of machinery is shunned now because it does not go far enough towards the look of non-art, which is presumably an "inert" look that offers the eye a minimum of "interesting" incident—unlike

the machine look, which is arty by comparison (and when I think of Tinguely I would agree with this). Still, no matter how simple the object may be, there remain the relations and interrelations of surface, contour, and spatial interval. Minimal works are readable as art, as almost anything is today—including a door, a table, or a blank sheet of paper. (That almost any non-figurative object can approach the condition of architecture or of an architectural member is, on the other hand, beside the point; so is the fact that some works of Minimal art are mounted on the wall in the attitude of bas-relief. Likeness of condition or attitude is not necessary in order to experience a seemingly arbitrary object as art.) Yet it would seem that a kind of art nearer the condition of non-art could not be envisaged or ideated at this moment.

That precisely is the trouble. Minimal art remains too much a feat of ideation, and not enough anything else. Its idea remains an idea, something deduced instead of felt and discovered. The geometrical and modular simplicity may announce and signify the artistically furthest-out, but the fact that the signals are understood for what they want to mean betrays them artistically. There is hardly any aesthetic surprise in Minimal art, only a phenomenal one of the same order as in Novelty art, which is a one-time surprise. Aesthetic surprise hangs on forever—it is still there in Raphael as it is in Pollock—and ideas alone cannot achieve it. Aesthetic surprise comes from inspiration and sensibility as well as from being abreast of the artistic times. Behind the expected, self-canceling emblems of the furthest-out, almost every work of Minimal art I have seen reveals in experience a more or less conventional sensibility. The artistic substance and reality, as distinct from the program, turns out to be in good safe taste. I find myself back in the realm of Good Design, where Pop, Op, Assemblage, and the rest of Novelty art live. By being employed as tokens, the "primary structures" are converted into mannerisms. The third dimension itself is converted into a mannerism. Nor have most of the Minimalists escaped the familiar, reassuring context of the pictorial: wraiths of the picture rectangle and the Cubist grid haunt their works, asking to be filled out—and filled out they are, with light-and-dark drawing.

Sculpture for the Space Age

RONALD BLADEN

• Two leading minimalists, Ronald Bladen and Tony Smith, reveal in the following statements the ambition of recent American sculpture to compete successfully with the vastness and complexity of the industrial landscape.

[FROM Barbara Rose, "ABC Art," *Art in America,* LIII, No. 5 (October–November, 1965).]

My involvement in sculpture outside of man's scale is an attempt to reach that area of excitement belonging to natural phenomena such as a gigantic wave poised before it makes its fall or man-made phenomena such as the high bridge spanning two distant points.

The scale becomes aggressive or heroic. The esthetic is a depersonalized one. The space exploded or compressed rather than presented. The drama taut in its implication is best described as awesome or breathtaking. In rare moments I think these things can be gathered to produce a particular beauty.

TONY SMITH

[FROM Samuel Wagstaff, Jr., "Talking with Tony Smith," *Artforum,* December, 1966.]

I view art as something vast. I think highway systems fall down because they are not art. Art today is an art of postage stamps. I love the Secretariat Building of the U.N., placed like a salute. In terms of scale, we have less art per square mile, per capita, than any society ever had. We are puny. In an English village there was always the cathedral. There is nothing to look at between the Bennington Monument and the George Washington Bridge. We now have stylization. In Hackensack a huge gas tank is all underground. I think of art in a public context and not in terms of mobility of works of art. Art is just there. I'm temperamentally more inclined to mural painting, especially that of the Mexican Orozco. I like the way a huge area holds on to a surface in the same way a state does on a map.

ROBERT SMITHSON

• Leader of the movement toward "land art" and earthworks, Robert Smithson assessed his contemporaries in the following essay, making a pessimistic comparison between the static quality of gestalt-oriented art and the physicists' concept of entropy as energy failure.

———————

[FROM "Entropy and the New Monuments," *Artforum*, June, 1966.]

Many architectural concepts found in science-fiction have nothing to do with science or fiction; instead they suggest a new kind of monumentality which has much in common with the aims of some of today's artists. I am thinking in particular of Donald Judd, Robert Morris, Sol LeWitt, Dan Flavin, and of certain artists in the "Park Place Group." The artists who build structured canvases and "wall-size" paintings, such as Will Insley, Peter Hutchinson and Frank Stella, are more indirectly related. The chrome and plastic fabricators such as Paul Thek, Craig Kauffman, and Larry Bell are also relevant. The works of many of these artists celebrate what Flavin calls "inactive history" or what the physicist calls "entropy" or "energy-drain." They bring to mind the Ice Age rather than the Golden Age, and would most likely confirm Vladimir Nabokov's observation that "The future is but the obsolete in reverse." . . .

Instead of causing us to remember the past like the old monuments, the new monuments seem to cause us to forget the future. Instead of being made of natural materials, such as marble, granite, or other kinds of rock, the new monuments are made of artificial materials, plastic, chrome, and electric light. They are not built for the ages, but rather against the ages. They are involved in a systematic reduction of time down to fractions of seconds, rather than in representing the long spaces of centuries. Both past and future are placed into an objective present. This kind of time has little or no space; it is stationary and without movement, it is going nowhere, it is anti-Newtonian, as well as being instant, and is against the wheels of the time-clock. Flavin makes "instant-monuments"; parts for "Monument 7 for V. Tatlin" were purchased at the Radar Fluorescent Company. The "instant" makes Flavin's work a part of time rather than space. Time

becomes a place minus motion. If time is a place, then innumerable places are possible. Flavin turns gallery space into gallery time. Time breaks down into many times. Rather than saying "What time is it?" we should say "Where is the time?" "Where is Flavin's Monument?" The objective present at times seems missing. A million years is contained in a second, yet we tend to forget the second as soon as it happens. Flavin's destruction of classical time and space is based on an entirely new notion of the structure of matter.

Time as decay or biological evolution is eliminated by many of these artists; this displacement allows the eye to see time as an infinity of surfaces or structures, or both combined, without the burden of what Roland Barthes calls the "undifferentiated mass of organic sensation." The concealed surfaces in some of Judd's works are hideouts for time. His art vanishes into a series of motionless intervals based on an order of solids. Robert Grosvenor's suspended structural surfaces cancel out the notion of weight, and reverse the orientation of matter within the solid-state of inorganic time. This reduction of time all but annihilates the value of the notion of "action" in art.

Mistakes and dead-ends often mean more to these artists than any proven problem. Questions about form seem as hopelessly inadequate as questions about content. Problems are unnecessary because problems represent values that create the illusion of purpose. The problem of "form vs. content," for example, leads to illusionistic dialectics that become, at best, formalist reactions against content. Reaction follows action, till finally the artist gets "tired" and settles for a monumental inaction. The action-reaction syndrome is merely the leftovers of what Marshall McLuhan calls the hypnotic state of mechanism. According to him, an electrical numbing of torpor has replaced the mechanical breakdown. The awareness of the ultimate collapse of both mechanical and electrical technology has motivated these artists to build their monuments to or against entropy. As LeWitt points out, "I am not interested in idealizing technology." LeWitt might prefer the word "sub-monumental," especially if we consider his proposal to put a piece of Cellini's jewelry into a block of cement. An almost alchemic fascination with inert properties is his concern here, but LeWitt prefers to turn gold into cement. . . .

This kind of nullification has re-created Kasimir Malevich's "non-

objective world," where there are no more "likenesses of reality, no idealistic images, nothing but a desert!" But for many of today's artists this "desert" is a "City of the Future" made of null structures and surfaces. This "City" performs no natural function, it simply exists between mind and matter, detached from both, representing neither. It is, in fact, devoid of all classical ideals of space and process. It is brought into focus by a strict condition of perception, rather than by any expressive or emotive means. Perception as a deprivation of action and reaction brings to the mind the desolate, but exquisite, surface structures of the empty "box" or "lattice." As action decreases, the clarity of such surface-structures increases. This is evident in art when all representations of action pass into oblivion. At this stage, lethargy is elevated to the most glorious magitude. In Damon Knight's Sci-fic novel "Beyond the Barrier," he describes in a phenomenological manner just such surface-structures: "Part of the scene before them seemed to expand. Where one of the floating machines had been, there was a dim lattice of crystals, growing more shadowy and insubstantial as it swelled; then darkness; then a dazzle of faint prismatic light— tiny complexes in a vast three-dimensional array, growing steadily bigger." This description has none of the "values" of the naturalistic "literary" novel, it is crystalline, and of the mind by virtue of being outside of unconscious action. This very well could be an inchoate concept for a work by Judd, LeWitt, Flavin, or Insley.

It seems that beyond the barrier, there are only more barriers. Insley's "Night Wall" is both a grid and a blockade; it offers no escape. Flavin's fluorescent lights all but prevent prolonged viewing; ultimately, there is nothing to see. Judd turns the logic of set theory into block-like façades. These façades hide nothing but the wall they hang on.

LeWitt's first one-man show at the now defunct Daniel's Gallery presented a rather uncompromising group of monumental "obstructions." Many people were "left cold" by them, or found their finish "too dreary." These obstructions stood as visible clues of the future. A future of humdrum practicality in the shape of standardized office buildings modeled after Emery Roth; in other words, a jerry-built future, a feigned future, an ersatz future very much like the one depicted in the movie "The Tenth Victim." LeWitt's show has helped to neutralize the myth of progress. It has also corroborated Wylie

Sypher's insight that "entropy is evolution in reverse." LeWitt's work carries with it the brainwashed mood of Jasper Johns' "Tennyson," Flavin's "Coran's Broadway Flesh" and Stella's "The Marriage of Reason and Squalor."

Morris also discloses this backward-looking future with "erections" and "vaginas" embedded in lead. They tend to illustrate fossilized sexuality, by mixing the time states or ideas of "1948" with "One Million B.C." Claes Oldenburg achieves a similar conjunction of time with his prehistoric "ray-guns." This sense of extreme past and future has its partial origin with the Museum of Natural History; there the "cave-man" and the "space-man" may be seen under one roof. In this museum all "nature" is stuffed and interchangeable. . . .

Many of Morris's wall structures are direct homages to Duchamp; they deploy facsimiles of ready-mades within high Manneristic frames of reference. Extensions of the Cartesian mind are carried to the most attenuated points of no return by a systematic annulment of movement. Descartes' cosmology is brought to a standstill. Movement in Morris's work is engulfed by many types of stillness: delayed action, inadequate energy, general slowness, an all over sluggishness. . . . Morris's monstrous "ideal" structures are inconsequential or uncertain ready-mades, which are definitely outside of Bergson's concept of creative evolution. If anything, they are uncreative in the manner of the sixteenth-century alchemist-philosopher-artist. . . .

The impure-purist surface is very much in evidence in the new abstract art, but I think Stella was the first to employ it. The iridescent purple, green, and silver surfaces that followed Stella's all-black works conveyed a rather lurid presence through their symmetries. An exacerbated, gorgeous color gives a chilling bit to the purist context. Immaculate beginnings are subsumed by glittering ends. . . .

Stella's immaculate but sparkling symmetries are reflected in John Chamberlain's "Kandy-Kolored" reliefs. "They are extreme, snazzy, elegant in the wrong way, immoderate," says Judd. "It is also interesting that the surfaces of the reliefs are definitely surfaces." Chamberlain's use of chrome and metalflake brings to mind the surfaces in "Scorpio Rising," Kenneth Anger's many-faceted horoscopic film about constellated motorcyclists. Both Chamberlain and Anger have developed what could be called California surfaces.

Sidney Tillim

SIDNEY TILLIM

• Looking at the phenomenon in a historical context, realist painter Sidney Tillim saw a close connection between earthworks and late eighteenth-century picturesque landscape painting. In Tillim's opinion, both earthworks and picturesque landscapes are types of travel illustration.

[FROM "Earthworks and the New Picturesque," *Artforum*, December, 1968.]

Earthworks represent a special and conceptual involvement with literal nature. . . . Either passages of landscape are turned into art or object-art is turned into a kind of landscape, or object and landscape are combined in a way that is both esthetic and atavistic. Dennis Oppenheim proposes to mow rings up to ten miles wide in the wheat fields surrounding an active volcano in Ecuador next July, whereas Robert Morris assembles, in a gallery, and for one time, a compost of dark soil, a profusion of pipes, lengths of felt and a gelatinous mass of thick industrial grease. Other varieties of the literalist landscape experience, either illustrated or actually shown in the exhibition [at the Dwan Gallery, New York, 1968], include the vast parallel lines drawn across a Western wasteland by Walter de Maria, and a gallery in Munich with wall-to-wall dirt, also by de Maria. Rough-hewn blocks of wood by Carl Andre were illustrated snaking through forest underbrush; Michael Heizer dug slit trenches in forests and sun-baked mud flats. Claes Oldenburg showed some dirt in a palstic container; the dirt was said to be seeded with worms. The hole he had dug and filled up again behind the Metropolitan Museum of Art was presented on film.

What I think is involved in earth art in particular and actual media art in general is a twentieth-century version of the *picturesque*. The picturesque was a theory of landscape that emerged in the late eighteenth and early nineteenth centuries, especially in England. As the word itself implies, the picturesque referred to landscape seen in an essentially pictorial way. Landscapes were judged for their pictorial beauties and the same effects in painting were highly praised. In other words it was a way of seeing nature and the setting was very im-

portant. An extensive body of literature describing and illustrating picturesque tours came into being.

Minimalist art is likewise dependent on setting. Whether of the technological and hard-edged sort or the geological and much softer kind, minimalist art is a form of man-made nature or nature made over by man. It does not present objects with art on them but useless artifacts that create a setting rather than a space. The relationship, then, between an observer of minimalist art [and] a minimalist object-scape. . . . is analogous to the relationship between the cultivated man of taste and his picturesque view. It was this quality which provoked Michael Fried to describe minimalist or, as he called it, literalist sculpture pejoratively as "theatrical." For in the theatrical work the observer is no longer outside of the work of art but is instead a part of its setting. The work thus "performs" for the observer. Some minimalist sites can only be appreciated from the air. On the other hand, Robert Smithson virtually parodied the modern picturesque when he visited the "monuments" of Passaic, carrying his Instamatic camera [as] the older connoisseur carried a sketchbook, perhaps. And like him, Smithson wrote up his tour and illustrated it with photographs—of a factory building, sand pits, drainage pipes and the effluvia of industrialism generally.

As in the earlier and original picturesque, the values of judging and choosing "sites" or "non-sites" (as Smithson calls his gallery objects) or the style in which a landscape is made over derive entirely from art. A thorough knowledge of modernist art is therefore a prerequisite for the refinement actually involved in the literalist picturesque. For instance, qualities of shape and composition or non-composition derive from specifically abstract precedents. Thus some are purely planar and/or linear (Heizer's earth rings, de Maria's lines), some are Pop (Smithson's bins of rocks and photographs, his trip to Passaic, Oldenburg's hole in Central Park), others are virtually Abstract Expressionist in a conceptualized way (Morris's dirt pile). Earthworks was limited to a geological palette and other artists are working in other mediums which interpolate a corresponding landscape of tactility. And much of it combines both soft and hard components to recapitulate the basic formal dichotomy (edge versus mass) at the root of all art since the very moment, in fact, when the cult of the picturesque began to flourish. . . .

As the twentieth-century form of the picturesque, Earthworks signifies an analogous degree of over-cultivation of the modernist idiom. And it implements the condition of over-refinement in the course of seeking to renew modernism by a direct involvement with "actual" media, an involvement that has run the gamut from wood, metal, plastics, the entire industrial process and now common dirt. It thus links up with Pop art as a kind of precious primitivism seeking revitalization through willful banality. And like Pop art, it is effective only insofar as it confirms the stylistic attrition it seeks to reverse.

We can understand now why formalists restrict the possibility of quality to an increasingly narrow sector of art. As more and more art defects from what formalists consider rigorous historical self-criticism, as more and more artists substitute their own historical-theoretical definitions of modernist art history, the fewer [are] the options for a preponderantly formalist solution to problems of contemporary style. Thus the intensity of the formalist position increases to the degree that its conception of quality is isolated in an art culture that has turned to other means, including the extravagant ones in Earthworks, for solutions to problems of contemporary style. . . .

Earthworks, then, arrives at a moment when modernism is at the lowest ebb in its history, and is therefore implicated in, indeed signals, the weakness of modernism as a whole.

BILLY KLÜVER

• As artists began interacting with their environment, descending from the ivory tower of art-for-art's sake to become more socially engaged, a movement gained ground to marry art to technology, the moving force of contemporary society. Such experimental projects as the Los Angeles County Museum's survey of art and technology, organized by Maurice Tuchman in 1969–70, which represented the United States at Expo '70, the world's fair held at Osaka, Japan, attracted much attention. In proportion to the amount of cooperation corporations were willing to extend in terms of materials, hardware, and technical assistance, these projects grew in complexity. The most ambitious example of art in partnership with technology was the Pepsi-Cola Pavilion, designed by a collaborative of artists and engineers chosen by EAT (Experiments in Art and Technology), an organization that grew out of an initial collaboration between artist Robert Rauschenberg and physicist J. Wilhelm (Billy) Klüver.

Sculpture for the Space Age

In the following description of the Pepsi-Cola Pavilion, Klüver chronicles the reasons for the demise of joint efforts by artists and industry. By the late sixties, the art and technology movement had been eclipsed by such ecologically oriented concerns as earthworks, as it became clear that the aims of artists and those of business were at odds.

———————

[FROM "The Pavilion," introduction to *Pavilion* (New York: E. P. Dutton & Co., 1972). Copyright © 1972 by Experiments in Art and Technology. Reprinted by permission of E. P. Dutton & Co., Inc.]

The initial concern of the artists who designed the Pavilion was that the quality of the experience of the visitor should involve choice, responsibility, freedom, and participation. The Pavilion would not tell a story or guide the visitor through a didactic, authoritarian experience. The visitor would be encouraged as an individual to explore the environment and compose his own experience. As a work of art, the Pavilion and its operation would be an open-ended situation, an experiment in the scientific sense of the word. . . .

The artist is a positive force in perceiving how technology can be translated to new environments to serve needs and provide variety and enrichment of life. He may be the only one who can transcend cultural bias and deal with the individuals of a culture on their own terms. The direct, straight-ahead sensibility of the active artist is needed in these difficult problems. Based on this commitment to the artist, one of E.A.T.'s objectives in relation to the Pavilion was to demonstrate physically the variety and multiplicity of experiences that the new technology can provide for the individual.

The Pavilion was a living responsive environment. The Fog surrounding the Pavilion responded to the meteorological conditions; Suntrak sculpture was to follow the path of the sun; the moving floats reacted to physical contact. The inside of the Pavilion was an experiment in individual experience. It represented a new form of theatre space, which completely surrounded the audience, and where every part of the space had the same theatrical intensity for the individual.

The space in the Mirror was gentle and poetic, rich and always changing. It was complex in spite of its simplicity. We discovered new and complicated relationships every day, optical effects that no one had described before. As theatre space it was unique. It was a tangible

268

space; the effect was not psychological as in the case of someone witnessing a drama on stage. Instead, the visitor became part of the total theatre experience. Anything that one did in this environment was beautiful.

The sound system was constructed for automated control, which could be overridden by live manipulation. The system was designed for the spherical symmetry of the space and to preserve the basic concept of the visitor's free choice in the space. Sounds could be moved in patterns; but, for instance, it would be impossible to begin a sound at a given speaker, rotate it around the dome, and stop it exactly at the same speaker. Exact synchronization and time sequencing were impossible to accomplish. Instead the sound space was as open-ended and changing as the image space.

Traditionally, the artist assumes complete personal responsibility for his work. In the types of collaborations we set up, this approach was assumed. . . .

If all the separate sections of a project are to be of the best quality, then they must develop independently. Interfacing of the various elements becomes the overriding problem and good communication between members of the project is necessary. This horizontal operating situation requires that each member of the group understand his responsibility as well as his limitations. Complications arose when engineering and aesthetic considerations became confused: when engineers wanted to be artists, when accountants wanted to be engineers, or when artists were intimidated by engineering. The artist had to express his aesthetic criteria in order to determine the scale, and so that the engineer would be aware of the boundary conditions. . . .

Both the Fog and the Mirror were "firsts" in terms of scale. In addition, their technology had further applications. The Fog surrounding the Pavilion was the largest water-vapor mass ever produced without the use of chemicals. The insistence on using pure water for the Fog led to a system that offered interesting possibilities for environmental irrigation systems, outdoor air conditioning, and protection of crops from frost. The Mirror was the largest spherical mirror ever made and was the first use of a Melinex, negative-pressure, air structure. It used the inside reflective surface of a sphere for the first time. It is conceivable that this method of making a concave reflective surface could be used in making various types of antennas.

Live programming was designed to use the space in an organic way. The hardware ideas were so rich in possibilities that the concept of a continuously changing environment developed organically. A changing group of four artists (composers, dancers, painters, or scientists) were to reside at the Pavilion at all times and determine the activities and programming. . . . The Pavilion became theatre conceived of as a total instrument, using every available technology in which the accumulated experience of all the programmers expanded and enriched the possibilities of the space. The programming and operations of the Pavilion were as important as the design of the hardware. . . .

Postscript

The Pepsi-Cola project was remarkable in its attempt to involve contemporary artists in a nonart situation. This attempt raised a number of interesting questions particularly in the area of the relation of the artist to industry and the legal position of the artist in society, which were dramatized by the breakdown in our relationship with Pepsi over the programming of the Pavilion. The usual form of industrial support of the arts is patronage of existing art or art forms. In this project the artist was considered a resource in an actual physical situation with a functional end. The fact that there was no recognized definition of this role of the artist was at the root of the misunderstandings.

Traditionally, the artist operates in a legal, institutional, and value structure of his own, which is different from some standard practices in the rest of society, some of the peculiarities of which are recognized by law: works of art can be imported duty free, even if they are made of taxable materials; a serious work of art is not subject to the usual standards of obscenity laws. The artist does not copyright his work; he has no control over it after it is sold, except that it cannot be changed. Furthermore, the artist takes his material from his environment and is not required to get permission or pay for rights—Andy Warhol's *Brillo Box* series is a famous example. Further, if the work of one artist is clearly derivative from the work of another, he is dismissed as a bad artist. Underlying this whole complex of values and practices there is the assumption of consistency and integrity of authorship. These operational, quasi-legal, and legal aspects of the

artist's activity must be taken into account if he is to be able to contribute effectively as a resource outside his own field.

In the specific case of the Pepsi-Cola Pavilion, I suggested the following solution to Donald Kendall, President of PepsiCo., Inc., in a letter, April 8, 1970:

> . . . As you know, the Pavilion and the programming were designed through a collaboration of a large number of contemporary artists, engineers, scientists, and other professionals. The question that has arisen comes from the legal distinction between a work of fine art and a commercial product, or more specifically between the creative artist and the commercial artist or designer.
>
> Our legal relationship to Pepsi-Cola has developed so that the artists are put in the category of commercial artists designing a commercial product. One consequence of this is that we must obtain rights from all artists and engineers and others involved, particularly with regard to use of the Pavilion after Expo '70. Of course there is no question of Pepsi's ownership and right to use and exhibit the Pavilion during Expo '70. Our dilemma is whether the artists have created a work of fine art or a work of commercial art to which there are rights which must be guaranteed.
>
> Traditionally, the artist claims no "rights" to his work: his commitment to originality is unquestioned and he contributes his work to the world when it is finished. . . .
>
> A decision to recognize the Pepsi Pavilion as a work of art and to treat it as such will set a much-needed precedent in this area. The project will be a model for future industrial participation in projects where the artist moves into society and involves increasing numbers of people in his work.

MARK DI SUVERO

• After building the Los Angeles Peace Tower, a structure symbolizing the protest of the art community against the Vietnam war, decorated with works by many of the best-known contemporary American artists, Mark di Suvero left America to live in exile in Venice, Italy, his family's native city, and Chalon-sur-Saône, France, where he created a series of monumental public sculptures for the community, which financed the project.

Di Suvero has been among the last remaining American artists to maintain a commitment to resistance and a heroic stance in the seventies.

Below, he writes of kinetic images, the self, clarity of thought and structure, and the meaning of art as an emblem of human freedom.

[FROM an unpublished manuscript.]

Moving Images

Communication generally depends upon symbolic transmission in civilization (i.e. soundwaves phonetic correlation to ink-distribution across pages). Not until the last century does the image (photo) enter as a current mass-used information carrier: an almost equal retinal response, it has modernized into terrifying dimensions the old Chinese proverb "an image is worth a thousand words." How much more is a moving image worth?

If majority humanity has become illiterate anal[ph]abets because of moving images (TV movies) and the human consciousness, reasoning-powers depend upon a conditioned syntax, what is the likely result of new-communication training? Can we postulate image-reasoning power?

Surely the demystification/female/religion/myth and advertising-consumer learned-response are some of the results when reality is equated with photographic image. To restore the sense of our limited spectrum-vision: out of the electromagnetic spectrum we see only our window.

If we saw the subway jam-rush with [X]-ray vision what would we think?

Individuality and Mass Communications

With modern communications systems television congress telephone vote-in direct democracy becomes possible. Since all decisions are based upon information, information-channels will be more scrupulously open in a direct democracy. The closed non-alternative information position of dictatorship societies is not the cultural ambience which gives rise to a free-imagination Renaissance society. The representative form of democracy is not true democracy but is a reflection of the aristocratic distrust of the masses. When much power is given to a few only Folly says they will not profit from it.

Most people live second-hand lives. Learned emotional responses; parents movies, books, neighbor judged or expected behavior lead toward conformity. Everything an individual *is*; ego's necessity to initiate projects, myth of freedom, demands that the individual feel separate and unique *yet* everything that a herd demands says: limit. For example: we learn how to love and hate (parents' model form[s] our most basic imitation pattern) racial prejudice is obviously taught as scapegoat regressive behavior, etc. The key to the belief that we are all individual has to do with our sense of being unique. If we were to know that what we had thought and felt was an exact duplication of that which many others were going thru we could feel, honestly, individual. It is that each of us has a gift in us that could be given out: a special name (and being unlocked from the set of sounds or ink print-outs that our parents gave us must be the first step towards that liberation). The Renaissance Florentines called it your *virtù* and it means using the violin as a violin, not as a hammer. Happiness is doing that which we can do best (functionalist definition) to find this gift (special name) must be the function of education's panorama (offering us as many fields as possible) but that is also our *job* the basic search for our own individuality and hence our happiness.

Just as the first mass machine-language was the typewriter (with its know communication change-results in literature everyday news etc.), the machine-language of the computer has yet to expose its full results. Who can give an accurate predictive diagnosis of what the combination TV-computer will produce? The photos of the moon and Mars are only the beginnings of the answer. . . .

Certain habits form their own necessities. Once people begin to travel, they need to travel (the air-travel boom in the USA) never having seen television they did not *need* TV. Now the need for media supports a huge industry: and television concretizes and offers vicarious living (tangible dreams) to the bored residents of the bureaucratic factory/office. The capacity to read depends upon a capacity for imagination, in TV there is only output.

When viewer-input will begin, TV as a participant art-form will emerge as a life-giving force instead of its present lulling bottle-force-fed means of stupefying the population and politically controlling thought patterns.

Sculpture for the Space Age

What Is Luxury?

A bought consciousness, a consciousness in which overfeed extra luxuries' satiation has engendered a blindness to injustice, a preference for the status quo with an ego's self-gratifying hedonistic urge satisfied. The distance from a bought consciousness to a bankrupt. What is a luxury? Anything not a necessity. How few are the necessities: you cannot count the luxuries, there is no end to them.

Information and Knowledge

In a world of information *knowledge* is power, wealth and energy-giving in that organization is a potential storing-place in the energy-transfer relationship. In the existence of knowledge the world's organization-structure is changed, i.e. river, dam. The function of education is to make knowledge. Anti-knowledge education which blunts the hunger-to-know is too often what schools specialize in. . . .

To accept the freak occurrence that is our life is one of the hardest things that the human mind can bear. It renders into cosmic insignificance the role of any individual and denies the objective validity of any aim. The most difficult part to endure of this realization is that the sense of special-case-rareness that is basic to the ego is nullified.

Complex Structures

Structure, the basic alternation and relation of position, determines all the qualities of non-living matter. Complex structures' functioning result[s] in a general process called "life." The functions of structure are systematic (i.e. face-centered lattices) and total: independent of size from subatomic spacetime to galactic planes. Repeatability (signification) across undividuated units is a basic need of language, logic and mathematics.

Structure has as one of its most basic divisions symmetry/asymetry.

All poems are in one book: the dictionary; only the structure varies from one poem to another. To apply the suddenly opened doors of poetry to our lives is to move from anaesthetic hollowness to an aesthetic existence.

Sometimes looking at the contrary/mirror-reversed/language helps

us see the wanted-thing-in-itself. Numbness of the dentist's novocaine; anaesthetic, to be made numb, no feeling. Aesthetic is, then, feeling.

The safecracker who sandpapers his fingertips to feel the tumblers fall knows something about the application of poetry to life.

To be open to other consciousnesses imagining's play-flex willing to experiment with interplay must be a way to open one's self maximally towards our personal development (to the limit [to] which our personality can be influenced by interchange). Let no one underestimate the limit/conditioning-domain which interchange between humans effects the individual. Each of us has a mother. Think a moment about her. How much shaping has she made in your mind's life?

Freedom can only exist when there is real choice. The demonstration that freedom is a subjective state is "Freedom is less coercion than we are used to." The dynamic (change subjective state) is a necessary complement to the endless static question on the nature of the universe: determinism. We have not yet seen one demonstration that the question "does determinism exist?" has an *answer*. If determinism exists, strict and total, chemical and of consciousness, so that every act is predictable: then ethics does not exist as a real subject but is only culture pattern reflex. Ethics then (in the history of philosophy) begins assuming the possibility of freedom and real choice.

That consciousness exists as an organizing form on the world is obvious if you look up from this page at the *immediate* space around you.

Freedom to develop implies freedom to express. To reach full capacity of growth-rate the freedom to develop must be given maximal opportunities. The leap-frogging relation of original scientific discovery technological exploitation and economic boom (post—WW II electronic industry) demands that the greatest attention must be given to the development of the original imaginative individual. The exploration of the imaginative is not solely an individual thing, but comes from a total culture's ambience.

Homo sapiens has a killer instinct which must derive from hunting antecedents. Surviving canine (carnivorous) dental structure is a skeletal proof. What seems to be the highest interspecific aggression rate known (wars) coinciding with discovery and exploitation of scientific knowledge has produced a species which has exterminated

other species in an evolutionary genocide which is even more horrible because of its unintentionality. The poisoning of the interwebbed interdependent balance we call ecology can only reach its maximum in Homo sapiens-suicide radioactive annihilation. Humanity may prove to be a greater disaster to evolutionary species than any known natural event. We must re-channel the killer instinct. Unless we can change we cannot survive. Remember this. Unless Homo sapiens can change we cannot survive.

Bibliography

When consulting this bibliography, check the listings under several chapter headings: Entries dealing with the subjects of the text readings are often included in several places. Most works cited in the source notes are not included here.

GENERAL

Art in America 53, No. 4 (August–September, 1965). Archives of American Art issue.

BARKER, VIRGIL. "Americanism in Painting," *Yale Review,* Summer, 1936.

———. *A Critical Introduction to American Painting.* New York: Whitney Museum of American Art, 1931.

———. *From Realism to Reality in Recent American Painting.* Lincoln: University of Nebraska Press, 1959.

BAUR, JOHN I. H. *Revolution and Tradition in Modern American Art.* New York: Frederick A. Praeger, 1967.

CAHILL, HOLGER, and BARR, ALFRED H., JR. *Art in America in Modern Times.* New York: Reynal & Hitchcock, 1934.

CORTISSOZ, ROYAL. *American Artists.* New York: Scribner's, 1923.

GELDZAHLER, HENRY. *American Painting in the Twentieth Century.* New York: Metropolitan Museum of Art, 1965.

GOODRICH, LLOYD. *American Genre.* New York: Whitney Museum of American Art, 1935.

———. *Three Centuries of American Art.* New York: Frederick A. Praeger, 1966.

GOODRICH, LLOYD, and BAUR, JOHN I. H. *American Art of Our Century.* New York: Frederick A. Praeger, 1961. Catalogue of the Whitney Museum of American Art collection.

HARTMANN, SADAKICHI. *A History of American Art.* 2 vols. Rev. ed. Boston: Page, 1932.

HUNTER, SAM. *American Art of the Twentieth Century.* New York: Harry N. Abrams, 1973.

Bibliography

———. *Modern American Painting and Sculpture.* New York: Dell Publishing Co., 1959.

Index of Twentieth-Century Artists. New York: College Art Association, 1933–37. A bibliography on American artists.

KOZLOFF, MAX. *Renderings: Critical Essays on a Century of Modern Art.* New York: Simon & Schuster, 1969.

KRAMER, HILTON. *The Age of the Avant Garde.* New York: Farrar, Straus and Giroux, 1973.

LARKIN, OLIVER W. *Art and Life in America.* Rev. ed. New York: Holt, Rinehart & Winston, 1964.

LIPPARD, LUCY R. *Changing: Essays in Art Criticism.* New York: E. P. Dutton, 1971.

McCAUSLAND, ELIZABETH. "A Selected Bibliography on American Painting and Sculpture," in *Who's Who in American Art.* Washington, D.C.: American Federation of Arts, 1947, vol. 4: 611–53. Originally appeared in the *Magazine of Art* 39 (November, 1946): 329–49.

McCOUBREY, JOHN W. *American Tradition in Painting.* New York: George Braziller, 1963.

MATHER, FRANK J., JR., et al. *The American Spirit in Art.* New Haven: Yale University Press, 1927.

PACH, WALTER. *Modern Art in America.* New York: Kraushaar Galleries, 1928.

ROSE, BARBARA. *American Art Since 1900: A Critical History,* Rev. ed. New York: Praeger Publishers, 1975.

———. *American Painting: The Twentieth Century.* New York: Skira, 1969.

ROSENBERG, BERNARD, and FLIEGEL, NORRIS E. "The Vanguard Artist in New York," *Social Research* 32, No. 2 (Summer, 1965): 141ff.

WHEELER, MONROE. *Painters and Sculptors of Modern America.* New York: Thomas Y. Crowell, 1942.

CHAPTER ONE

"Artists of the Philadelphia Press," *Philadelphia Museum Bulletin* 41 (November, 1945).

BAUR, JOHN I. H. *The Eight.* New York: Brooklyn Museum, 1934.

BRAIDER, DONALD. *George Bellows and the Ashcan School of Painting.* New York: Doubleday, 1971.

BROOKS, VAN WYCK. *John Sloan: A Painter's Life.* New York: E. P. Dutton, 1955.

GLACKENS, IRA. *William Glackens and the Ashcan Group.* New York: Grosset & Dunlap, 1957.

GOODRICH, LLOYD. *Thomas Eakins: His Life and Work.* New York: Whitney Museum of American Art, 1933.

HENRI, ROBERT. *The Art Spirit.* Compiled by Margery A. Ryerson. Philadelphia: J. B. Lippincott, 1960.

———. "My People," *The Craftsman* 27 (February, 1915).

————. "Review of the Independent Show, 1910," *The Craftsman* 18 (May, 1910).
Hoⴊ ER, WILLLIAM INNESS. *Robert Henri and His Circle*. Ithaca, N.Y.: Cornell University Press, 1969.
Hoᴘᴘᴇʀ, EDWARD. "John Sloan and the Philadelphians," *The Arts* 11 (April, 1927).
KATZ, LESLIE. "The Centenary of Maurice Prendergast," *Arts Magazine* 34 (November, 1960).
————. *William Glackens in Retrospect*. St. Louis: City Art Museum of St. Louis, 1966.
New York Realists, 1900–1914. New York: Whitney Museum of American Art, 1937.
PACH, WALTER. "The Eight Then and Now," *Art News*, January 1–14, 1944.
PERLMAN, BENNARD P. *The Immortal Eight: American Painting from Eakins to the Armory Show*. New York: Exposition Press, 1962.
POTTER, MARGARET. *George Bellows*. New York: Gallery of Modern Art, 1965.
READ, HELEN A. *Robert Henri*. New York: Whitney Museum of American Art, 1931.
SAWYER, CHARLES H. *Paintings and Watercolors by Maurice Prendergast*. New York: M. Knoedler & Co., 1966.
SHINN, EVERETT. "Recollections of the Eight," in *The Eight*. Brooklyn: Brooklyn Institute of Arts and Sciences, 1943. Catalogue of an exhibition at the Brooklyn Museum, 1943–44.
SLOAN, JOHN. *The Gist of Art*. New York: American Artists Group, 1939.
————. *John Sloan's New York Scene*. Ed. Bruce St. John, with an Introduction by Helen Farr Sloan, New York: Harper & Row, 1965.
ST. JOHN, BRUCE. *John Sloan*. New York: Praeger Publishers, 1971.

CHAPTER TWO

America and Alfred Stieglitz. Ed. W. Frank, L. Mumford, D. Norman, P. Rosenfeld, H. Rugg. New York: Doubleday, Doran & Co., 1934.
"An American Collection," *Philadelphia Museum Bulletin* 40 (May, 1945).
BENSON, EMANUEL M. *John Marin, The Man and His Work*. New York: Museum of Modern Art, 1935.
BENTON, THOMAS HART. "America and/or Alfred Stieglitz," *Common Sense* 4 (January, 1935).
CAHILL, HOLGER. *Max Weber*. New York: Downtown Gallery, 1930.
Camera Work, 1902–17.
COKE, VAN DEREN. *Taos and Santa Fe: The Artist's Environment, 1882–1942*. Albuquerque: University of New Mexico Press, 1963.
COX, KENYON. "The Modern Spirit in Art," *Harper's Weekly*, March 15, 1913.
DE CASSARES, BENJAMIN. "American Indifference," *Camera Work*, No. 27 (1909).
————. "Insincerity: A New Vice," *Camera Work*, No. 42 (1913).
————. "Modernity and the Decadence," *Camera Work*, No. 37 (1912).

Bibliography

————. "The Unconscious in Art," *Camera Work*, No. 36 (1911).

Dow, A. W. "Talks on Art Appreciation," *The Delineator*, January, 1915.

Goodrich, Lloyd and Bry, Doris. *Georgia O'Keeffe*. New York: Whitney Museum of American Art, 1970.

Greenberg, Clement. "John Marin," in *Art and Culture*. Boston, Beacon Press, 1961.

Hartley, Marsden. *Adventures in the Arts: Informal Chapters on Painters, Vaudeville and Poets*. New York: Boni and Liveright, 1921.

————. "Art—and the Personal Life," *Creative Art* 2 (June, 1928).

Hartmann, Sadakichi. "The Photo-Secession, A New Pictorial Movement," *The Craftsman* 6 (April, 1904).

Haskell, Barbara. *Arthur Dove*. San Francisco: San Francisco Museum of Art, 1974–75.

Helm, MacKinley. *John Marin*. New York: Pellegrini & Cudahy, 1948.

Johnson, Dorothy Rylander. *Arthur Dove: The Years of Collage*. College Park: University of Maryland (J. Millard Tawes Fine Arts Center), 1967.

McCausland, Elizabeth. *A. H. Maurer*. New York: A. A. Wyn, 1951.

————. *Marsden Hartley*. Minneapolis: University of Minnesota Press, 1952.

Marin, John. "A Few Notes," *Twice a Year*, No. 2 (1939).

————. "John Marin by Himself," *Creative Art* 3 (October, 1928).

————. *Letters of John Marin*. Ed. H. J. Seligmann. New York: Pellegrini & Cudahy, 1931.

————. *Selected Writings of John Marin*. Ed. and with an Introduction by Dorothy Norman. New York: Pellegrini & Cudahy, 1949.

Mather, Frank J. "The Forum Exhibition," *The Nation* 102 (March 23, 1916).

————. "Some American Realists," *Arts and Decoration*, November, 1916.

Melquist, Jerome. *The Emergence of an American Art*. New York, Scribner's, 1942.

Miller, Dorothy C. *Lyonel Feininger and Marsden Hartley*. New York: Museum of Modern Art, 1944.

Plagens, Peter. "Marsden Hartley," *Artforum*, May, 1969.

Rich, Daniel Catton. *Georgia O'Keeffe*. Chicago: Art Institute of Chicago, 1943.

————. *Georgia O'Keeffe*. Worcester, Mass.: Worcester Art Museum, 1960.

Rosenfeld, Paul. *Port of New York: Essays on Fourteen American Moderns*. New York: Harcourt, Brace, 1924.

Stein, Gertrude. *The Autobiography of Alice B. Toklas*. New York: Modern Library, 1933.

Stieglitz, Alfred. "Modern Pictorial Photography," *The Century* 64 (October, 1902).

————. "Six Happenings," *Twice a Year*, Nos. 14–15 (1946–47).

————. "Stories, Parables and Correspondence," *Twice a Year*, Nos. 8–9, (1942).

Ten Americans, Masters of Watercolor: Avery, Burchfield, Demuth, Dove, Homer, Hopper, Marin, Prendergast, Sargent, Wyeth. New York: Andrew Crispo Gallery, 1974.

291. Ed. Alfred Stieglitz. Nos. 1–12 (1915–16).

WEBER, MAX. "Chinese Dolls and Modern Colorists," *Camera Work,* No. 31 (July, 1910).

———. "The Fourth Dimension from a Plastic Point of View," *Camera Work,* No. 31 (July, 1910).

WIGHT, FREDERICK S. *Arthur G. Dove.* Berkeley: University of California Press, 1958.

WILDER, MITCHELL. *Georgia O'Keeffe: An Exhibition of the Work of the Artist from 1915 to 1966.* Fort Worth: Amon Carter Museum of Western Art, 1966.

WILLIAMS, W. C., PHILLIPS, D., and NORMAN, D. *John Marin.* Los Angeles: University of California Press, 1955.

ZAYAS, MARIUS DE, and HAVILAND, PAUL. *A Study of the Modern Evolution of Plastic Expression.* New York: "291" Gallery, 1913.

CHAPTER THREE

BLASHFIELD, EDWARD. "The Painting of Today," *The Century* 87 (April, 1914).

BRINTON, CHRISTIAN. "American Painting at the Panama-Pacific Exposition," *International Studio* 61 (August, 1915).

———. "Evolution Not Revolution in Art," *International Studio* 49 (April, 1913).

BROWN, MILTON. *American Painting from the Armory Show to the Depression.* Princeton, N.J.: Princeton University Press, 1955.

———. *The Story of the Armory Show.* New York: Joseph H. Hirshhorn Foundation, 1963.

Collection of the Société Anonyme. New Haven: Yale University Art Gallery, 1950.

COX, KENYON. "The Illusion of Progress," *The Century* 85 (May, 1913).

DAVIES, ARTHUR B. "Explanatory Statement: The Aim of the A.A.P.S.," *Arts and Decoration,* March, 1913.

DU BOIS, GUY PÈNE. *Artists Say the Silliest Things.* New York: American Artists Group, 1940.

EDDY, ARTHUR, J. *Cubists and Post-Impressionists.* Chicago: McClurg, 1914.

The Forum Exhibition. Anderson Gallery. New York: Hugh Kennerly, 1916.

GREGG, F. J. "The Attitude of the Americans," *Arts and Decoration,* March 1913.

———. "A Remarkable Art Show," *Harper's Weekly,* February 15, 1913.

HAMBIDGE, J., and HAMBIDGE, G. "The Ancestry of Cubism," *The Century* 87 (April, 1914).

KUHN, WALT. *The Story of the Armory Show.* New York: Privately printed, 1938. Supplemented by a similar article in the *Art News Annual* (1939).

MACCALL, W. D. "The International Exhibition of Modern Art," *Forum* 50 (July–December, 1913).

MATHER, FRANK J., JR. "Newest Tendencies in Art," *The Independent* 74 (March, 1913).

———. "Old and New Art" [at the Armory], *The Nation* 96 (March 6, 1913).

Bibliography

MELLQUIST, JEROME. "The Armory Show Thirty Years Later," *Magazine of Art* 36 (December, 1943).

MYERS, JEROME. *An Artist in Manhattan.* New York: American Artists Group, 1940.

PACH, WALTER. *Queer Thing, Painting.* New York: Harper & Bros., 1938.

PHILLIPS, DUNCAN. "Fallacies of the New Dogmatism in Art," *American Magazine of Art,* 9 (January, 1918).

———. "Revolution and Reaction," *International Studio* 51 (November–December, 1913).

ROOSEVELT, THEODORE. "A Layman's Views of an Art Exhibition," *The Outlook* 29 (March 9, 1913).

SCHAPIRO, MEYER. "Rebellion in Art," in *America in Crisis.* Ed. Daniel Aaron. New York: Alfred A. Knopf, 1952.

TILLIM, SIDNEY. "Dissent on the Armory Show," *Arts Magazine* 37 (May–June, 1963).

WRIGHT, WILLARD H. "An Abundance of Modern Art," *Forum* 55 (January–June, 1916).

———. "The Aesthetic Struggle in America," *Forum* 55 (January–June, 1916).

CHAPTER FOUR

AGEE, WILLIAM C. *Synchromism and Color Principles in American Painting.* New York: M. Knoedler & Co., 1965.

ANDREWS, EDWARD D., and ANDREWS, FAITH. "Sheeler and the Shakers," *Art in America* 53, No. 1 (February, 1965).

BAUR, JOHN I. H. *Joseph Stella.* New York: Praeger Publishers, 1971.

———. "The Machine and the Subconscious: Dada in America, *Magazine of Art* 44 (October, 1951).

BREESKIN, ADELYN. *Roots of Abstract Art in America, 1910–1950.* Washington, D.C.: National Collection of Fine Arts, 1965.

BRINTON, CHRISTIAN. *Modern Art at the Sesqui-Centennial Exhibition.* New York: Société Anonyme, 1926.

BROWN, MILTON. "Cubist-Realism: An American Style," *Marsyas* 3 (1943–45).

BUFFET-PICABIA, GABRIELLE. "Some Memories of Pre-Dada: Picabia and Duchamp," in *Dada Painters and Poets.* Ed. Robert Motherwell. New York: Wittenborn, Schultz, 1951.

BURCHFIELD, CHARLES. "On the Middle Border," *Creative Art* 3 (September, 1928).

Charles Sheeler. Washington, D.C.: Smithsonian Institution, National Collection of Fine Arts, 1968.

DASBURG, ANDREW. "Cubism—Its Rise and Influence," *The Arts* 4 (November, 1923).

DOCHTERMAN, LILLIAN. *The Quest of Charles Sheeler.* Iowa City: State University of Iowa Press, 1963.

Bibliography

FALSON, S. LANE. "Fact and Art in Charles Demuth," *Magazine of Art* 43 (April, 1950).

FRIEDMAN, MARTIN. *The Precisionist View in American Art.* Minneapolis: Walker Art Center, 1960.

GOODRICH, LLOYD. *Pioneers of Modern Art in America: The Decade of the Armory Show, 1910–1920.* New York: Frederick A. Praeger, 1963.

GORDON, JOHN. *Geometric Abstraction in America.* New York: Museum of Modern Art, 1962.

HAMBIDGE, J., and HAMBIDGE, G. "The Ancestry of Cubism," *The Century* 87 (April, 1914).

HAMILTON, GEORGE HEARD. "John Covert, Early American Modern," *College Art Journal* 12 (Fall, 1952).

JAFFE, IRMA B. *Joseph Stella.* Cambridge, Mass.: Harvard University Press, 1970.

LANGSNER, JULES. *Man Ray.* Los Angeles: Los Angeles County Museum of Art, 1966.

LEBEL, ROBERT. *Marcel Duchamp.* New York: Grove Press, 1939.

MCBRIDE, HENRY. "A Hero Worshipped," *The Dial* 69 (July–December, 1920).

Max Weber. Santa Barbara: University of California at Santa Barbara Art Gallery, 1968.

MORRIS, GEORGE L. K. "To Charles Demuth," *Partisan Review,* March, 1938.

PACH, WALTER. *Modern Art in America.* New York: Kraushaar Galleries, 1928.

REICH, SHELDON. *John Marin: A Stylistic Analysis and Catalogue Raisonné.* 2 vols. Tucson: University of Arizona Press, 1970.

RITCHIE, ANDREW C. *Abstract Painting and Sculture in America.* New York: Museum of Modern Art, 1951.

———. *Charles Demuth.* New York: Museum of Modern Art, 1950.

ROSE, BARBARA. "New Paintings by Georgia O'Keeffe," *Artforum,* November, 1970.

ROURKE, CONSTANCE. *Charles Sheeler: Artist in the American Tradition.* New York: Harcourt, Brace, 1938.

RUBIN, WILLIAM. "Man Ray," *Art International* 7 (June, 1963).

SCOTT, DAVID W. *The Art of Stanton Macdonald-Wright.* Washington, D.C.: Smithsonian Institution, National Collection of Fine Arts, 1967.

SIMONSON, LEE. "No Embargos," *Creative Art* 8 (April, 1931).

STELLA, JOSEPH. "The Brooklyn Bridge (A Page of My Life)," *transition,* Nos. 16–17 (June, 1929).

WATSON, FORBES. "Charles Sheeler," *The Arts* 3 (May, 1923).

WESCHER, HERTA. *Collage.* Trans. Robert E. Wolf. New York: Harry N. Abrams, 1968.

WIGHT, FREDERICK S. *Stanton Macdonald-Wright: A Retrospective Exhibition, 1911–1970.* Los Angeles: University of California at Los Angeles Art Galleries, 1970.

WOLF, BEN. *Morton Livingston Schamberg.* Philadelphia: University of Pennsylvania Press, 1963.

Bibliography

WRIGHT, WILLARD H. *American Painting and Sculpture.* New York: Museum of Modern Art, 1932.
——. *The Future of Painting.* New York: B. W. Huebsch, 1923.
——. *Modern Painting.* New York: John Lane, 1915.

CHAPTER FIVE

ABELL, WALTER. "The Limits of Abstraction," *Magazine of Art* 28 (December, 1935).
American Abstract Artists. Annual exhibition catalogue and checklist from 1937.
ARNASON, H. H. *Stuart Davis.* Washington, D.C.: National Collection of Fine Arts, 1965.
BALDINGER, W. S. "Formal Change in Recent American Painting," *Art Bulletin* 19 (December, 1937).
BARR, ALFRED H., JR. *Cubism and Abstract Art.* New York: Museum of Modern Art, 1936.
BAUR, JOHN I. H. *Charles Burchfield.* New York: Whitney Museum of American Art, 1956.
BENTON, THOMAS HART. *An American in Art: A Professional and Technical Autobiography.* Lawrence: University of Kansas Press, 1969.
——. *An Artist in America.* Rev. ed. Kansas City: University of Kansas City Press, Twayne Publishers, 1951.
BLUME, PETER. "After Surrealism," *The New Republic* 80 (October 3, 1934).
BREESKIN, ADELYN. *Milton Avery.* New York: American Federation of Arts, 1960.
BRUCE, EDWARD, and WATSON, FORBES. *Art in Federal Buildings: An Illustrated Record of the Treasury Department's New Programs in Paintings and Sculpture.* Washington, D.C.: Art in Federal Buildings, Inc., 1936.
BURROUGHS, ALAN. *Kenneth Hayes Miller.* New York: Whitney Museum of American Art, 1931.
CAHILL, HOLGER. *Art as a Function of Government.* Washington, D.C.: Federal Art Project, 1937.
——. *New Horizons in American Art.* New York: Museum of Modern Art, 1936.
CAMPBELL, LAWRENCE. "Paintings from WPA," *Art News,* September, 1961.
CHENEY, MARTHA C. *Modern Art in America.* New York: McGraw-Hill Book Co., 1939.
CRAVEN, THOMAS. *Men of Art.* New York: Simon & Schuster, 1931.
——. *Modern Art—the Men, the Movements, the Meaning.* New York: Simon & Schuster, 1934.
——. "Naturalism in Art," *Forum* 95 (January–June, 1936).
——. *Thomas Hart Benton.* New York: Associated American Artists, 1939.
DAVIS, STUART. "Abstract Art in the American Scene," *Parnassus* 13 (March, 1941).

————. "Abstract Painting," *Art of Today,* April, 1935.

————. "Arshile Gorky in the 1930's: A Personal Recollection," *Magazine of Art* 44 (February, 1951).

DENBY, EDWIN. *The 30's: Painting in New York.* New York: Poindexter Gallery, 1957.

FARBER, MANNY. "Jack Levine," *Art News,* March, 1955.

GALLATIN, A. E. *Museum of Living Art.* New York: George Grady Press, 1940. A. E. Gallatin collection.

GEIST, SIDNEY. "Prelude: The 1930's," *Arts Magazine* 30 (September, 1956).

GOODRICH, LLOYD. *Edward Hopper.* New York: Whitney Museum of American Art, 1964.

————. *Edward Hopper.* New York: Harry N. Abrams, 1971.

————. *Pioneers of Modern Art in America.* New York: Whitney Museum of American Art, 1946.

GOOSSEN, E. C. *Stuart Davis.* New York: George Braziller, 1959.

GORKY, ARSHILE. "Stuart Davis," *Creative Art* 9 (September, 1931).

GRAHAM, JOHN D. *System and Dialectics of Art.* New York: Delphic Studios, 1937.

GREENBERG, CLEMENT. "Milton Avery," in *Art and Culture.* Boston: Beacon Press, 1961.

————. "New York Painting Only Yesterday," *Art News,* Summer, 1957.

HOPPER, EDWARD. "Charles Burchfield, American," *The Arts* 14 (July, 1928).

KELDER, DIANE (ed.). *Stuart Davis.* New York: Praeger Publishers, 1971.

KIRSTEIN, LINCOLN, and LEVY, J. *Murals by American Painters and Photographers.* New York: Museum of Modern Art, 1932.

KOOTZ, SAMUEL. *Modern American Painters.* New York: Brewer and Warren, 1930.

KRAMER, HILTON. "The Legendary John Graham," *The New York Times,* May 29, 1966, Sec. 2, p. 13.

LANES, JERROLD. "Edward Hopper," *Artforum,* October, 1968.

LARKIN, OLIVER. *Twenty Years of Paintings by Philip Evergood.* New York: Whitney Museum of American Art, 1947.

MILLER, DOROTHY C., and BARR, ALFRED H., JR. (eds). *American Realists and Magic Realists.* With statements by the artists and an Introduction by Lincoln Kirstein. New York: Museum of Modern Art, 1943.

MORRIS, GEORGE L. K. *American Abstract Art.* New York: St. Etienne Galerie, 1940. Exhibition catalogue.

————. "To the American Abstract Artists," *Partisan Review,* March, 1938.

MORRIS, GEORGE L. K., and KIRSTEIN, LINCOLN. "Life or Death for Abstract Art?" *Magazine of Art* 36 (March, 1943).

MORSE, JOHN D. (ed.). *Ben Shahn.* New York: Praeger Publishers, 1972.

O'CONNOR, FRANCIS V. *Art for the Millions: Essays from the 1930's by Artists and Administrators of the WPA Federal Art Project.* Greenwich, Conn.: New York Graphic, 1973.

Bibliography

————. *Federal Art Patronage, 1933–1943.* College Park: University of Maryland Press, 1966.

————. *Federal Support for the Visual Arts: The New Deal and Now.* Greenwich, Conn.: New York Graphic, 1969.

O'CONNOR, FRANCIS V. (ed.). *The New Deal Art Projects: An Anthology of Memoirs.* Washington, D.C.: Smithsonian Institution Press, 1972.

O'DOHERTY, BRIAN. "Portrait: Edward Hopper," *Art in America* 52, No. 6 (December, 1964).

PEARSON, RALPH. "The Failure of the Art Critics," *Forum and Century* 94 (November, 1935–January, 1936).

Plastique (Paris), No. 3 (1938). Special number dedicated to American art.

RUBIN, WILLIAM. *The Paintings of Gerald Murphy.* New York: Museum of Modern Art, 1974.

SCHAPIRO, MEYER. "The Nature of Abstract Art," *Marxist Quarterly* 1 (January–March, 1937).

————. "Populist Realism," *Partisan Review,* December 1937–May, 1938.

SOBY, JAMES T. *Ben Shahn.* New York: Museum of Modern Art, 1947.

Stuart Davis Memorial Exhibition. Washington, D.C.: Smithsonian Institution, National Collection of Fine Arts, 1965.

WHEELER, MONROE. *Painters and Sculptors of Modern America.* New York: Museum of Modern Art, 1942.

WIGHT, FREDERICK S. *Hyman Bloom.* Boston: Institute of Contemporary Art, 1954.

WILSON, EDMUND. *The American Earthquake.* New York: Doubleday & Co., 1958.

CHAPTER SIX

ALBERS, JOSEF. *Interaction of Color.* 2 vols. New Haven: Yale University Press, 1963.

BAUR, JOHN I. H. *Bradley Walker Tomlin.* New York: Whitney Museum of American Art, 1957.

————. *Nature in Abstraction.* New York: Whitney Museum of American Art, 1958.

BLESH, RUDI. *Modern Art USA.* New York: Alfred A. Knopf, 1956.

CAHILL, HOLGER. *Modern Art in the United States: A Selection from the Collection of the Museum of Modern Art.* London: Tate Gallery, 1956.

CAMPBELL, LAWRENCE. "Diller: The Ruling Passion," *Art News,* October, 1968.

DAVENPORT, RUSSELL (ed.). "A *Life* Round Table on Modern Art," *Life,* October 11, 1948.

"Eleven Europeans in America," *Museum of Modern Art Bulletin* 13, Nos. 4–5 (1946).

GREENBERG, CLEMENT. "The Present Prospects of American Painting and Sculpture," *Horizon,* October, 1947.

286

GUGGENHEIM, PEGGY. *Confessions of an Art Addict.* New York: Macmillan Co., 1960.

———. *Out of This Century.* New York: Dial Press, 1946.

HESS, THOMAS B. *Willem de Kooning.* New York: Museum of Modern Art, 1968.

HOFMANN, HANS. *Search for the Real and Other Essays.* Rev. ed. Cambridge, Mass. M.I.T. Press, 1967.

HUNTER, SAM. *Hans Hofmann.* New York: Harry N. Abrams, 1963.

———. "Jackson Pollock," *Museum of Modern Art Bulletin* 24, No. 2 (1956–57).

"The Ides of Art: The Attitude of Ten Artists," *Tiger's Eye,* No. 2 (December, 1947).

Jackson Pollock. New York: Marlborough-Gerson Gallery, 1964.

JANIS, SIDNEY. *Abstract and Surrealist Art in America.* New York: Reynal & Hitchcock, 1944.

JOYNER, BROOKS. *The Drawings of Arshile Gorky.* College Park: University of Maryland (J. Millard Tawes Fine Arts Center), 1969.

KOOTZ, SAMUEL, and ROSENBERG, HAROLD. *The Intrasubjectives.* New York: Kootz Gallery, 1949.

MOTHERWELL, ROBERT. "The Modern Painter's World," *Dyn* 6 (1944).

———. "Painter's Objects," *Partisan Review,* Winter, 1944.

———. "The Rise and Continuity of Abstract Art," *Arts and Architecture* 68 (September, 1951).

O'CONNOR, FRANCIS V. "The Genesis of Jackson Pollock: 1912 to 1943." Unpublished Ph.D. dissertation, Johns Hopkins University, 1965.

The Peggy Guggenheim Collection. London: British Arts Council, 1964. Catalogue of an exhibition at the Tate Gallery, London, 1964–65.

"La Peinture aux Etats-Unis," *Art d'aujourd'hui,* June, 1951. Special number.

PEREIRA, I. R. "An Abstract Painter on Abstract Art," *American Contemporary Art,* October, 1944.

ROSENBERG, HAROLD. *Arshile Gorky.* New York: Grove Press, 1962.

RUBIN, WILLIAM S. "Arshile Gorky, Surrealism and the New American Painting," *Art International* 7 (February 25, 1963).

———. "Notes on Masson and Pollock," *Arts Magazine* 33 (November, 1959).

SCHAPIRO, MEYER. "Gorky: The Creative Influence," *Art News,* September, 1957.

SCHWABACHER, ETHEL K. *Arshile Gorky.* New York: Whitney Museum of American Art, 1957.

———. *Arshile Gorky: Memorial Exhibition.* New York: Whitney Museum of American Art, 1951.

SEITZ, WILLIAM C. "Abstract Expressionist Painting in America." Unpublished Ph.D. dissertation, Princeton University, 1955.

———. *Arshile Gorky.* New York: Museum of Modern Art, 1962.

———. *Hans Hofmann.* New York: Museum of Modern Art, 1963.

———. *Mark Tobey.* New York: Museum of Modern Art, 1962.

SPIES, WERNER. *Josef Albers.* New York: Harry N. Abrams, 1970.

Tiger's Eye. Nos. 1–9 (1947–49). Ed. R. and J. Stephan.

Bibliography

VVV. Nos. 1–4 (1924–44). Ed. David S. Hare. Editorial advisers: A. Breton, M. Duchamp, M. Ernst.

CHAPTER SEVEN

ALLOWAY, LAWRENCE. *Barnett Newman: The Stations of the Cross.* New York: Solomon R. Guggenheim Museum, 1966.

———. "The New American Painting," *Art International* 3, Nos. 3–4 (1959).

———. "Notes on Rothko," *Art International* 6 (Summer, 1966).

———. "Sign and Surface: Notes on Black and White Painting in New York," *Quadrum*, No. 9 (1960).

American Paintings: 1945–1957. Minneapolis: Minneapolis Institute of Arts, 1957.

American Vanguard. Washington, D.C.: United States Information Agency, 1961–62.

ARNASON, H. H. *Abstract Expressionists and Imagists.* New York: Solomon R. Guggenheim Museum, 1961.

———. "Robert Motherwell: 1947–1965," *Art International* 10 (April, 1966).

Artforum, September, 1965. A special number devoted to Abstract Expressionism.

ASHTON, DORE. *L'Art vivant aux Etats-Unis.* St. Paul de Vence: Fondation Maeght, 1970.

———. *Philip Guston.* New York: Grove Press, 1959.

———. *The Unknown Shore: A View of Contemporary Art.* Boston: Little, Brown and Co., 1962.

BAKER, ELIZABETH. "Barnett Newman in a New Light," *Art News,* February, 1967.

BRYANT, EDWARD. *Jack Tworkov.* New York: Whitney Museum of American Art, 1964.

Catalogues of the annual exhibitions: Art Institute of Chicago; Whitney Museum of American Art; Corcoran Gallery; University of Illinois Biennial; "Americans" exhibitions, Museum of Modern Art, selected by Dorothy Miller.

Clyfford Still: Paintings in the Albright-Knox Art Gallery. Buffalo, N.Y.: Buffalo Fine Arts Academy, 1966.

Contemporary American Painting. Columbus, Ohio: Solumbus Gallery of Fine Arts, 1960.

DEKOONING, ELAINE. *Franz Kline.* Washington, D.C.: Washington Gallery of Fine Art, 1962.

DOTY, ROBERT, and WALDMAN, DIANE. *Adolph Gottlieb.* New York: Whitney Museum of American Art and Solomon R. Guggenheim Museum, 1968.

Expressionism 1900–1955. Minneapolis: Walker Art Center, 1955.

The Face of the Fifties. Ann Arbor: University of Michigan Art Museum, 1961.

FRIEDMAN, B. H. (ed.). *School of New York: Some Younger Artists.* New York: Grove Press, 1959.

FRIEDMAN, MARTIN. *Adolph Gottlieb.* Minneapolis: Walker Art Center, 1963.

FULLER, MARY (ed.). "An Ad Reinhardt Monologue," *Artforum,* October, 1970.

288

GOLDWATER, ROBERT. "Reflections on the New York School," *Quadrum*, No. 8 (1960).

———. "Reflections on the Rothko Exhibit," *Arts Magazine* 35 (March, 1961).

GOOSSEN, E. C. "The Big Canvas," *Art International* 2 (November, 1958).

———. "Clyfford Still, Painting as Confrontation," *Art International* 4 (January, 1960).

———. "The Philosophic Line of Barnett Newman," *Art News*, Summer, 1958.

———. "Rothko: The Omnibus Image," *Art News*, January, 1961.

GORDON, JOHN. *Franz Kline: 1910–1962*. New York: Whitney Museum of American Art, 1968.

GOTTLIEB, ADOLPH. "Artist and Society, A Brief Case History," *College Art Journal* 14 (Winter, 1955).

———. "My Paintings," *Arts and Architecture* 68 (September, 1951).

GREENBERG, CLEMENT. "American-Type Painting" and "The Crisis of the Easel Picture," in *Art and Culture*. Boston: Beacon Press, 1961.

———. "The 'Crisis' of Abstract Art," in *Arts Yearbook 7*. New York: The Art Digest, 1964.

HAMILTON, GEORGE HEARD. *Josef Albers: Paintings, Prints, Projects*. New Haven: Yale University Art Gallery, 1956.

———. "Object and Image: Aspects of the Poetic Principle in Modern Art," in *Object and Image in Modern Art and Poetry*. New Haven: Yale University Art Gallery, 1954.

HESS, THOMAS B. *Abstract Painting: Background and American Phase*. New York: Viking Press, 1951.

———. *Barnett Newman*. New York: Walker, 1969.

———. *Barnett Newman*. New York: Museum of Modern Art, 1971.

———. *Willem de Kooning*. New York: George Braziller, 1959.

HUNTER, SAM. "Abstract Expressionism Then and Now," *Canadian Art* 21 (September–October, 1964).

———. *Art Since 1950*. Catalogue of an exhibition at the Seattle World's Fair, 1962.

———. *Philip Guston: Recent Paintings and Drawings*. New York: Jewish Museum, 1966.

———. "USA," in *Art Since 1945*. New York: Harry N. Abrams, 1958.

HUNTER, SAM, and LIPPARD, LUCY R. *Ad Reinhardt Paintings*. New York: Jewish Museum, 1967.

"Is Today's Artist With or Against the Past?" *Art News*, Summer and September, 1958. Article in two parts.

JUDD, DON. "Barnett Newman," *Studio International* 179 (February, 1970).

KAVOLIS, VYANTAS. "Abstract Expressionism and Puritanism," *Journal of Aesthetics and Art Criticism*, Spring, 1963.

KOZLOFF, MAX. "The Critical Reception of Abstract Expressionism," *Arts Magazine* 40 (December, 1965).

———. "The Impact of De Kooning," in *Arts Yearbook 7*. New York: The Art Digest, 1964.

Bibliography

————. "The Many Colorations of Black and White," *Artforum,* February, 1964.

KRAUSS, ROSALIND. "Robert Motherwell's New Paintings," *Artforum,* May 1969.

LITTMANN, ROBERT. *Bradley Walker Tomlin.* Hempstead, N.Y.: Emily Lowe Museum, Hofstra University, 1975.

McCAUGHEY, PATRICK. "Clyfford Still and the Gothic Imagination," *Artforum,* April, 1970.

MOTHERWELL, ROBERT. "The Painter and His Audience," *Perspectives USA,* No. 9 (Autumn, 1954).

MOTHERWELL, ROBERT, and REINHARDT, AD (eds.). *Modern Artists in America.* First Series. New York: Wittenborn, Schultz, 1952.

Museum of Modern Art Bulletin 18, No. 3 (Spring, 1951). Statements by members of the New York School.

The New American Painting. New York: Museum of Modern Art, 1959.

New York School. Los Angeles: Los Angeles County Museum of Art, 1965.

O'CONNOR, FRANCIS V. JACKSON POLLOCK. New York: Museum of Modern Art, 1967.

O'HARA, FRANK. *Jackson Pollock.* New York: George Braziller, 1959.

————. *Robert Motherwell.* New York: Museum of Modern Art, 1966.

Paintings by Clyfford Still. Buffalo, N.Y.: Albright Art Gallery, 1959.

POLLOCK, JACKSON. *Jackson Pollock.* Ed. Bryan Robertson. New York: Harry N. Abrams, 1960.

ROBERTSON, BRYAN. *Mark Rothko.* London: Whitechapel Art Gallery, 1961.

ROSENBERG, HAROLD. *The Anxious Object.* New York: Horizon Press, 1964.

————. "Hans Hofmann's Life Class," *Art News Annual (Portfolio),* No. 6 (1962).

————. "Tenth Street: A Geography of Modern Art," *Art News Annual,* No. 28 (1959).

————. *Tradition of the New.* New York: Horizon Press, 1959.

ROSENBLUM, ROBERT. "Abstract Sublime," *Art News,* February, 1961.

RUBIN, WILLIAM. "Adolph Gottlieb," *Art International* 3, Nos. 3–4 (1959).

————. *Jackson Pollock and the Modern Tradition.* New York: Harry N. Abrams, 1967.

SANDLER, IRVING. *The Triumph of American Painting: A History of Abstract Expressionism.* New York: Frederick A. Praeger, 1970.

SCHAPIRO, MEYER. "The Liberating Quality of Abstract Art," *Art News,* Summer, 1957.

————. "The Younger American Painters of Today," *The Listener* (London), January 26, 1956.

SEITZ, WILLIAM C. "Spirit, Time, and Abstract Expressionism," *Magazine of Art* 46 (February, 1953).

SELZ, PETER. *Mark Rothko.* New York: Museum of Modern Art, 1961.

SHARPLESS, TI-GRACE. *Clyfford Still.* Philadelphia: University of Pennsylvania Press, 1963.

————. *Clyfford Still: Thirty-Three Paintings in the Albright-Knox Art Gallery.* Buffalo, N.Y.: Albright-Knox Art Gallery, 1966.

Bibliography

60 American Painters, 1960. Minneapolis: Walker Art Center, 1960.
SWEENEY, JAMES J. "Recent Trends in American Painting," *Bennington College Alumnae Quarterly* 7, No. 1 (Fall, 1955).
TUCHMAN, MAURICE. *The New York School: Abstract Expressionism in the 40's and 50's.* London: Thames and Hudson, 1969.

CHAPTER EIGHT

ALLOWAY, LAWRENCE. *The Photographic Image.* New York: Solomon R. Guggenheim Museum, 1966.
———. *The Shaped Canvas.* New York: Solomon R. Guggenheim Museum, 1964.
———. *Six Painters and the Object.* New York: Solomon R. Guggenheim Museum, 1964.
———. *Systemic Painting.* New York: Solomon R. Guggenheim Museum, 1966.
AMAYA, MARIO. *Pop Art and After.* New York: Viking Press, 1965.
BAKER, ELIZABETH C. "The Light Brigade," *Art News,* March, 1967.
CAGE, JOHN. *Silence.* Middletown, Conn.: Wesleyan University Press, 1961.
CONE, JANE HARRISON. "Kenneth Noland's New Paintings," *Artforum,* November, 1967.
COPLANS, JOHN. "The Earlier Work of Ellsworth Kelly," *Artforum,* Summer, 1969.
———. "John McLaughlin, Hard Edge, and American Painting," *Artforum,* January, 1964.
———. "The New Paintings of Common Objects," *Artforum,* November, 1962.
———. *Roy Lichtenstein.* Pasadena, Calif.: Pasadena Art Museum, 1967.
COPLANS, JOHN (ed.). *Roy Lichtenstein.* New York: Praeger Publishers, 1972.
DE WILDE, E., and SCHMIED, WIELAND. *San Francis.* Amsterdam: Stedelijk Museum, 1968.
Exhibition catalogues: Venice and Sao Paulo biennials.
FINCH, CHRISTOPHER. *Pop Art: Object and Image.* New York: E. P. Dutton, 1968.
FORGE, ANDREW. *Robert Rauschenberg.* New York: Harry N. Abrams, 1969.
FRIED, MICHAEL. "Frank Stella's New Paintings," *Artforum,* November, 1966.
———. *Kenneth Noland.* New York: Jewish Museum, 1965.
———. "Modernist Painting and Formal Criticism," *The American Scholar,* Autumn, 1964.
———. *Morris Louis.* New York: Harry N. Abrams, 1970.
———. "Olitski and Shape," *Artforum,* January, 1967.
———. *Three American Painters.* Cambridge, Mass.: Fogg Art Museum, 1965. Olitski, Noland, Stella.
GOODRICH, LLOYD. *Young America 1965: Thirty American Artists Under Thirty-five.* New York: Frederick A. Praeger, 1965.
GOOSSEN, E. C. *Ellsworth Kelly.* Greenwich, Conn.: New York Graphic, 1973.

Bibliography

GREENBERG, CLEMENT. "After Abstract Expressionism," *Art International* 6 (October 25, 1962).

——. "Louis and Noland," *Art International* 4 (May 25, 1960).

——. *Post-Painterly Abstraction.* Los Angeles: Los Angeles County Museum of Art, 1964.

HOPPS, WALTER. *Catalogue of the VIII Sao Palo Biennial.* Washington, D.C.: National Collection of Fine Arts, 1966. Additional bibliography: Bell, Bengston, Irwin, Judd, Newman, Poons, Stella.

HUNTER, SAM. *Larry Rivers.* New York: Jewish Museum, 1966.

KAPROW, ALLAN. "The Legacy of Jackson Pollock," *Art News,* October, 1958.

KAUFMANN, RUTH, and McCOUBREY, JOHN. *The Disappearance and Reappearance of the Image: American Painting Since 1945.* Washington, D.C.; National Collection of Fine Arts, 1969.

KIRBY, MICHAEL. *Happenings.* New York: E. P. Dutton, 1965.

Kompass III, New York (Painting After 1945 in New York). Eindhoven: Stedelijk van Abbemuseum, 1967.

KOZLOFF, MAX. "Men and Machines," *Artforum,* February, 1969.

——. "'Pop' Culture, Metaphysical Disgust and the New Vulgarians," *Art International* 6 (March, 1962).

——. "Problems of Criticism, III: Venetian Art and Florentine Criticism," *Artforum,* December, 1967.

KRAUSS, ROSALIND. *Jules Olitski: Recent Paintings.* Philadelphia: University of Pennsylvania, Institute of Contemporary Art, 1968.

——. "On Frontality," *Artforum,* May, 1968.

——. "Problems of Criticism, X: Pictorial Space and the Question of Documentary," *Artforum,* November, 1971.

LIPPARD, LUCY R. "Larry Poons: The Illusion of Disorder," *Art International* 11 (April, 1967).

——. "Perverse Perspectives," *Art International* 11 (March, 1967).

——. *Pop Art.* New York: Frederick A. Praeger, 1966.

McSHINE, KYNASTON. *Josef Albers.* New York: Museum of Modern Art, 1964.

New Abstraction, Das Kunstwerk 18, Nos. 10–12 (April–June, 1965).

OLDENBURG, CLAES. "The Artists Say," *Art Voices* (Summer, 1965).

PINCUS-WITTEN, ROBERT. "'Systemic' Painting," *Artforum,* November, 1966.

REISE, BARBARA. "Greenberg and The Group: A Retrospective View," *Studio International* 175 (May and June, 1968). Article in two parts.

Richard Diebenkorn. Washington, D.C.: Washington Gallery of Modern Art, 1964.

ROSE, BARBARA. "Abstract Illusionism," *Artforum,* October, 1967.

——. "Dada Then and Now," *Art International* 7 (January, 1963).

——. "The Primacy of Color," *Art International* 8 (May, 1964).

ROSENBLUM, ROBERT. "Morris Louis at the Guggenheim Museum," *Art International* 7 (December, 1963).

——. "Pop and Non-Pop: An Essay in Distinction," *Canadian Art* 23 (January, 1966).

RUBIN, WILLIAM. "Ellsworth Kelly: The Big Form." *Art News,* November, 1963.
————. "Younger American Painters," *Art International* 4 (January, 1960).
SANDLER, IRVING. "Baziotes: Modern Mythologist," *Art News,* February, 1965.
SEITZ, WILLIAM C. *The Responsive Eye.* New York: Museum of Modern Art, 1964.
SOLOMON, ALAN. *The Popular Image Exhibition.* Washington, D.C.: Washington Gallery of Modern Art, 1963.
————. *Robert Rauschenberg.* New York: Jewish Museum, 1963.
————. *XXXII International Biennial Exhibition of Art, Venice, 1964, United States of America.* New York: Jewish Museum, 1964. Chamberlain, Dine, Johns, Louis, Noland, Oldenberg, Rauschenberg, Stella.
STEINBERG, LEO. *Jasper Johns.* New York: George Wittenborn, 1963.
TILLIM, SIDNEY. "The New Avant-Garde," *Arts Magazine* 38 (February, 1964).
————. "Realism and the Problem," *Arts Magazine* 37 (September, 1963).
————. "What Happened to Geometry?" *Arts Magazine* 33 (June, 1959).
TUCKER, MARCIA. *The Structure of Color.* New York: Whitney Museum of American Art, 1971.
WALDMAN, DIANE. *Roy Lichtenstein: Drawings and Prints.* New York: Chelsea House, 1969.

CHAPTER NINE

Art in Process: The Visual Development of a Painting. New York: Finch College Museum of Art, 1965.
BANNARD, WALTER D. "Present-Day Art and Ready-Made Styles," *Artforum,* December, 1966.
BATTCOCK, GREGORY (ed.). *Minimal Art: A Critical Anthology.* New York: E. P. Dutton, 1968.
BOCHNER, MEL. "The Serial Attitude," *Artforum,* December, 1967.
CALAS, NICOLAS, and CALAS, ELENA. *Icons and Images of the Sixties.* New York: E. P. Dutton, 1971.
CARMEAU, E. A. *The Great Decade of American Abstraction.* Houston, Tex.: Houston Museum of Fine Arts, 1974.
CONE, JANE HARRISON. *Walter Darby Bannard.* Baltimore: Walters Art Gallery, 1974.
COPLANS, JOHN. *Andy Warhol.* Greenwich, Conn.: New York Graphic, 1970.
————. *Ellsworth Kelly.* New York: Harry N. Abrams, 1972.
————. *Serial Images.* Pasadena, Calif.: Pasadena Art Museum, 1968.
CRONE, RAINER. *Andy Warhol.* New York: Praeger Publishers, 1970.
Documenta III: Internationale Ausstellung Malerei und Skulptur. Kassel: Museum Fridericianum, 1964.
Documenta IV: Internationale Ausstellung. Kassel: Museum Fridericianum, 1968.
FRIED, MICHAEL. "Art and Objecthood," *Artforum,* June, 1967.

Bibliography

GELDZAHLER, HENRY. *New York Painting and Sculpture: 1940–1970.* New York: E. P. Dutton, 1969.

GOOSSEN, E. C. *The Art of the Real: U.S.A. 1948–1968.* New York: Museum of Modern Art, 1968.

GREENBERG, CLEMENT. "Avant-Garde Attitudes: New Art in the Sixties," *Studio International* 179 (April, 1970).

HESS, THOMAS B. "Phony Crisis in American Art," *Art News,* Summer, 1963.

JUDD, DON. "Black, White and Gray," *Arts Magazine* 38 (March, 1964).

KOZLOFF, MAX. "Art and the New York Avant-Garde," *Partisan Review,* Fall, 1964.

——. "The Inert and the Frenetic," *Artforum,* March, 1966.

KOZLOFF, MAX (ed.). *Jasper Johns.* New York: Harry N. Abrams, 1967.

KRAMER, HILTON. "Episodes from the Sixties," *Art in America* 58, No. 1, (January–February, 1970).

LIPPARD, LUCY R. "Homage to the Square," *Art in America* 55, No. 4, (July–August), 1967.

——. "The Third Stream: Constructed Paintings and Painted Structures," *Art Voices* 4 (Spring, 1965).

MELLOW, JAMES R. (ed.). "The Art World," *Arts Yearbook* 7. New York: The Art Digest, 1964.

MURDOCK, ROBERT M. *Modular Painting.* Buffalo, N.Y.: Albright-Knox Art Gallery, 1970.

NODELMAN, SHELDON. "Sixties Art: Some Philosophical Perspectives," *Perspecta 11: The Yale Architectural Journal,* 1967.

PLAGENS, PETER. "Present-Day Styles and Ready-Made Criticism," *Artforum,* December, 1966.

——. *Sunshine Muse.* New York: Praeger Publishers, 1974.

ROSE, BARBARA. "ABC Art," *Art in America* 53, No. 5 (October–November, 1965).

——. *A New Aesthetic.* Washington, D.C.: Washington Gallery of Modern Art, 1967.

——. *Helen Frankenthaler.* New York: Harry N. Abrams, 1971.

——. "Pop Art in Perspective," *Encounter,* September, 1963.

——. "Problems of Criticism, IV: The Politics of Art, Part 1," *Artforum,* February, 1968.

——. "Problems of Criticism, V: The Politics of Art, Part 2," *Artforum,* January, 1969.

——. "Problems of Criticism, VI: The Politics of Art, Part 3," *Artforum,* May, 1969.

——. "The Value of Didactic Art," *Artforum,* April, 1967.

ROSENBERG, HAROLD. *Artworks and Packages.* New York: Horizon Press, 1969.

ROSENBLUM, ROBERT. *Frank Stella.* Baltimore: Penguin Books, 1970.

RUBIN, WILLIAM S. *Frank Stella.* New York: Museum of Modern Art, 1970.

RUSSELL, JOHN, and GABLIK, SUZI. *Pop Art Redefined.* New York: Praeger Publishers, 1969.

Bibliography

TILLIM, SIDNEY. "Scale and the Future of Modernism," *Artforum*, October, 1967.
WOLLHEIM, RICHARD. "Minimal Art," *Arts Magazine* 39 (January, 1965).

CHAPTER TEN

ALDRICH, LARRY. *Lyrical Abstraction*. New York: Whitney Museum of American Art, 1971.
ANTIN, DAVID. "Art and the Corporations," *Art News*, September, 1971.
BATTCOCK, GREGORY (ed.). *Idea Art: A Critique*. New York: E. P. Dutton, 1973.
BURNHAM, JACK. "Alice's Head: Reflections on Conceptual Art," *Artforum*, February, 1970.
————. "Corporate Art," *Artforum*, October, 1971.
BURNHAM, JACK, and NELSON, T. H. *Software*. New York: Jewish Museum, 1970.
CALAS, NICOLAS. "Documentizing," *Arts Magazine* 44 (May, 1970).
CELANT, GERMANO. *Art "Povera."* New York: Frederick A. Praeger, 1969.
————. *Photo-Realism*. Hartford: Wadsworth Atheneum, 1974.
COE, RALPH T. *The Magic Theatre: An Exhibition*. Kansas City: Nelson Gallery–Atkins Museum, 1968.
DAVIS, DOUGLAS. *Art and the Future: A History/Prophecy of the Collaboration Between Science, Technology and Art*. New York: Praeger Publishers, 1973.
DOTY, ROBERT. *Light: Object and Image*. New York: Whitney Museum of American Art, 1968.
Earth Art. Ithaca, N.Y.: Andrew Dickson White Museum of Art, Cornell University, 1968.
FRY, EDWARD F. (ed.). *On the Future of Art*. New York: Viking Press, 1970.
Gilliam/Edwards/Williams: Extensions. Hartford: Wadsworth Atheneum, 1974.
GOLDIN, AMY, and KUSHNER, ROBERT. "Concept Art as Opera," *Art News*, April, 1970.
KAPROW, ALLAN. *Assemblage, Environments and Happenings*. New York: Harry N. Abrams, 1966.
————. "Experimental Art," *Art News*, March, 1966.
————. "The Happenings are Dead—Long Live the Happenings," *Artforum*, March, 1966.
KIRBY, MICHAEL. *The Art of Time: Essays on the Avant-Garde*. New York: E. P. Dutton, 1969.
————. *Happenings, An Illustrated Anthology*. New York: E. P. Dutton, 1966.
KOSUTH, JOSEPH. "Art After Philosophy," *Studio International* 178 (October–December, 1969). Article in three parts.
KOZLOFF, MAX. "The Multimillion Dollar Art Boondoggle, *Artforum*, (October, 1971).
————. "9 in a Warehouse," *Artforum*, February, 1969.
LEWITT, SOL. "Paragraphs on Conceptual Art," *Artforum*, June, 1967.

Bibliography

LICHT, JENNIFER. *Eight Contemporary Artists.* New York: Museum of Modern Art, 1974.

———. *Spaces.* New York: Museum of Modern Art, 1969.

LIPPARD, LUCY R. *Six Years: The Dematerialization of the Art Object.* New York: Praeger Publishers, 1973.

LIPPARD, LUCY R., and CHANDLER, JOHN. "The Dematerialization of Art," *Art International* 12 (February, 1968).

McSHINE, KYNASTON. *Information.* New York: Museum of Modern Art, 1970.

MEADMORE, CLEMENT. "Thoughts on Earthworks, Random Distribution, Softness, Horizontality and Gravity," *Arts Magazine* 43 (February, 1969).

MEYER, URSULA. *Conceptual Art.* New York: E. P. Dutton, 1973.

MICHELSON, ANNETTE. "10 x 10: Concrete Reasonableness," *Artforum* (January, 1967).

MORRIS, ROBERT. "Anti-Form," *Artforum,* April, 1968.

NEMSER, CINDY. "Subject–Object: Body Art," *Arts Magazine* 46 (September–October, 1971).

NOCHLIN, LINDA. *Philip Pearlstein.* Athens, Ga.: Museum of Art, University of Georgia, 1970.

———. "The Ugly American," *Art News,* September, 1970.

PINCUS-WITTEN, ROBERT. "Anglo-American Standard Reference Works: Acute Conceptualism," *Artforum,* October, 1971.

POMEROY, R. "Soft Objects," *Arts Magazine* 43 (March, 1969).

Projected Images: Peter Campus, Rockne Krebs, Paul Sharits, Michael Snow, Ted Victoria, Robert Whitman. Minneapolis: Walker Art Center, 1974.

ROSE, BARBARA. "The Graphic Work of Jasper Johns," *Artforum,* March and September, 1970. Article in two parts.

———. *The Vincent Melzac Collection.* Washington, D.C.: Corcoran Gallery of Art, 1972. Washington Color School paintings.

SHARP, WILLOUGHBY. "Air Art," *Studio International* 175 (May, 1968).

SIEGELAUB, SETH (ed.). *Carl Andre, Robert Barry, Douglas Huebler, Joseph Kosuth, Sol LeWitt, Robert Morris, Lawrence Weiner.* New York: Siegelaub–Wendler, 1968.

Soft Art. Trenton: New Jersey State Museum, 1969.

TILLIM, SIDNEY. "Realism and 'The Problem,'" *Arts Magazine* 37 (September, 1963).

———. "The Reception of Figurative Art: Notes on a General Misunderstanding," *Artforum,* February, 1969.

———. "A Variety of Realisms," *Artforum,* Summer, 1969.

TUCHMAN, MAURICE. *Art and Technology.* New York: Viking Press, 1971.

TUCKER, MARCIA. "PheNAUMANology," *Artform,* December, 1970.

WALDMAN, DIANE. "Samaras: Reliquaries for St. Sade," *Art News,* October, 1966.

WHITMAN, SIMONE. "Nine Evenings of Theater and Engineering: Notes of a Participant," *Artforum,* February, 1967.

CHAPTER ELEVEN

AGEE, WILLIAM C. *Don Judd.* New York: Whitney Museum of American Art, 1968.
"American Sculpture," *Artforum,* Summer, 1967. Special issue.
ANDERSEN, WAYNE V. *The Sculpture of Herbert Ferber.* Minneapolis: Walker Art Center, 1962.
ARNASON, H. H. *Alexander Calder.* Princeton, N.J.: Van Nostrand, 1966.
————. *Theodore Roszak.* New York: Whitney Museum of American Art, 1956.
"Contemporary Sculpture," *Arts Yearbook* 8. New York: The Art Digest, 1965. Introduction by William C. Seitz.
ASHTON, DORE. *Modern American Sculpture.* New York: Harry N. Abrams, 1968.
BAKER, ELIZABETH C. "Critics' Choice: Serra," *Art News,* February, 1970.
BARO, GENE. *Claes Oldenburg: Drawings and Prints.* New York: Chelsea House, 1969.
BOCHNER, MEL. "Primary Structures," *Arts Magazine* 40 (June, 1966).
BURNHAM, JACK. *Beyond Modern Sculpture: The Effects of Science and Technology on the Sculpture of This Century.* New York: George Braziller, 1968.
————. *The Structure of Art.* New York: George Braziller, 1971.
Catalogues of the Whitney Museum of American Art Annual.
CONE, JANE HARRISON. *David Smith.* Cambridge, Mass.: Fogg Art Museum, 1965.
COPLANS, JOHN. *Don Judd.* Pasadena, Calif.: Pasadena Art Museum, 1971.
CORTESI, ALESSANDRA. "Cornell," *Artforum,* April, 1966.
DEVELING, ENNO. *Carl Andre.* The Hague: Gemeentemuseum, 1969.
FORSYTH, ROBERT J. *John B. Flannagan.* Notre Dame, Ind.: University of Notre Dame Press, 1963.
Fourteen Sculptors: The Industrial Edge. Minneapolis: Walker Art Center, 1969.
FRIEDMAN, MARTIN, and VAN DER MARCK, JAN. *Eight Sculptors: The Ambiguous Image.* Minneapolis: Walker Art Center, 1966.
FRY, EDWARD F. *David Smith.* New York: Solomon R. Guggenheim Museum, 1969.
GIEDION-WELCKER, CAROLA. *Contemporary Sculpture: An Evolution in Volume and Space.* New York: George Wittenborn, 1955. Calder, Ferber, Hare, Lassaw, Lippold, Lipton, Smith.
GOODALL, DONALD. "Gaston Lachaise, 1882–1935," *Massachusetts Review,* Summer, 1960.
GOOSSEN, E. C. "The End of the Object," *Art International* 3, No. 8 (1959).
————. "Herbert Ferber," in *Three American Sculptors.* New York: Grove Press, 1959.
GORDON, JOHN. *Louise Nevelson.* New York: Whitney Museum of American Art, 1967.
GRAHAM, DAN. "Models and Monuments: The Plague of Architecture," *Arts Magazine* 41 (March, 1967).

Bibliography

Gray, Cleve (ed.). *David Smith by David Smith.* New York: Holt, Rinehart & Winston, 1968.

Greenberg, Clement. "Cross-Breeding of Modern Sculpture," *Art News,* Summer, 1952.

———. "David Smith" and "Modernist Sculpture, Its Pictorial Past," in *Art and Culture,* Boston: Beacon Press, 1961.

———. "David Smith's New Sculpture," *Art International* 8 (May, 1964).

———. "Recentness of Sculpture," *Art International* 11 (April, 1967).

Gregor, Waylande. "The Present Impasse in Sculpture," First American Writers Congress, 1936.

Griffen, Howard. "Auriga, Andromeda, Camelopardis," *Art News,* December, 1957. On Joseph Cornell.

Hess, Thomas B. "New Directions in American Sculpture," *Art News Annual (Portfolio),* No. 1 (1959).

Hudson, Andrew. "Scale as Content," *Artforum,* December, 1967.

Hulten, K. G. Pontus. *Edward Kienholz: 11 + 11 Tableaux.* Stockholm: Moderna Musset, 1970.

Hunter, Sam. "David Smith," *Museum of Modern Art Bulletin* 25, No. 1 (1957).

Hutchinson, Peter. "Earth in Upheaval: Earthworks and Landscapes," *Arts Magazine* 43 (November, 1968).

"The Ides of Art: 14 Sculptors Write," *Tiger's Eye,* No. 4 (June, 1948).

Johnson, Ellen. *Claes Oldenburg.* London: Penguin, 1971.

Kirstein, Lincoln. *Elie Nadelman.* New York: Museum of Modern Art, 1948.

———. *Gaston Lachaise.* New York: Museum of Modern Art, 1935.

Kozloff, Max. "Further Adventures of American Sculpture," *Arts Magazine* 39 (February, 1965).

———. "Mark di Suvero," *Artforum,* Summer, 1967.

Kramer, Hilton. *David Smith.* Los Angeles: Los Angeles County Museum of Art, 1965–1966.

———. The Sculpture of David Smith," *Arts Magazine* 34 (February, 1960).

———. *The Sculpture of Gaston Lachaise.* New York: Eakins Press, 1967.

Krauss, Rosalind. *Terminal Ironworks: The Sculpture of David Smith.* Cambridge, Mass.: M.I.T. Press, 1971.

Leering, Jan. *Don Judd.* Eindhoven: Stedelijk van Abbemuseum, 1970.

Lippard, Lucy R. "Eva Hesse: The Circle," *Art in America,* 59, No. 3 (May–June, 1971).

———. *Minimal Art.* The Hague: Gemeentemuseum, 1968.

———. "Sol Lewitt: Non-Visual Structures," *Artforum,* April, 1967.

———. "Tony Smith: 'The Ineluctable Modality of the Visible,' " *Art International* 11 (Summer, 1967).

Livingston, Jane, and Tucker, Marcia. *Bruce Nauman.* New York: Whitney Museum of American Art, 1973.

MacAgy, Douglas. *On the Move.* New York: Howard Wise Gallery, 1964.

McCoy, Garnett (ed.). *David Smith.* New York: Praeger Publishers, 1973.

McShine, Kynaston. *Primary Structures.* New York: Jewish Museum, 1966.

MICHELSON, ANNETTE. "Noguchi: Notes on a Theatre of the Real," *Art International* 8 (December, 1964).
————. *Robert Morris.* Washington, D.C.: Corcoran Gallery of Art, 1969.
MILLER, DOROTHY C. (ed.). *The Sculpture of John Flannagan.* New York: Museum of Modern Art, 1942.
MORRIS, GEORGE L. K. "Relations of Painting and Sculpture," *Partisan Review,* January–October, 1943.
————. "Le Sculpture abstraite aux U.S.A.," *Art d'aujourd'hui,* January, 1953.
MORRIS, ROBERT. "Notes on Sculpture, Part 1," *Artforum,* February, 1966.
————. "Notes on Sculpture, Part 2," *Artforum,* October, 1966.
————. "Notes on Sculpture, Part 3: Notes and Nonsequiturs," *Artforum,* Summer, 1967.
————. "Notes on Sculpture, Part 4: Beyond Objects." *Artforum,* April, 1969.
"The New Sculpture: A Symposium." New York: Museum of Modern Art, 1952. Typescript of a symposium with Ferber, Lippold, Roszak, and David Smith.
NOGUCHI, ISAMU. "Meanings in Modern Sculpture," *Art News,* March, 1949.
————. *A Sculptor's World.* New York: Harper & Row, 1968.
O'HARA, FRANK. *Nakian.* New York: Museum of Modern Art, 1966.
PINCUSS-WITTEN, ROBERT. "Eva Hesse: Post-Minimalism into Sublime," *Artforum,* November, 1971.
POPPER, FRANK. *Kunst Licht Kunst.* Eindhoven: Stedelijk van Abbemuseum, 1966.
RICKEY, GEORGE. *Constructivism: Origins and Evolution.* New York: George Braziller, 1967.
RITCHIE, ANDREW C. *Sculpture of the Twentieth Century.* New York: Museum of Modern Art, 1952.
ROSE, BARBARA. "Blowup—the Problem of Scale in Sculpture," *Art in America* 56, No. 4 (July–August, 1968).
————. *Claes Oldenburg.* New York: Museum of Modern Art, 1970.
————. "Ellsworth Kelly as Sculptor," *Artforum,* Summer, 1967.
————. "Looking at American Sculpture," *Artforum,* February, 1965.
ROSENSTEIN, HARRIS. "Di Suvero: The Pressures of Reality," *Art News,* February, 1967.
RUBIN, WILLIAM. "David Smith," *Art International* 7 (December 5, 1963).
SCHNIER, JACQUES. *Sculpture in Modern America.* Berkeley: University of California Press, 1948.
Sculpture in America Today. Los Angeles: Los Angeles County Museum of Art, 1967.
SEITZ, WILLIAM C. *The Art of Assemblage.* New York: Museum of Modern Art, 1961.
SHIREY, DAVID L. "Impossible Art—What It Is (Earthworks)," *Art in America* 57 (May–June, 1969).
SMITH, DAVID. "The Language Is Image," *Arts and Architecture* 69 (February, 1952).

Bibliography

————. "The Secret Letter," in *David Smith*. New York: Marlborough-Gerson Gallery, 1964. Interview by Thomas B. Hess.

SMITHSON, ROBERT. "A Sedimentation of the Mind: Earth Projects," *Artforum,* September, 1968.

SWEENEY, JAMES J. *Alexander Calder.* New York: Solomon R. Guggenheim Museum, 1964.

TILLIM, SIDNEY. "The Underground Pre-Raphaelitism of Edward Kienholz," *Artforum,* April, 1965.

TUCHMAN, MAURICE. *American Sculpture of the Sixties.* Los Angeles: Los Angeles County Museum of Art, 1967.

TUCHMAN, PHYLLIS. "An Interview with Carl Andre," *Artforum,* June, 1970.

VARIAN, ELAYNE H. *Art in Process: The Visual Development of a Structure.* New York: Finch College Museum of Art, 1966.

WALDMAN, DIANE. *Carl Andre.* New York: Solomon R. Guggenheim Museum, 1970.

————. "Holding the Floor," *Art News,* October, 1970.

Index

Index

Index

Index

Index

Twice recipient of the College Art Association's Mather Award for Distinguished Art Criticism, **Barbara Rose** has taught at Queens College, Sarah Lawrence College, the University of California at Irvine, Yale University, and Hunter College. Formerly a contributing editor of *Art International, Art in America,* and *Artforum* magazines, she is currently making documentary films on American art and writing art criticism for *Partisan Review.*